REWARD OF MERIT.

This Certifies, that by diligence and good behaviour, merits the approbation of Friends and Instructor.

REWARD OF MERIT.

This Certifies, that by diligence and good behaviour, merits the approbation of Friends and Instructor.

REWARD OF MERIT.

This Certifies, that by diligence and good behaviour, merits the approbation of Friends and Instructor.

REWARD OF MERIT.

This Certifies, that by diligence and good behaviour, merits the approbation of Friends and Instructor.

REWARD OF MERIT.

TEN CENTS.

This Certifies, that by diligence and good behaviour, merits the approbation of Friends and Instructor.

REWARD OF MERIT.

May all who worth distinguish, worth regard,
And give to MERIT its deserv'd reward.

This Certifies, that by diligence and good behaviour, merits the approbation of Friends and Instructor.

REWARD OF MERIT.

This Certifies, that by diligence and good behaviour, merits the approbation of Friends and Instructor.

REWARD OF MERIT.

TEN CENTS.

This Certifies, that by diligence and good behaviour, merits the approbation of Friends and Instructor.

REWARD OF MERIT.

This Certifies, that by diligence and good behaviour, merits the approbation of Friends and Instructor.

REWARD OF MERIT.

This Certifies, that by diligence and good behaviour, merits the approbation of Friends and Instructor.

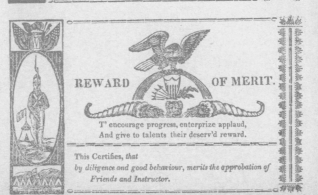

REWARD OF MERIT.

T' encourage progress, enterprize applaud,
And give to talents their deserv'd reward.

This Certifies, that by diligence and good behaviour, merits the approbation of Friends and Instructor.

REWARD OF MERIT.

This Certifies, that by diligence and good behaviour, merits the approbation of Friends and Instructor.

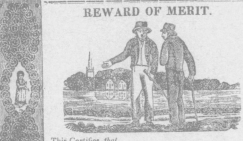

REWARDS OF MERIT

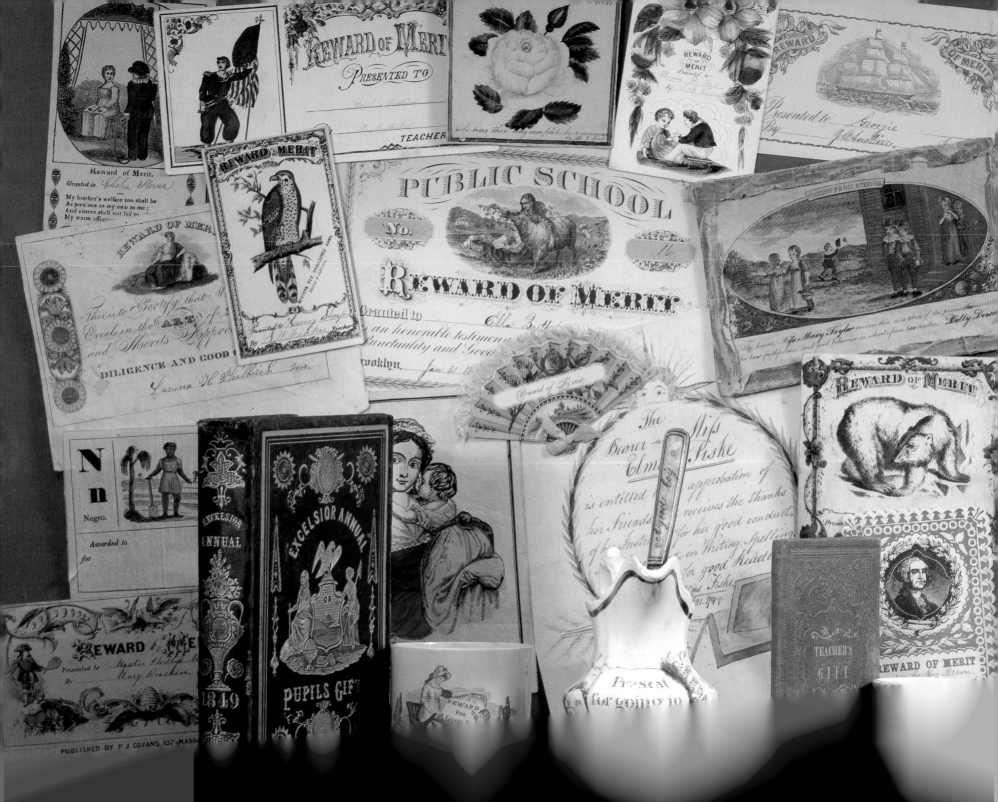

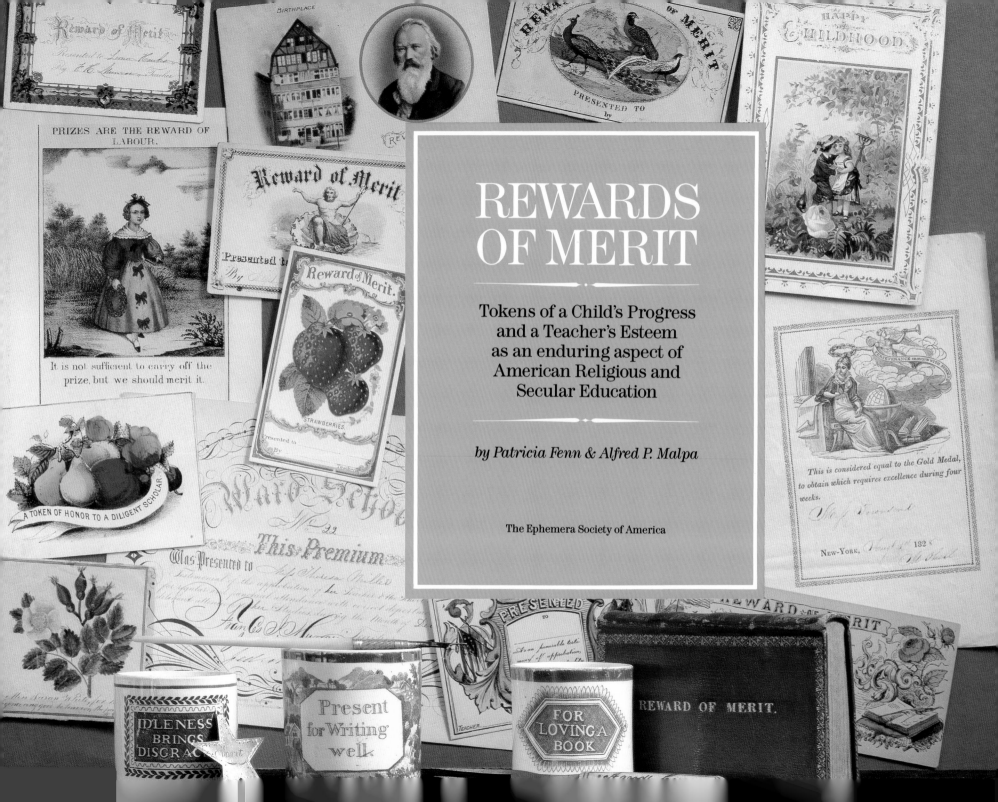

REWARDS OF MERIT

Tokens of a Child's Progress
and a Teacher's Esteem
as an enduring aspect of
American Religious and
Secular Education

by Patricia Fenn & Alfred P. Malpa

The Ephemera Society of America

Book design by Jack Golden

Printed and bound in Hong Kong

Library of Congress Cataloging-in-Publication Data
Fenn, Patricia.
 Rewards of merit: tokens of a child's progress and a teacher's
 esteem as an enduring aspect of American religious and secular
 education/Patricia Fenn.
 p. cm.
 Includes bibliographical references and index.
 ISBN 0-943231-68-X

1. Education—United States—History. 2. Printed ephemera—
United States—History. 3. Rewards (Prizes, etc.)—United States—
History. 4. Reward (Psychology) in children—United States—
History. 5. Sunday schools—United States—History. I. Title.

LA230.F46 1994 370.973 QB194-1706

The Ephemera Society of America

Distributed by Howell Press, Inc., 1147 River Road, Suite 2.
Charlottesville, Virginia 22901. Telephone 804-977-4006

First printing

TABLE OF CONTENTS

Rockwell Gardiner, known as Rocky to everyone, was both self-taught and an expert in the revelations of Ephemera. Young Rocky collected stamps with zeal; by the age of twenty he had become an antiquarian entrepreneur. He was indefatigable at tracking down the scholarly history of each and every item he handled, whether a pewter tankard, a Shaker basket, or a first edition. And he became adept at perceiving and telling the story behind artifacts.

Rocky told me one of the most important things about the antiques business was that each and every item has an equal value and should be handled the same. For him, a small advertising label or a George Washington document were respected alike for what they revealed about the past. And, for Rocky, having them pass through his hands was a particular joy—easily communicated to his friends, colleagues, and disciples. His passion for the scraps of history was expressed in a paraphrase of Will Rogers: "I never met a piece of ephemera I didn't like."

Rocky was a dealers' dealer—virtually everything he amassed was available for sale to fellow enthusiasts. But there was one type of treasure that he quietly squirreled away. His secret collecting of Rewards of Merit surfaced when I introduced him to another passionate collector, Alfred P. Malpa, in 1980.

Al had been collecting Rewards of Merit for about ten years; Rocky for over forty. When these two grown men began to compare notes and show off their finest pieces, they were like two kids in a candy store not knowing the limit of the "goodies." The two were thereafter bonded—committed to discovering everything they could about the educational practice of rewarding children with gifts.

Prior to Rocky's death in 1986, they had discussed publishing a book on their shared love. At the time, not even they knew the extent of the story which would be found as these small historic documents were brought into focus. They agreed to amalgamate the best of their two collections, in Al's care. The Rockwell Gardiner and Alfred P. Malpa Collection of Rewards of Merit and School Ephemera is the foundation of this book.

The Ephemera Society of America, Inc., is proud to be affiliated with the Rockwell Gardiner Memorial Fund, established in 1986 to foster this publication. We were indeed fortunate to find Patricia Fenn, an historian of education, to collaborate with Al Malpa while researching and writing this important study of Rewards of Merit.

William Frost Mobley
President,
The Ephemera Society of America Inc.

Rocky Gardiner was a nice man. Of course, he was far more than nice, but that is what always comes to mind first in my memories of him. Certainly, anyone who knew him would agree it is reason enough alone to dedicate this volume to him. However, the actual reason is something quite different—curiosity.

Rocky grew up in a fairly remote part of upstate New York, had a basic education there, and then got on to more important and interesting things. And what was more important and interesting? Anything that increased his knowledge about everything! For Rocky was blessed with the most insatiable curiosity I have ever known. It is the basic reason he became the person we knew, and why he did not spend his life on the banks of the upper Hudson River. It is also the reason we have this book.

Let's face it—Rewards of Merit do not necessarily stir the loins of all of us. Nevertheless, they do perfectly symbolize Rocky's unlimited curiosity. Tom Sawyer may have been the first to recognize their value as trading material, but Rocky was almost certainly among the first to appreciate fully their importance in the record of our heritage. He used to say that he collected Rewards of Merit because he liked them, but Rocky liked a lot of things and collected very little. His collection is evidence enough of their importance among his many interests.

Not surprisingly, a conversation with Rocky was like a trip through the Smithsonian, with frequent stops at the library. A name or place or event would send him to the bookshelf for the appropriate reference and the original topic would be left in the dust. You never knew where you were going to end up, but you did know it would not likely be where you began since Rocky's curiosity was charting the course. Curiosity shaped that most wonderful of places—Rocky's "barn." Here he kept the gatherings of a lifetime: everything from walking sticks to Wedgwood, but most especially the paper (lately, ephemera). Rocky was a pioneer in collecting all types of ephemera, including his beloved "cats." There were catalogs everywhere, often held together by his famous rubber bands—made out of slices of inner tubes! The "barn" was unique—as was his security system, which consisted of handmade signs: "Warning! Booby-Trapped! Keep Out!"

Of course, there were no booby traps. Rocky liked people too much for that. Avis Gardiner, Rocky's wife, has often said that she never heard him criticize anyone and that he seemed to like everybody. Well, certainly everybody liked, and loved, Rocky. And why not? He had time for all, and he shared anything he knew with any who asked. His booming voice in the next aisle at a show was a welcome sound for legions of dealers and collectors. He was always surrounded by admirers and one wonders how he ever managed to buy anything.

Even when he no longer had much "wim and wigor," most days Rocky would be standing at the kitchen sink soaking and washing his paper. He never stopped reaching for the references and searching for the knowledge. We are pleased to be able to share his collection and his curiosity about his favorite things—Rewards of Merit.

George N. Johnson, Jr.

"Everything is so interesting." This quote from my father, Rockwell Gardiner, sums up his passion for knowledge in general and antiques in particular. Born on March 8, 1911, he grew up in a handsome 1812 house full of antiques and paintings, in Hadley, New York, near Lake Lucerne. Even in the seventies, I could wander through the rooms and find a treasure such as an ornately carved nineteenth-century mandolin with a sterling silver fretboard. The house slowly lost its precious furnishings over the years but I saw photos of some of the many paintings that had hung on its walls. From these and my father's reminiscences, I can imagine that the visual input my father had as a child from such unusual surroundings was a major factor in where his inquiring mind found its focus.

My father found school easy and was valedictorian of his high school class. As a youth growing up in a rural area, he discovered a paper mill built in the 1800's and serving in the 1920's as a recycling center. He became interested in the stamps attached to letters in big batches of paper arriving at the mill from New York City. Not limiting his interest to stamp collecting alone, he found a furniture label showing the name "Duncan Phyfe" in a bale containing earlier letters than usual. Over a year later, he saw the same name on a sideboard in a shop he and his father had visited. He put two and two together, sold the label to the shop owner, and, while just a teenager, had begun his life-long hunt for treasures of all kinds.

During World War II, my father served for three years in France, Germany, Belgium and Okinawa. His letters from the European countries are full of descriptions of antique architecture and the countryside, and my mother still uses a fine hardwood tray he dug out of the mud in Okinawa and brought to her.

Following the war, my father married Avis Roemer, my mother, and set up business in earnest with her. The many decades when my father's keen eye for the rare and unusual made him well-known and well-respected are remembered and expressed better than I could in articles written after his death on May 10, 1986. His encyclopedic knowledge, ever-widening interests, huge collections and kindly nature were fondly described in pieces by Joe Rubenfine, Al Malpa and Bill Guthman. Antiques he found are now in the collections at the American Museum in England, Shelburne, Sturbridge, Williamsburg and Winterthur. He died way too soon for his own liking, and almost to the end was looking forward to getting back to his many projects.

Not many children are lucky enough to have a father who could reel off, for example, the names of manufacturers of political handkerchiefs of a certain area of the United States over several decades and appear mildly surprised that the listener was not already possessed of this valuable piece of lore! My father was always putting such facts into a broader picture of the social and political outlines of the time for me and it is in that spirit — of placing minute details into an historical overview — that my father would have liked you to read this book.

Following the death of Rockwell Gardiner on May 10, 1986, his wife Avis Gardiner made a donation to The Ephemera Society of America, Inc. for the purpose of publishing a memorial to Rocky. It was at that time the Society put plans in motion to publish the book "REWARDS OF MERIT." The Society also decided to ask Rocky's friends to help with this publishing effort by making donations to The Rockwell Gardiner Memorial Fund and to the benefit auction organized by Steve Finer and Wm. Frost Mobley. Those people responded generously, and have over the years encouraged and supported The Ephemera Society's efforts to publish this book in memory of Rocky. We wish to sincerely thank everyone for their support of this project. Those who made contributions are:

George Abraham
Marjorie P. and Michael Adams
Robert Bahssin
Elizabeth Baird
Howard, Frances and Fred Baron
Bee Publishing Co.
David B. Belcher
Marjorie H. Brizee
Anne and David Bromer
Charles and Margaret Brown
Carolyn Buckingham
Mr. and Mrs. Fisher Ames Buell
Barbara and Jerome Buff
Lillian Caplin
Dorothy M. Cochran
Bertram M. Cohen
Audrey R. Conniff
Judith A. Costantini
Linda and Al Coombs
Harold and Florence Corbin
C. Bradley Cox
Claudia C. Cox
John D. Cox
M. Ellen Cox
Ray and Dick Cox
Lois R. Dater
Margaret and Robert Dean
Diane DeBlois
Oliver and Marion Deming
Velta E. DiGiorgio

Hugh Duffield
Jane T. Dunne
Phillip R. Dunne
Jas. E. Elliott
Nancy Goyne Evans
Joseph J. Felcone
Patricia Fenn
Alberto Galuppo
Avis Gardiner
Jack and Inez Golden
Joyce Golden
Elinor Gordon
Patricia Guthman
William H. Guthman
Robert M. Halliday
Henry J. Harlow
Ada Y. Harris
Robert Dalton Harris
Irving Herschbein
Carl T. Hotkowski
George N. Johnson Jr.
Philip H. Jones
John and Eleanor Kebabain
Eric Knott
Jeremie Rockwell Gardiner Knott
Stephanie Knott
Teresa F. Kurau
William R. Kurau Jr.
Linda and Julian Lapides
Paul and Judy Lenett
Ross Levett

Mr. and Mrs. Bertram K. Little
Mable and Randolph Lomas
Margaret R. Lorini
R. L. MacDowell Jr.
Ladd and Margery MacMillan
Virginia A. Makis
Jan and Larry Malis
Rev. and Mrs. Alfred P. Malpa
Paul D. Marinucci
Andrew Mason
Elizabeth L. Matlat
Gilbert May
William G. Mayer
David and Georgiana McCabe
Marcus and Janet McCorison
Virginia Bouck McIntosh
Barbara and Lois Meredith
Herbert Mitchell
Emily Davis Mobley
Wm. Frost Mobley
Charles F. Montgomery
Florence M. Montgomery
William P. Montgomery
Howard S. Mott
George A. Nama
Harold R. Nestler
Kenneth M. Newman
Mr. and Mrs. Eric P. Newman
Arlene and Richard Orcutt
Stephen D. Paine

Peter Pellettieri
Oscar A. Penoyer
Pfizer Inc.
Gennaro and Christina M. Piro
Stephen and Carol Resnick
Rosenau Foundation
Marvin Sadik
Edward and Margaret Sawyer
Wendy J. Shadwell
Matt and Betty Sharp
Robert D. Silvern
Edgar and Charlotte Sittig
Elaine and Sam Skinner
Mr. and Mrs. Frank Smith
Constance R. and Thomas F. Spande
John D. Spencer
Edward L. Steckler
Mark D. and Nancy N. Tomasko
Elizabeth Trace
Timothy Trace
Cynthia Cox Turner
Kate F. Urquhart
William L. Warren
Leslie and Peter Warwick
Everett and Rowena Whitlock
Gilbert Whitlock
Thomas and Constance Williams
Peter Winkworth
Stephanie A. Wood
William P. Wreden

THE GARDINER/MALPA COLLECTION OF REWARDS OF MERIT

The Gardiner/Malpa Collection of thousands of examples of educational awards and ephemera is believed to be the most comprehensive in the country. Material from the mid-18th century to the present includes manuscript, engraved, lithographed and photo-offset paper ephemera; watercolor paintings; pen and ink drawings; silhouettes, woven and embossed paper; paste mugs, plates and pitchers; gold, silver and white metal medals and pins; books, pamphlets, photographs, ribbons, prints, maps; teacher's diaries, school record books and report cards; broadsides, catalogs and many miscellaneous pieces given as Rewards of Merit or used in the classroom.

While a music teacher, Al recognized the role of positive reinforcement in motivating students to better perform. At the same time, he saw in school ephemera the same theory of encouragement that was used for hundreds of years in many different educational environments. His collection was formed to illustrate that theory.

The Gardiner/Malpa Collection represents approximately seventy-five years of collecting by Rockwell Gardiner and Alfred P. Malpa, who united their separate collections before Rocky's death in 1986.

Al lives with his wife Liz in the Farmington Valley area.

THE JOHN M. SALLAY COLLECTION OF SCHOOL MEDALS

The Sallay Collection of over eight hundred American school medals—from grammar through graduate schools, from the late 18th through the early 20th centuries—is also the most comprehensive of its kind in the country. The focus is on awards given for overall scholarship and excellence in specific academic subjects, but included as well are medals for attendance, attitude and deportment. Most of the medals are made of silver, though sixty are gold and the rest copper, bronze, or white metal. One-third of the medals in the collection are hand-engraved upon a thin planchet of silver or gold, while virtually all the rest are struck from dyes. Most were awarded by the school itself or by the local school committee, often financed by the local philanthropist.

The collection began twenty years ago with John rescuing a Boston Franklin medal from a coin dealer's "junk box." His research into that one medal was the beginning of his building an important historical collection.

John works in Boston as a partner in the Aeneas Group, the affiliate of the Harvard Management Company responsible for the private equity investments of the Harvard University endowment. He lives with his wife Ann and three children in the Boston area.

This book celebrates American Ephemera and the collectors who, through research about ephemera, are constant contributors to our understanding of America's history. In The Ephemera Society of America, Inc., many of those ephemerist historians gather together, share their knowledge, and heighten the excitement which come from their own particular searches. *Rewards of Merit* is a product of that excitement. Special recognition is due especially to the members of the Board of Directors of the Society and the Publishing Committee for the major role which they played in supporting this project.

Maurice Rickards, founder of The Ephemera Society (UK) also gave inspiration and support for the undertaking of this project.

The authors wish particularly to express their sincere gratitude to The Ephemera Society officers and staff: William Frost Mobley, Jack Golden, Calvin Otto and Diane DeBlois without whose efforts this project would not have been possible.

Wm. Frost Mobley, President of The Ephemera Society of America, Inc. for over 15 years has encouraged research into Rewards of Merit and school ephemera. He introduced the authors to Rocky Gardiner and rekindled many times the flame needed to see us through to publication.

Jack Golden, past Society President and owner of Designers 3, Inc. of New York City, gave continuous guidance, research and financial support of this project over the many years of its evolution. In addition, he provided the Society with the meticulous design and mechanical production of the book, as well as the supervision of its printing. We also wish to thank Diana Oliver Turner, assistant to Jack Golden at Designers 3.

Calvin P. Otto, co-founder of The Ephemera Society (UK) and The Ephemera Society of America, Inc., Chairman of the Board of Directors and Publishing Committee, and member of the American Antiquarian Society, gave valued business and publishing advice.

Diane DeBlois, Editor of *Ephemera News, The Ephemera Journal*, and one of the editors of this book, assisted with invaluable consultation and support to the authors and gave direction in making editorial, publication, and format decisions.

John Sallay, whose collection of school medals featured in Chapter Six, was most generous with his time and knowledge and was particularly helpful in supplying information and suggesting resources for the Franklin medals and the Ridgway medal.

Al Malpa especially thanks Dr. Edmund Sullivan, professor, author and historian, who recognized the importance of Rewards of Merit in the process of education and presented those ideas in his classroom.

Patricia Fenn gives heartfelt thanks to Richard Tilman Vann for making so freely the sacrifices which only he could make, and for giving so fully the moral support which only he could give.

Those who helped substantially in particular areas of expertise were: Elizabeth Baird, Valentines; Georgia Barnhill of the American Antiquarian Society, the Lancaster papers; Harriet Vann Holmes and Barbara Scaggs, Hollins College; The Rev. Alfred P. Malpa, illustrations on religious Rewards; Jane Pomeroy, material on Alexander Anderson; Robert Presbie, SUNY, New Paltz, materials and consultation on Behavior Modification; Margaret F. Sax, introduction to, and consultation about, the collections of children's literature and Rewards of Merit at the Watkinson Library of Trinity College; Ed Schwing, the Dutch Rewards; F. R. Smith, advice on the DeBenneville Reward; and Helena Zinkham, the publish-

er, Charles Magnus. We also thank David Eversley, introductions to the Hitchin British School Museum project; Philip J. Fenn, office space and consultation; the late Carol B. Ohmann, editing; Bowers and Merena Galleries, Inc., and Cathy Dumont, photography of the school medals; Richard J. Ulbrich, the loan of the Amos Doolittle engraving, "Napoleon In Trouble" and Ronald D. Stegall, a gift of the Valentine/Reward of Merit.

The following libraries, museums and people assisted in the research for the Directory at the end of this book;

Akron-Summit Public Library, Akron, OH; Albany Institute of History & Art, McKinney Library, Albany, NY; Alstead Historical Society, Alstead, NH; American Antiquarian Society, Cathy Titus, Worcester, MA; Baldwin Memorial Library, Wells River, VT; The Kit Barry Collection, Brattleboro, VT; Boston Public Library, Boston, MA; Brown University, Barton St. Armand, Providence, RI; California Historical Society, San Francisco, CA; Cass County Historical Society Inc., Logansport, IN; Chicago Historical Society Library, Chicago, IL; Cincinnati Historical Society Library, Cincinnati, OH; Public Library of Cincinnati & Hamilton County, Cincinnati, OH; Central Connecticut State University, Frank Gagliardi, New Britain, CT; Connecticut Historical Commission, David White, Hartford, CT; Connecticut Historical Society, Hartford, CT; Curtis Memorial Library, Brunswick, ME; DeWitt Historical Society, Ithaca, NY; Dodge County Historical Society, Fremont, NE; Dover Public Library, Dover, NH; Forbes Library, Northampton, MA; Georgia Historical Society Library, Savannah, GA; Herbert P. Gray, Melrose, MA; Herkimer County Historical Society, Jim Greiner, Herkimer, NY; Historic Northampton, Marie Panik, Northampton, MA; Historical Society Library of Pennsylvania, Philadelphia, PA; Howe Library, Hanover, NH; Keene Memorial Library, Fremont, NE; Jay T. Last, Beverly Hills, CA; Library Of The Boston Athenaeum, Sally Pierce, Boston, MA; Maine Historical Society, Portland, ME; Maine State Library, Augusta, ME; City of Manchester City Library, Manchester, NH; Manchester Public Library, Manchester, CT; Maryland Historical Society Library, Baltimore, MD; Museum & Library of Maryland History, Baltimore, MD; Michigan Library and Historical Center, Lansing, MI; New Hampshire Historical Society, Concord, NH; New Haven Colony Historical Society Library, Jim Campbell, New Haven, CT; New Haven Free Public Library, New Haven, CT; New York Historical Society, Wendy Shadwell and Diana Arecco, New York, NY; New York State Historical Association, Cooperstown, NY; Newport Historical Society, Newport, RI; Ohio Historical Center, Columbus, OH; State Library of Ohio, Columbus, OH; Old County Historical Society, Taunton, MA; Peabody Essex Museum, Salem, MA; The Peterborough Historical Society, Peterborough, NH; The Peterborough Town Library, Peterborough, NH; Plymouth Public Library, Plymouth, MA; Portland Public Library, Portland, ME; Portsmouth Public Library, Portsmouth, NH; Enoch Pratt Free Library, Baltimore, MD; Rhode Island Historical Society, Providence, RI; The Sheldon Museum, Middlebury, VT; Donald Smith, Barry, MA; State Museum, New Orleans, LA; Stonington Historical Society, Stonington, CT; Old Sturbridge Museum Library, Sturbridge, MA; Summit County Historical Society, Akron, OH; Diana R. Tillson, New Canaan, CT; Suplician Archives, Baltimore, MD; Vermont Museum, Barney Bloom, Montpelier, VT; University of Vermont, Bailey/Howe Library, Burlington, VT; Warren County Historical Society, Warren, PA; Worcester Public Library, Worcester, MA.

To the children who shared their Rewards of Merit and their opinions of them, our thanks to Farrah, Raymond and Rodney Johnson, Katie Wilkinson and Will Rae.

In our attempts to discover how widespread the use of Rewards of Merit had been, the following librarians, school officials, and collectors responded to our requests for information:

Ellie Arguimbau, Montana Historical Society, Helena, MT; Susan Baer, Boston Latin School, Boston, MA; B. Basore, Oklahoma Historical Society, Oklahoma City, OK; John W. Bowen, Suplician Archives, Baltimore, MD; Frederick C. Bunker, Lakewood, NJ; Christina Burns, Canton, CT; Marybelle Burch, Indiana State Library, Bloomington, IN; Patricia M. Cassidy, Maryland Historical Society, Baltimore, MD; William Copeley, New Hampshire Historical Society, Concord, NH; Laura S. Cox, Maryland Historical Society, Baltimore, MD; North Carolina Department of Cultural Resources, Raleigh, NC; J. B. Dobkin, University of South Florida, Tampa, FL; Chad J. Flake, Bringham Young University, Harold B. Lee Library, Provo, UT; Charles G. Frischmann, Ivyland, PA; Randy Goss, Lela Goodell, Hawaiian Mission Children's Society, Honolulu, HI; Margaret N. Haines, Oregon Historical Society, Portland, OR; Michael Hennen, Mississippi Department of Archives and History, Jackson, MI; Mary Anne Hines, Library Company of Philadelphia, Philadelphia, PA; Clyde Hordusky, State Library of Ohio, Columbus, OH; Ruth Horie, Bishop Museum, Honolulu, HI; Ann M. B. Horsey, Delaware Division of Historical and Cultural Affairs, Dover, DE; Mrs. Charles S. Judd Jr., Punahou School, Honolulu, HI; James C. Kelly, Tennessee State Museum, Nashville TN; Gloria Marie Lambert, North Carolina Historical Society, Elon College, NC; Bertram Lippincott III, Newport Historical Society, Newport, RI; Elizabeth Singer Maule, Maine Historical Society, Portland, ME; Tom McNeel, West Virginia Department of Education, Charleston, WV; Eileen J. O'Brien, Barbara Scaggs, Hollins College, Roanoke, VA; New York Historical Association, Cooperstown, NY; Jeff Thomas, Ohio Historical Society, Columbus, OH; Elisabeth Wittman, Archives of the Evangelical Lutheran Church in America, St. Paul, MN.

Our thanks also to Robert Dimsdale, Brian Limbrick, and Fiona Dodwell for their introduction to the Lancasterian school building and the Jill Grey Collection of School Ephemera being prepared for the Hitchin British Schools Museum Project, Hitchin, Herts, England.

The following libraries furnished space and reference help:

American Antiquarian Society, Worcester, MA; Library of Congress, Washington, DC; Connecticut Historical Society, Hartford, CT; British Library, London, England; Hitchin British Schools Museum Library, Hitchin, Herts, England; New York Public Library, New York, NY; Olin Library, Wesleyan University, Middletown, CT; Prince George's County Library, Oxon Hill, MD; Massachusetts Historical Society Library, Boston, MA; Russell Library, Middletown, CT; Sterling Library of Yale University, New Haven, CT; Virginia Historical Society, Richmond, VA; Watkinson Library, Trinity College, Hartford, CT; Winterthur Museum, Winterthur, DE.

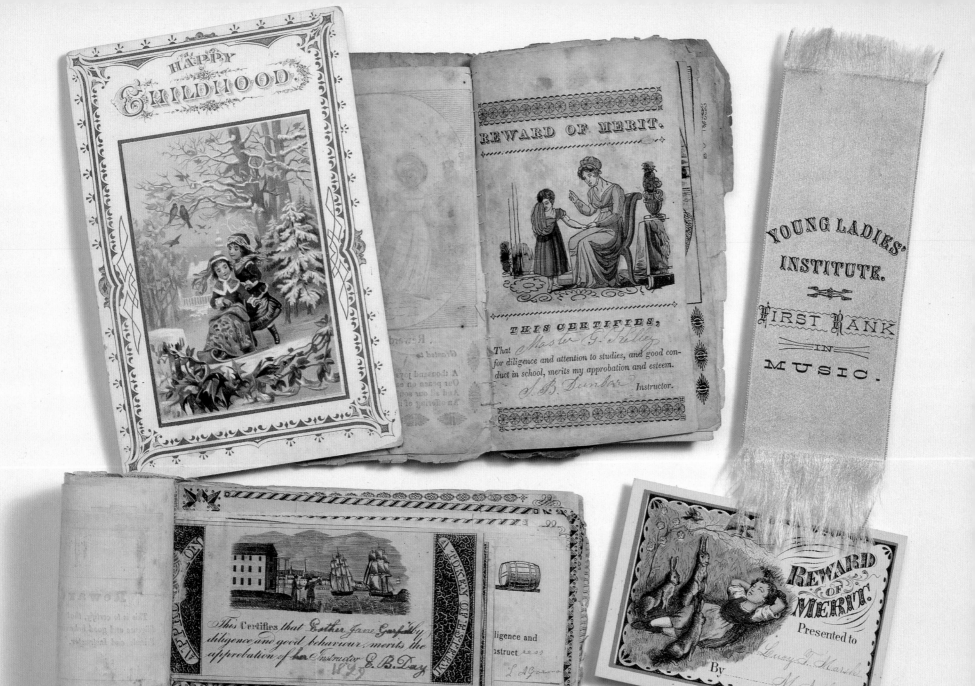

WITH "APPROBATION AND ESTEEM"
The Message of Rewards of Merit

ewards of Merit, tokens of a pupil's progress and a teacher's esteem, have been an enduring aspect of American education for more than three hundred years. Most were small pieces of paper —printed or hand written documents which were the bearers of a potent message. A child went to school, did well, and was praised by the teacher.

"Merit," "approbation," and "esteem"—these were the words which appear on countless of these certificates. The phrasing varies slightly in different eras and on different Rewards, but the message, that this young scholar "merits the approbation and esteem of Friends and Teacher" was universally understood. Sometimes, but by no means always, the occasion for the Reward was also recorded: "for diligence and good behavior;" "for being head of the class in spelling;" for "good conduct, and improvement, in Writing, Spelling, and especially for good Reading." It was the message behind the words which mattered to eighteenth- and nineteenth-century children and their parents; it was the message which made the tokens a prize of singular value. Whether given for a month's, a week's, a day's, or even a single lesson's scholarly accomplishments, these small documents were valued highly, and retained proudly. That is why we can examine so many of them today.

Rewards of Merit were given by teachers to their young scholars, but there was always at least a tacit understanding that it was the parents who would be the final recipient of these marks of the teacher's esteem. By the mid-nineteenth century, some of the verses made it explicit that Rewards of Merit were a valued gift from children to their parents.

> See, Father, Mother, see!
> To my Brother, and to me,
> Has our Teacher given a card,
> To show that we have studied hard!

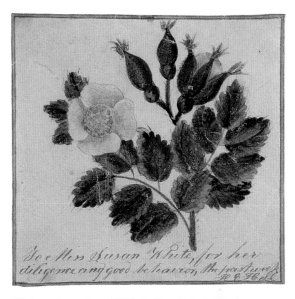

Watercolor, circa 1830. A floral style that was popular in this period and which appears on many Rewards of Merit. Examples vary from a single flower to an entire plant.

PRIZES ARE THE REWARD OF LABOUR.

It is not sufficient to carry off the prize, but we should merit it.

Watercolored wood engraving, circa 1835. Depiction of a school girl carrying the ancient prize of a laurel wreath, still a symbol in the nineteenth century. Here the message is that the winning of recognition should be accompanied by the deserving of recognition.

To you we think it must be pleasant
To see us both with such a present.

PARENT:
Children who well perform their part,
Always rejoice a parent's heart.
Such children's joy we fondly trace
Mantled high on a blooming face.[1]

By the early 1830s, when Sarah M. Jones' teacher, M. Farrar, granted her the following Reward "for diligence in study and for good behavior," the absence of a Reward evidently could be regarded as evidence of disapprobation. The legend on Sarah's Reward of Merit, curiously spaced and punctuated, reads:

Mama, see what my teacher has/ given me
for being a good scholar to-
day—see that picture of a sheep and
those little lambs; how pretty.
Well, dear child, I hope you will be a good
scholar every day; then your teach-
er and parents too will love you.—
Good children may always expect
Rewards of Merit from their teachers.[2]

Praise by the teacher was clearly most important, but Rewards of Merit were also highly prized for their decorative value. When printed Rewards were not widely available, and often even after they were available, many teachers expended considerable talent to create a Reward which was highly artistic. Teachers knew of many homes where decoration was non-existent, where a Bible or almanac might be the entire library. A Reward penned by a teacher who was skilled in calligraphy, or sketched and painted by a teacher gifted in the decorative arts, had a special place on many an otherwise unadorned wall. On printed Rewards the decorative borders of those which were otherwise crudely printed, and the embellishment of color on mass-produced black and white Rewards, were later replaced by the magnificently colorful Rewards produced during the era of chromolithography. Rewards of Merit, with their images and their message, were not simply a part of a flurry of similar paper artifacts in the homes of early America—nor in the working-class homes served by the charity schools

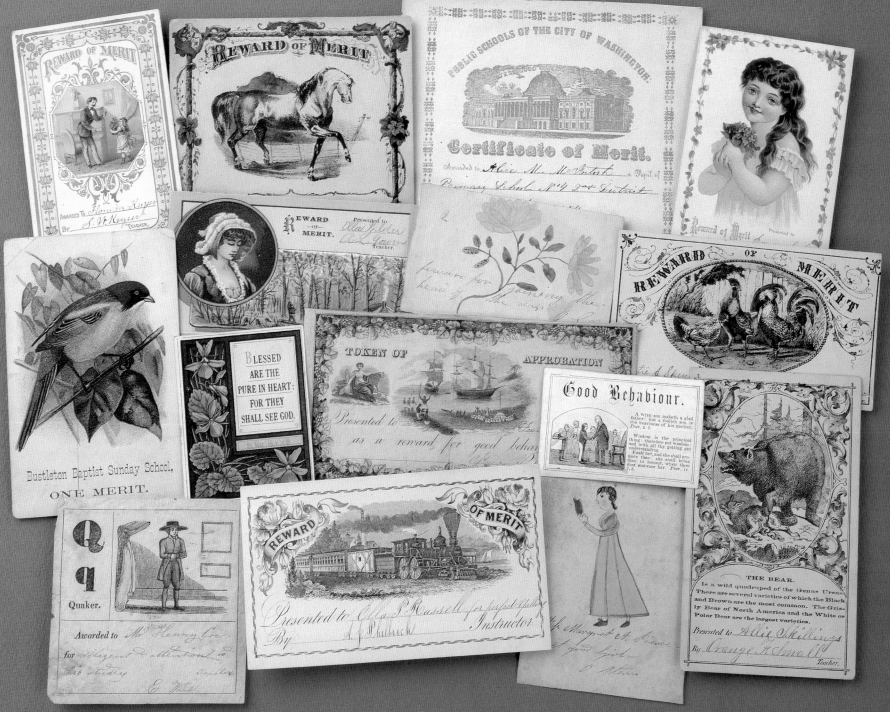

A miniscule introduction to the virtually limitless varieties of Rewards of Merit executed between the 1820s through the 1890s.

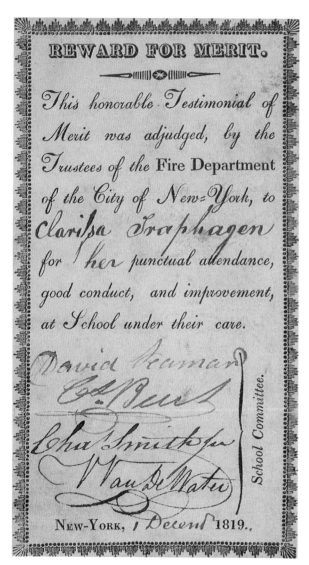

Reward of Merit showing the cooperation between the Fire Department of the City of New York and the local School Committee, 1819. It was most likely given at an exhibition.

of the second half of the nineteenth century. They had personal messages making them all the more important when used in the home as a display of accomplishment.

The size and physical characteristics of the paper Rewards of Merit varied. Some were large enough for framing and displaying on a significant wall; others were tiny enough to appeal by their smallness. The families who lovingly preserved them carefully pasted them in scrapbooks, pressed them in Bibles, sewed them together like chapbooks, kept them in leather cases like calling cards, or even created from them a lining for a memento box. Mary Waldo's twelve little Rewards were saved in a box manufactured for the sale of pen points. Hers are merely quickly penned notes, the smallest just 1 X 2 inches, the largest twice that: "Mary Waldo merits the approbation of her teacher," "Mary Waldo learns nicely and has the respect of her teacher," until, triumphantly, "Mary Waldo is at the head of her class."

Useful objects designated as Rewards of Merit were also given as early as the mid-sixteenth century and often appear in American collections from later centuries. Writing pens, thimbles, plates, knives, forks, letter openers, and mugs have survived in mint condition, indicating that they too were displayed or carefully stored. Even kites, games, and toys presented as Rewards survived intact for many years, as if the teacher's words of approbation made them inviolable.

Though Rewards of Merit were created on separate continents and in a variety of media throughout the history of schooling, in America they form a unique, tangible record of the development of one of America's greatest gifts to the world— schooling for all. Their similarities and differences, especially among those given by teachers of particular immigrant groups, help recreate the history of special teachers, their schools, and their distinctive communities. Through the messages on the Rewards, the gradual changes in teaching methods and philosophy of education are often revealed in their most significant effect—the changes in childrens' classrooms.

These are not merely the spontaneous gift of an especially creative and dedicated teacher; they are concrete evidence of a community's values. Teachers in the oldest schools for America's elite gave them, teachers in the Sunday schools and the large city charity schools gave them, and teachers in the first public schools with compulsory attendance gave them.

Because of the long history of the giving of Rewards of Merit, it is possible to trace through them the evolution of American printing. From the crudest wood block printing to the most lavish chromolithographs, Rewards of Merit display, in a peculiarly charming medium, the progress of American printing. They show how printing processes and decorative fashion changed over the span of two hundred years.

18

Giving Rewards of Merit has by no means been unquestioned through the centuries. Indeed, arguments about their usefulness in encouraging learning and their effect on students who do, and who do not, merit them, are as old as the records of their use. Tracing this story also gives us insights into their importance. Though the giving of Rewards of Merit was both espoused and disdained by thoughtful educators throughout history, the practice continues to this day.

As teaching methods changed, the reasons for giving the Rewards altered; as social mores shifted, the very meaning of esteem was reinterpreted; as printing techniques developed, the physical format varied. But whether we look at the precursors of the American tradition, the sixteenth-century English school Rewards and the calligraphic certificates of Dutch writing masters; or examine the early New England printed examples with woodcut illustrations; or help create the latest computer-generated and copier-multiplied Rewards, there is a common message. One boy, or one girl, in a particular school at a specific time, merited the approbation and esteem of an attentive teacher.

NOTES

1. Reward of Merit sold by Warren Lazell, circa 1845. 2. Reward of Merit, no printer given, circa 1830.

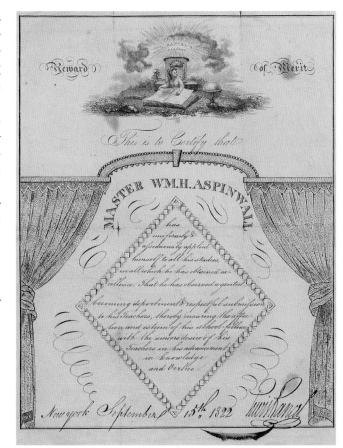

Copperplate engraved stationery embellished with a carefully executed pen and ink drawing with verse, dated 1822. Unique, not only for the rendering of hand lettering and calligraphy but also because of its application on the single known piece of Reward of Merit stationery.

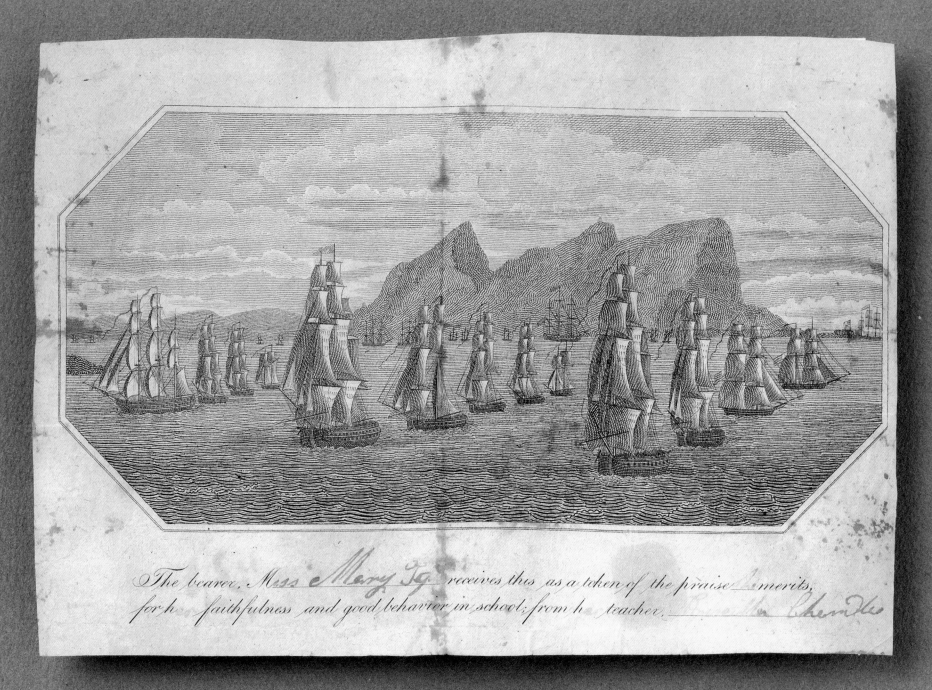

The bearer, Miss *Mary F.* receives this as a token of the praise & merits, for h_ faithfulness and good behavior in school, from h_ teacher. _____

Copperplate engraving attributed to Nathaniel Jocelin of New Haven, Connecticut, circa 1820. Jocelin (Jocelyn after 1823) engraved several large Rewards of Merit with expansive outdoor views during this period. Only a few of the copperplates were signed by him.

FROM LAUREL WREATHS TO SCHOOL REWARDS
Sixteenth-century traditions—from the Old World to the New

> [a school master should] bend all his endeavours
> to provoke all his Scholars, to strive incessantly,
> which of them shall carry away the worthiest
> praise and commendation.
>
> JOHN BRINSLEY, 1612

iving prizes or rewards, some object of material value for exceptional achievement, is as old as recorded history. The first known school rewards imitated rewards given by kings to loyal aristocrats, by civic rulers to worthy citizens, and by organizers of sports competitions to the best athletes.

These rewards included objects similar to those which are still given at school commencements—medals, reward books, mementoes of the school, and certificates, both hand lettered and printed. By the nineteenth century, inexpensive printing favored printed certificates, and these later printed Rewards of Merit display surprisingly enduring legacies from sixteenth-century Old World schools.

The earliest literary references to prizes given for achievement are probably those in Homer's *Iliad*, written in the seventh century B.C. from oral poetry of the previous four centuries. The prizes described are items of some value, such as tripods and horses, given by Achilles at the funeral games of Patroclus.[1] In the earliest Greek Olympic games, victorious athletes were rewarded with a laurel wreath—a tangible prize but not one of exchangeable value. Perhaps the best known early reference to a prize, however, is St. Paul's from the New Testament, which surely refers to a spiritual reward: "I have won the victory, I have won the prize."

Of objects which were specifically made to be prizes, three large gold medals dating from between 212 and 235 B.C. are thought to be the earliest which have sur-

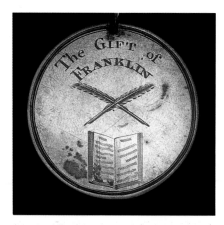

REWARD OF MERIT.

Granted to *Osburn Harrington*

for diligence and attention to study, and good

behaviour in school. *B. Houghton &c*

Sold by Munroe & Francis, 128 Washington-street.

Above— This Franklin Medal was presented in 1792 at the Reading and Writing School in Boston, the first year it was awarded. The crossed quill image on the medal was used frequently on Rewards of Merit.

vived for our examination. These prizes, found near Tarsus in Cilicia,[2] were awarded to the victors of games in honor of the memory of Alexander the Great. The earliest prize medals known to have been given to "victors in knowledge" in European schools, are thought to be either one dated 1577[3] from the Nurenberg gymnasium (school) in Altdorf, Germany, or a number of school medals which are undated but believed to have been made as early as 1538.[4]

Prizes, thought to have been books, were given at the school of the Brethren of the Common Life in Liege as early as 1525.[5] There is evidence that "*praemia,*" which may have been certificates, were given in 1556, and "*virtutis coronae,*" prizes we know were neither medals nor books, were awarded between 1535 and 1546.[6]

John Stow in his *Survey of London* refers to English school awards in the form of bows and arrows of silver, presumably miniatures, presented sometime in the reign of Edward VI (1547-1553). The prizes were given by the aptly-named Sir Martin Bowes (a goldsmith who was the Lord Mayor of London in 1545) at public "disputations" held in the cloisters of Greyfriars' Priory. The recipients were scholars from certain London schools who were judged to have been the best in public speaking and debating. Stow also reports having personally witnessed the presentation of garlands to scholars after such disputations in the churchyard of St. Bartholomew at the Priory in Smithfield.[7] He describes a prize-giving in 1555 at Christ's Hospital within Newgate, again after public debates by the scholars of three schools. Three silver pens, of decreasing value, were awarded to the three winners before the Lord Mayor and the Aldermen of London. Interestingly, money, corresponding to the value of the pens (from 6 shillings 8 pence to 4 shillings), was given to the masters of the boys who were awarded the pens.[8]

It was these schools, with their disputations, which first established the context in which Rewards of Merit were given. More importantly for the continuation of reward giving, the organization, the teaching methods, the books, and the curriculum of the schools from which these masters and scholars came were continued for more than two further centuries in both the Old World and the New.

Those prize-giving London grammar schools and their methods of teaching were a type of school which had taken root well before the Reformation. Though the schools were modified (reformed) by the religious upheavals of the sixteenth and seventeenth centuries, they were the successors of schools dating back to the arrival of Augustine in England in 597 and the conversion of the English to Christianity. Augustine and his colleagues realized that schools had to be created in order to train clergy.[9] Religion and learning were bound together virtually from the beginning of formal instruction, from a time when teaching was largely confined to private

chaplains instructing individual pupils. Before the Reformation, and before the possibilities for communication brought about by the printing press, the small number of the elite who had access to hand-copied manuscripts were educated by the clergy. The church was responsible for educating the clergy; the clergy then taught the aristocracy and kings; and from the clergy and their students, aristocratic or otherwise, came the civil servants—the influencers and the implementors of policy for hereditary rulers.

Though the first teaching methods within the church were designed as individual instruction for rulers and members of the nobility, the first schools for groups of pupils of somewhat lesser status also arose within the church—inside cathedrals, monasteries, and convents. As more people became determined to learn to read and write, semi-monastic free schools taught by "detached priests" grew up outside the walls of both monasteries and cathedrals to accommodate even more and younger pupils. The purpose of these grammar schools was to transmit the theological truths of the church, and as well to instruct the young in Latin "Grammar," the language not only of the church but also of government and commerce.

The advent of pressure on parents in England to teach their own children came after Henry VIII's suppression of the monasteries (1537-39). Most of the schools for older pupils, as well as those classes of the "detached" priests who taught the first skills to children, were disbanded along with the monasteries. Priests who remained loyal to the pope were rejected as teachers for Protestant children.

The shortage of theologically acceptable teachers coincided not only with growing Protestant conviction that everyone should be able to read the Bible but also with concern about the rising numbers of poor who needed support. One of Henry's solutions to the dilemma was to issue royal injunctions concerning the duties of parents to "bestow their children and servants, even from their childhood, either to learning, or to some other honest exercise, occupation or husbandry:...lest any time afterward they be driven, for lack of some mystery or occupation to live by, to fall to begging, stealing, or some other unthriftiness."[10] Note that learning here is treated as an alternative to other "honest exercises," and both are alternatives to begging and stealing.

Seventy-five years later, for the separatists who settled in New England, parents were the only available first teachers of their children. The Puritans passed a law demanding that everyone learn to read—not primarily for vocational reasons, since land was available for working, but because individualist Protestantism required that people have direct access to the Word of God inscribed in the Bible. Parents were therefore charged with the responsibility of seeing to it that every member of their household could read.

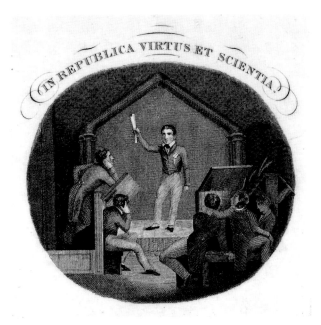

A typical scene of how a recitation performance may have been staged. Copperplate engraving, 1835.

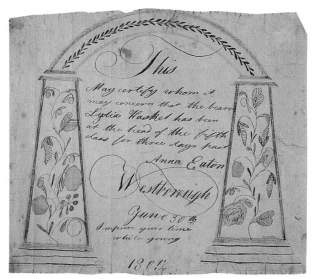

This hand drawn and primitively decorated Reward and Catalogue on the opposite page, illustrates how a design element popular in the late eighteenth and early nineteenth century was used by professionals and lay people alike.

Whether in the oldest centers of culture or in the unexplored wildernesses, however, societies that value literacy have seldom been able to rely entirely on parents or to do long without schools. In England, after Henry VIII's break with Rome, the role of the "detached" priests was often taken over by women who administered the first instruction in reading in their homes. In New England, children who for some reason could not be taught by their parents were often instructed in the ABCs in just such "dame schools," usually located in the houses of widows who combined baby-sitting with giving lessons in the rudiments of reading.

For the more advanced pupils, those learning grammar for positions in government or church, the English thought that lay teachers could be supplied to the old cathedral grammar schools to take the place of the priests. This solution failed because there were simply not enough educated lay people available. When lay-taught cathedral schools proved insufficient, there developed a zeal for founding, or refounding, free Latin schools—free of ecclesiastical control and free to propagate the Protestant faith. By 1577 most English corporate towns had at least one Grammar School, and in New England, by 1635, only five years after the settling of the Massachusetts Bay colony, the colony established its own Latin School in Boston.

The conviction that each person, not merely the clergy, should be able to read the Bible may have been a new and socially transforming belief, but the conviction that teachers—whether parents, priests, or schoolmasters—were responsible for transmitting religious faith to the young, was not. This view of teaching had even intensified as the English break with Rome was followed by proliferating conflicts over the "true" faith— conflicts which caused some Protestants to emigrate to an unknown wilderness in order to be free to follow their religious beliefs.

The colonists, particularly the English Puritans who settled Massachusetts, brought with them from the Old World not only the memory of the methods, but also the Bibles, primers and hornbooks with which they had been taught. For the establishment of schools in the New World, they also had manuals for schoolmasters—books which gave advice on the giving of Rewards.

Thomas Elyot's *Boke Named the Governour* (1531) was probably the first major treatise on education printed in English. Designed to train future "governors" of the state, it contains a detailed curriculum as well as Elyot's philosophy and suggestions for appropriate teaching methods. Elyot himself was friendly with Cardinal Wolsey and Thomas Cromwell and served on the king's council (but was dismissed in 1530 after Cardinal Wolsey fell). He was also appointed by Henry to be ambassador to the greatest empire of the time, the unified Hapsburg empire under Charles V. The pop-

ularity and influence of the book is perhaps best judged by its eight editions in the sixteenth century and by its having been the model for other popular books on pedagogy, including Roger Ascham's *The Scholemaster*.[11]

In Elyot's book we find references to decorated items as testimonies to merit. Elyot advises that the house of a noble man, or man of honor, should contain "ornaments of halle and chambres" such as painted tables or images containing histories:

> wherein is represented some monument of vertue/most cunnyngly wroughte/with the circumstance of the mater briefly declared/ whereby other men in beholdyng/may be instructed or at the lest wayes to vertue persuaded.[12]

His reasoning, that seeing such objects will "instruct" or "persuade to vertue" other men, is an appeal to what was later said to be "emulation."

In 1612 in England, *Ludus Literarius* (The Literary Game) by John Brinsley (1585-1665), followed Elyot in a more specific way, advising that a school master "bend all his endeavours to provoke all his Scholars, to strive incessantly, which of them shall carry away the worthiest praise and commendation." Brinsley, however, intended his book to help teachers to bring education to all—"for the helping of the younger sort of Teachers, and of all Schollars, with all others desirous of learning; for the perpetuall benefit of Church and Common-wealth."[13] A later version of it, *A Consolation for Our Grammar Schooles* was written explicitly for "all ruder countries and places," including Ireland, Wales, Virginia, and Bermuda. In Virginia, in fact, in 1621-22, a committee was appointed by the East India Company to study Brinsley's book for its relevance to a proposed public free school.[14] It is doubtful that Brinsley's book was actually used in Virginia because that colony's progress toward schooling was interrupted by the Indian massacre of 1622. It is probable, however, that the Puritan colonists were familiar with it. Brinsley was a Puritan of intense convictions who had been removed from his teaching position at Ashby-de-la-Zouch in Leicestershire for promoting the education of the common man.

Brinsley sounds a theme which continues in most references to Rewards through the centuries: the contrast between rewarding pupils and punishing them. Brinsley cautioned that care must be taken, particularly with the youngest, that no one of them be in any way discouraged "eyther by bitternesses of speech, or by taunting disgrace; or else by severity of correction, to cause them to hate the Schoole before they knowe it." His goal was rather that "all things in Schooles be done by emulation, and honest contention, through a wise commending in them everything, which anyway deserveth prayse, and by giving preeminence in place, or such like rewards."[15]

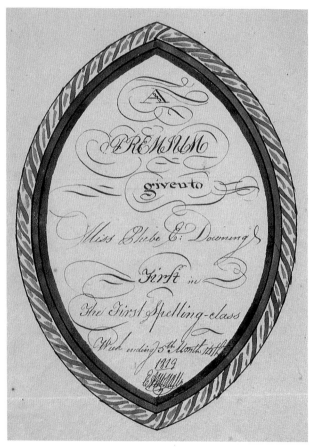

Above and opposite page are two of four elaborate watercolor Rewards of Merit in the collection, which were given to Mary E. Downing in 1818–1819. They were awarded on a weekly basis.

"Emulation"— that word which is so consistently used in reference to, and in controversies about, Rewards of Merit—was probably first used by Brinsley. To inspire emulation, "the endeavour to equal or surpass others in any achievement or quality...the desire or ambition to equal or excel,"[16] was the frequently expressed pedagogical goal of school Rewards for centuries to come.[17]

Brinsley provides detailed instructions for successive lessons in language along with advice on school organization and teaching methods. He recommended that schools be divided into forms (classes) which could strive against one another and within which each student could strive to achieve the highest place. The forms were to have enough scholars to "further one another very much" and "everyone of a fourme may some way help the rest."[18]

Brinsley's descriptions of these early seventeenth-century school contests bear a resemblance to those in the decades and centuries following, from the contests of monitorial charity schools in American cities to the spelling bees of frontier one-room schoolhouses. In Brinsley's grammar schools, the contest required answering "questions learned in Grammar or Authors" posed by the other scholars of the school to the seniors of the highest forms. Every scholar, not just the master, was to give something to the victor

> for a Praemium—as each one a point or a counter or more; or else better gifts if they be well able, of such things as they may without their hurt, or the offence of their parents....These to bee divided equally betweene the two Victours, as a reward of their diligence and learning; to incourage them, and all the rest of them by their ensample to strive at length to come unto the Victorshippe, because then besides the honour of it, each may come to receive again more than ever they gave before.[19]

Brinsley also describes another custom which was transferred to the American Colonies—the yearly examination by "The Governours of the schools—or someone specially appointed for the purpose." On these exhibition days, scholars were examined and gave demonstrations. Their exercise books were shown and compared with those of former years and the "highest" scholars gave orations for entertainment. All who did well were encouraged by praise from visitors and by "rewardes to give all kinde of hartning and incouragement both to Masters, Ushers, and Schollars."

> The Visitors encouraged those who did the best with some Praemium from them: as some little booke, or money; to everyone something: or at least with some speciall commendation.

26

It were to be wished that in great schooles, there were something given to this end, to be so bestowed, five shillings, or ten shillings. It would exceedingly incourage and incite all to take paines.[20]

This, then, is the kind of advice which English schoolmasters were reading at the time of the settlement of the New World.

Though the Southern and New England colonies of North America were predominantly English, New York, New Jersey, Pennsylvania, and Delaware had substantial numbers of German, Swedish, and Dutch settlers. The continuous history of the Dutch colony of New Netherland, and the settlements along the Hudson and lower Delaware rivers beginning in 1664, also had a considerable cultural impact on educational practices in the New World. When England took New Netherland from the Dutch in 1664, the Duke of York proclaimed New Amsterdam to be New York and judiciously left intact many of its Dutch institutions, including those provided for the education of their youth.

Like the English, the Dutch settlers were determined to insure that their children should be literate, and for them, also, their Protestant faith was central to their lives. But New Netherlanders had an additional immediate concern for teaching their youth to read and to write. The colony had originally been founded primarily as a trading post for the Dutch West India Company. Unlike the Massachusetts Puritans, who had purposefully sought to isolate themselves from the influence of other settlers, New Netherland from its beginning sought and depended upon contact and trade with all who came to the New World.

The Dutch educational impetus was to bring to civility some of the ruder youth who had found their way to their trading center and to make certain that the next generation was sufficiently literate and numerate to engage in international commerce. The international sea trade of the seventeenth century was not one which could be carried on by face-to-face spoken agreements between traders in Europe and their colonial customers. The New Netherland youth needed to know how to write business letters and contracts as well as how to read the Bible.

The Dutch solved the need to educate their children by inviting Dutch teachers, hired by the West India company, to keep school. Adam Roelantsen in 1638 was the first of the teachers hired in the Netherlands to conduct a school in New Amsterdam. The schoolmasters in the Netherlands had formed a "schoolmeesters gilde"[21] which required and issued its own license after the candidate passed a test and registered with the guild. This was in addition to the license issued by the Classis, the institution of the Calvinist church which investigated the moral character of the can-

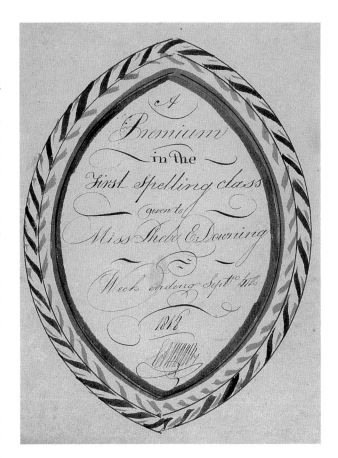

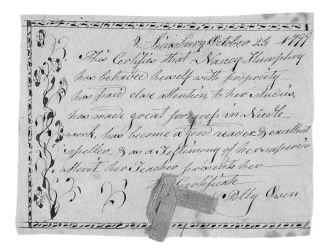

Rewards of Merit from eighteenth-century America are rare, this one for "progress in needlework" was awarded in a private girl's school in Simsbury, Connecticut, 1799.

Opposite—(Fig. I-1) Translation of Reward of Merit from Dutch colonies in New York. "Honor Certificate from E.C. Werenfteijn. Given to A. Morel in Honor of Accomplishments." Circa 1820, copperplate engraved and hand decorated with watercolors.

didates for teaching. Roelantsen and his successors, since they were listed as "school-masters," would have had such licenses, and it is therefore likely that he would have known about the manual for intending schoolmasters by Dirk Adriaanszoon Valcooch.

Regel der Duytsche Schoolmeesters, first published in 1591,[22] was written by Valcooch for those who were going to teach in the country, rather than in the cities, which makes it even more likely that teachers emigrating to the colonies would have used it for a model. Valcooch's manual had gone through four editions by 1638.[23] The 1612 edition had to be revised after the Reformation in order to take out "Catholic" references and to make certain that it contained proper Protestant religious views.

The importance of, and the responsibility for, instilling religious belief is omnipresent in Valcooch's manual, as it is in Brinsley's English manual. Sentences to be copied for writing practice, for example, are filled with admonitions to live both a religious and a moral life. Valcooch assumes that classes will usually be held in a room attached to a church and that the church will oversee education. The "rules" for living are many and moralistic and include some as mundane as "pupils shall not swear."

Valcooch, like Brinsley, believed in encouragement, not punishment, and planned that more advanced pupils should help the younger ones. His rationale for giving Rewards is explicit— "work is made sweeter by the winning of rewards." He urges masters to give awards for the best writing and spelling on each Saturday, and to organize calligraphic (writing) contests for attractive prizes three times a year.

> On the last day of the week
> Together to do the best writing and spelling aloud
> The best performer will receive for his reward
> An attractive letter or very beautiful
> calligraphic example
> This [Reward] lays the foundation to understand
> that _____ [word unknown]
> For work is made sweeter by the winning of rewards.[24]

One of the prizes was to be a piece of calligraphy by the master himself, a tradition in Rewards appropriate to any schoolroom in any century. These specimens of calligraphy, embellished entirely by the hand of the writing master, later evolved into Rewards with printed borders[25] (Fig. I-1) which were filled out in particularly careful calligraphic style by the instructor. The precise, formal beauty of the writing remained an accomplished art form, its value as a Reward enhanced by the personal skill of the teacher as artist.

28

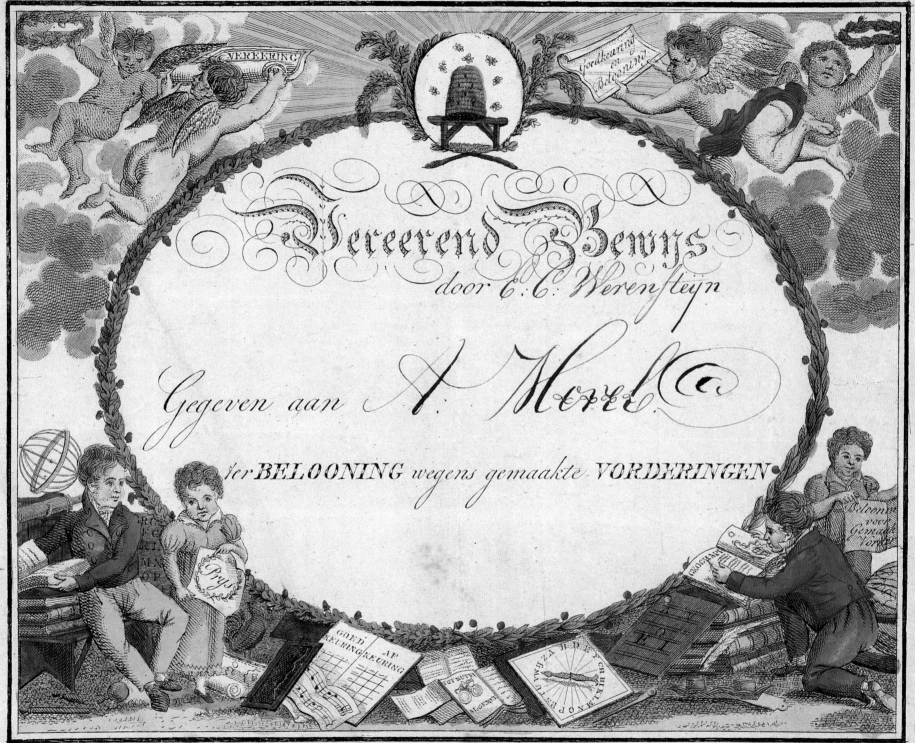

Vereerend Bewys
door C. C. Werensteyn

Gegeven aan A. Merll

ter BELOONING wegens gemaakte VORDERINGEN

C. Bok del.

Fig. I-I

Fig. I-2

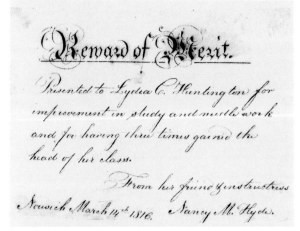

An example of calligraphy on a Reward of Merit, March 14th, 1816 that represents the importance given to a teacher's as well as a child's ability to write in calligraphic style.

Though Latin and Greek grammar was being taught in both England and Holland, though both countries were striving to educate a learned ministry, and though trade by sea was a matter of basic necessity in both countries, the specific emphasis on calligraphy by Dutch schoolmasters differs markedly from the prejudice against writing among English "scholars."

Brinsley did devote a chapter in his advice to English schoolmasters on the importance of teaching scholars to write a "faire hand," but his discussion begins by answering the widespread opinion that "a good Scholler can not be a good writer." He admits that he is replying to parents' complaints that after grammar school their children had to be sent to a scrivener because, not having been taught to write, they were not fit for any trade. Brinsley's chapter, "How the Master may direct his Schollars to write verie faire, though himselfe be no good Pen-man,"[26] ends with the argument that by following his advice for the teaching of writing the "Schooles also may be freed from having any need of the Scriveners, which go about the country" and

draw away the mindes of many of the Schollars from their bookes; even of all such as cannot indure to take paines, nor have any great love of learning and cause many, of good hope to leave the school utterly."[27]

Brinsley's argument shows that penmanship was customarily not included in an English-style curriculum. Until the early nineteenth century, in Boston in particular, pupils who attended a grammar school in the morning often went to a separate writing school in the afternoon. Benjamin Franklin's father, for example, withdrew Franklin from the grammar school in order to send him to a writing school where he could learn the skills practical for business.

Dutch and English differences in curriculum and attitudes toward writing influence Rewards of Merit given a century and a half later—from the Dutch tradition, the skillfully written Rewards which could be used as patterns for penmanship, and from the English tradition, the printed Rewards with Bible verses and moral strictures to be studied and memorized. The two traditions were increasingly intermingled as different kinds of schools were founded in the same cities.

Another imported tradition which greatly influenced the form of American Rewards of Merit was the illumination of manuscripts, favored particularly by the German colonists who settled in Pennsylvania starting in 1683. Fraktur, so called because the style of the lettering resembles an early print type, was most often used for the creation of birth and marriage certificates to be displayed in the home, but it was also natural to decorate paper Rewards of Merit given in schools in the Fraktur style (Fig. I-2). Many of these *Vorschriften* were carefully collected in the late nineteenth cen-

30

tury by Samuel W. Pennypacker,[28] who also translated the writings of schoolmaster Christopher Dock.[29]

During the first part of the eighteenth century, Dock taught three days each week in Shippack and three in Salford, Pennsylvania. He was known for his use of Rewards of Merit, for his piety, and for his even temper as well as for what he did not use—the all too familiar canes or long switches for discipline.

Christopher Dock's Rewards were various—particular ones given for particular accomplishments. When "young scholars" learned their ABCs, he asked the mother of the scholar to cook two eggs for the child as a treat and the father to give the child a penny. On the day the boy or girl began to read, Dock gave a ticket carefully written or illuminated with his own hand, with the words "industrious—one penny." If the pupil became idle or disobedient, he took the ticket away.

The most prized Rewards were drawings of birds and decorated texts, which he painted by hand. They were sometimes given for special accomplishment, and sometimes for such special efforts in school as offering to teach a particularly ragged-looking child who was new to the class.

In the Gardiner-Malpa Collection one of the first examples of a school Reward is one written by George de Benneville (1703-1793) of Bucks County, Pennsylvania, who lived a more exciting life than the average schoolmaster. De Benneville immigrated to the German community in Olney Valley, Pennsylvania, from Germany, but he had been born in England of exiled French Huguenot parents and was raised, after his mother's death in his childbirth, under the care of his Godmother, Queen Anne. After her death he returned to the country and religion of his parents and, by the age of seventeen, was sentenced to be beheaded for preaching universalism in France. Fortunately, he was reprieved on the scaffold by Louis XV and went to Germany, where he learned German, with difficulty, and received his doctorate from a pietist medical faculty about 1739.

In Wittgenstein, de Benneville helped with the translation and interpretation of the Berlenburg Bible, issued in eight volumes between 1728 and 1742. Christopher Sower, the Pennsylvania agent for the Berlenburg Bible, persuaded de Benneville to come to Pennsylvania to help with the thirty-fourth edition of the Martin Luther translation of the Bible. De Benneville selected the texts of special significance to restorationists and other radical pietists, which were set in boldface type.

In 1742, de Benneville settled in the Olney Valley, where he became both schoolmaster and physician and taught Jimy, whose Reward we have. Three years after teaching Jimy, he built a stone mansion with a large room upstairs for religious meetings and for a school, which could seat one hundred pupils.[30]

Not all teachers could afford watercolors to decorate their handmade Rewards of Merit; when color was unavailable they took extra care to execute fine pen and ink drawings, 1854.

Fig. I-3

De Benneville's Reward bears an appealing message, one which we can imagine might have helped persuade young Jimy to strive again to be the "best" in the school, and one which indicates that the child was willing to work for praise.

Today the best was
This Jimy of our school
And for himself for his energy
This solicited praise received

GEORGE DI BINDER SCHOOLMASTER [31] (FIG. I-3)

Immigrants of other nationalities undoubtedly also brought to the New World their own traditions of educational rewards. The Puritans, however, had the most abiding impact. Long after the settlers of the Massachusetts Bay colonies had anything resembling a monopoly on belief and behavior in the new country, English Puritanism still had a profound influence on the North American colonies. The early date of the Puritans' Massachusetts settlement, their commitment to the importance of the family, their strong belief in education, and their conviction that printed information was vital to the perpetuation of their religious faith and freedom—all contributed to their cultural power. Thousands of Rewards of Merit printed with the tenets of the faith of those first Puritans flooded the American schoolrooms well into the nineteenth century.

NOTES

1. Herbert J. Erlanger, *Origin and Development of the European Prize Medal to the end of the XVIII Century* (Haarlem: Schuyt & Co. C.V. 1975), 1.

2. Ibid., 2.

3. Ibid., 30. Erlanger is quoting C. A. Im Hov, Sammlung eines *Nürnbergischen Münzcabinetes* (2 vols.: Nürnberg, 1780 – 82), Vol. II, 218, sq no. 1–3.

4. Erlanger, quoting G. A. Will, *Nürnbergischen Münzbelustigunen* (4 vols., 1764–67), Vol. III, 283. One author, Schatzler, believes that these school prize medals originated in Strassburg in a school organized by Johannes Sturm in 1583.

5. *Enzyklopädie des Unterrichtswesens*, Vol. III, 528 (from Erlanger footnotes, 30).

6. Erlanger, 31.

7. M. E. Grimshaw, *Silver Medals, Badges and Trophies from Schools in the British Isles 1550–1850* (Cambridge, England: Published by M. E. Grimshaw, Printed by Crampton & Sons Ltd., n.d.), 7.

8. Ibid.

9. Lawrence Cremin, *American Education: The Colonial Experience 1607–1783* (New York: Harper and Row, 1970), 167.

10. *Proclamations of the Realm (Henry VIII)*.

11. Cremin, 61–66.

12. Elyot, *Boke Named the Governour*, 1531. From the Series *English Linguistics 1500–1800*

(A Collection of Facsimile Reprints) Selected and Edited by R. C. Alston, No. 246. (Menston, England: The Scolar Press Limited, 1968.) Further editions were reprinted in 1537, 1544, 1546, 1553, 1557, 1565, and 1580. Folio 1010 (b).

13. John Brinsley, *Ludus Literarius: or, The Grammar Schoole* (London: Printed for Thomas Man. 1612), 13, 49. From the Series *English Linguistics 1500–1800* (A Collection of Facsimile Reprints) Selected and Edited by R. C. Alston, No. 62 (Menston, England: The Scolar Press Limited, 1968).

14. Ibid., 13.

15. Ibid., 1.

16. The 1612 use of the word "emulation" in Brinsley's *Ludus Literarius* is, according to the *Oxford English Dictionary* one of the first uses of the word. The Oxford Universal Dictionary (1955) gives, more negatively, a 1651 definition, "ambitious rivalry; contention or ill will betwen rivals"; and a 1771 definition, "Jealousy; dislike of those who are superior."

17. See the later section on Joseph Lancaster's reliance on emulation, Chapter Five, and the arguments for and against the continuance of the Franklin Medals in the Boston schools in the 1840s, Chapter Six.

18. Brinsley, 48.

19. Ibid., Chapter XXVIII, titled "Of Preferments and incouragements," 281.

20. Brinsley, 220.

21. This guild followed the example of the first such guild organized in Antwerp in 1591.

22. Valcooch, Dirk Adriaanszoon. *Valcooch's Regel der Duytsche Schoolmeesters*, ed., Pieter Antonie De Planque. Groningen: P. Noordhoff, 1926. Though Valcooch's is one of the earliest and most popular source on teaching in the primary school, Valcooch refers to other books on which he had drawn for his rules.

23. 1591, 1597, 1607, 1628. Source: Peter Antonie de Planque, Introduction to "Valcooch's Rules for Schoolmasters," (PhD. Thesis, University of Utrecht: Noordhoff, 1926).

24. Valcooch, 280. Translations from the Dutch have been made by Ed Schwing, Durham, Connecticut.

25. A. R. A. Croiset van Uchelen to Alfred P. Malpa, 29 August 1984. Alfred Malpa papers, Farmington, Connecticut. Croiset, the Curator of Rare Books at Universiteits-Bibliotheek, Amsterdam, gave Mr. Malpa this information in response to an enquiry about a Dutch Reward in his collection.

26. Brinsley, 27. This is the title of his Chapter III.

27. Ibid., 38.

28. The collection was unfortunately sold in lots in 1920, and a careful record of their whereabouts is no longer available. (information from Linda Stanley of the Pennsylvania Historical Society).

29. Edward Eggleston, "A School of Long Ago," *St. Nicholas* (July 1885), 644-645.

30. Thomas R. Smith, Upper Darby, PA, a collector who became interested in a small Reward found with a larger writing sample (*Vorschriften*), discovered from research and from a handwriting analysis, that the signature, George de Binder, was one of the signatures used in America by George de Benneville (1703-1793).

31. The translation made for Thomas R. Smith was
 Today (Heute) was the best
 This Jim(m)y of our school
 And for himself for his energy
 This sued praise received.
 GEORGE DI BINDER SCHOOLMASTER
Thomas R. Smith, "Satisfying a Curiosity of The Process of Researching a Prized Possession," TD, Gardiner-Malpa Collection.

Wood engraved illustration, circa 1820. The Puritan ethic is evident in many Rewards of Merit through this period. As this example indicates, childhood is not too soon to prepare to meet the Creator.

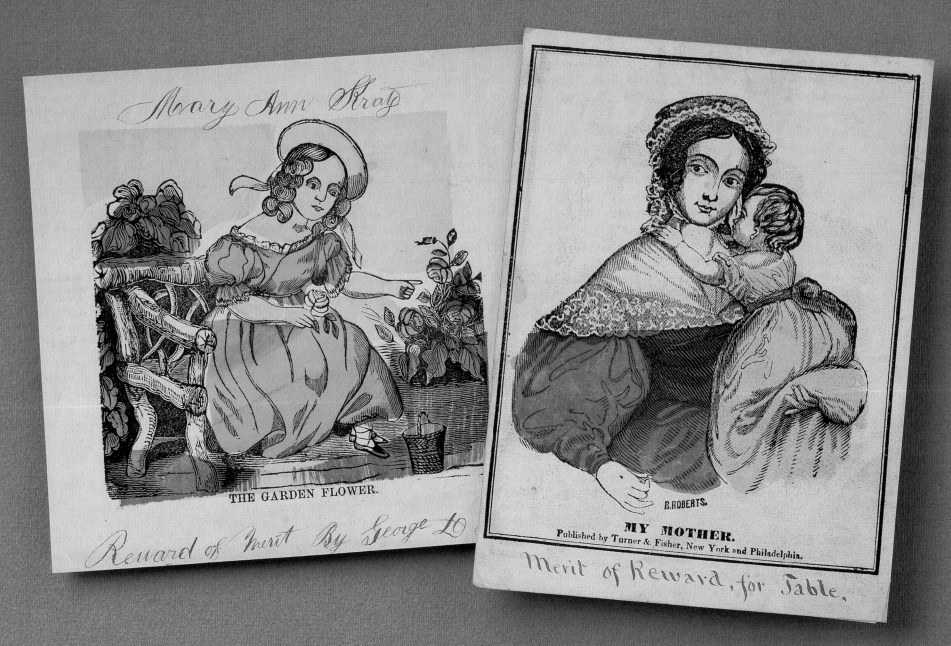

Mary Ann Kraft

THE GARDEN FLOWER.

Reward of Merit By George L.

R.ROBERTS.

MY MOTHER.
Published by Turner & Fisher, New York and Philadelphia.

Merit of Reward, for Table.

Rewards of Merit were not always titled as such. These beautifully drawn, wood engraved single sheets were hand-colored and sometimes presented with the accumulation of a sufficient number of smaller recognitions.

PURITANS, PARENTS AND GODLINESS
Children prepared for a moral life and an early death

O may the work of prayer and praise
Employ our daily breath
Thus we're prepared for future days
Or fit for early death
Divine Songs for Children, XII
ISAAC WATTS

 he earliest American printed Rewards of Merit to survive are from the last quarter of the eighteenth century. It is not known when the first Rewards of Merit in the American Colonies were printed or how many handwritten ones pre-date the first printed ones. What does become clear is that the size, illustrations and messages of many of the earliest printed Rewards of Merit reflect the interests, concerns, and beliefs — above all, the religious beliefs — of the colonists of the first one hundred and fifty years of settlement.

To read,

"Thou shalt surely die. Gen. 2:17",

on the first line of a Reward of Merit[1]—a piece of ephemera which was a cherished gift from a teacher—does, at the very least, arrest one's attention. Many of the Rewards of the late eighteenth and early nineteenth century, printed for use with beginning pupils, have similarly bleak quotations.

The religious ideas and institutions which the Puritans were determined to preserve, many of which were reinforced by the fervor of the Great Revival under Jonathan Edwards in the 1740s, had an unsentimental view of childhood. Theirs was a stark picture of the world as the theater of a cosmic conflict between the Elect and the reprobate majority of humankind. Puritan settlers were determined to build a new society based on their convictions of God and human life—a City Set upon a Hill to be a

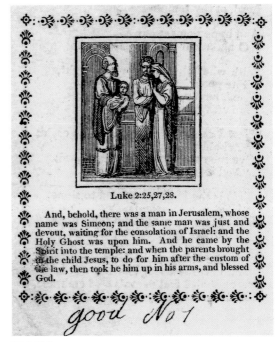

Luke 2:25,27,28.

And, behold, there was a man in Jerusalem, whose name was Simeon; and the same man was just and devout, waiting for the consolation of Israel: and the Holy Ghost was upon him. And he came by the Spirit into the temple: and when the parents brought in the child Jesus, to do for him after the custom of the law, then took he him up in his arms, and blessed God.

good No 1

Fig. II-1

35

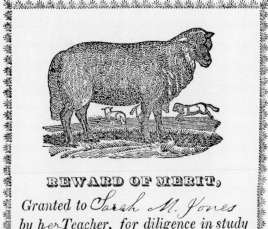

REWARD OF MERIT,

Granted to *Sarah M. Jones*
by her Teacher, for diligence in study
and for good behavior. *M. Farrar*

Mamma, see what my teacher has
given me for being a good scholar to-
day—see that picture of a sheep and
those little lambs ; how pretty. Well,
dear child, I hope you will be a good
scholar every day ; then your teach-
er and parents too will love you.—
Good children may always expect
Rewards of Merit from their teachers.

One of the very few Rewards of Merit which
expressly implies the parents' expectations of
the child's desired behavior, with the resulting
benefits. Wood engraved illustration, circa 1825.

beacon to mankind—and had an all-encompassing commitment to imparting their beliefs to their children.

For those purposes, they brought with them a surprisingly unquestioned acceptance of the books, teaching methods, schools, and school curricula which had developed when England was still Catholic and the printing press was still new. Thus The Bible and a Primer (for basic teaching in the home) and Latin grammar schools (for educating their teacher/preacher leaders) became the primary means for transmitting religious and political views to the next generation of the New World colonies. More than a century and a half later, the contents, and even the typography, which appeared in the books used for beginning reading lessons and on Rewards of Merit (Fig. II-1) bore the characteristics of the first books printed for mass distribution.

The Puritans were most determined to teach children their belief that "no mass or prayer, no priest or pastor, stood between man and his Creator, each soul being morally responsible for its own salvation."[2] Grace could only be granted by God according to His inscrutable will; and the means for securing that salvation was not baptism, or as the Puritans would describe it, any similarly "superstitious" practice, but rather by understanding and obeying the teachings of the Bible. Everyone therefore, needed to be able to read and to reason. The importance which that placed on education for all was unprecedented.

One early nineteenth-century Reward of Merit, printed by Munroe and Francis, Boston, MA, has a poem, albeit in language less elegant than the well-educated Puritan fathers would have used, which succinctly reiterates this point of view. On one side of the Reward there is a woodcut illustration of three children praying (Fig. II-2). On the other is the poem "The Bible," which ends with the lines:

> Be thankful, children, that you may
> Read this good Bible every day:
> 'Tis God's own word, which he has giv'n
> To show your souls the way to heaven.

Another of the Puritans' most basic beliefs was that infants were born with the burden of original sin. Since, unlike the Roman Catholics or some Anglicans, they did not believe that baptism cancelled the effect of original sin, sinfulness had to be rooted out. The will of the child had to be broken. It was not merely "spoiling the child" which might be the result of "sparing the rod"; rather, the result might be to leave children to the terrors of hell fire and damnation for all eternity. To bring the child to know the Bible, to obey the will of God, and to have an experience of conversion, were understood to be matters of the gravest necessity. It was to help children share the same sense of urgency, this same sense of hell just a heartbeat away, that parents constantly placed

before their children the possibility of early death. Children were to be frightened into faith in the redeemer and into an experience of conversion, for the sake of their salvation.

A characteristically Puritanical warning appears on the Certificate of Merit, sold by Samuel T. Armstrong between 1813 and 1827, which quotes the verse from *Genesis* in which God warns Adam and Eve that if they eat the fruit of the tree of knowledge "Thou shalt surely die." That Bible verse is followed by the poem:

> Ah! how swift the moments fly,
> Time with me will soon be o'er;
> Soon shall I be call'd to die,
> And be known on earth no more.
> But if I the Saviour love—
> If he shed his blood for me,
> I shall reign with him above,
> Through a long eternity.

It is the line "But if I the Saviour love" which Puritan parents were so determined to inculcate in their children. If children did "the Saviour love," and if they were of the elect, "If he shed his blood for me," they could be assured that instead of suffering hell, they would "reign with him above, Through a long eternity."

Another Certificate of Merit sold by Armstrong begins with the more hopeful verse from *Proverbs* 8:17, which gives God's promise that

> I love them that love me; and those
> that seek me early shall find me

The verses which follow, though in the elegant language of Isaac Watts, stress infant depravity, but also assure the child that by believing in Christ's atonement, he or she shall reign in heaven.

> LORD, teach a little child to pray,
> Thy grace betimes impart;
> And grant thy Holy Spirit may
> Renew my infant heart.

> A sinful creature I was born,
> And from my birth I stray'd.
> I must be wretched and forlorn,
> Without thy mercy's aid.

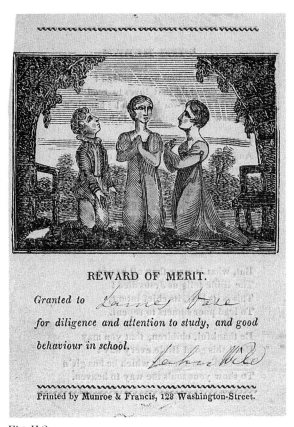

REWARD OF MERIT.

Granted to *James Dale*

for diligence and attention to study, and good behaviour in school.

Printed by Munroe & Francis, 128 Washington-Street.

Fig. II-2

Wood engraving of child praying on one side of the Reward with the prayer "Our Father Who Art in Heaven" printed on the other side. Sold by Cory and Daniels, booksellers and stationers. Providence, RI., circa 1840.

But Christ can all my sins forgive,
And wash away their stain;
And fit my soul with him to live
And in his kingdom reign.

To him let little children come,
For he hath said they may;
His bosom then shall be their home,
Their tears he'll wipe away.

It was also this dedication to make children realize that they might die at any time and should therefore have a conversion experience as soon as possible that inspired writers and artists to impress children with stories of the deaths of other children. On a Reward of Merit sold by S. G. Simpkins of Boston (1827-1831) the illustration is of a child near a grave in a cemetery, and the poem below is entitled "On the Death of a Scholar." The poem does assume that

He has gone to the home of the angels on high,
Where the sins of this world are forgiven;
Oh why should we wish to detain from the sky,
A soul so well fitted for heaven.

As late as the mid-nineteenth century the poem, "Death of a Schoolmate," appears on a Reward of Merit sold by Warren Lazell of Worcester, MA.

Death has been here and borne away
A sister from our side;
Just in the morning of her day,
As young as we—she died.

Not long ago she fill'd her place,
And sat with us to learn;
But she has run her mortal race,
And never can return.

Perhaps our time may be as short,
Our days may fall as fast;
O Lord impress the solemn thought
That this may be our last!

We cannot tell who next may fall
Beneath thy chast'ning rod;
One must be first;—but let us all
Prepare to meet our God.

The Puritanical influence was so strong that nineteenth-century Rewards of Merit still bore their theological teachings even when much gentler, and even childishly sentimental, verses and pictures became popular.

One of the reasons for this persistence of influence lies in the Puritan attitude toward literacy and their association with printing. In their zeal to teach everyone to read the Bible, the Puritans were well aware of, and experienced in, using the relatively new technology of printing. According to some historians, the Reformation could only have begun when printing made multiple copies of the Bible possible; and Puritanism could only have succeeded when not only each congregation but each person could read and study his or her own Bible.

In their advocacy of universal literacy and the development in each individual of the power to reason independently, however, the Puritans soon encountered a problem. It was not just that each new Puritan child needed to read the Bible. Think for themselves they must, yet what they thought must be what their elders thought. "Teachers," as the Separatist clergy were first called, were chosen to tell their congregations what they were to think for themselves, but clearly a book of doctrine, of creed, was essential—one which insured that each independent reader would glean from their study of the Bible what the first Puritan fathers of the church had discovered from their reading. The omnipresence of a book of religious belief, used in all religious homes, was needed to guarantee that the omnipresence of God would be felt in the same way down through the generations. In the New World such a book was to guarantee that the omnipresence of God as defined by the Massachusetts Puritans would be felt throughout the new country—long after many Massachusetts congregations had become Unitarian.

The New England divines had experience in causing such books to "evolve" in ways which would reflect their own particular dissensions, while holding closely to the appearance of those which were authorized or approved. In devising such a book the Separatists in England and Holland had followed closely the model of the primer, one of the first books printed. The primer was the primary (primer) explication of the church service used by Roman Catholics for the specific purpose of instilling the doctrines which the Catholic clergy, who did mediate between the people and their creator, wished their parishioners to understand. In the Church of England it antedated the

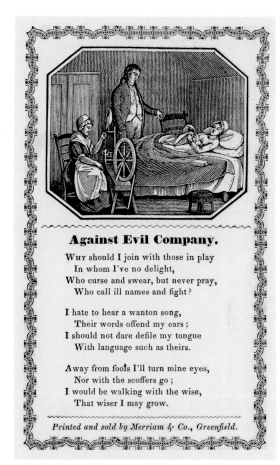

Against Evil Company.

Why should I join with those in play
In whom I've no delight,
Who curse and swear, but never pray,
Who call ill names and fight?

I hate to hear a wanton song,
Their words offend my ears;
I should not dare defile my tongue
With language such as theirs.

Away from fools I'll turn mine eyes,
Nor with the scoffers go;
I would be walking with the wise,
That wiser I may grow.

Printed and sold by Merriam & Co., Greenfield.

This Reward of Merit establishes a model for the receiver. It illustrates that the good child realizes the importance of identifying proper peer associations and the type of conduct most esteemed in good children. Reward is printed on reverse side. Wood engraving, circa 1835.

EVENING PRAYER.

Thou art our Father and our constant Friend!
To thee we bend and raise our evening prayer.
On thee our lives and dearest hopes depend ;
We pray to thee, who dwellest every-where.

Protect us, while in darkness we repose,
Beneath the shadow of thy shielding wing,
Be with us, Father ! when our eyelids close,
And guard us safe, while we are slumbering.

Our God, and Father ! who dost never sleep,
Here would we humbly kneel and pray to thee ;
Wilt thou this night above our pillow keep
That we may wake, another morn to see.

Watercolored, wood engraved Reward with a typical religious admonition printed on one side and the Reward itself printed on the reverse side. Circa 1840.

publication of the *Book of Common Prayer*.[3] Among the Puritans, it evolved into various Protestant primers including by 1690, *The New England Primer*. The layout and much of the content of the earliest school books and Rewards of Merit came from that Primer. Sections from the catechism to be memorized, including the Bible verses which were considered the most important, were reproduced on Rewards of Merit; and Rewards of Merit were given for memorizing those Bible verses more than a century later.

The New England Primer, like Henry VIII's Primer, also had prayers for use in the home—before and after dinner. It was, as Henry VIII's had become, a book of instruction of godly behavior for children. It was a practical solution to learning to read, to knowing God's will, in the home and later in the schools.

Primers through the centuries had remarkably similar religious overtones, contents, printing style, and catechetical modes of teaching. Their several sections, which appeared in some form in nearly every version, often were printed in separate books or on single sheets. These printed separate sheets were most easily seen on Rewards of Merit via the hornbook, a device for making certain that one precious printed page would last through more than one child's first reading lessons.

The history of the horn book preceded printing. For those children destined to become literate, a teacher would write out the alphabet on a sturdy piece of animal skin or bark and attach it to a rectangular board with a handle. This paddle-shaped board became a horn book when a single printed sheet of fragile paper, traditionally the alphabet or the syllabarium[4] from a primer, was covered by a thin sheet of horn. Horn was used as a glass or plastic covering was later used—to protect the paper from becoming worn by the constant handling of young children. Hornbooks were among the first items imported to the American colonies, and from them children of the new land learned and memorized from single pages of the Primer.

Thus the Primer, learned by rote, page by page, on hornbooks used again and again, was ingrained in the American mind. In some schools the youngest learners were called until late in the nineteenth century the "abecedarians"—an inheritance from the *Enschede Abecedarium* of 1490 to the alphabet page which was on the hornbooks. Children became accustomed, thereby, to one-page instructional pieces and a one-page instructional style. Many nineteenth-century printed Rewards of Merit, particularly those with a religious theme, reflect that style—a page from a small book with a didactic poem or Bible verse to be memorized.

The mode for learning the correct Biblical interpretation from the Primers was catechizing—answering set questions with memorized set answers. These questions and answers were set forth in the catechism section of the Primer or printed as a separate book.[5]

40

Cotton Mather, the third-generation Massachusetts Puritan divine, describes the catechetical method as follows:

It is a way of Teaching wherein one puts a Question and another gives an Answer. To Examine another about his Knowledge is to Catechise him; to Catechise another is to demand from him an Echo to what he Enquires of him.[6]

Mather's definition of catechizing and his admonition to parents to catechize their children was written more than seventy years after the Puritans first landed in New England, and immediately precedes what he had particularly on his mind: "it is the Duty of Parents to CATECHISE their Children." Several generations later, teachers were still catechizing, while some Rewards of Merit displayed admonitions, questions, or answers which reflected the content of Primers and their catechism sections.

Following the Old World experience and assumptions, and adjusting to their particular needs, the colonists had legislated that parents were responsible for teaching all in their family— servants and apprentices as well as children. Parents were to teach the fundamentals of religious faith, reading, and proficiency at a trade or skill. It was this linkage of the Puritan belief in living a godly life with mastering a life-sustaining proficiency of some kind which led to their peculiarly effective emphasis of learning practical skills along with understanding the Bible. The practical emphasis was not what one would expect to find among people who did not believe in salvation by "good works," but it is one which was expedient for avoiding becoming a public charge in England and for being a contributor to the settlement of a new land. This combination of emphases frequently appears, sometimes confusingly, on Rewards of Merit.

The New England Primer made it possible to teach skills simply as a regular part of the work of daily life which would later be taught in school rooms. With the Bible and a Primer, reading was often taught on an each-one-teach-one basis[7] and the daily activities of the household included individual reading, responsive reading, and unison reading. John Cotton's grandson Josiah (1680-1756) wrote in his diary that although "My younger days were attended with the follies and vanities incident to youth, howsoever I quickly learned to read, without going to any school I remember."[8]

Though the combination of preaching, catechizing, and parental teaching was the first most common type of education, schools were established early to prevent surrendering to barbarism or floundering in dependency.

When those first New World schools came into being, the Primer, as it had been in the home, was the first school book for most American school children. The Puritan

Pray Always.

Go, when the morning shineth,
 Go, when the noon is bright,
Go, when the eve declineth,
 Go, in the hush of night;

Go, with pure mind and feeling,
 Send earthly thoughts away,
And in thy chamber kneeling,
 Do thou in secret pray.

Remember all who love thee,
 All who are loved by thee;
And pray for those who hate thee,
 If any such there be.

Then for thyself in meekness,
 A blessing humbly claim,
And link with each petition,
 Thy great Redeemer's name.

Printed and sold by Merriam & Co., Greenfield.

Another example of a Reward printed on two sides. Printers utilized the wide variety of borders supplied by type founderies of the period to enhance such awards. Wood engraving, circa 1835.

Fig. II-3

Fig. II-4

emphasis on religion was thus reprinted over and over. The Primer also standardized and dominated the method of teaching the ABCs and reading; the methods continued to be rote memorization and the question-and-answer mode of catechizing. It influenced textbooks including spellers, geographies, and even the stories included in the first readers. Not surprisingly, the religious views which we find on Rewards of Merit are also those set forth in the Primer.

By the time those Rewards were being printed in any variety, stark Puritanical themes were often moderated by the beauty of the language of Isaac Watts (1674-1748), the popular writer of Protestant poetry and hymns.[9]

To the early seventeenth-century Puritans, music was suspect, except for the metrical chanting of the psalms. For Watts, dedication to composing hymns came from his observation that the congregation, as they intoned the usual psalms, showed on their faces a lack of understanding of the lines they sang. He believed that hymns should represent and communicate commonly-felt joys and sorrows. His method was to omit parts of the Scriptures which had little bearing on the life of most people, and to paraphrase hymns and psalms by abridging, transposing, and expanding key words and phrases.[10] For children, Watts wrote *Divine Songs*[11] in 1715 and *Catechisms* in 1730. Songs from the former appear frequently on Rewards of Merit printed between 1810 and 1845, sometimes slightly disguised by misprints and printers' emendations.

On the back of a Reward printed by Glazier and Masters[12] sometime between 1828-1847, for example, Watts' hymn number XII in *Divine Song for Children*, "The Advantages of Early Religion," appears in a somewhat altered version (Fig. II-3). Watts himself often changed his words, but so did many other people. There is, of course, no attribution to Watts on the Rewards; it was uncommon to identify the authors of such verses. Another Reward (Fig. II-4) printed by George Daniels between 1830 and 1847 in Providence, RI, follows Watts' own words in the 1781[13] editions far more faithfully than does the earlier Reward. The only changes in the later Daniels Reward are the substitution of an "e" for the earlier apostrophe in such words as "offer'd."

On the earlier Glazier and Masters Reward, the changes are probably typical of the kinds of emendations which were made. A number of changes are minor, such as

...*to* his eyes	to	*in* his eyes
...*that* grow old	to	*who* grow old
...*in* their crimes	to	*by* their crimes

The more major changes are:

42

Happy the Child Whose Tender Years
is changed to
Happy is he whose early years

When we devote our Youth to God
is changed to
Youth, when devoted to the Lord

Grace shall preserve our following years
is changed to
With joy it crowns succeeding years,

Let the sweet work of prayer and praise
Employ my youngest breath;
Thus I'm prepared for longer days,
Or fit for early death.
is changed to
O may the work of prayer and praise
Employ our daily breath:
Thus we're prepared for future days,
Or fit for early death.

The last line, "Or fit for early death" is a reference to the need to prepare for conversion and salvation because of infant depravity, but much less harshly posed than poetry previously printed, or earlier written, on Rewards of Merit.

The theme of early death is even further softened in the verses on the back of an Ezra Collier Reward (Fig. II-5).[14] The reasons given in "The Good Child's Resolution for early service to the Lord" include neither early death nor damnation specifically, but rather, they stress that Jesus "loves to hear his praise."

Since Jesus loves to hear his praise
Arise from infant tongues;
Let us not waste our youthful days
In vain and idle songs.

We can't too early serve the Lord,
Nor love his name too dear;
Nor prize too much His blessed word,
Nor learn too soon his fear.

The reverse of this Reward aptly presents the poem "God sees and knows all things."

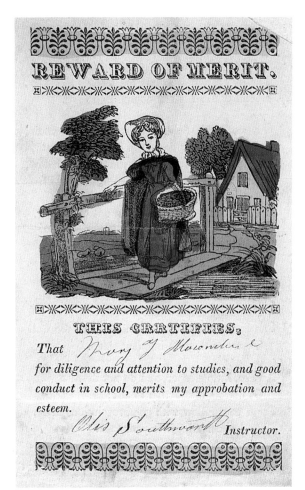

REWARD OF MERIT.

THIS CERTIFIES,

That *Mary J. Moxendine*

for diligence and attention to studies, and good conduct in school, merits my approbation and esteem.

Otis Southworth Instructor.

Fig. II-6

The pleasures that His children find,
Exceed the sinner's mirth,
Are food for the immortal mind,
And suit our humble birth.

The line "Nor learn too soon his fear" alludes to damnation and death but is far removed from the use of the Bible verse, "Thou shalt surely die."[15] As on the Glazier Reward of Merit, the Watts hymn appears on the reverse side of the Reward.

Since, by the early 1800s, Rewards of Merit were being sold by various printers and booksellers in various locales, one might expect to find that only a few would continue the theme of early death into the new century, particularly since the themes of patriotism and social behavior became so popular after the Revolution. Such is not the case, however. The three verses quoted above were sold by three booksellers at three progressively later dates.

If the theme of early death did not frighten young children into good behavior, that of the omnipresence of God may have been more effective. All children have the experience of being continuously watched by parents, loving but fearful of their sinfulness (or, more usually now, of their naughtiness). Children used to be told that even if they succeeded in hiding disobedience from their parents, they could not hide it from an omniscient God.

...our most secret actions lie,
All open to thy sight.

These lines appear on a Certificate of Merit sold by Armstrong in Boston (1813-1827) and again on a Reward of Merit sold by Daniels in Providence (Fig. II-6).[16] Perhaps the most severe of these Reward admonitions, Armstrong titled it "Praying for Pardon," but Daniels printed it under its original title, "All-seeing God." The poem is, in fact, Song IX, "The All-seeing God," in Watts' *Divine Songs Attempted in Easy Language for the Use of Children* (stanza 2).

There's not a sin that we commit,
Nor wicked word we say,
But in thy dreadful book 'tis writ
Against the judgment day.

Another poem, "God Sees and Knows Every Thing," appears on a Reward sold by Daniels and on another one with no identification of the printer or seller. It gives us

a glimpse of a child's reaction to ministers who were yet another adult authority watching over their behavior.

> If some good minister is near,
> It makes us careful what we do;
> And how much more we ought to fear
> The Lord, who sees us through and through.

The poem, "God Every Where Present," on a Reward sold by Marshall, Brown, & Co., of Providence, RI (1832-1837), also aims to inspire fear: "He's sure to know it if I sin." At least, however, it has the hopeful tone that such fearsome reminders are for the purpose of helping the child behave.

> Then when I want to do amiss,
> However pleasant it may be,
> I'll always try to think of this—
> I'm not too young for God to see.

One double-sided Reward has a less admonitory poem, but combines that poem with illustrations—a Biblical scene occupies one side; small cuts in the style of hieroglyphic Bibles accompany the poem on the certificate side. The poem is short and snappy and omits threats, but the effect of the total message is powerfully succinct:

> He sees our thoughts and actions
> With his ever watchful sight.

Sabbatarianism, the belief that Sunday must be a day devoted entirely to worship and rest, ordered the cycle of work and life of the New Englanders. For children, not born with a sense of a first or a seventh day, the holiness of Sunday was another of their parents' beliefs which they had to learn. The "Little Child's Prayer for the Sabbath" repeats in three slightly different phrases the rule of conduct for the Sabbath.

> I must not work, I must not play
> Upon God's holy Sabbath day.

And, should there be any possibility that motivation beyond knowing the rule was needed, the poem also reminds the child that God is He "on whom for life I must depend," and "All Sabbath breakers thou does hate."

Do good to them that hate you.

Father, we see thy sun arise,
To cheer thy friends and enemies;
And when from Heaven thy rain descends,
Thy bounty both alike befriends.

Enlarge our souls with love like thine;
Our mortal powers by grace refine;
So shall we feel for others' wo,
And sympathize with friend and foe.

We hope for pardon through thy Son,
For all the faults which we have done—
Then may the grace that makes us free
Constrain us to forgive like thee.

Printed and sold by Merriam & Co., Greenfield.

One of several Rewards with a poem embellished with a border and wood engraving. The reverse side contains the Reward, circa 1835.

Fig. II-7

Fig. II-8

Fig. II-9

Fig. II-10

Another early poem assumes the child knows the rules. Rather than prescribing suitable behavior for the Sabbath, or even defining appropriate observations for the day, this poem prays for admission to an eternity of Sabbaths—something hard for modern readers to imagine a child doing, given the severity of the Sabbath prohibitions.

From the beginning of mass printing of Rewards of Merit the availability of type and woodcuts and the general small-shop arrangements of printing establishments meant that those Rewards of Merit printed to be sold cheaply often appear to be a curious conglomeration of text and illustration. The less expensive editions of books, and particularly of popular primers, chapbooks, and broadsides, often seemed to have been quickly put together. This is also apparent on Rewards of Merit on which poems seem to have been printed on one side without regard to illustrations on the other side.

Many Rewards from the early nineteenth century have illustrations, but not texts, which clearly show their link with the primers, catechisms, and Bible study. The illustrations are reminiscent of the primer illustrations, but they are combined not with the severe early Puritan texts; but with comparatively bland and much later verses. These Rewards were sold primarily in Worcester by Lazell and by Dorr, Howland and Company.[17] All have the square Biblical illustrations of primers and catechisms, and most of the verses at least reiterate general Puritan beliefs. The more dramatic emphasis on infant depravity, however, has been considerably softened. In the poem "Praise for Christian Birth," for example, emphasis on infant depravity has been replaced by

> My God! I thank thee, who has plan'd
> A better lot for me;
> And plac'd me in this happy land,
> And where I hear of thee.

"Duty to Our Neighbors" is an exposition of the Golden Rule which emphasizes works and right conduct rather than faith for salvation. On the back of a Dorr and Howland Reward with the illustration of the conversion of Saul on the Road to Damascus (Fig. II-7) are no less than four stanzas of that familiar nursery rhyme "Twinkle, Twinkle, Little Star."

The illustrations on all these Rewards are old, no doubt familiar, square woodcut Biblical illustrations of the kind used from the first printing of children's religious reading materials. Almost all are from the Old Testament: Samson killing the lion (Fig. II-8), Cain killing Abel (Fig. II-9), Moses in the bullrushes, the boatmen throwing

Jonah overboard in the storm (Fig. II-10), the treaty between Lot and Abraham (Fig. II-11), Adam and Eve in the garden (nude, but discreetly covered from the waist down by foliage) (Fig. II-12), the children who mocked the prophet Elijah being eaten by bears (Fig. II-13), and Lot's wife turned into her familiar pillar of salt (Fig. II-14). The New Testament scenes include—particularly appropriate for a Reward of Merit—the Christ child teaching in the temple and confounding his elders with his knowledge (Fig. II-15), and the good Samaritan (Fig. II-16).

Signs of the American Enlightenment also begin to make an appearance in Reward Texts. The Golden Rule,

> To do to others as I would
> That they should do to me

is not, for example, one of the Bible rules which the Puritans would have most emphasized with their children. It is obviously a code for living with other people—not one which emphasizes conversion and one's relationship to God alone. The poem, "The Golden Rule," on a Reward of Merit printed by Daniels not only has no reference whatever to dangers of sinning, but gives a personal, secular, and self-interested reason for obeying the Golden Rule:

> But any kindness they may need,
> I'll do, whate'er it be;
> As I am very glad indeed
> When they are kind to me.

The illustration, as if to emphasize even further the distancing from religious severity, shows a very pleasant scene of a well-coiffed, prettily dressed young woman apparently looking at her pet bird. It was an illustration frequently used by Daniels and other Providence printers for both Rewards of Merit and chapbooks (Fig. II-17).

Another Reward of Merit (Fig. II-18), attributable to Lazell, refers to Christ and the Bible on the side with the blank to be filled out by the teacher, but the poem, "The Saviour," contains no hint of the need to behave in order to avoid the wrath of God. Rather it merely concludes

> He was gentle, lowly, meek
> So should little children be.

Fig. II-11 Fig. II-12

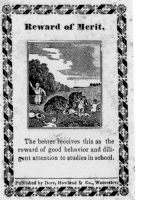

Fig. II-13 Fig. II-14

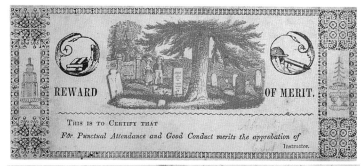

REWARD OF MERIT.

THIS IS TO CERTIFY THAT
For Punctual Attendance and Good Conduct merits the approbation of
Instructor.

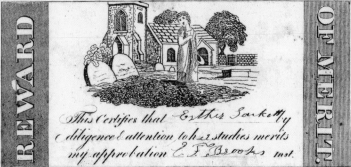

REWARD OF MERIT.

This Certifies that Esther Sackett My diligence & attention to her studies merits my approbation E F Brooks mst.

Above, copperplate engravings, circa 1820. Graveyard views were frequently depicted during this period. Such illustrations were meant to remind the child of the prospects of early death, preparation for which meant having read the word of God.

GOING TO SCHOOL.

I must go to school to day,
And if I should chance to meet
Idle children in the street,
I will neither stop nor play.

If I study all the while
I shall get my lesson well;
Then I will go home and tell
Dear Mamma, and make her smile.

Fig. II-18

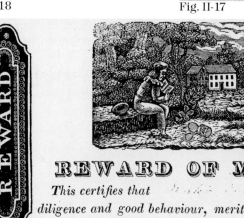

REWARD OF MERIT.

THIS CERTIFIES,
That Mary P. Burnap for diligence and attention to studies, and good conduct in school, merits my approbation and esteem.

Julia Ann Woodbury Instructor.

Dec 15 1851

Fig. II-17

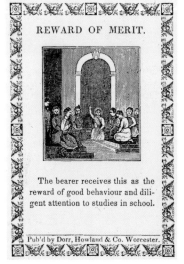

REWARD OF MERIT.

The bearer receives this as the reward of good behaviour and diligent attention to studies in school.

Pub'd by Dorr, Howland & Co. Worcester.

Fig. II-15

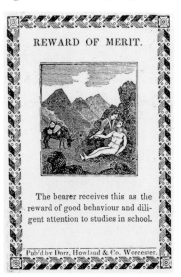

REWARD OF MERIT.

The bearer receives this as the reward of good behaviour and diligent attention to studies in school.

Pub'd by Dorr, Howland & Co. Worcester.

Fig. II-16

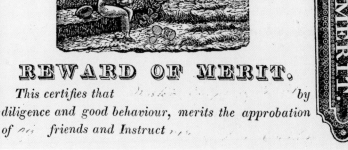

REWARD OF MERIT.

This certifies that _____ by diligence and good behaviour, merits the approbation of his friends and Instructor.

Fig. II-19

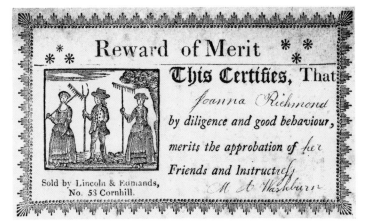

Fig. II-20

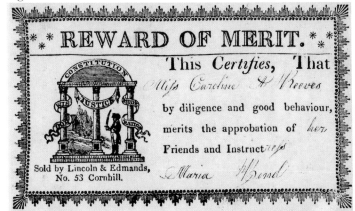

Fig. II-21

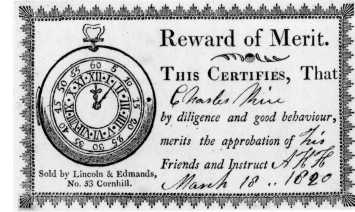

Fig. II-22

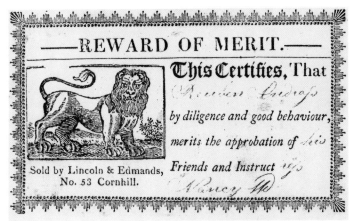

Fig. II-23

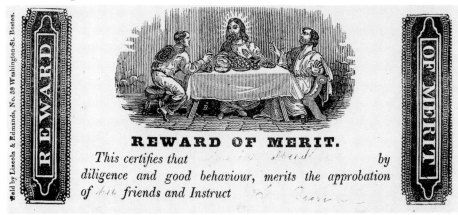

Fig. II-24

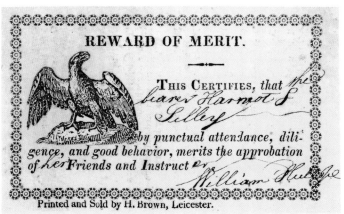

Fig. II-25

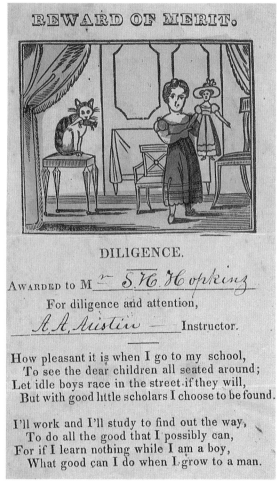

REWARD OF MERIT.

DILIGENCE.

Awarded to Mr. S. H. Hopkins

For diligence and attention,

A. A. Austin ———— Instructor.

How pleasant it is when I go to my school,
 To see the dear children all seated around;
Let idle boys race in the street if they will,
 But with good little scholars I choose to be found.

I'll work and I'll study to find out the way,
 To do all the good that I possibly can,
For if I learn nothing while I am a boy,
 What good can I do when I grow to a man.

Fig. II-26

The poem on the reverse side, "Going to School," is illustrated by another pleasant scene—a mother watching her children off to school—and is written in the voice of the children who resolve to go to school and "get my lesson well" and

Then I will go home and tell
Dear Mamma, and make her smile.

Indeed, it is easy when looking through a large collection of Rewards of Merit to recognize the falling away from strident insistence that children learn to read the Bible in order to have a conversion experience and save themselves from eternal damnation. The use of religion—the Bible, the love of Christ—continues, but the reason to "study all the while" is now to make dear mamma smile.

Even themes which seem at first glance to be deeply religious show signs of a changing sensibility. A Reward sold by Lincoln and Edmands of Boston and dated 1829 is illustrated with a woodcut showing a boy reading and obviously ignoring the toys on the ground around him (Fig. II-19). True, it recommends reading the Bible, but, as its title, "World Renounced," indicates, it praises neither daily work nor communication with others. Rather

I'd urge no company to stay,
But sit alone from day to day,
And converse with the Lord.

Renouncing the world in order to read the Bible seems initially consonant with the theology of the first settlers, but though the Puritans believed that studying the Bible in order to know and do God's will was the path to salvation, it is unusual to find anywhere in their culture a theme of religious retreat from daily toil. Retreat would have recalled to them monasticism —the antithesis of the Puritan religious ideal. Besides, the shortage of labor, the lack of wealth, and the practical problems of a new land meant that daily work was also a matter of obedience to parents and, in that way, a religious duty.

Two Rewards speak of a saint and of religious doubt. Puritans considered the beatification and reverence of "saints" to be superstitious because no saints are mentioned in the Bible. The poem "The Expiring Saint" does speak of the atonement (stanzas 5 & 6), but the reference to saints seems to indicate a later, less self-consciously Puritan theology.

The poem "The Contrite Heart" not only refers to saints, but expresses religious doubt.

Thy saints are comforted, I know,
And love thy house of prayer;
I sometimes go where others go [church],
But find no comfort there (stanza 5).

The illustrations are scenes of farmers (Fig. II-20), models of the industriousness needed in the new nation, and patriotism (Fig. II-21)—the figure of George Washington stands under the symbol of the Constitution decorated with wisdom, justice, and moderation.

He knows his Saviour died,
 And from the dead arose;
He looks for victory o'er the grave,
And death, the last of foes.

Another Lincoln and Edmands Reward with a Bible verse heading,

Remember thy Creator in the days of thy Youth.
Eccl. xii. 1.

implores

In the soft season of thy youth (stanza 1)

Make him thy fear, thy love, thy hope,
Thy confidence, thy joy (stanza 2)

but stresses living a long life, rather than arousing fear of damnation from an unrepentant early death.

He shall defend and guide thy course
Through life's uncertain sea:
Till thou art landed on the shore
Of bless'd eternity (stanza 3).

The illustration on the reverse side, an often-used one of a watch (Fig. II-22), perfectly symbolizes the transition from Puritanism to Enlightenment. Its emphasis on the passage of time might still evoke fear that a child's time might run out before he or she had entered the right relationship to God; but it also could symbolize the rationalist argument for the existence of God (Deists compared the universe to a watch and God to the required watchmaker). Furthermore, it invokes the discipline of work, no hour wasted, appropriate to a country just beginning to industrialize.

Fig. II-27

Fig. II-28

Fig. II-29

51

Good Resolution.

When my father comes home in the evening from
work,
 Then I will get up on his knee,
And tell how many nice lessons I learn,
 And show him how good I can be:.

He shall hear what a number I know how to
count,
 And I'll tell him what words I can spell,
And if I can learn something every day,
 I hope soon I shall read very well.

I'll say to him all the nice verses I know,
 And tell him how kind we must be,
That we never must hurt poor dumb creatures
at all.
 And he'll kiss me and listen to me.

Fig. II-30

Two other Lincoln and Edmands Rewards of Merit have poems which, though they do not contradict early religious beliefs, again indicate a transition from the more severely Puritanical concerns. These poems by Isaac Watts seem to assume that the reader is already a converted Christian. Their themes are

> My feeble powers can never rise
> To praise thee as I ought:
> (from the poem "Praise to God" by Isaac Watts)

and

> Religion is the chief concern,
> Of mortals here below:
> (from the poem "Religion")

and, emphasizing the passage of years in contrast to early death,

> Waken, O God, my careless heart
> Its great concern to see;
> That I may act the Christian part,
> And give the year to thee.
> (from the poem "Reflections on our Waste of Years")

Not only does this poetry hardly seem appropriate to young children, but the illustrations on the reverse sides are again peculiarly inappropriate. The lion on one (Fig. II-23) appears to be a cut like those in the Abecedariums used to illustrate the letter L; the scene of two disciples with Christ at a table is an illustration of the supper at Emmaus (Fig. II-24), a traditional emblem of the Eucharist, which played little part in Puritan worship.

On a Reward printed by H. Brown of Leicester, the poem "Shortness of Time" is again written from the perspective of an already converted person. In this case, however, the poetry is particularly fine, and the patriotic eagle on the reverse side (Fig. II-25) is appropriate to a time of national expansion and pride; this is not a random or careless pairing. The fourth stanza of the poem declares

> But thanks to thine unbounded grace,
> That in my early youth,
> I here am taught to seek thy face,
> And know the way of truth.

The religious beliefs displayed on Rewards of Merit constitute the most consistent and fully-representative group of messages on a single theme. These explicitly religious Rewards finally gave way to messages which, without the theological references, were intended to impart standards of acceptable behavior (Fig. II-26), particularly toward parents and teachers, and present models of appropriate industries and industriousness (Fig. II-27).

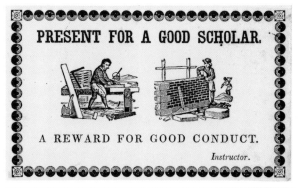

Puritan parents were obligated to teach their children to read the Bible in order to come to know God and to learn a trade or skill in order to lead a Godly life. The first schools for teaching reading were only established when parents did not, or could not, teach their children themselves. Obedience to parents, proper behavior, and industriousness thereby became the responsibility of the teachers.

There are many Rewards of Merit which have verses and illustrations (Fig. II-28) which relate to children being taught to read at home, or even more generally to the proper relationship of children to their parents. The illustration printed on a White and Read Reward of Merit[18] depicts that well-remembered scene, childen reading to their mother (Fig. II-29). The injunction to obey is often an exhortation to obey parents, and the context is often still the parent as teacher—not a schoolmaster or schoolmistress. Even when the poetry is not strictly about obedience, it often concerns the proper relationship of a child to parents—not to the teacher.

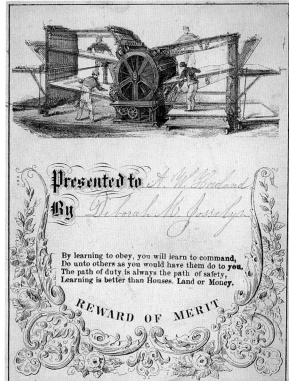

The poem "Pleasures of Innocence" on a George Daniels Reward of Merit reads:

> I love my parents to obey,
> Their word is wisdom's guide,—
> A rich reward, I'm sure 'twill pay
> And be my future pride.

A typical Reward of this genre and period has on one side a statement of Reward, "for diligence and attention to studies and good conduct in school," and on the other an illustration and poem depicting an affectionate relationship between a father and a daughter (Fig. II-30).

These Rewards reflect the assumptions of those first American schools which were substitutes for parents. Basic reading and writing was taught in the classroom only because parents, for some reason, were unable to fulfill that parental obligation themselves. Parental involvement in schools through the centuries has been encouraged and required, but in the earliest colonial schools, a principal duty of the teachers was to reinforce the omniscience of parents as the earthly representative of God, or at the very least, the final authority to be obeyed and pleased.

Fig. II-31

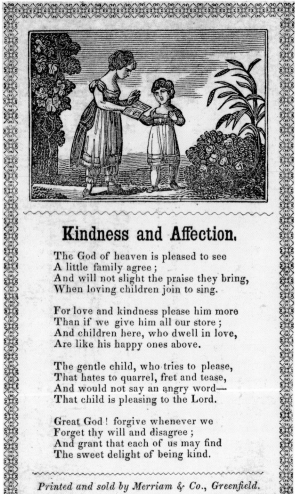

Kindness and Affection.

The God of heaven is pleased to see
A little family agree;
And will not slight the praise they bring,
When loving children join to sing.

For love and kindness please him more
Than if we give him all our store;
And children here, who dwell in love,
Are like his happy ones above.

The gentle child, who tries to please,
That hates to quarrel, fret and tease,
And would not say an angry word—
That child is pleasing to the Lord.

Great God! forgive whenever we
Forget thy will and disagree;
And grant that each of us may find
The sweet delight of being kind.

Printed and sold by Merriam & Co., Greenfield.

Fig. II-32

Because the first schools, particularly in the newer and more remote communities, were for fulfilling obligations which parents for some reason could not fulfill, they were often established without legislation, foundation, or support. It was not uncommon, for example, for good neighbors to take in a child whose parents could not teach reading. In New England if such a neighboring goodwife decided to teach a few other children on a regular basis and charge a small fee, the school became a "Dame School."[19] In Virginia when a family hired a servant or tutor to teach its own and perhaps some neighbor's children in the family home, it became a "petty" school.[20] In either case, the parents remained closely associated with these arrangements for the teaching of their children.

It was also concerns about parents who could not themselves fulfill their duty to teach their children, and yet had made no provisions for someone else to do so, which brought about the first laws mandating the establishment of schools. Not surprisingly, the first such legislation was in Puritan Massachusetts,[21] and it came quite early. The Massachusetts General Court passed a law in 1647 ordering every township of fifty householders to establish a petty school, and all townships of one hundred households to establish grammar schools.[22] No parent escaped responsibility for educating the young by this law, however. Parents became responsible for the schools—the building, the hiring of a teacher, the attendance of the children.

The General Court required schools but did not supply enough money for them, so various means of financing had to be used, including private arrangements by different groups of parents for various lengths of time. Parents were responsible for the schools and for seeing that their children were educated in the town school if not at home. It is not surprising, therefore, that the theme of obedience to parents, along with other themes of leading a godly life, appears in schoolbooks and on Rewards of Merit through most of the nineteenth century—a prolonged period when religion, home, and school were certainly not separate.

One of Isaac Watts' hymns, "Obedience to Parents"[23] thus links God, parents, and teachers as the authorities a child must hear and obey.

> Let children that would fear the Lord
> Hear what their teachers say;
> With reverence meet their parent's word,
> And with delight obey.
>
> Have you not heard what dreadful plagues
> Are threaten'd by the Lord,

To him that breaks his father's law
Or mocks his mother's word?

What heavy guilt upon him lies!
How cursed is his name!
The ravens shall pick out his eyes,
And eagles eat the same.

But those who worship God, and give
Their parents honor due,
Here on this earth they long shall live,
And live hereafter too.

Any and all of the virtues of a godly life could also be appealed to by referring to any of those natural authorities. "If my father was ragged and poor," for example, is the first line of the poem "Poverty" on a Reward ca. 1830. It invokes the father as an appeal to sympathy for ragged beggars. On the other hand obedience to mothers at this time was giving way to Victorian sentimentality. The subject of the verse on another contemporary Reward, for example, consists of reasons why a child must not tease her mother. Stanza three cites two reasons familiar to most mothers.

I must not tease my mother;
And when she likes to read,
Or has the headache, I will step
Quite silently indeed.

A hand-penned Reward given in 1840 at the Indiana Female Institute begins with a motto on the consequence of having been a worthy scholar:

an approving conscience,
the smile of Parental complacency,
and advancement in Knowledge
are a Pupil's best reward.

Complacency here does not mean, as it does now, self-satisfaction or smugness, but comes from the Latin "with pleasure."

Although it was the intention to have different kinds of schools —petty schools separate from the grammar schools or writing schools—the shortage of students, masters, and money meant that most schools became "general schools" taking

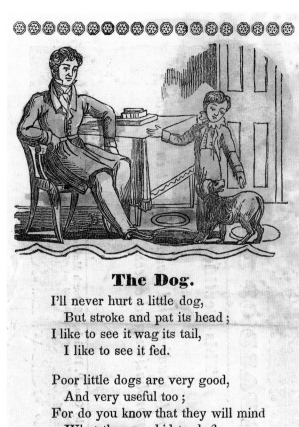

The Dog.

I'll never hurt a little dog,
 But stroke and pat its head;
I like to see it wag its tail,
 I like to see it fed.

Poor little dogs are very good,
 And very useful too;
For do you know that they will mind
 What they are bid to do?

Then I will never beat my dog,
 Nor ever give him pain;
Poor fellow! I will give him food,
 And he'll love me again.

Fig. II-33

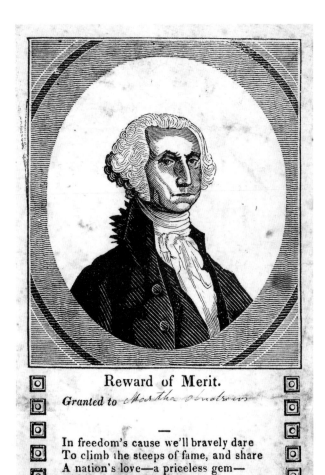

Reward of Merit.

Granted to *Martha Johnson*

—

In freedom's cause we'll bravely dare
To climb the steeps of fame, and share
A nation's love—a priceless gem—
Who wins it, wants no diadem !

Fig. II-34

children of all ages, usually no more than forty, and teaching each according to his or her achievement.

As the nineteenth century began, other emphases in the effort to guide children's conduct appear on Rewards of Merit. Rewards continue to appear which encourage industriousness, skill at particular trades (Fig. II-31), polite behavior (Fig. II-32), compassion towards animals (Fig. II-33), and patriotic awareness (Fig. II-34), but later in the nineteenth century, some Rewards of Merit abandon didactic intent altogether and aim to amuse or delight children with the prettiness of colorful, sentimental pictures—with scenes of favorite pets or various kinds of play. The Rewards of Merit which have the more secular and less admonitory themes, however, never approached in influence or ideological coherence the Rewards which convey Puritan religious messages. Inevitably the country became too diverse, its history too long, and its schools and printers too far flung to hold to any one theme or themes with the persistence and severe simplicity of the Rewards of Merit which reflected Puritan New England. At the same time that some Rewards still portrayed the Puritan mind addressing itself to childhood and childhood's immortal destiny, others began to reflect the intensifying trends towards the secularism and pluralism of the America we know today.

NOTES

1. Sold by Samuel T. Armstrong, Boston, MA.

2. Paul Leicester Ford, ed., *The New England Primer* (New York, 1897.)

3. The *Goodly Prymer in Englysshe*. The third primer was known as the *Henry the VIIIth Primer*.

 One of the signs, indeed, that the Reformed ideas were beginning to stir the people of England in the early sixteenth century had been the printing of unauthorized primers—a practice against which Henry VIII, when he was still concerned to keep his people true to Catholicism, issued proclamations and injunctions. After Henry's defection from the Roman church, he issued, as one method of fighting the pope, his own "Reform Primer," designed to teach the English what they should now believe. It was published in 1534—the first Primer in English. Within the year, he again changed his own beliefs, and licensed the issue of a second version and then a third, in both of which

he set other new, and only, paths to heaven. After Henry, each successive English sovereign—Edward VI, Mary, Elizabeth, and James I—who were brought up in different faiths—tried to suppress unauthorized "little books" and heterodox preachers and printers. With the flight of James II in 1688, more than fifty years after the persecuted Separatists had settled in the New World, it was finally clear that it was easier for the people to change their King than for the monarch to enforce conformity in religion. The place of the "little books" of catechism, from which each person was to memorize the creed of his or her religion, was now definitively established, in the American colonies as well as in England.

4. Lawrence A. Cremin, *American Education: The Colonial Experience. 1607-1783* (New York: Harper and Row, 1970), 394.

5. This rote, oral learning technique was older than printed texts. A group of students could learn

memorized questions and answers when only a teacher had a handwritten text available.

6. From Cotton Mather, *Cares About the Nurseries. Two Brief Discourses. The One, Offering Methods and Motives for Parents to Catechise Their Children While Yet Under the Tuition of Their Parents. The Other, Offering Some Instructions for Children, How They May Do Well, When They Come to Years of Doing for Themselves* (Boston, 1702), quoted in Wilson Smith, ed. *Theories of Education in Early America 1655-1819* (Indianapolis: Bobbs-Merrill Co., 1973), 12.

7. Cremin, 128.

8. Ibid. This section is followed by his discussion of what was used—including Edmund Coote's *The English Schoole-Maister*, which he says "went systematically from letters, syllables, and words, to sentences, paragraphs, and colloquies." These handbooks on pedagogy had very little on "how" to teach; most of the emphasis was on what was to be taught when.

9. Isaac Watts (1674-1748) was born to a Nonconformist family which suffered persecution for its beliefs. He spent his life in England as a pastor of an exclusive Independent (Congregationalist) congregation and later, when ill health limited his active life, as a tutor and writer. He was extraordinarily influential among churchmen and educators, and although accepted as a Puritan, he was one of several popularizers of the works of John Locke. Watts carried on a voluminous correspondence with American colonists and remained greatly interested in the developments in the New World. He disagreed with Locke, who remained an Anglican, on some important theological issues, but he shared with Locke a more benevolent piety, a greater tolerance for disagreements than that of the first New England Puritan fathers, and a considerable interest and talent for educational thought. Those of his poems (hymns) for children which appear on Rewards of Merit both reiterate the most severely Puritanical concerns with damnation and salvation and, by the use of a much gentler language and by introducing the themes of some of Locke's more enlightened attitudes toward children, provide part of the transition to more enlightened, more comforting, poetry for the Rewards of Merit.

10. Selma L. Bishop, *Isaac Watts: Hymns and Spiritual Songs 1707-1748: A Study in Early Eighteenth Century Language Changes* (London: The Faith Press. 1962), xxi.

11. Isaac Watts, D.D., *Divine Songs Attempted in Easy Language for the Use of Children.* (London: J. Buckland, J. F. and C. Rivington; T. Longman; W. Fenner; T. Field, and C. Dilly, 1781).

12. Glazier and Masters & Company, Hallowell, ME. 1828-1847.

13. Ibid., 17.

14. Ezra Collier, Plymouth, MA., 1822-1830.

15. Although Watts' poems are sometimes somewhat garbled and seldom appear with his name, a reader can often tell whether the poem on a Reward is that of Isaac Watts or an imitation of Watts' style. The verses of even the less successful imitators of Watts contrast dramatically with those which appear merely to be last-minute printers' doggerel.

16. Samuel T. Armstrong, bookseller, Boston, MA. (1813-1827) and George Daniels, Providence, RI.

17. Dorr, Howland and Company, Worcester, MA.

18. Wells River, VT.

19. Vermont Historical Society, 371.53 R 328a.

20. Cremin, 173. Both names were ancient. Petty was a version of "petties," a name used in England in the fifteenth and sixteenth century for the youngest children—those preparing to be able to go to a grammar school. The term "Dame School" arose after the Reformation when women took over the teaching of the "detached priests" (see Chapter Two).

21. Even though Massachusetts had at least nine schools by 1647, including one town-initiated petty school in Salem, it was nonetheless feared that children were being left untaught and that the impetus for founding schools was waning.

22. Ibid., 181. This law is commonly referred to as Ye Oulde Deluder Satan law.

23. Watts, Song XXIII, 33.

Reward of Merit.

Granted to ~~Fg James Price~~

—

A thousand joys our God hath given,
Our peace on earth, our hopes of heaven;
And all our souls shall join to raise
An offering of immortal praise.

Fig. II-34

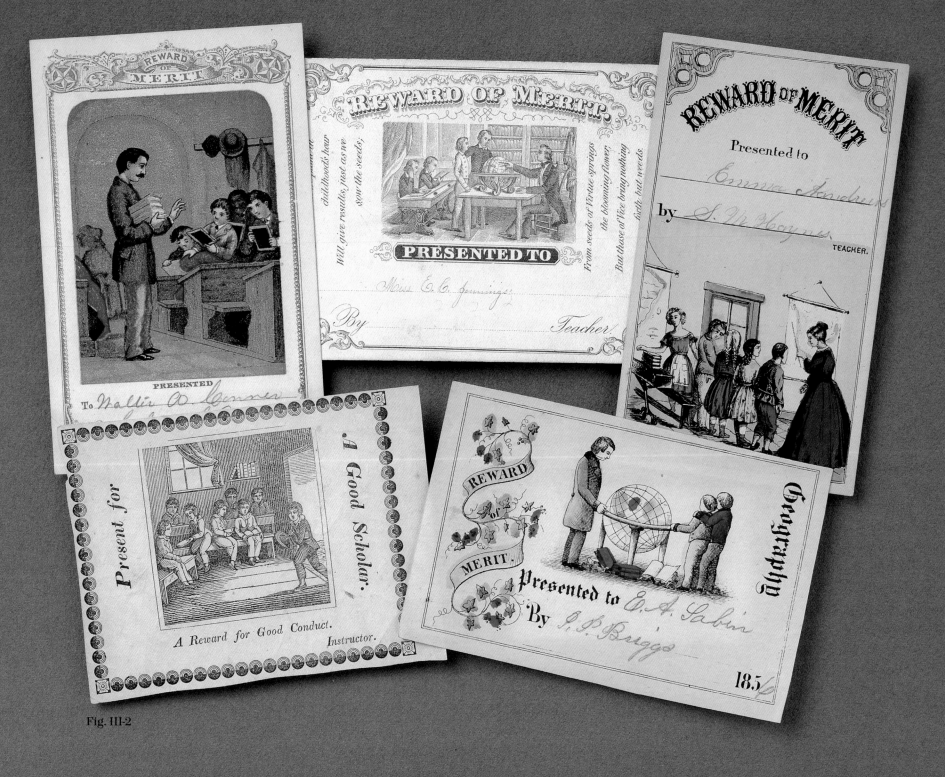

Fig. III-2

CHILDREN THEIR TEACHER MUST OBEY
From the sting of the rod to the pride of Rewards

How lovely, how charming the sight,
When children their teacher obey!
The angels look down with delight,
This beautiful scene to survey.[1]

Reward of Merit, ca. 1860

 t was relatively unusual that "children their teacher must obey" was explicitly stated on Rewards of Merit, but that message was obviously universally implied (Fig. III-1). It was part of that for which the child "merited esteem." In the early nineteenth century growing numbers of untrained and inexperienced men and women learned from hard experience that keeping order was the basic business of keeping school. Without order little learning took place. Some teachers used harsh punishments to assure good behavior; others gave Rewards of Merit; some did both.

Apparently many discovered that Rewards with stark theological warnings, verses to memorize, and admonitions to be heeded, were no longer effective. On a few of the printed Rewards, a well-ordered classroom is portrayed; on others, incongruously, pictures of the punishments to be avoided appear. Both give us interesting views of school room life now nearly forgotten (Fig. III- 2).

A Reward of Merit from the 1810s not only depicts interesting details of the schoolroom, but also shows the affectionate nature of a schoolmaster (Fig. III-3). Hats are hung on the wall of the school room which has high windows, backless benches, and an imposingly large teacher's desk. Beside the teacher's desk, on the level with the children, the schoolmaster is seated with his arm around a boy who is leaning against his knee. It is certainly not a picture of a rod-wielding taskmaster, nor does the Reward have a verse of admonition to good behavior. The picture itself portrays the rewards of good behavior.

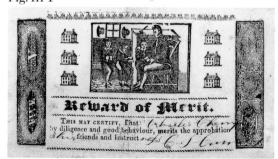
Fig. III-1

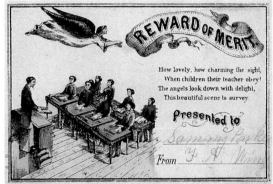
Fig. III-3

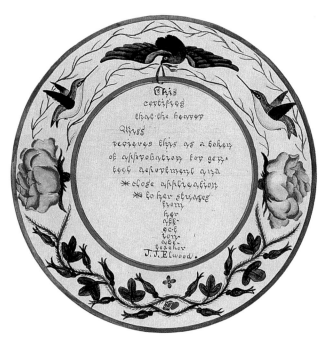

Uncommon in form and for its large size, this watercolor Reward of Merit, circa 1825, was made without a recipient's name. It suggests that this type of elaborate Reward was created by the teacher, in advance, for awarding recognition to a worthy student. It most likely comes from a school for girls.

On a Reward sold by Merriam & Co., Greenfield, MA, ca. 1820, the verse entitled "The Dunce" describes behavior teachers would have liked to change.

> I hate to see an idle dunce
> Who don't get up till eight,
> Come slowly moping into school,
> A half an hour too late.
>
> I hate to see a scholar gape,
> And yawn upon his seat,
> Or lay his head upon his desk,
> As if almost asleep.
>
> I hate to see a scholar's desk
> With toys and playthings full,
> As if to play with rattle traps,
> Were all he did at school.
>
> I hate to see his shabby book,
> With half the leaves torn out,
> And used as if the owner thought
> 'T were made to toss about.

The poem printed on a Reward from George P. Daniels gives a much more optimistic version of what goes on in school. It also clearly indicates that obedience, proper behavior, and learning were inevitably linked in the minds of parents and teachers. Everyone seems to have expected that learning would be useful in the future, but in a different way for girls than for boys.

> School is begun, so come everyone,
> And come with smiling faces,
> For happy are they, who learn when they may,
> So come and take your places.
>
> Here you will find, your teachers are kind,
> And with their help succeeding;
> The older you grow, the more you will know,
> And soon you'll love your reading.

Little boys, when you grow to be men,
And fill some useful station;
If you should be once found out as a dunce,
O think of your vexation.

Little girls, too, a lesson for you,
To learn is now your duty,
Or no one will deem you worthy esteem,
Whate'er your youth or beauty.

Such light-hearted descriptions of classroom scenes contrast dramatically with the stark admonitions of the Biblical rewards. Those Rewards, which were themselves a lesson to take home and learn or a prize for having memorized lessons from Bible and Primer, became less and less common.

As teachers in classrooms away from the closed societies of the first settlements faced the growing problems of discipline, complaints of school committees made it clear that the ability to keep order in a classroom was not a talent possessed by all new teachers. Reports of harsh physical punishments became ever more common. Some new teachers quickly realized that giving Rewards of Merit was one effective method of encouraging good behavior; that possibility evidently did not occur to many others.

How teachers in so many separate schools came to use Rewards of Merit, to believe in their usefulness, seems somewhat puzzling in the light of so many known instances of discipline by harsh punishment. The practice, however, if by no means universal, was geographically quite widespread. Some teachers seemed instinctively to realize that giving Rewards was more productive than meting out punishment. Other teachers, of succeeding generations, without much questioning did as their own Reward-giving teachers had done. Some of the better educated masters may have read of the giving of Rewards from the writers of two centuries earlier, such as Brinsley or Valcooch. We know from the writings of some American teacher-philosophers that they thought about rewards and punishments, read the theories, and wrote their own opinions of Reward-giving only after they had themselves had years of teaching experience. Other teachers probably only considered giving Rewards of Merit when they were suggested by a parent or another teacher as a substitute for the exclusive and over-zealous use of the birch-switch, the rod, or the bridle.

In the early nineteenth century when the number of schools rapidly increased beyond the capacity to provide sufficient numbers of well educated, professionally

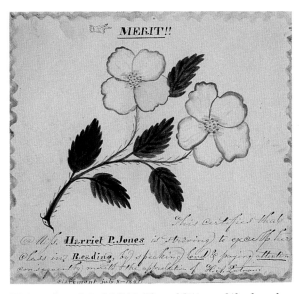

Watercolor, dated 1841. The addition of the hand pointing to Merit, not uncommon for the period, is infrequently found on handmade Rewards.

Both Rewards are drawn and colored by hand, circa 1820.

dedicated teachers, it is probable that only an elite percentage of schoolmasters had read philosophy. The English philosopher John Locke (1632-1704), however, was widely read by many American parents as well as teachers. Among many other subjects, Locke discussed the giving of rewards to children. His ideas "dominated English, French, and American thought in the first half of the eighteenth century and became part of the common sense of political and intellectual thought."[2]

We know that Locke's *Thoughts on Education*, although reprinted only once in the United States between 1783 and 1861, was

in many old library lists in New England and among the scant volumes belonging to persons who had but a single bookshelf. Abstracts and transpositions of his precepts appeared in almanacs, the most universally studied of all eighteenth-century books save the Bible....[and] pedagogical guides during the first half of the eighteenth century were partial to his stress on character training.[3]

John Locke held beliefs which were antithetical to the Puritan emphasis on original sin, on the need to bring a child to know God's will through the Bible, and on the necessity of having a conversion experience in order then to be "saved." Locke believed that an infant's mind is a *tabula rasa*, a blank tablet, and that childhood experience and education basically determine a person's development and character.

A child, Locke thought, is a rational creature, whose behavior is shaped or molded by his experiences, and by the rewards and punishments provided by the environment.

He believed

that good and evil, reward and punishment, are the only motives to a rational creature; these are the spur and reins, whereby all mankind is set on work and guided, and therefore they are to be made use of to children too.

Locke was not thinking of "things" or "objects" as rewards nor of giving rewards for particular performances. His own experience in the education of younger children came primarily from being a tutor to one child, the 3rd Earl of Shaftsbury, so he was furthermore not thinking of a class in a school in which a Reward of Merit might be a prize won in competition with, or in emulation of, a classmate. But whether a child was with a group of children being taught in a school or in an individual relationship

with parents or a tutor, Locke makes it clear that he believes in the giving of rewards and that the reward should be a

> plentiful enjoyment of whatsoever might innocently delight them; provided it be with this caution, that they have those enjoyments only as the consequences of the state of esteem and acceptation they are in with their parents and governors; but they should never be offered or bestowed on them as the rewards of this or that particular performance.
>
> Esteem and disgrace are, of all others, the most powerful incentives to the mind, when once it is brought to relish them. Children are very sensible of praise and commendation. They find a pleasure in being esteemed and valued, especially by their parents and those whom they depend upon.[4]

On many Rewards of Merit the only message is a simple sentence such as "_____ merits the esteem of h___ teacher and friends." The style and words echo Locke's seventeenth-century advice that rewards should be given for the "esteem and acceptation they are in with their parents and governors."

In the eighteenth century the Swiss/French philosopher Jean-Jacques Rousseau (1712-1778) also had great influence among American colonists—particularly those who were in favor of the Revolution. Rousseau's views presaged the argument about the use of Rewards of Merit—the controversy which has continued through the centuries. Fortunately for the flourishing of Rewards of Merit, Rousseau's views were more dramatically influential in politics than in the newly developing schools. When the French Revolution, inspired in part by Rousseau's political philosophy, proceeded to its Reign of Terror, many new Americans turned away from their admiration of Rousseau.

Rousseau's views of "emulation" among pupils, the rationale which had been used for the giving of Rewards by philosophically-minded schoolmasters from the time of Brinsley, was negative in the extreme:

> It is strange that, ever since men have engaged in the education of children, they should never have thought of any other means to effect their purpose but emulation, jealousy, envy, vanity, greed, and servile fear—all passions the most dangerous, the most apt to ferment, and the most liable to corrupt the soul, even before the body is formed.

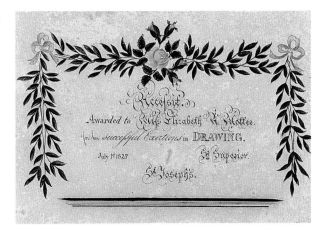

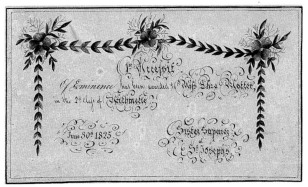

These two Rewards of Merit are unusual not only because they are so finely executed, but also because they are both signed by "Sister Superior" of "St. Joseph's"—the only two such pieces in the collection.

The Dunce.

I hate to see an idle dunce
 Who don't get up till eight,
Come slowly moping into school,
 A half an hour too late.

I hate to see a scholar gape,
 And yawn upon his seat,
Or lay his head upon his desk,
 As if almost asleep.

I hate to see a scholar's desk
 With toys and playthings full,
As if to play with rattle traps,
 Were all he did at school.

I hate to see his shabby book,
 With half the leaves torn out,
And used as if the owner thought
 'T were made to toss about.

Printed and sold by Merriam & Co., Greenfield.

Fig. III-4

He addresses this denunciation to teachers who used such methods:

Senseless preceptors! who think they are doing marvels when, in order to teach children the theory of virtue, they drive them to the practice of vice! And then they actually tell us, Such is man! Yes, such is the man whom you make.[5]

Rousseau's ideas were echoed one hundred years later when serious discussions of the advantages and disadvantages of the giving of Rewards of Merit were put forth in respected American teachers' manuals.

Whatever the philosophical grounding, a discussion of rewards and punishments centered on how to keep discipline—and, if discipline was achieved, how to encourage learning. And, inevitably, as soon as there were schoolmasters or schoolmistresses, there had been complaints about the way in which they could and did keep discipline.

In colonial New England, even in Dame Schools for the youngest children, the reports of ways to keep discipline surface as early as the descriptions of the schools. Some Dame Schools were undoubtedly kept by women with motherly, affectionate dispositions and an interest and talent for teaching. It was just such a Dame, for example, who provided that most appealing, albeit most ephemeral, reward: "premiums of gingerbread…now and then bestowed for good behavior."[6]

Not all Dame Schoolmistresses, however, were of such generous inclinations. The punishments used by those who were widows and destitute women with little real desire to be surrounded by children, could be severe. Apparently Dames had great faith in a thimble tapped sharply on the delinquents' heads.

In mixed-age schools with older pupils, the reported methods of discipline could be even more strenuous. Whisperers were sometimes compelled to silence by having a short stick inserted in their mouths—like the bit of a bridle, with strings at the ends which could be tied at the back of the head. There were schools where transgressors were made to stand on the benches and wear dunce caps (Fig. III-4) or huge leather spectacles; or they might have pinned to their persons large labels lettered, "Lying Ananias," or "Idle Boy," or whatever the teacher thought was appropriate to the case.

Fortunately there seem always to have been teachers who did not need to rely on being harsh disciplinarians. When schools were established, no matter how small the class or crude the schoolroom, most pupils considered it a privilege to attend. Receiving some written testimony of the "approbation and esteem" of a teacher was all the more valued because it not only represented praise, it also was a record of having attended a school or, for parents, of having made it possible for their child to attend school.

It was this very value of Rewards as a record of attendance which paved the way for the flowering of giving of Rewards of Merit in the burgeoning number of schools for primary education which began to be established in the country and in the new small towns after the late eighteenth century. By 1790 the population had scattered from the old "towns of fifty households or more" into ever more rural areas, and ninety-five percent of the population lived in places with fewer than 2,500 inhabitants.[7]

Population dispersal and ruralization and its challenges brought new kinds of schools. Most well known is the district school, often located, absurdly so, at some equidistant point from the families who attended it.

The "moving school" developed as another solution to the dispersed population. It was an arrangement by which a teacher not only boarded with first one household and then another, but also moved from locality to locality in order to teach children closer to their homes. In either case, when teachers were required to board with parents, the parents had considerable opportunity to tell the teacher what they expected to take place in the school room, and what they often demanded was not only learning but discipline.

Many of the teachers and parents were men and women who had grown up in New England and had later settled on the frontiers—some to be teachers for six months, some to teach for a lifetime, and others to be the parents who made their expectations known to the teachers. They took with them the memory of how things had been done in the schools "back East." Joseph Smith, the founder of the Church of Jesus Christ of the Latter Day Saints (Mormons), and his New England followers who founded the State of Utah may well have remembered, for example, that Smith's father, Joseph Smith, Sr., wrote out Rewards for his pupils. A Reward from the hand of Joseph Smith, Sr. in 1806 was given in Sharon, Vermont. It reads:

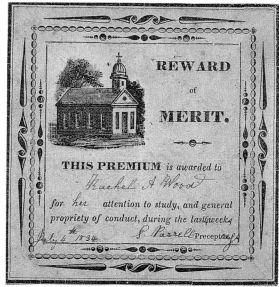

This may Certify that Polly _____ By her good attention to her Study and the Rules and Discipline of the School this winter that She excelleth the rest of her class in reading and Spelling and has stood at the head the most of the winter and likewise She Stands at the head this Day it being the last Day of the School.

> Attest Jos. Smith, Teacher
> Sharon March the 15th 1806[8]

When schools had two sessions of three months each, a winter and a summer session, there were often quite different groups of pupils who might be given Rewards of Merit which were quite different in style. The summer session (during months when the older boys were busy as farm laborers for their families) more often included girls

The image of a schoolhouse exterior appears infrequently on Rewards of Merit. This is particularly true for those schools which were supported by local taxes. Public school buildings such as those illustrated on the Rewards of Merit above, are more an idyllic vision than a true historic representation.

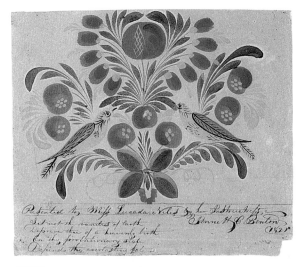

Top—A large meticulously drawn watercolor fraktur type Reward of Merit, dated 1821.

Bottom—This watercolor Reward of Merit dated 1852, from the "Sunny Side School," was partially made with the use of stencils.

and the youngest children. Women, in the early national period, were rarely employed as teachers at all in some areas (particularly in the rural South),[9] and they were a minority in northern district schools. In some school districts, if women were hired at all, they were hired only for the summer session. In the winter the youngest children were considered vulnerable to the harsh winter weather, and girls often were not supplied with the extra-heavy winter clothing for farm chores, particularly heavy boots, which allowed their brothers to walk to school.

In some schools, the older boys developed such a tradition of bullying the teacher and younger children during the winter session that their anticipated behavior, and the far more severe punishments used to keep them in line, also kept the girls and younger children away from school. As might be expected, the youngest children usually required less corporal punishment. Girls, because they were assumed to need less discipline and because they took instruction in their feminine sphere at home, were considered more amenable to rewards, but striving to get an award sometimes developed into a battle of the sexes. In discussing how girls, in particular, wanted to be at the "head of the class" in spelling, the author Warren Burton, in a tribute to district schools, describes the thinking of one such determined young woman:

"Now, Mr. James, get up again if you can," thinks Harriet during a spell-down. Burton replies for James,

> I pity you, poor girl, for James has an ally that will blow over your proud castle in the air. Old Boreas, the king of the winds, will order out a snow-storm by and bye, to block up the roads so that none but booted and weather-proof males can get to school, and you, Miss, must lose a day or two, and then find yourself at the foot with those block-head boys who always abide there.[10]

The differences in the schoolroom atmosphere, whether from the weather or from the presence of bully-boys, not only perpetuated the notion that only men could teach the winter session, but also institutionalized different expectations for the styles and methods of teaching of men and women.

Rewards—Designed and Painted for One Special Pupil

As the country grew West and the cities became crowded, more and more teachers began producing their own unique, hand-drawn and hand-painted Rewards. The earliest individually created and painted Rewards of Merit were probably those of the middle colony fraktur tradition of men such as Christopher Dock and David H. Munroe, Jr. (Fig. III–5), or from those created with the penmanship exercises of

66

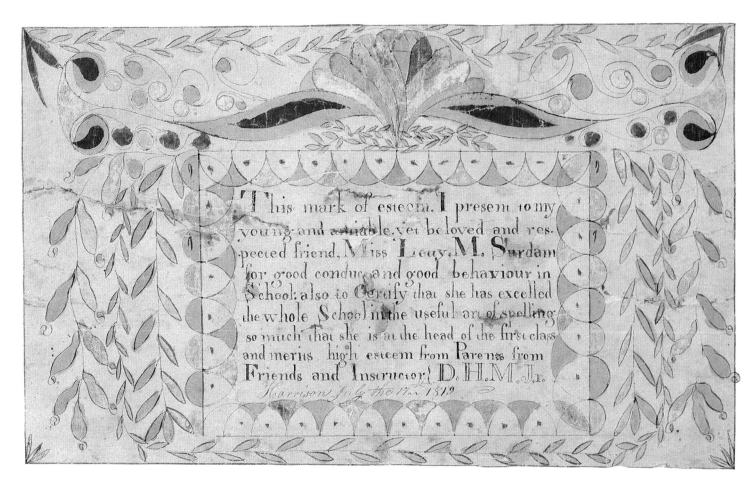

Fig. III-5

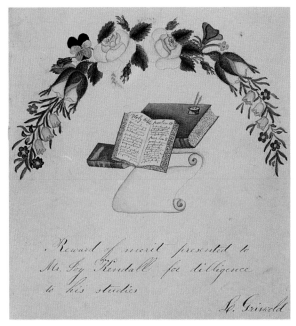

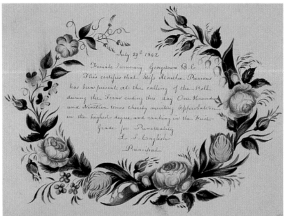

Two elaborate floral designs, the lower one, dated 1842, is one of three similar pieces presented to the same student. The top piece is not dated but is from the same period.

itinerant writing masters. Those hand-created Rewards continue throughout all periods of Reward giving, and the Rewards we have from after 1810 follow in the succession of messages and styles already familiar but with a new, American style.

In the period from approximately 1810 to 1840, the Rewards colored with inks or watercolors are particularly numerous. It is in this period that the majority of the more than 200 handmade watercolored Rewards in the Gardiner-Malpa Collection were made. A part of the proliferation of hand-drawn Rewards at this time may have been related to the "feminization of teaching" in the first decades of the nineteenth century, when the demand for schools increased and correspondingly more women became teachers.

The Pennsylvania German type of penned and painted decoration, by the nineteenth century, may have influenced teachers of New England to paint their Rewards. It is more likely, however, that the increase in the numbers of hand drawn and colored Rewards came more from the on-going general interest in developing the skills necessary for acceptable drawing and painting for practical purposes. Benjamin Franklin in making his "Proposals Relating to the Education of Youth in Pensilvania" in 1749 had proposed that all should learn something of

Drawing [which] is a kind of Universal Language, understood by all Nations. A Man may often express his Ideas, even to his own Countrymen, more clearly with a Lead Pencil, or Bit of Chalk, than with his Tongue.[11]

But regardless of whether the teacher was influenced to learn to draw and paint primarily in order to record, illustrate, or decorate, these Rewards are clearly the creative work of individual teachers, and have the immediate appeal of being unique.

The increased interest and number of private classes available for learning to paint with watercolors was an expectable extension of the interest in painting which had been associated with America from its earliest settlement. Pictorial descriptions had always been in demand to help in efforts to raise money for colonization and for conveying impressions of America to potential settlers. The first known example is that of Jacques le Moyne de Morgues, a cartographer and artist who accompanied a 1564 expedition to Florida in order to map the Florida coast and to make a visual record of the natives and their customs.[12] His watercolors were among the first visual "advertisements" for the New World. His later botanical studies survived as early examples of studies of plants and animals, a genre also sought after for information about strange lands.

The nature of watercolors in comparison with oil paints—water soluble pigments requiring very little paraphanelia for use —was a principal reason why the medium became so popular and why it spread so far throughout the new nation. Before 1760, for example, the artist Benjamin West, "struggled, self-taught, painting with Indian pigments and with brushes made of cat's hairs." His work, before he was set up with a patron who supplied him with imported brushes and better paints, may have been "amateurish" and "pioneeringly crude"[13] but for West the easy availability of the basic tools of the watercolor medium made it possible for him and others, including school teachers, to become practiced watercolorists. Watercolor painting came to be seen as a skill which observant, educated people should develop.

Whether imported paints, Indian pigments, hand ground and mixed inks, or American manufactured paints, were being used, watercolor supplies were highly portable. The development of paper especially for the professional watercolorists did not come before the 1780s, but the high content rag paper used in copy and ledger books sufficed long before that period for the dedicated self-taught artist intent on recording, copying, or creating.

Such paper was also sufficient for teachers penning and coloring their Rewards of Merit. The paper of many of the pre-1850 hand-painted Rewards in the Gardiner-Malpa Collection appears to have been either sheets of household stationery or, more likely, unused paper cut out of partially filled copy and ledger books of ten, fifteen, or more years earlier. It is likely, therefore, that they were not done on the most contemporary paper and that many of the earlier nineteenth- century Rewards may well be on eighteenth-century paper. Throughout the first quarter of the nineteenth century, the paper of these hand-produced Rewards still had higher rag content than that of the post-1853 period when more and more wood pulp was introduced into paper making.

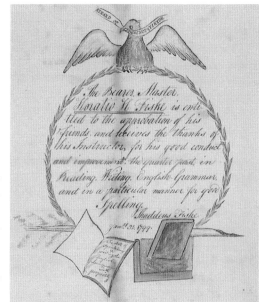

Fig. III-6

While the available paper was at least sufficient for the watercolorists, the popularity of using watercolors was greatly boosted by the increasing availability of the paints and brushes in the early nineteenth century. "Artists' materials and color stores" had been among the early American newspaper advertisers, and by the late eighteenth century, pigments made up into the easily portable cakes were being imported from England and being sold in major American cities at prices which many could afford. The graphic arts were temporarily disrupted by the restrictions and chaos of the Revolution, but that very disruption stimulated the creativity and work of American artists. And when the Revolution ended, "talent, in the form of painters, engravers and *teachers,* literally flowed to America"[14] to join and to teach in the aspir-

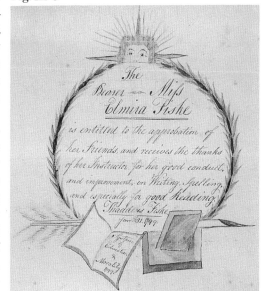

Fig. III-7

69

Fig. III-8

ing artistic community in the new nation. The influx of artists brought books, tools, and supplies. The New York Morning Post of November 7, 1782, carried the advertisement of Robert Looseley "in Water Street, betwixt the Coffee House and Old Slip," for "a fine assortment of the newest drawing books, and Reeve's Superfine Patent Water Colours."[15] Robert Looseley's imports were just one example of the increased everyday opportunities which led to the flowering of American amateur drawing and painting.

One of the earliest Rewards of Merit in the Gardiner-Malpa Collection comes from that early national period, January of 1799, and is particularly interesting because of the American motif which it carries (Fig. III-6). It was done with pen, ink, and watercolor, by Thaddeus Fiske. Though painted, the design is not done in fraktur style, but rather in a style which we would identify more with the New England schools. The ribbon in the eagle's beak, a popular symbol in this self-consciously national period, reads "Reward of Diligence and Virtue." The rubric is also in the restrained form of "approbation and esteem" Rewards.

> "The Bearer, Master *Horatio H. Fiske* is entitled to the approbation of his friends, and receives the thanks of his Instructor, for his good conduct and improvement, the quarter past, in Reading, Writing, English Grammar, and in a particular manner for your Spelling. Thaddeus Fiske, January 31, 1799.

The script on the open book at the bottom reads "The Art of Speaking and writing the English language with propriety."

This Reward of Merit (one of a pair, the other illustrating a rising sun) (Fig. III-7) is not only an example of a style which might have been used in New England in previous decades, but also illustrates what was to become more and more common—a Reward of Merit as a record of having attended school. In this case the length of attendance noted, however, is only in "the quarter past."

While the more general demands for visual representations of America may have influenced the painting for pictorial information, there was another reason why American women, in particular, had early been involved with drawing and painting. Necessity had demanded that most women, in the sparsely settled land with few servants, be personally occupied with the physical comfort of a house and the clothing for their families. Wall coverings against the cold drafts, bedding for unheated houses, and clothing for the family had to be made at home. Whether or not there had been time for recording the flora, fauna, and topography of their new country, women by necessity had been involved in activities which drew their concentration to drawing, needlework

and design. Their aesthetic and artistic impulses were often engaged in this practical work which was sometimes translated onto Rewards of Merit.

Pattern books designed to instruct women in lace-making, embroidery, cut-work, crewelwork, and pattern weaving came over with the earliest colonists.[16] Almost every ship from London which docked in America during the middle of the seventeenth century contained parcels of books—not solely the theological and governmental treatises to supply the ministers and governors, but also newer pattern books and books of instructions which could be used by women. These were a genre of do-it-yourself treatises which easily found their way into the hands of young ladies and homemakers throughout eighteenth- and nineteenth-century America. Designs from these books are evident in the borders and swags with which early nineteenth-century Rewards are sometimes decorated (Fig. III-8).

From 1810 to 1840, the subject matter of handmade Rewards of Merit is mostly floral, and is frequently bordered with designs reminiscent of familiar stitches. There are occasional birds and animals and a few depictions of little girls in dresses but, noticeably, not of little boys (Fig. III-9).

Some of those with other designs, particularly those of the little girls, lead one to want to describe these Rewards as "folk art." Certainly the most crudely drawn and roughly painted very little resemble "fine art." Using the definition that American Folk Art includes objects and paintings "which have aesthetic values but were created by men and women who worked outside the traditions and canons of the academies teaching the fine arts,"[17] many of these uniquely created Rewards of Merit can be considered examples of American folk art of the school art genre.

This impression of naïveté is further enhanced by the varying sizes of the earlier watercolor Rewards, which is part of the charm of the pieces. More of the earliest Rewards have the look of "a little scrap", but there are also a goodly number of larger ones. Those which are larger are also not of any recognizable standard size, and the unpredictability of size enhances their character and individuality.

"School art," however, may be excluded as "folk art" by purists who feel that having had instruction disqualifies the painting. Indeed, some of the Rewards are quite formal, seemingly "painted to pattern and to perfection," and the difference is not consistently one of earlier or later date. Examples of both the crude and the precise, for instance, were done in the 1820s (Fig. III-10), and it is likely that the painters of even the most crudely executed of these Rewards were attempting to work according to the "traditions and canons" of the professional art academies, or at least those of the art teachers in their secondary school seminaries and academies. If such classes were not available to them, they may well have studied the numerous instruction books available.

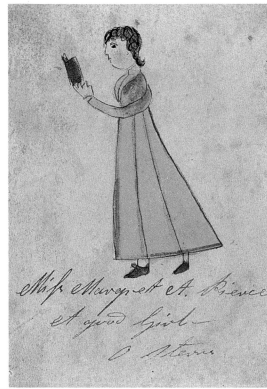

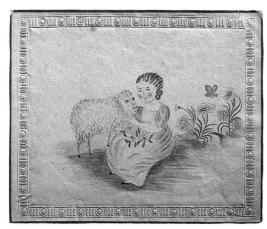

Fig. III-9

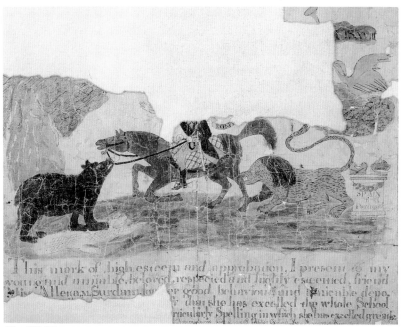

Fig. III-10

Fig. III-12

Top—Pen and ink Reward, dated 1823. Center—Watercolor Reward, circa 1830. Bottom—Watercolor Reward, dated 1865.

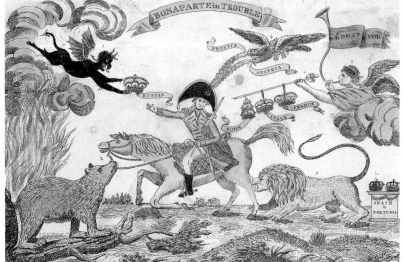

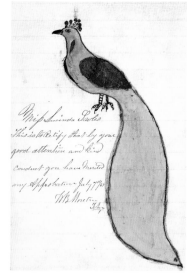

Fig. III-11

Fig. III-12a

Some of these Rewards of Merit may be repetitions of art lessons done when the teacher herself was a student, a few are either actual theorem (stencil) paintings (Fig. III-11) or freehand copies of one of the popular theorem designs, and a few are attempts at copying reproductions of famous engravings—a method frequently suggested for learning to draw and paint.

One of the most ambitious and interesting pieces in the Gardiner-Malpa Collection is a fragment of a Reward of Merit (Fig. III-12) copied from the 1814 engraving "Bonaparte in Trouble" by the Connecticut engraver, Amos Doolittle (Fig. III-12a)."[18] This Reward of Merit, done by teacher David H. Munrose, Jr. for student Alletta M. Surdam, must have been, when complete, a most extravagant example of a teacher's effort to bestow recognition. It is almost exactly the same size as the original, fifteen inches by thirteen inches, and was awarded most likely between 1819 and 1820. In part the teacher's penned comment is

> This mark of high esteem and approbation, I present to my young and amiable, beloved, respected, and highly esteemed, friend, Miss Alletta M. Surdam for her good behavior and amicable deportment. (This is to certify) that she has excelled the whole School...particularly Spelling in which she has excelled greatly...from her Acquaintance and her preceptor, David H. Munrose, Jr.

Copying engravings in watercolor paints for Rewards of Merit was a practice that used as its originating image not only large display type engravings, but also, and more often, those small engravings found in chapbooks (Fig. III-13).

As interest and expressions of American artistic endeavors blossomed, the dependence on foreign, particularly British, art instruction books came to an end. In 1815, Fielding Lucas, Junior, of Baltimore published his first drawing book, *The Art of Colouring and Painting Landscapes*. After Lucas published another monumental *Progressive Drawing Book*, students responded as did other publishers and art instructors, and the American art instruction book market proliferated.[19]

The interest in art was no doubt inspired by a growing interest in home and civic decoration, but for teachers in the first part of the nineteenth century, being able to create original, skillfully executed designs on Rewards of Merit was a professional skill. It signified that a woman had had a "higher education", was therefore qualified to teach older pupils, and could herself teach the skills of drawing and painting and produce samples worthy of emulation by her pupils.

The classes in painting and drawing which more and more women had completed were part of the experience of the new institutions for women's education

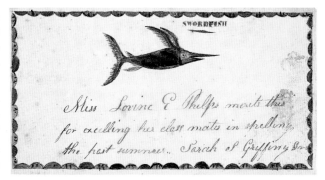

Fig. III-13

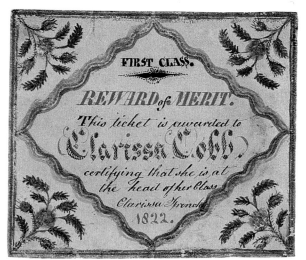

Fig. III-14

which burgeoned in the first part of the nineteenth century. The academies for men, which had been founded since the 1730's, had come into being as a response to the demand for more modern, more practical courses than those offered by the Latin Grammar schools. By the early 1800s there was a demand for similar institutions for women. Often these were established as Female "Seminaries" after the wording of the ordinances of 1785 and 1787, which set aside revenues from land for "seminaries of higher learning." The "practical courses" for women almost always included drawing and painting, as had also been the case in many of the earlier academies for men. The seminary curriculum was both a response to the importance already accorded to painting and drawing, and an affirmation of that importance. Female seminaries were not first established to be "teacher training" institutions, but that is what they became, for women acquired there the post-elementary education which they needed to be able to teach older pupils. It was assumed that the subjects studied in the Ladies Seminaries or Academies, including drawing and painting, were the proper spheres of endeavor both for teachers and for the pupils whom they were going to teach.

As the interest in, and availability of, lessons in fine penmanship, drawing, painting, grew, so, too, did the variations on the types of skills taught. In addition to instructions for copying illustrations in the instruction books, views in portfolios, and the graphic art on the increasingly available printed materials, there were also instructions for quite specific techniques. Pupils also learned from each other as they created their own interesting techniques.

The Rewards given to Clarissa Cobb seem to represent a particularly comprehensive employment of skills and fads in decoration. There are two of these Rewards in the same style, on the same shape and size paper, by the same teacher. On one 3 1/2 x 3" Reward the teacher, Clarissa French (Fig. III-14), has penned and painted, in four different styles of printing and lettering, an extremely fine design under the words "First Class." This example displays a fine calligraphic technique offset by corner decorations of roses and leaves resembling needlework designs. In addition to this particularly beautiful artistic rendition, glitter has been carefully applied to the borders surrounding the words and on the roses and their leaves, all of which still catch the light in the last decade of the next century. This surely would be classified as a piece of "decorative art," but it is decorative art created by a working woman for use in her profession. When such similar Rewards are found, their style and execution seem to be a signature, a part of the identification of a particular teacher.

Other techniques familiar to the makers of love-tokens and valentines also appear in Rewards of Merit, though there does not seem to be a locality or period in

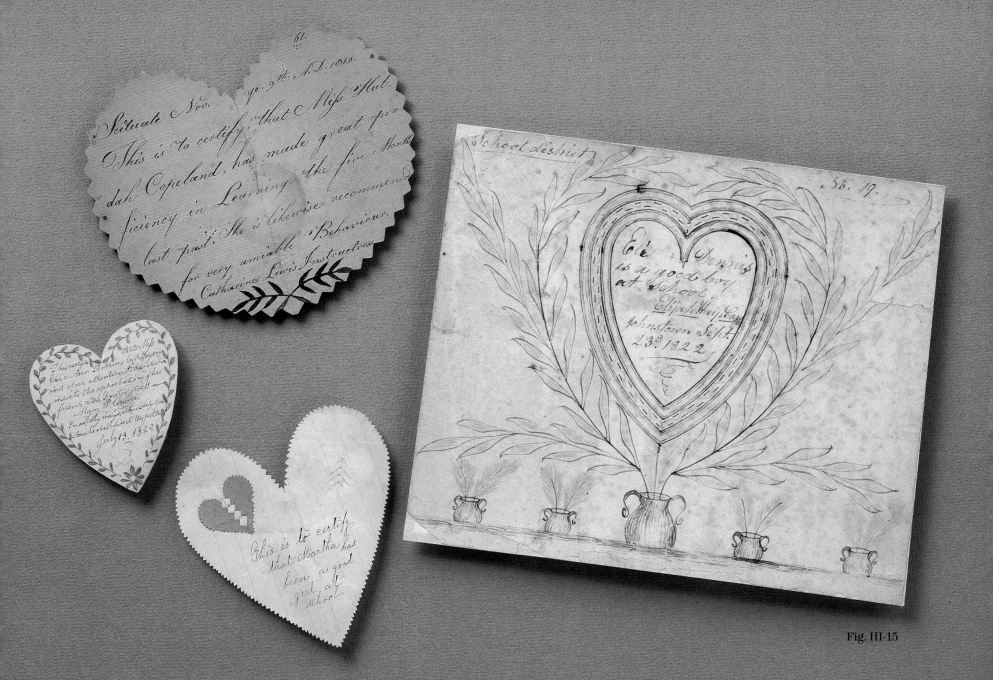

Fig. III-15

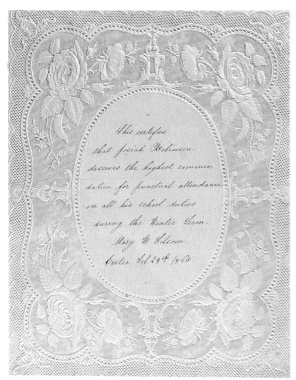

Fig. III-17

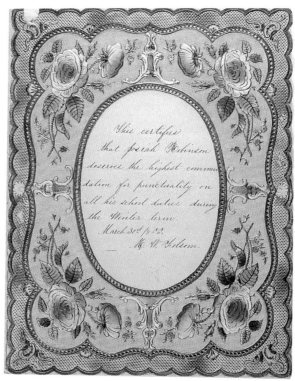

Fig. III-18

Fig. III-19

Fig. III-16

Fig. III-21

Fig. III-16

which they predominate. The Gardiner-Malpa Collection has several such Rewards of interwoven and shaped hearts, a puzzle purse, and watercolored hearts, all of which show the influence of the making of valentines (Fig. III-15).

It is also apparent from the Rewards in the collection that teachers developed "efficiency" in producing their Rewards. Rewards of Merit have been found in groups, evidently preserved by the teachers' families, of which some have no writing while one or two have pupils' names already written in. Obviously the teacher created numbers of these, perhaps in one sitting, in his or her own style, in order to have them ready to use as they were needed. Certainly, when it became obvious during the course of a day that a Reward for a certain child for a special accomplishment would be particularly helpful, there would have been no opportunity to create one as the lesson continued.

Though only a minority of the Rewards in the Gardiner-Malpa Collection have been produced on special (costlier) papers, there are some. Perforated cards, embossed paper, and gold bordered cards appear from 1838 to 1865. In some cases the special paper has perhaps been used because the Reward is considered a more important one, but in other examples that paper, particularly perforated cards (Fig. III-16) and embossed stationery (Fig. III-17), have been used as a substitute for taking the time and trouble to draw and paint a hand-created design.

An 8" x 10" embossed and colored paper lace folder[20] (Fig. III-18) and a 6 x 8" gold-bordered card (Fig. III-19) are clearly special Rewards meant to be preserved as a record of having attended school for a term. The one written on paper lace depends on its watercolored embossing paper for an appealing yet manufactured design. However, the gold-bordered card of L. I. English, Principal, displays an elaborately painted floral arrangement seemingly done by a very skilled artist.

Special embossed paper and folders, embellished with elaborate painting, were indeed often used, surprisingly, for minor Rewards. Two examples, given by A. M. Guild in 1840 and 1841, are decorated with especially fine floral work and extraordinarily fine cursive writing combined with names printed with an expertise worthy of a government proclamation. The identically made Rewards, however, are for "proficiency in studies" and merely "correctness of deportment" during *one half lesson and session* (Fig. III-20).

There are a few Rewards with messages written in the blank spaces of perforated cards of the kind which were produced as early as 1797 by John Fairburn in London. Most of these are undated, but two which are dated were given in 1837 and 1839. One of these is graced by a ribbon and flower design bearing the words "Reward of Merit" (Fig. III-21). The design is pleasingly proportioned to the 2 1/2" by 1 1/4"

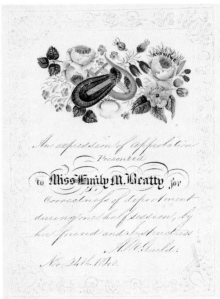

Fig. III-20

77

Top—A Reward of Merit with a pen and ink drawing, presumably of the recipient but possibly the teacher, with the traditional verse encircling the portrait and the whole being decoratively cut.

Bottom—A crudely painted house with the word "Reward" penciled on the reverse side.

blank space intended for a message. The motto on the reverse is simply, "Application deserves reward." Another has a much less proficient pencilled sketch of a bowl of fruit on the front side with "Miss Emily A. Evans from her instructress, Sarah Watson," beautifully penned on the reverse. Others of these, however, obviously rely on the cards themselves to furnish an attractive design and have simply written on them such sentiments as "A token of respect from an affectionate Teacher."

The number of hand-painted Rewards decreases sharply in the 1850s and 1860's. The last quarter of the century was not a time when home decoration depended on individual homemakers or when amateurs were the best recorders of America's natural wealth. By that time, the accomplishments of American chromolithographers were bringing, not just to the wealthy but to the masses, reproductions of the most inspiring art from the previous five centuries as well as the work of the most accomplished American artists—all in magnificent color.

Attempting to become a painter, particularly a watercolorist, late in the nineteenth century was widely regarded as an appropriate endeavor for a leisured woman—a pastime imposed on women who, whether artistically inclined or not, were being kept on the confining pedestal of Victorian conspicuous consumption and respectability. Rather than a highly esteemed skill for all teachers, drawing and painting became, for many, part of a social milieu which hampered women's fight for access to a broad education and for the vote. As one observer at the Centennial Exhibition in Philadelphia in 1876 commented about some particularly fine English needlework:

> ...the general result is so satisfactory, and the work itself so thoroughly feminine that we sincerely trust something of the same kind will be attempted in this country.
>
> We have a fancy that our lack of art schools and other institutions where women can learn to employ themselves usefully and profitably at work which is in itself interesting and beautiful, is one of the causes which drives them to so unsex themselves as to seek to engage in men's affairs. Give our American women the same art facilities as their European sisters and they will flock to the studios and let the ballot box alone.[21]

The teachers who continued to give these Rewards of Merit escaped these Victorian strictures. They prepared themselves conscientiously for the responsibilities of their profession. Undoubtedly many among them derived great pleasure from quiet evenings of creativity with their pens and paints. Others, however, may have wished dearly for an assistant to prepare their Rewards of Merit and rejoiced as the

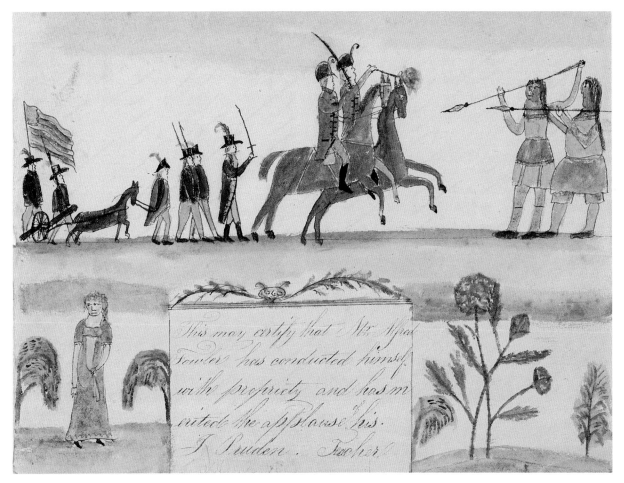

A watercolor Reward of Merit from a group of Rewards received by Alfred Fowler in the 1820s in Milford, Connecticut. Depicting an Indian conflict in the making is an unusual subject for a Reward of Merit. Although such a scene may have been popular for the period, it is also quite unusual to depict such subject matter on a Reward of Merit.

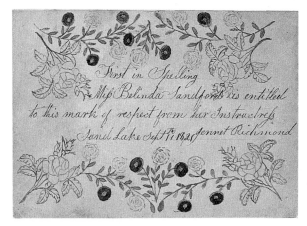

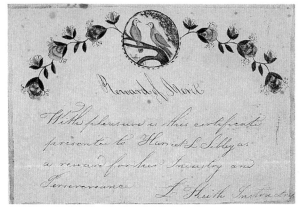

One cannot help but admire these Rewards not only for their delightful watercolor renderings but more so for the time and effort teachers spent in creating them, since they were undoubtedly produced for more than one or two students. The top Reward is dated 1821, the lower one, circa 1820.

printed ones became more available. Becoming a "New England lady watercolorist" would have been small recompense for the barriers to the greatly expanded range of skills and interests which men were experiencing.

As more and more women became teachers in an ever expanding number of schools, as revulsion against harsh physical punishments grew, and as appeals to religious faith (or fears) became less effective, methods other than constant punishments were increasingly sought for preserving decorum and a conducive learning environment. Rewards of Merit "for good behavior" were one of the most pleasant solutions. Had the messages of Rewards of Merit been limited to propagation of preparation-for-death theology, their use could scarcely have survived the growing numbers of Americans who either belonged to non-Puritanical religious groups or were religious skeptics. But as long as the use of Rewards of Merit was firmly grafted onto the recommended teaching methods, they continued to be produced—in even greater numbers.

Printed Rewards of Merit proved even more useful and more popular with the teachers caught up in the first effort to bring education to the masses of children who were trapped in the slums of the industrializing cities. These were children whose parents worked not on their farms or in their homes, but whose long days in the factory separated them from their children for the entire day, day after day. The few schools which had been established in cities were certainly not prepared for the influx of thousands of children. Neither were the parents of children already in those schools willing or able to pay the school fees for the thousands of poor, ragged, offspring of newly arriving immigrants.

The use of Rewards continued at a seemingly ever increasing pace, but children who were crowded into a charity school with hundreds of other children rarely received a beautiful penned and watercolored Reward created by the teacher. Such gifts were the privilege of those who were lucky enough to attend the smaller schools in which the teachers could know, and think about, and teach, and reward, each of the children who were their pupils.

NOTES

1. No printer is identified on this Reward, circa 1860. The date 1871 is pencilled on the reverse side of the Reward.

2. Lloyd J. Borstelmann, "Children Before Psychology: Ideas About Children From Antiquity to the Late 1800s," Chapter 1 in William Kessen, ed., *Handbook of Child Psychology*, Vol. I, 22.

3. *Ibid.*, 9.

4. John Locke, *Some Thoughts on Education*, abridged and edited by F. W. Garforth (Woodbury, N.Y.: Barron's Educational Series, 1964), quoted in Borstelmann, 22.

5. Jean Jacques Rousseau, *Emile Book II. (On Education from Five to Twelve)*, 1. f. "Education Negative," in R. L. Archer, ed., *Rousseau on Education* (London: Edward Arnold, 1916), 97.

6. Clifton Johnson, *Old Time Schools and School Books* (New York: The Macmillan Company, 1904). See pages 44-45 for a discussion of punishment methods.

7. Carl F. Kaestle, *Pillars of the Republic: Common Schools and American Society, 1780-1860* (New York: Hill and Wang, 1983), 13.

8. Reward of Merit signed by Joseph Smith, Sr., from the collection of E. William Jackson, and quoted with his permission.

9. Kaestle, 20.

10. Warren Burton, *The District School As It Was by One Who Went To It* (Boston: Carter, Hendee, and Co. 1838), 59.

11. Benjamin Franklin, *Writings*, "Proposals Relating to the Education of Youth in Pensilvania," ed. Leo Lemay (New York: Literary Classics of the United States, 1987), 329.

12. Christopher Finch, *American Watercolors* (New York: Abbeville Press, 1986), 27.

13. Carl W. Drepperd, *American Pioneer Arts & Artists* (Springfield, Mass: Pond-Ekberg Co., 1942), 11.

14. Ibid., 15.

15. Ibid.

16. Notable examples of such pattern books are "A Schole-House for the Needle" (London 1624 and 1632) and "The Needle's Excellency" (London, 1634, 1636, and 1640). Both apparently were used in early New England and Pennsylvania. Patterns from each one are found carved on furniture, and painted on chests made in these colonies. (Dreppard, 13)

17. Beatrix T. Rumford, Gen. ed., *American Folk Paintings: Paintings and Drawings Other Than Portraits from the Abby Aldrich Rockefeller Folk Art Center* (Boston: Little, Brown & Co. in association with the Colonial Willamsburg Foundation, 1988), 10. The definition used by Louis Jones as the label text for the exhibition on which this book reads in part, "American Folk Art includes objects in our culture such as paintings, carvings, metal and needlework which have aesthetic values but were created by men and women who worked outside the traditions and canons of the academies teaching the fine arts." Of the two groups, Traditional Folk Art (which "derives from long standing hand craft traditions, usually brought here from Europe") and Associative Folk Art, these Rewards would fall into the category of Associative Folk Art which "includes other non-academic items which have been considered folk art in this country for half a century: school taught arts such as theorems, memorials, needlework pictures, paintings derived from prints, and portraits showing some exposure to the academic tradition but still outside that tradition."

18. Amos Doolittle was born in Cheshire, CT in 1754, and died in New Haven in 1832. "Bonaparte in Trouble" was produced in 1814. This Doolittle engraving is from the collection of Richard Ulbrecht.

19. See the discussion in Drepperd, 16-18.

20. Embossed 8 x 10 folder. "This certifies that Josiah Robinson deserves the highest commendation for punctual attendance on all his school duties during the Winter Term. Mary W. Folsom, Exeter, February 24th, 1865." The name of the paper company does not appear.

21. Wendell Garrett, ed. *Antiques*, Vol. CIX, No. 4, April 1976. (New York: Straight Enterprises, 1976), 726. The comment by Emily Julia Reynolds is cited in the column "Clues and Footnotes," from Walter Smith, *The Masterpieces of the Centennial Exhibition*, Philadelphia, 1876, 2, 94.

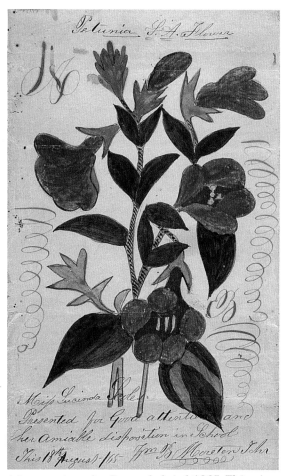

A large watercolor Reward, dated 1865. This piece, crude compared to earlier watercolor Rewards, precedes what would soon become an avalanche of chromolithographed Rewards of Merit.

81

A group of Sunday School Rewards of Merit, all chromolithographed just prior to, and after, the turn of the 20th century; except for the Sabbath School Certificate lithographed in the 1870s by Charles Shober. Awarding religious Rewards spans the widespread use of Rewards of Merit, but unlike secular Rewards, consistently carried the same message throughout the centuries.

IT IS LAWFUL TO DO GOOD ON THE SABBATH

"Licet Sabbatis Beneficere"

Teaching and learning on one day of the week

If any check can be given to the corruption of a
state increasing in riches and declining in
morals, it must be given, not by laws enacted to
alter the inveterate habits of men, but by educa-
tion adapted to form the hearts of children to a
proper sense of moral and religious excellence.

Charge, The Bishop of Landaff [1788]

eserving pupils who received handpainted Rewards of Merit in small schools of late eighteenth-century and early nineteenth-century America all too quickly became the exceptional ones, the privileged minority. In the fast-growing cities there were constantly increasing numbers of other children, the children of new immigrants from Europe and of rural migrants to city jobs, who had little hope of being taught to read or write— with or without Rewards. Their enemies were not only their poverty and crowded living conditions but also the entrenched attitudes of previous generations.

For many in the eighteenth century, particularly in England, the idea that everyone should be taught to read, and possibly even to write, was not only controversial—it was frightening. It was especially threatening to those of the upper classes who still fervently believed in the God-given rightness of a class structured society. Who would contentedly do the manual labor necessary to maintain the order of society if all were taught to read? But the waning of the eighteenth century, and the rising of the nineteenth, brought new fears which began to crowd out the old—a growing alarm over the depraved morality of the urban masses and particularly of their children. These children hardly resembled those of the previous generations of manual workers who

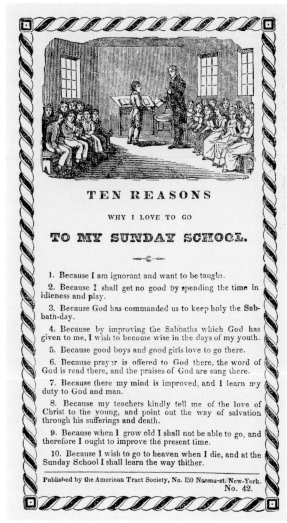

Fig. IV-1

"knew their place." It began to seem a matter of urgent practical necessity that the hearts of all children somehow should be formed "to a proper sense of moral and religious excellence." If education could accomplish the task of protecting chastity, sobriety, and virtue, and if, as had long been claimed by Protestants, learning to read the Bible was necessary for moral and spiritual salvation, some way had to be found to teach the children of the poor to read. (Fig.IV-1)

In the new democratic nation across the ocean, many of the later-eighteenth century immigrants were hardly disposed to accept that the "social positions" they had left behind in Europe had anything to do with any place given by God. Whether they intended to leave their old low social positions behind or not, however, the monstrous growth of the new immigrant slums also caused many Americans to despair that the conviction that every American child should learn to read could ever be achieved. The apprenticeship system was rapidly disappearing under the upheavals of industrialization, and large numbers of poor parents left their children unattended and untaught while they went to exhausting jobs away from home. Furthermore, more and more children were themselves working, and they were working not as apprentices but at menial low-wage jobs without the supervision which either parents or the master of apprentices had given. And yet, how could there be a moral nation if the children were not taught to read? Or how, then, could order and discipline in society be maintained?

School on Sunday, the one day when child-workers were not occupied, was not only one of the first solutions for a desperate need, it was also a solution which had a long lasting impact on the creation of weekday schools. The Sunday school movement originated in 1780 in England, where industrialization and accompanying social horrors were already distressingly apparent. The first widely publicized Sunday schools were an experiment carried on by Robert Raikes, a printer and philanthropist, in Gloucester, England. Raikes' interest in giving street children basic education grew partly out of his long-time campaign for prison and judicial reform and partly from his personal fear of mobs of child-workers. The unsupervised, noisy play of street urchins on Sundays went on in Sooty Lane between his home and the offices of his newspaper. What Raikes heard outside his windows was the quarreling, cursing, and fighting of children who were in a "ragged, wretched, vicious state." The play often ended with petty, and not so petty, violence and vandalism.[1]

Raikes became convinced that education was the prerequisite for reforming the lives of these children; he had already concluded that it was too late to reform their

parents. School on Sunday was an inspired idea for making at least the rudiments of an education available to the poorest children as well as quelling the Sunday quarrels and fights near his home. His Sunday school was not formed with permissions from the Church of England nor carried on according to its regulations; it was not a church school. It was simply a school held on the one day on which the children were not at work, a day on which they habitually turned not to church-going but to vandalism and petty thievery.

Raikes' idea of schooling, however, was the view of his times. All education was thought to be "religious" education; it was therefore only logical to use the Bible as the main textbook. Furthermore, because school was held on Sunday, Raikes himself accompanied the children to church during the hours of services. This did not, however, protect him from the open antagonism of many clergy and lay people who felt that any activity on Sunday, other than church-going, was a desecration of the Sabbath.

Raikes worked at his experiment to see if he could create a new race out of social "waste" with the enthusiasm, dedication, and tenacity of a scientist determined to prove his own hypothesis. Since it was an experiment, and since even the idea of school on only one day of the week was new, it was not necessary that he be bound by previously known pedagogical practices. After three years of experimentation Raikes published, in 1783, a brief notice of his experiment in his *Gloucester Journal*. By that time he was able to show his visitors the unschooled urchins playing in the street on the way to introducing them to the children of his experiment. Even Raikes was astonished by the comparison.

Raikes' first method for getting the children to attend his school on their one work-free day was whatever worked— persuasion or coercion. Some children were marched to school with their feet and legs hobbled with clogs and logs of wood to keep them from running away. But getting them there did not solve the problem of disciplining them and forcing them to learn. After the first mistress threw up her hands in despair, Raikes moved the school to a house situated opposite his own. There every attempt was made to maintain discipline, and such rules as having combed hair and clean hands and faces were vigorously enforced. If necessary Raikes himself strapped or caned the scholars. He was also known to march them home, insist that their parents "leather" them, wait to see it done, and then march them back to school again.[2]

It was only after some experience that it became obvious that giving Rewards of Merit was a more positive method for insuring discipline, good behavior, and even atten-

This type of card, describing the teacher's expectations of the child was almost exclusively used in Sabbath Day schools. This piece was distributed by the Massachusetts Sabbath School Society, circa 1830.

THE GEM REWARDS

Moses smiting the Rock

Chromolithographed package of 8 Rewards of Merit were produced by W. & C.K. Herrick of New York and bears a copyright date of 1863. Each Reward was uniquely designed with a different border on each card as exemplified by those on the opposite page.

dance. Raikes had no elaborate theories of pedagogy; with rewards, as well as with punishments, he employed whatever seemed natural to him and effective with children.

The first Rewards given in the 1780s in the Raikes schools, and copied in the first English Sunday schools, were apparently purely practical ones. Incentives were needed to get children to school, and school supplies which children from richer families might have considered mere necessities were used as inducements. For children who had no shoes for the cold winter, a pair of shoes was a powerful incentive. For children wrapped in layers of thin rags, warm material actually cut and sewn into a coat was certainly more desirable than would have been any piece of paper with words on it.

Special food for the whole class or cards for all were favorite Rewards. For special achievement, a Bible or a reading-book, particularly things which Raikes himself had touched or used in his lessons, were often given to a responsive scholar. These were among the objects which were treasured among Raikes' Sunday school scholars many years after his death. Other Rewards were objects copied from those which trickled down from the customs of the aristocracy, such as a portrait of himself on china or on a printed card. Many of these Rewards were given more in the manner of grandparents who reward all of their grandchildren for behaving well in church than as a systematic attempt to single out the best or brightest child for all others to emulate.

Though the publicity Raikes was able to generate with his own newspaper, the *Gloucester Journal*, was part of the reason why his Sunday school became widely known, the timing of his experiment was also of critical importance. Opposition of the clergy and aristocracy to universal schooling notwithstanding, it was obvious to Raikes and to like-minded others that neither the Dissenters nor the Church of England had been reaching his child-laborers. Raikes could see that "the Church had neglected the masses and the masses had retaliated by neglecting the Church." The charity schools provided by the Anglican churches in England (and in the colonies before the Revolution) by the Society for the Propagation of the Gospel in Foreign Parts, and by some churches in America, were by no means keeping up with the need for schools. While many of his friends and acquaintances were among the strict Sabbatarians (those who even objected to his accompanying his ragged Sunday scholars to church services between the sessions of his school), others sensed the value and the urgency of his ideas.

When Raikes was convinced he had succeeded in significantly changing the lives of the children in his school, he publicized his schools in the *Gentleman's Magazine*. As a result of the publicity, an almost immediate one, Sunday School Unions were formed in London and in other cities. Furthermore, in a surprisingly short time

after that first publicity, Raikes had also secured the patronage of George III and several members of the royal family. Royal patronage was an on-going source of publicity certain to spread interest throughout England and its colonies. Within a decade Sunday schools were being founded in the American colonies.

One of Raikes' most influential visitors was John Wesley. Wesley's indefatigable evangelical preaching had created in Methodism the first mass religious movement in English history. Wesley, more than anyone, could reach the working poor, including the coal miners of Wales, who had been virtually untouched by organized religion. Wesley not only praised the idea of providing schools on Sunday from his pulpit, but wherever a Methodist Society was formed in England or America, Wesley encouraged the establishment of a Sunday school to teach the new members to read. The Wesleyan Sunday schools, like those of Robert Raikes, were not meant to be a part of a church service; rather they were for the purpose of teaching reading and writing to those new Methodists who had no other opportunity for schooling.

The primary interest of Robert Raikes had been, and remained, finding ways of educating the poor. Although the schools which met only on Sunday were successful, Raikes never abandoned the search for ways to bring schooling on weekdays to poor children. In his newspaper, the *Gloucester Journal,* Raikes urged the formation of as many Sunday schools as possible, but he also advocated industrial day schools (weekday schools) in which education would be free. Often money for schools for the poor, which was raised in English churches, was simply divided between a Sunday school and an industrial day school. That campaign notwithstanding, it was the skills of basic literacy, taught on Sunday only, which succeeded in changing the lives of thousands during Raikes' lifetime. Even more important was the contribution of the Sunday schools in bringing about a change in the opinions of thousands of others about the value of universal education.

In America a Sunday school was organized in Hanover County, Virginia, as early as 1786. In 1787, only seven years after the first Raikes experiment, a Sunday school for African children was organized at Charleston, South Carolina, and a first attempt to introduce a Sunday school in Philadelphia was made. It was the Sunday school established in Philadelphia which became the prototype of American Sunday schools.[3] Philadelphia at that time had a population one-third larger than New York and was the civil as well as commercial center of the new, and now securely united, nation. But in Philadelphia, also, the lack of education of young people apprenticed to trades, and, as industrialization proceeded, the breaking down of the apprenticeship system, was threatening order. As in England, Sunday seemed to be employed for unre-

Four Rewards, being half the contents of the package shown on the preceding page. All are beautifully drawn biblical scenes with pertinent excerpts from the Bible on the reverse side.

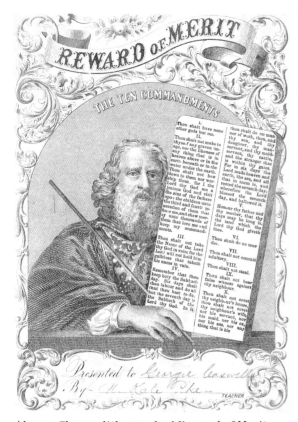

Good Effects of Sabbath Schools.

NEIGHBOR JOE.

CHARLES.

Pa', did you know that neighbor Joe
 Had turned to be a sober man?
He minds his work, and never swears,
 And tries to do what good he can.
It seems so strange—because he used
 To be so idle, and so cross:
He beat his wife and children too—
 I never saw a man act worse.

FATHER.

Oh yes, my son, I have observed
 The pleasant change in neighbor Joe;
I told him I was very glad,
 And asked what made him alter so.
"I'll tell you truly, sir," said he,
 "I wasted all my youthful days:
I would not read the word of God,
 And did not love his holy ways.
I was not happy in my sins—
 My conscience checked me every day—
But I cast off the fear of God,
 And rather chose to swear than pray.
At length I thought I'd settle down,
 And so I picked me out a wife,
But wretchedly did I perform
 The duties of a married life.
In managing our little ones
 My mate and I could not agree;
I was not fit to govern them,
 While wicked passions governed me.
I was imperious and unkind,
 They were unruly, pert, and vain—
They disobeyed me to my face,
 And when I stormed, they stormed again.
At last, grown weary of my home,
 I to the tavern bent my way,
And drank and gambled many a night,
 And idly wasted many a day.
It happened that a Sabbath school,
 About that time, was opened here;
My eldest daughter chose to go,
 And followed it about a year.
But in that year, I was surprised
 To see how altered she appeared;

No disobliging act was seen,
 And not one fretful word was heard.
When I came reeling home at night,
 Disposed to fight with all I met,
She'd beg the children not to speak
 One word to put me in a fret.
The best our cottage could afford,
 She for my supper would prepare,
And do whatever I required,
 With cheerful and unwearied care.
When she did every thing she could,
 And found herself forever blamed,
She would be silent, or reply
 So meekly, that I felt ashamed.
Once I had eaten up my milk,
 And ordered her to bring me more;
She hit her foot, and spilt it all,
 Enraged, I struck her to the floor.
She rose in tears, but did not speak,
 And handed me another bowl—
I could not drink a single drop—
 Her patience cut me to the soul.
Go—leave me, Emeline, I said,
 So vile a creature does not live—
I am not worthy such a child;
 Leave me—I *know* you *can't* forgive.
She threw herself into my arms;
 'Dear father, do not tell me so,
I've been a disobedient child;
 Forgive *me*, sir—I cannot go.'
I sobbed aloud—where, where, I cried,
 Did you obtain so sweet a mind?
Go, tell me who has taught you thus,
 To be so tender and so kind.
'The Bible, sir, it taught me all,
 Showed me how wicked I had been,
And that to treat my parents ill,
 Was in God's sight a dreadful sin.'
My heart was melted—straight I sought
 With earnestness the blessed word;
I felt my guilt—I owned my sins,
 And begged forgiveness of the Lord.
He heard my cry—He gave me strength
 To hate and leave my wicked ways;
He filled my soul with thankful love,
 And to his name be all the praise."

BOSTON CHEMICAL PRINTING COMPANY.

Above—Chromolithographed Reward of Merit showing Moses with the tablet of the Ten Commandments, circa 1875. Sabbath Day schools usually distributed Rewards displaying the guidelines for living a Christian life.

Right—Child's instructional cotton kerchief with border of stock woodcuts, circa 1850; possibly given as an end of semester prize for scripture recitations, attendance or good behavior.

strained display of vice and depravity. The religious toleration for which Penn's colony and Franklin's city was known, however, had long been translated into the city's dedication to philanthropy and benevolence. Philadelphia was therefore a particularly likely place for people representing various churches to cooperate for the moral and religious improvement of the children of poor, illiterate, or foreign-speaking parents.

Nonetheless, the first attempt at Sunday schools in Philadelphia was rejected. The Rev. William White, while traveling to England to be consecrated Episcopal Bishop of Pennsylvania, had visited the by then much-publicized Sunday schools of Robert Raikes. White made his first attempt to establish Sunday schools in Philadelphia soon after his return, but even his own church was not ready to sponsor a school on the day reserved for worship. In 1790, however, White tried again, this time with a broader and more obviously nonsectarian group. They proceeded quickly and successfully to form one of the first charitable and educational societies which became, between the 1810s and 1900s, a part of the state and national network of organizations which became known as the "evangelical united front." White's group set a good example for other dedicated groups to follow.

Just seven days after William White's group met, a constitution for the First Day Society (Sunday is referred to as "First Day" by Quakers) was presented, discussed, amended, and adopted. Rooms were rented, masters were hired, and volunteers were recruited. Schools were soon being held on Sundays from eight to ten a.m. and from two to four or four-thirty p.m. Sunday schools spread quickly both in and beyond Philadelphia. Separately, in that same year (1790) a Methodist conference in Charleston, South Carolina, ordered the establishment of Sunday schools in or near each place of worship. Though organized by Methodists, their schools, as in England, were dedicated to teaching basic literacy to all who would come. In 1797, a Sunday school which was attended by mill workers was opened at Pawtucket, Rhode Island. Other Sunday schools were opened in New York in 1793 and successively in Boston, Pittsburgh, Patterson, New Jersey, and Portsmouth, New Hampshire. In the first ten years the new Society had provided free education for over two thousand "Sunday school scholars" of both sexes. By 1803, when Sabbath schools were begun in New York, the movement had taken hold of the American imagination across the new country.

The founders of the American Sunday schools had in mind from the beginning the clear purpose of providing education for the masses—on Sunday or on weekdays, whichever was possible. Their purposes were to teach reading and writing and to improve the moral and religious character of the learners. In Pennsylvania, for

SABBATH SCHOOL.
Punctual Attendance.—No. 6.

Let Children, who would fear the Lord,
Hear what their Teachers say,
With rev'rence hear their Parents' word,
And with delight obey.

SABBATH SCHOOL:

NEW SCHOLAR.

God of my youth, to thee I pray,
Help me to tread thy holy way;
And when my days on earth are past,
Take me to dwell with Thee at last.

Children who attend this School, must be punctual and regular in their attendance; and come to School with hands, face and clothes clean; they must be silent and attentive to their lessons and obedient to their Teachers; they must be kind to their Companions and attend Public Worship regularly.

Two small Rewards of Merit, circa 1830. Appearing at the bottom is the reverse side of the "New Scholar" Reward in the center.

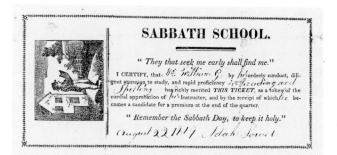

Fig. IV-2

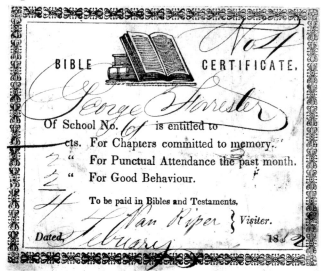

Bible Certificate, dated 1832. This piece was used more as a report card than a Reward of Merit. When students accumulated enough credit in pennies, they could purchase a Bible or Testament with those credits.

example, those who established the original First Day (Sunday) schools proceeded soon thereafter to petition their legislature to establish public, free schools to help accomplish the teaching of reading and writing. They cited the success of their Sunday schools as proof the children could and should be taught.

The free schools, when they came, also reflected the way in which the Sunday school societies had gone about their second purpose—to improve the morals and religious character of their pupils. In the original Philadelphia Society schools, students were to spend their time reading and writing copies from the Bible.[4] As more materials were necessary, the Sunday school societies were determined to select and print their own materials in order to guarantee an appropriate moral tone. The materials of the Sunday school organizations, including the Rewards of Merit, came to be used in homes, churches, and schools and affected far more people than merely those who were pupils in the first schools. Reading lessons were still from the Bible, the primers and spelling books consisted of words and short sentences from the Scriptures, and the Rewards of Merit, which were used almost from the beginning, usually had Bible verses on them (Fig. IV-2).

The teaching methods used in the Sunday schools, including the methods for insuring discipline, also came to be used in the later weekday schools—particularly when large numbers of teachers whose first experience with reading and writing had been in Sunday schools became teachers themselves. To insure discipline, explicit rules of behavior were made and were sometimes printed on the back of Rewards of Merit (Fig. IV-3) which were awarded to the pupils and taken home to parents to read. Some Sunday schools encouraged students to confess any "lying, swearing, pilfering, indecent talking, or other misbehavior." If the pupils continued such behavior after being corrected by the teacher, there was a visiting committee to determine whether such delinquents should be publicly expelled from the school in the presence of their class. Pupils who behaved acceptably, on the other hand, were given Rewards of Merit—often those on the back of which the rules of the school were printed. Rewards of Merit thereby served the dual purpose of publishing the school's rules and positively reinforcing the students' adherence to those rules. As more and more Rewards of Merit were printed, some were also designed for another dual purpose—they were printed so they could be used in either a Sunday school or a weekday school.

An elaborate "ticket economy" of Rewards was introduced early in the nineteenth century by a Philadelphia society, The Union Society for the Education of Poor Female Children, which was one of the many societies which were springing up to join with the Sunday schools to develop new schools. It was a society which turned out to have importance not only for education but for the status of women and their ability to

participate in educational movements. Both to raise money and to generate awareness of their work, The Union, which was formed by a group of Philadelphia women of different denominations, held an annual public examination at which premiums were awarded to scholars. Their public examination was among the earliest of many which served to publicize the giving of Rewards. With regard to their status as managers of a society, twenty-six of the all-female managing board, rather than relying on their husbands or other male benefactors of schools, themselves applied to the state for an act of incorporation. That application, granted in 1808, was accompanied by the explanation that women too were "citizens of this commonwealth."[5] It was an encouragement to the participation of women in the Sunday school movement and other educational and charitable societies for decades thereafter.

The Sunday schools had a particular advantage in the availability of teachers. Though the teachers of the original Sunday schools of Robert Raikes and the First Day Society of Philadelphia were paid, when the Sunday schools were taken up and expanded by the evangelical movement of the early nineteenth century, they were taught by armies of unpaid, Sunday only, teachers. They could and did have, therefore, small classes which, in many cases, were taught by the most capable and dedicated citizens in the town or neighborhood. Those small classes were one reason why Sunday schools in the cities, even though they met only one day per week, were sometimes preferred by parents even when weekday monitorial schools, which sometimes had classes with as many as 400 pupils, became available. The "monitors" or "teachers" in Sunday schools not only were usually adults, but more importantly, these adults were from the community from which the Sunday scholars came. Parents could be assured not only that their children would have adult teachers, but that they would not be subjected to the "bullying" of some neighbor's older child who had been appointed a monitor or assistant teacher.[6]

By the second decade of the nineteenth century the First Day Society's motto, "Licet Sabbatis Beneficere," "It is lawful to do good on the Sabbath," was understood and accepted. Teaching children to read and write was "to do good." School on Sunday was not merely acceptable to the Sabbatarians who had objected in previous generations, but Sunday schools were being espoused by many as the means to developing an educational system across the nation.

From Sunday schools, to monitorial charity schools, and finally to a public school system for all—such became a common transition in the establishment of schools. In the large cities of the older states as well as in the small towns of the expanding territories, the passage from no schools, to some schools, to schools for all, was a manageable pattern of transition.

RULES OF THE **SABBATH SCHOOL.**

Every Scholar in this School must agree to the following Rules:

1. I must always mind the Superintendant and ALL the Teachers of this School.
2. I must come every Sunday, and be here when School goes in.
3. I must go to my seat as soon as I come in.
4. I MUST ALWAYS BE STILL.
5. I must not leave my seat till School is through.
6. I must take good care of my books.
7. I must not LEAN on the next scholar.
8. I must walk SOFTLY in the School.
9. I must learn all my lessons well, and be ready to say them when called upon by my Teacher.
10. I must not make a noise by the Church door, or School door, but must go in as soon as I come there.
11. I must always go to Church.
12. I must behave well in the street when I am going to Church.
13. I must walk softly into Church.
14. I must sit still in my place till Church goes out.
15. I must go away from the Church as soon as I go out.

Fig. IV-3

Sabbath Morning.

Welcome, welcome, quiet morning;
I've no task, no toil to-day;
Now the Sabbath morn returning,
Says a week has passed away.

Swift my childhoods dreams are passing,
Like the startled doves they fly;
Or bright clouds each other chasing
Over yonder quiet sky.

Let me think how time is gliding,
Soon the longest life departs;
Nothing human is abiding,
Save the love of humble hearts.

The reverse side of a printed Reward by George P. Daniels, Providence, RI. The woodcut of the children is identical to that used in Fig. II–4, and is probably of the same period.

Important as the first Sunday schools in the eastern United States were, it was the Sunday schools of the ever expanding Western frontiers which not only guaranteed that the Sunday school movement would leave a national legacy but also helped guarantee the continuing popularity of Rewards of Merit.

Before new frontier communities could hope for weekday schools, they could establish a school on Sunday, and many did. Americans were already convinced that the only way for the great experiment in liberty to succeed would be through the participation of a literate and virtuous citizenry—a citizenry who would "choose God's way, individually and collectively" to fulfill God's plan for the nation.[7] With their purpose clearly before them, the Sunday School Unions evolved into a carefully-planned, creatively organized, missionary effort to bring that needed literacy and morality to the American frontiers.

Sunday schools substituted for weekday schools in remote, sparsely settled areas, where parents frequently established the one-day-a-week Sunday schools not only for moral education, but deliberately to speed the process of getting a regular school. Often the Sunday school also had an institutional advantage which few such popular organizations ever enjoyed. Sunday schools, and their supporters, were not forced out of existence when the primary purpose of establishing a town-supported school was accomplished. Rather, when Sunday school organizers had been overseeing a weekday school which was later taken over by town or state, they could easily transfer their energies to a Sunday-only church school for adults as well as children. Frequently the Sunday school then functioned as a general charitable society.

Whether the Sunday school was still substituting for a weekday school or was continuing as a part of a church program, memorizing one Bible verse every Sunday was standard practice. For beginning readers still struggling to recognize words easily, reading a particular Bible passage over and over was a beneficial learning exercise. For those who could already read well, memorizing large numbers of scripture passages was a pleasant challenge and an accomplishment which could be displayed with pride. As friends and relatives quoted the Bible, more and more were motivated to memorize favorite verses which they could repeat to themselves and others. They were also powerfully motivated by the tangible evidence of the Rewards of Merit which were commonly given both for steady attendance and for memorizing specified numbers of verses. The Reward system was clearly highly applicable, and some felt necessary, to that primary activity of Sunday schools—memorization.

The Reward system of the later American Sunday schools, however, was no longer Raikes' original, unsystematic Reward-giving. The much expanded Reward

system of Joseph Lancaster (see Chapter Five), who had originally been inspired by Raikes, was imported into the American Sunday schools shortly after their first founding. The Rev. Robert May, a missionary to India for the London Missionary Society, is credited with having introduced Lancasterian methods into the American Sunday schools. May was familiar with the latest English Sunday school methods, and he had also visited the first weekday charity school founded by Lancaster in which astonishing numbers of Rewards were given. When May visited the Sabbath meetings of the Philadelphia Sunday and Adult School, he began the practice not only of having the attenders recite memorized passages of Scripture, portions of hymns, and phrases from catechisms approved by the parents—he also gave Rewards for each small success in recitation.

This practice of hymn and scripture recitation can often be seen on Rewards of Merit of the early nineteenth century. Two such examples were printed for the specific purpose of recording the specific number of recitations (Figs. IV-4, 5). Red and blue tickets, often with verses of scripture printed on them, soon became a familiar part of a Sunday school's equipment. The Reward tickets all had nominal values exchangeable for tickets of higher value and then for Reward books and other gifts.

As the Sunday schools took more and more seriously the challenge not only of teaching reading and writing but also of bringing morality to the expanding nation, they were more and more challenged by the enormity of their task. In 1790, the population beyond the Alleghenies was 100,000. By 1820, it was 2,500,000. Those who remained in the East constantly heard that the Western pioneers had a tendency to leave their religious and cultural standards behind and adopt less rigid moral standards.[8] The moral laxity of Sabbath-breaking apprentices in Philadelphia, with which the First Day Society had grappled, now seemed to threaten the entire nation as thousands of people moved westward into what was perceived as unknown, ungoverned and uncivilized territory. Many deeply feared that churches were losing their grip on society. The nation's political leaders decried more and more vociferously the possibilities of an immoral, uneducated, Western electorate.

Heavy revival preaching was one of the responses to these threats.[9] A kind of Second Great Awakening, reminding new Americans of the revivalism of the 1740s under Jonathan Edwards, swept the nation. More importantly for education, it was the evangelical energy which followed the revivals which translated itself into the founding of a plethora of related benevolent societies. The Sunday school movement was joined by missionary and charity societies, tract and Bible Societies, and peace and educational societies, and together they became America's impressive nineteenth century evangelical united front.

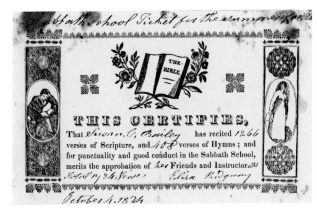

Fig. IV-4

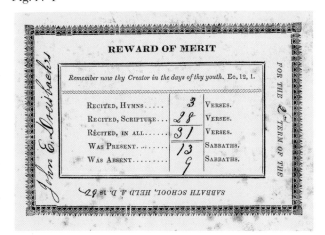

Fig. IV-5

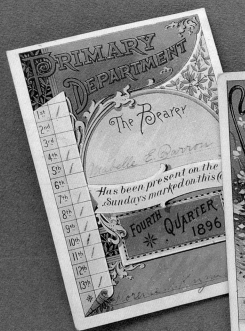

PRIMARY DEPARTMENT

The Bearer

Mabelle E. Barron

Has been present on the
Sundays marked on this Card

FOURTH QUARTER
1896

1st
2nd
3rd
4th
5th
6th
7th
8th
9th
10th
11th
12th
13th

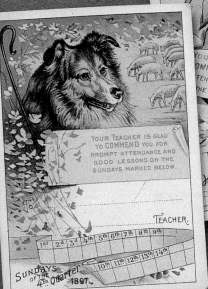

YOUR TEACHER IS GLAD
TO COMMEND YOU FOR
PROMPT ATTENDANCE AND
GOOD LESSONS ON THE
SUNDAYS MARKED BELOW.

To
TEACHER.

SUNDAYS OF THE 4th Quarter 1897

1st	2d	3d	4th	5th	6th	7th	8th	9th
10th	11th	12th	13th	14th				

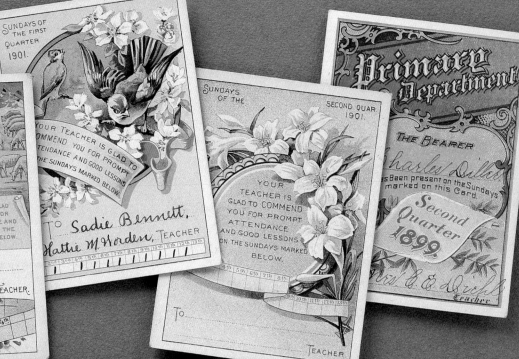

SUNDAYS OF THE FIRST QUARTER 1901.

YOUR TEACHER IS GLAD TO COMMEND YOU FOR PROMPT ATTENDANCE AND GOOD LESSONS ON THE SUNDAYS MARKED BELOW.

To Sadie Bennett.
Hattie M. Worden, TEACHER

SUNDAYS OF THE SECOND QUAR 1901.

YOUR TEACHER IS GLAD TO COMMEND YOU FOR PROMPT ATTENDANCE AND GOOD LESSONS ON THE SUNDAYS MARKED BELOW.

To
TEACHER.

Primary Department

THE BEARER

Charles Diller

Has Been present on the Sundays
marked on this Card

Second Quarter
1899

Mrs. C. E. Diehl
Teacher

Sundays of the First Quarter 1900

YOUR TEACHER IS GLAD TO COMM
FOR PROMPT ATT
AND GOOD LESSON
SUNDAYS MARKE

1st	2nd	3rd	4th	5th	6th	7th	8th	9th	10

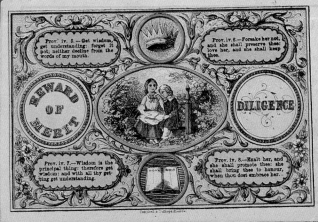

Prov. iv. 5.—Get wisdom, get understanding: forget it not; neither decline from the words of my mouth.

Prov. iv. 6.—Forsake her not, and she shall preserve thee: love her, and she shall keep thee.

REWARD OF MERIT

DILIGENCE

Prov. iv. 7.—Wisdom is the principal thing: therefore get wisdom; and with all thy getting get understanding.

Prov. iv. 8.—Exalt her, and she shall promote thee: she shall bring thee to honour, when thou dost embrace her.

Your Teacher is glad to COMMEND you for Prompt Attendance and Good Lessons on the Sundays Marked below.

To Sadie Bennett.
TEACHER.

1st	2d	3d	4th	5th	6th	7th	8th	9th	10th	11th	12th	13th	14th

2d QUAR. 1897.

The large groups of children who were totally outside of the churches or lost in the wildernesses of the frontiers, children who had never heard a catechism, were imagined to have an even more menacing potential than the adults. Sunday schools began to be seen as the one institution which might win the whole united new nation to a bible-reading Christian faith.[10]

Because of their emphasis on the leadership of lay people, the Sunday schools, even when they were led by fervent evangelicals, had a considerable additional democratic advantage over any association within a particular denomination or its clergy. Their Protestant, Christian, but non-denominational teachers operated with an enthusiasm which came from their conviction that they represented all moral Americans, not just one church. When a strong Sunday school organization existed in a community, it could keep control out of the hands of clergymen who felt a responsibility to insist on the tenets of their particular church. It was a carefully protected and nurtured advantage which was planted in peculiarly fertile American soil.

An all-out effort to establish Sunday schools appealed to a cross section of people as the best, and possibly the only, practical solution to the country's potential loss of faith, literacy, morality, and idealism. It also led the organizers to depend on already worked-out procedures and materials which were both effective and acceptable to all. Those procedures and materials notably included those which had evolved from the earliest catechetical methods elaborated by Lancaster—short lesson memorizing and use of Rewards of Merit.

In 1824, in order to become even more effective in their crusade, the numerous Sunday school societies united into a remarkably effective national network for organizing and supporting new Sunday schools. Their goal was to reach all American youth, and they set about doing so with the most efficient organizational skills which could be devised. Surveys and statistics, for example, were already a familiar part of the Adult and Sunday School Union, and the new managers of the American Sunday School Union enlarged and improved the system of questionnaires and constantly strived for more effective use of the information they gathered.

The increased strength and energy of the larger, unified American Sunday School Union organization was also immediately put into the book publishing activities which the larger of the previously separate Sunday school societies had already developed. The Society produced its own alphabet primers, spelling books, hymnals, catechisms, Bibles, Testaments, dictionaries, commentaries, manuals, lesson-helps, a great variety of tracts or stories (most of which came from English publications), and the full equipment deemed necessary for Sunday school and family study. The full

Above—An 1880 printed Reward from woodblocks by letterpress in three colors and gold. The back side of this Reward indicated credits for each quarter. Two credits were earned each Sabbath if early, one if late; one additional credit for Good Order and one for Good Lessons.

Below—An envelope used to package Sunday school Rewards by lithographer John Gibson, circa 1880.

Opposite page—A variety of chromolithographed Reward of Merit/attendance cards, used quarterly in Sunday schools, dated 1896–1901.

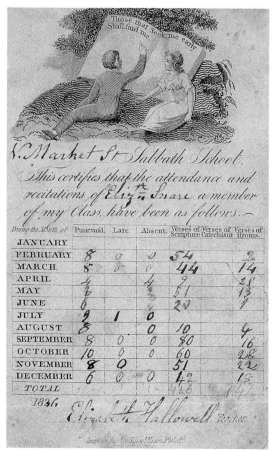

Fig. IV-6

equipment included yearly report cards (Fig. IV-6), and, of course, the red and blue Reward tickets. The Union also took care to safeguard their records for history. Preserved, for posterity, in the Society's records are stories of boys, often identified as those who received premiums and prizes,[11] who later became "opulent and respectable" members of the community.

One type of Reward which had been given in an unbroken tradition since the Middle Ages was given with a vengeance by the Sunday schools—the Reward book. Small moral books were to be lent or given to the scholars as incentives for good behavior as well as lessons learned. Among the better known books purchased, printed, and distributed were: *Doaley's Fables, Barbauld's Songs, Beauties of Creation, Catechism of Nature, Powers of Religion, Economy of Human Life, Watts' Songs, Whole Duty of Women, Fruits of the Father's Love,* and of course Bibles and Testaments.

One such book, *Not Afraid of Ridicule* published by the American Tract Society, has a title page illustrated with an engraving depicting a medallic Reward being bestowed on a student (Fig. IV-7). Another general Sunday school tract, published in 1819 by P. W. Gallaudet at his Theological Bookstore, is titled *Anniversary Reward. Rules For Good Living.* Its title page illustration is a woodcut engraving of young girls receiving instruction and reading aloud (Fig. IV-8). This tract has on its back cover an advertisement for "Watts Divine Songs," "Rewards," and "Tickets."

The Union's organizational directives came out in circulars and pamphlets in which Sunday school workers were urged to organize local, county, and state unions. These pamphlets contained rules and regulations for the efficient management of schools, instructions to help teachers and Sunday school librarians, and schemes for keeping the interest of scholars—particularly schemes of Reward giving.[12]

A Reward magazine which was published monthly to be given for punctual attendance, correct recitation, and good behavior was one of the publications which the new Union acquired when it took over the publications and presses of the joining societies. *The Teachers' Offering* or *Sabbath Scholars' Magazine* had been planned by the teachers of the New Haven Sabbath-School Union. The new Union purchased the monthly reward book in 1824 and changed its title to *The Youth's Friend.* It was enlarged to sixteen pages to include a variety of "excellent" reading for children, inspirational reading for the home, and perhaps most importantly, engraved illustrations. The Union also established a new monthly journal, the *American Sunday-School Magazine.*[13]

It was estimated that there were 180,000 pupils in the Sunday schools of the United States by 1825, and a total of 1,080,000 Sabbath scholars in the world.[14] It was already a large market for books and teaching supplies, including Rewards, and clearly the American Sunday School Union intended to much enlarge even that market.

The story of the elaborate organization, the number of people involved, and the success of the Sunday school movement from 1825 to the end of the century is another of those fascinating chapters in the forming of a nineteenth-century American identity. Certainly Sunday schools evolved dramatically from their first beginnings when they provided schooling, as well as practical assistance, to the poor children of a particular town.

Nineteenth-century Sunday schools became a part of a larger process of evangelical institution building which, in addition to their more specific goals, "explicitly promoted the notion that the fate of the republic depended upon the triumph of evangelical ideals and institutions." Acting effectively on this assumption, they became both a symbol of, and the agent of, nationalism.[15] The Sunday school also parallelled, was a part of, and was highly influenced by, the growth of America's most successful businesses—businesses which had as their market all of the fast growing United States as well as lands beyond its borders.

The first objective of the Union, "To secure unity of effort, federation and cooperation of all friends of religious instruction in all sections of the country," meant that they intended to encompass virtually all Americans in their appeals. The Sunday School Union, which became ever increasingly clearly Protestant even though not denominational, expended unbelievable energy into making certain that "all" were reached by their enthusiasm for moral education and national unity.

The Sunday School Union formed voluntary organizations, developed hugely successful publicity campaigns, kept up constant exhortations for continued recruitment, and, most effectively of all, divided the country into districts and sent missionaries with libraries. These full-time "agents," or missionaries, were paid, if at all, the magnificent sum of one dollar a day.[16] The agents and the Union's officers used their questionnaires and statistics for more efficiency, published pamphlets with rules and regulations for the efficient management of schools, and held county, state, and national conventions. During the Civil War, men discovered that "Sunday school" was a common background. One worker discovered that at a meeting of two hundred soldiers, 95% had been connected with Sunday schools.

By mid-century, the great influence of the monitorial system was declining in week-day schools from its early nineteenth-century dominance. Sunday schools and their methods had by that time, on the other hand, merely passed through a first stage in their influence. Through them the use of Rewards was dramatically continued.

After the Civil war, the leadership expanded to include entrepreneurs such as John Wanamaker, the enterprising Philadelphia merchant, and H. J. Heinz, of "57 varieties." These men, like many Northerners, were obsessed with the notion of "union"

NOT AFRAID OF RIDICULE.

—115—

PUBLISHED BY THE
AMERICAN TRACT SOCIETY,
150 NASSAU-STREET, NEW YORK.

Fig. IV-7

Fig. IV-8

and, from their business experiences, had a horror of inefficiency. They also had an enormous interest in using to the fullest America's developing technological genius—particularly the possibilities for advertising which were emerging with the remarkable advances in printing.

The elaborate organization and interdenominationalism also gave the Sunday school movement a remarkable degree of centralization. After 1872, for example, the same Sunday school lesson appeared each week in the newspapers throughout the nation. The lessons had been developed by John Vincent, who, as a young minister, had been appalled by the lack of order and system in the average Sunday school. After much organizing of support, campaigning, and discussion, in 1872 a "uniform lesson system" was adopted not only nationally, but internationally.

By that last quarter of the century, the Sunday school's own publications were having to compete increasingly with newspapers and popular magazines, so B. F. Jacobs, who had managed the campaign to get the lessons accepted, set his talents to securing coverage in the daily and weekly newspapers across the country. The lesson with its "Golden Text" came to be the big religious news of the week, and competition developed among syndicated columnists over who was assigned to write the commentaries on the Bible passages to be studied on Sunday. This weekly publicity finally brought Sunday schools into the lives of almost all Americans, including those who feared its non-clerical, Protestant, ascendancy.

After the adoption of the uniform lessons, a Sunday school attender in Idaho could visit a Sunday school in Massachusetts and find the same lesson being taught and the same Rewards of Merit handed out for memorization of the appropriate Scripture. Whether the Sunday school was in a Presbyterian, Baptist (Fig. IV-9), Congregational (Fig. IV-10), or Methodist church (Fig. IV-11), in small isolated Western communities or in Eastern cities, the same Scripture was being read and taught.

By this time, many of the Sunday schools in the more affluent cities and towns also printed some of their own materials—even though they might be using the same Golden Text as the most recently organized Sunday school in an isolated frontier community. Individual Sunday schools sometimes printed Rewards, cards or ribbons (Fig. IV-12), for their own scholars; and Sunday school cards, not published by the Sunday School Union and often embellished with designs identical to those on stationery and other special cards, were also printed and sold at stationers. Any Sunday school teacher could purchase them to use as a special Reward of Merit.

By 1900, more than three million English-speaking teachers were using Sunday School Union's weekly lessons (Fig. IV-13), and were handing out tickets and

Rewards of Merit to children who memorized the weekly "Golden Text" and other prescribed hymns and Bible passages. British and American missionaries used the same materials wherever they were, and the lessons were translated into forty languages and dialects for India alone.

As for the impact of Sunday school and Sunday school Rewards of Merit on the psyche of Americans, perhaps the best illustration is by that chronicler of American life and legend—Mark Twain. The efforts of the Sunday School Union had taken effect in Hannibal, Missouri, on the banks of the Mississippi.

In 1876 Twain (Samuel Clemens) gave us Tom Sawyer wreaking his usual havoc on whatever was important to others in his community—in this case, Sunday school Rewards.

Tom had, as usual, not "learned his verses" for Sunday school, but on this particular day, he had been rescued by Mary who, by promising him a "surprise" had managed to get Tom to

> "tackle it again"—and under the double pressure of curiosity and prospective gain, he did it with such spirit that he accomplished a shining success. Mary gave him a bran-new "Barlow" knife worth twelve and a half cents; and the convulsion of delight that swept his system shook him to his foundations.

On the way to Sunday school, Tom, with the wealth he had amassed in selling whitewashing privileges weighting down his pockets, dropped back a step from the family parade with Mary and Sid, and accosted a Sunday-dressed comrade.

> "Say, Billy, got a yaller ticket?"
> "Yes."
> "What'll you take for her?"
> "What'll you give?"
> "Piece of lickrish and a fishhook."
> "Less see 'em."

Tom exhibited. They were satisfactory and the property changed hands. Then Tom traded a couple of white alleys for three red tickets, and some small trifle or other for a couple of blue ones. He waylaid other boys as they came, and went on buying tickets of various colors ten or fifteen minutes longer.

Fig. IV-9

Fig. IV-10

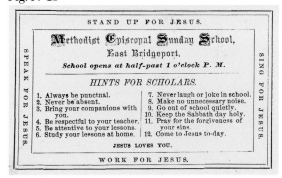

Fig. IV-11

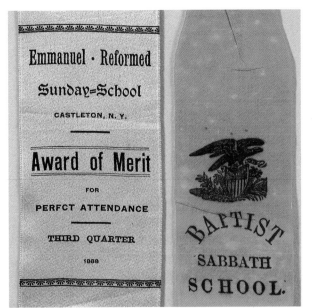

Fig. IV-12

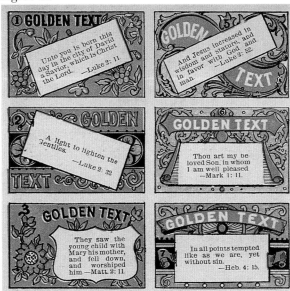

Fig. IV-13

Inside the church Tom, with his talents for instigating and maintaining disruption, managed to keep the class in the pattern by which it was known—restless, noisy, and troublesome.

When they came to recite their lessons, not one of them knew his verses perfectly, but had to be prompted all along. However, they worried through, and each got his reward—in small blue tickets, each with a passage of Scripture on it; each blue ticket was pay for two verses of the recitation. Ten blue tickets equaled a red one, and could be exchanged for it; ten red tickets equaled a yellow one; for ten yellow tickets the superintendent gave a very plainly bound Bible (worth forty cents in those easy times) to the pupil.[17]

According to Twain, the "mental stomach" of Tom "had never really hungered for one of those prizes, but unquestionably his entire being had for many a day longed for the glory and the eclat that came with it."[18]

On this particular Sunday, who should come in but the great Judge Thatcher in the company of the local Thatchers, including Becky, the sight of whom made Tom's soul "all ablaze with bliss in a moment."[19] The Sunday school superintendent, Mr. Walters, at the entry of this "prodigious personage," had fallen to "'showing off,' with all sorts of official bustlings and activities, giving orders, delivering judgments, discharging directions here, there, everywhere that he could find a target."[20]

Tom, with his peculiarly perceptive instincts, knew that "There was only one thing wanting, to make Mr. Walters' ecstasy complete, and that was a chance to deliver a Bible prize and exhibit a prodigy." And Tom had seldom wanted so much to show off to anyone as he did to Becky Thatcher, nor under any other circumstance had he longed more for "glory."

And now at this moment,…Tom Sawyer came forward with nine yellow tickets, nine red tickets, and ten blue ones, and demanded a Bible. This was a thunderbolt out of a clear sky. Walters was not expecting an application from this source for the next ten years. But there was no getting around it—here were the certified checks, and they were good for their face. Tom was therefore elevated to a place with the Judge and the other elect, and the great news was announced from headquarters. It was the most stunning surprise of the decade.

Though "the prize was delivered to Tom with as much effusion as the superintendent could pump up under the circumstances" the superintendent's instinct did

have some feeling that "it was simply preposterous that *this* boy had warehoused two thousand sheaves of Scriptural wisdom on his premises—a dozen would strain his capacity, without a doubt."[21]

Twain drew "the curtain of charity over the rest of the scene" after Tom, forced into having to display some of the knowledge he had gained from memorizing all those verses, attempted to answer the question "The names of the first two disciples were _____?" by replying: "David and Goliath!"

Twain's ridicule of Sunday school Rewards may have been indicative of a general decline of respect for Sunday schools and their Rewards, but it was also an acknowledgement of the sway they had held.

Older traditions of giving Rewards of Merit had also continued, however, throughout the period of the Sunday schools. Those city schools which had been established in the seventeenth century were still giving Rewards in the tradition of the European grammar schools which had been their inspiration. Their enduring customs would have guaranteed the continuation of the practice of awarding certificates and medals even if the Rewards of the monitorial and Sunday schools had never showered the American educational scene with their thousands of printed paper Rewards of Merit.

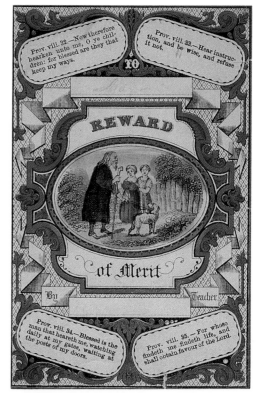

NOTES

1. J. Henry Harris, *The Story of Robert Raikes for the Young* (Philadelphia: Union Press, 1900), 54.

2. Ibid., 53.

3. Anne M. Boylan, *Sunday School: The Formation of an American Institution 1790-1880* (New Haven, CT: Yale University Press, 1988), 7.

4. Boylan, 7.

5. Edwin Wilbur Rice, *The Sunday-School Movement and the American Sunday-School Union 1780-1917* (Philadelphia: The Union Press, 1917), 51.

6. Thomas Walter Laqueur, *Religion and Respectability: Sunday Schools and Working Class Culture, 1780-1850* (New Haven, CT: Yale University Press, 1976), 110.

7. Cremin, 57.

8. Ron Mattocks, *On the Move* (Villanova, PA: American Missionary Fellowship, 1980), 9.

9. Ibid., 10.

10. Ibid.

11. Ibid.

12. Rice, 87.

13. Ibid., 91.

14. Ibid.

15. Boylan, 169.

16. Robert W. Lynn and Elliott Wright, *The Big Little School: Sunday Child of American Protestantism* (New York: Harper and Row, n.d.), 27.

17. Mark Twain, *The Adventures of Tom Sawyer*, 31-38. "Mental Acrobatics—Attending Sunday School—The Superintendent—'Showing Off'—Tom Lionized."

18. Ibid., 33.

19. Ibid., 34.

20. Ibid., 35.

21. Ibid., 36.

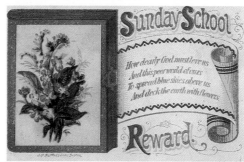

Above—Sunday school Reward, circa 1890, printed in black and gold. Below—Sunday school Reward lithographed in 2 colors by J.H. Bufford's Sons in Boston, circa 1875.

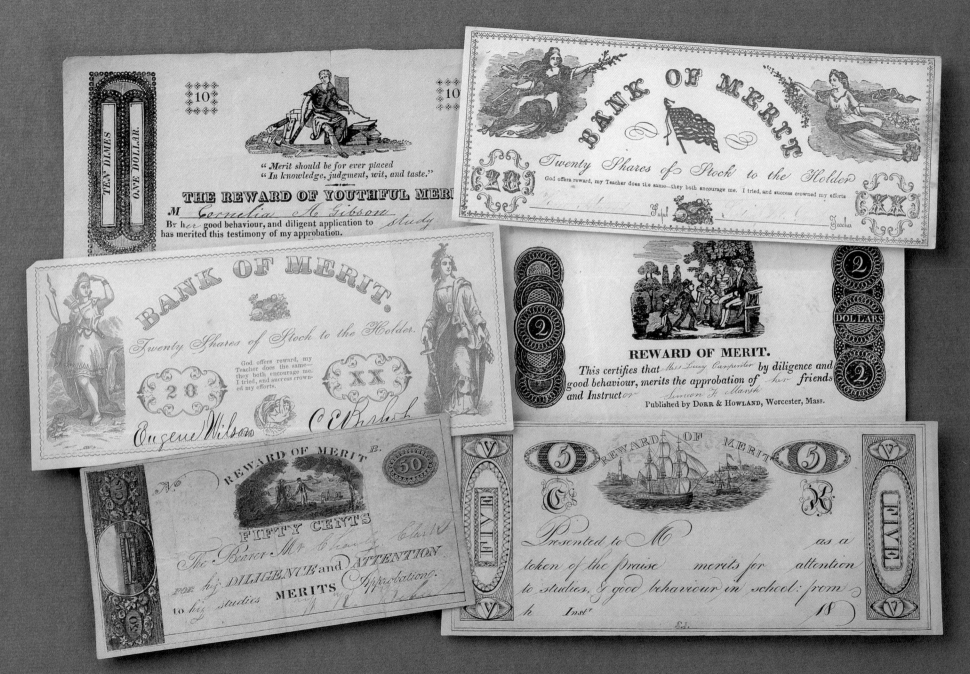

Fig. V-8. A group of bank note Rewards many of which were designed to imitate bank note currency of the early 1800s.

THE HOPE OF REWARD SWEETENS LABOR
Rewards by the thousands—the Lancasterian Schools

At times, through carelessness we blot,
'A fine in tickets, that's our lot;
But if the book throughout is fair,
Reward in tickets then's our share.
"Lines: On the manner of conducting a
Monitorial School"

chool, on Sunday only, was not the only contribution to the education of poor children made by Robert Raikes and his Sunday schools. By example, he also played a role in the sudden, dramatic creation of a very different kind of school—the monitorial schools advocated by Joseph Lancaster. The Sunday schools had a profound impact on American moral education, but it was their immediate successor, the monitorial schools, which provided the thousands of poor children in city slums the possibility of going to school every day. Joseph Lancaster visited Robert Raikes and his Sunday schools in Gloucester, England, and from him got inspiration and support for a new kind of school.

If schools were to be the source of sufficient education for the "masses" of children who would live and work and vote in a country of, by, and for the people, they had to be different from those which had preceded them. They had to be different in intent, in numbers of pupils, and in pedagogy. The ideas of the Enlightenment, and the urgings of the founding fathers such as Thomas Jefferson, provided the theories for universal education and the arguments for change; new methods of organizing the daily teaching, the pupils, and the teachers provided the possibilities. The schools which were to supply the opportunities were "institutions" where wealthy philanthropists, not parents, became the overseers. And, regardless of the myth of the lasting influence of the intimate one-room school houses in the small towns of rural America, these new institutional schools for the masses also directly led to, and put their stamp on, the first

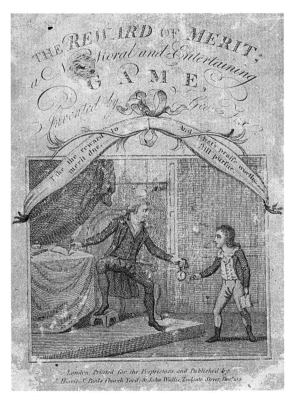

Fig. V-1

truly state systems of public schools. Schools were established and methods were adopted for efficiency in teaching hundreds of children in a single class, more pupils than anyone had previously been able to imagine in any one school.

Chief among the particular methods for creating pedagogical efficiency, however, was one which had long been used in elite grammar schools and in parent-controlled one-room schools—Rewards of Merit. But in the monitorial charity schools the number of Rewards given was unbelievably lavish, and the publicity attending their giving amounted to the ballyhoo of boosterism. The obvious use of Rewards of Merit was to reward children who did well; less obviously, but perhaps even more importantly, the giving of Rewards was great publicity for charity schools which needed money.

This new school system was hailed as the solution to the one most overwhelming problem which stood in the way of providing six-day-a-week schooling for the masses—the enormous expense. The enticement for the monitorial system was that it allowed many children to be taught at very low cost, and Reward-giving ceremonies helped impress the public with the idea that in their task of teaching reading and morality to poor children, the schools were successful. It was an impression vital to the raising of private money for their support.

The first edition of Lancaster's book, *Improvements in Education,*[1] outlining his monitorial system was published in 1803, before his own Borough Road school in London became well known. The book became so popular that six editions were published by 1806. His "modes of instruction," including the instructions for the use of Rewards of Merit, were fully expanded by the third edition of 1805, and it is that one which is most frequently quoted. An earlier edition of that book may well have influenced the procedures of the Philadelphia Society (The Union Society for the Education of Poor Female Children, see Chapter 4) first founded in 1805, which introduced a "ticket economy" of Rewards.

In Lancaster's No. 1 handwritten journal, the word, "EMULATION,"[2] is penned in large, display letters, covering half of the first page. Lancaster assumed that "Emulation and reward" are inseparable and were closely linked to that which he also believed to be inseparably linked: "inspection and application to learning." "Emulation"—to inspire one student to do as well as the most successful student—had been used as a reason for giving Rewards in schools for several centuries. By 1800 the climate of opinion was more than ever strongly in favor of a pedagogical system which purported to rely on "emulation" and on the giving of rewards for successful emulation. The idea of "Rewards of Merit" for incentives for all kinds of accomplishment had taken over the popular imagination.

"Emulation"—both the idea and the word—had become a constantly evoked principle to describe the proper aims of pedagogy, as the most effective way of inspiring morality, and even as a means of instilling "patriotism." To emulate the great, from America's political founders to a worthy neighbor, was being preached to adults as well as children with a frequency almost equal to admonition by repetition of favorite scriptures. For children there were not only stories which explained and insisted on emulation, there were even Games of Morals (board games) to remind them of emulation and rewards. *The Game of Human Life*, produced in 1790, took the players through a progression of life from infancy to old age with landing spaces marked with temptations or rewards which might be met along the way. *A New, Moral and Entertaining Game of the Reward of Merit*, by John Harris and John Wallis (Fig. V-1), came out in late December 1801, and *The New Game of Emulation* was published in 1804, also by John Harris. The moral games apparently continued to be popular for many decades. In 1843, W. and S. B. Ives, of Salem, Massachusetts, produced *The Mansion of Happiness*[3] which was followed by *The Reward of Virtue* (Fig. V-2) in 1850.

Lancaster's monitorial educational system both adopted the popularity of these ideas and by so doing greatly increased their common use. In Lancaster's schools, "Emulation" and "Rewards of Merit" became by-words; in American schools they remained for years thereafter unquestioned principles of pedagogy.

The heart of Lancaster's teaching method was the use of many older pupils to teach the younger ones. Instruction was largely by memorization and repetition of carefully prescribed and scheduled lessons which could be heard by student "monitors" (assistant teachers). "Let every child at every moment have something to do and a motive for doing it" was one of his guiding principals,[4] and the "motive" on which Lancaster most depended was a Reward. A glimpse into the importance of the Rewards of Merit to Lancaster is evident in the hand-written lists of Rewards in his journals.

These are the Rewards of Merit which he took with him to give at a school in Bristol which he was visiting:

Fig. V-2

2000	tickets of Merit for Rewards
18	lengths of medal chain
6	silver medals (Fig. V-3)
6	kings picture
3	silver pens 2s 6p, 3 at 3s, & 3 at 3s 6p
7	large metal medals
18	small ditto

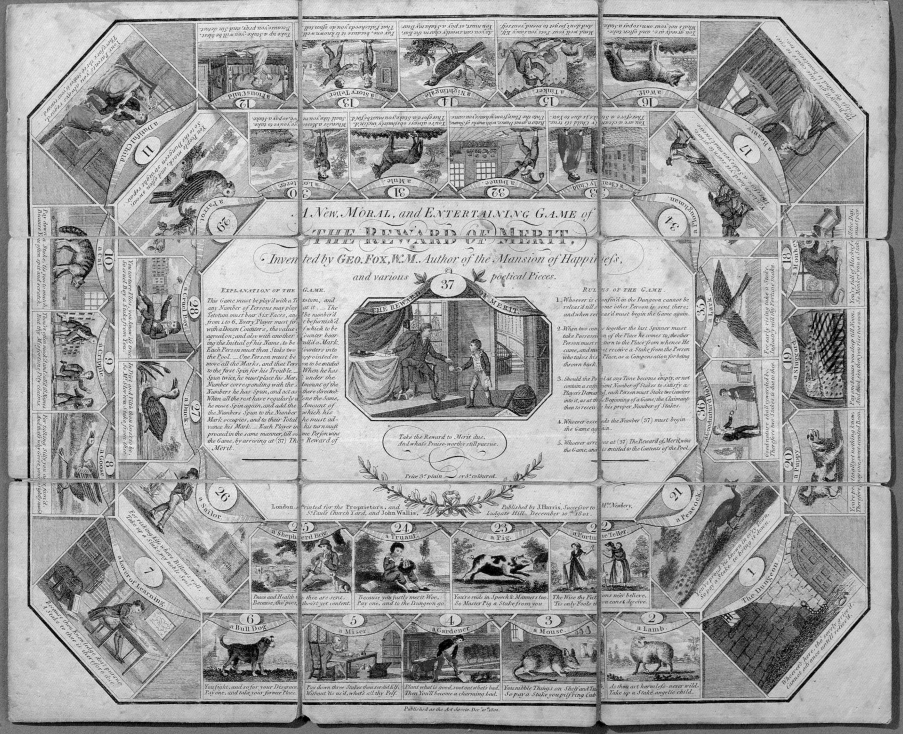

Fig. V-1

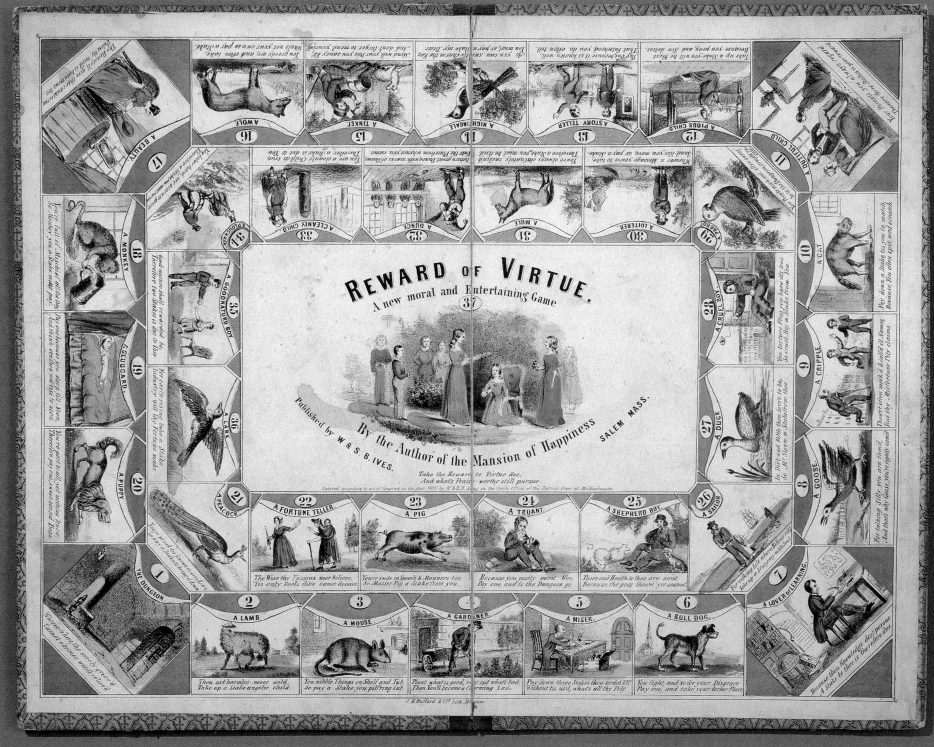

Fig. V-2

Fig. V-3
Above and opposite—Silver hand-wrought medals (both sides illustrated) are typical of those described in Joseph Lancaster's list of Rewards of Merit. Circa 1820s.

30	windmills
1	doz looking glasses
1/2	doz pen knives
6	boxes of paints
1	doz rulers and pencils
4	doz apples
1	doz whistles - 4d ea
1	doz watches - 6d ea
10	doz caps - 3d ea
30	books - 6d ea
6	packets - 2 at 1/ -2 at 1/6 -and 2 at 2/ each
2	large purses - 1/6 each
12	small ditto - 6d - each
3	dozen kites at 3d each
200	folio prize lessons
300	quarto ditto
200	8 ditto

money given in [word illegible] to the Best Boy by JL in person—at 4 separate times—£20
buns etc. for the whole school at 3 different times—£20

Another such list included:

1500	commendatory tickets
130	leather ditto, lettered "A Reward for Merit"

five thousand toys
several thousand toys as bats, balls, kites, etc.
 purses, silver pens, engraved half-crowns, star medals, (Fig. V-4) books for the School Circulating Library, which in the first year consisted of "above 300 vols. calculated to improve the morals of youth which they are permitted the use of gratis according to merit."

Lancaster developed his monitorial "system" in England; he had his first school in England; his remarkable talent for self-advertising was first displayed in England; and his fame was first established in England. It was in America, however, where a new nation was proud of having shed itself of the history-burdened English

attitudes toward social class and national religion, that Lancaster's ideas were taken up with few reservations and much enthusiasm. In America, as in England, there were far too few schools to accommodate the rapidly growing population of children in the cities, and most of the already-established schools required fees from parents. Any fee was likely to be one which the new immigrant factory workers could not possibly afford—even if they had been willing to forego what little money their children might earn on the streets. Americans also needed a cheap method of educating large numbers of city slum children.

The Americans had begun to cope with the problem by establishing more charity schools, particularly the Sunday schools, which were supported by private philanthropy. The problem clearly needed a much more massive effort, however. Lancaster's monitorial system seemed to offer a solution just as Americans were beginning to despair of making a democracy work in a country in which those who did not even know how to read were likely to overwhelm those who were educated. Ultimately, both the organization of the large Lancasterian monitorial schools and the pedagogical use of Rewards of Merit were probably more influential in the schools of the United States than in those of England.

Lancaster's was a system by which, he claimed, one school teacher could teach four hundred pupils. Furthermore, at his Borough Road School in Southwark (a borough of London), he demonstrated just such an accomplishment to amazed visitors. He intended his demonstration school to show that weekday schooling was financially feasible for the masses of the poor, and it did. Furthermore, with his astonishing flair for advertising, Lancaster managed to get extraordinary publicity for his unbelievably successful teaching methods.

Lancaster's use of Rewards, in fact, was not only a stimulus to pupils, it also greatly aided his efforts at self-advertisement. Lancaster was fond of hiring extravagant coaches and taking large groups of his pupils on expeditions—many of them designed to spread the gospel of his schools. For example, as a reward for attention to their learning, Lancaster took excursions with 180 of his London boys to Clapham and 450 to Green Park, along with such prizes as those listed previously from his trip to Bristol (and for which he also notes the cost of an inn for his entourage).

Obviously, though his schools were remarkably economical, Lancaster's expenses for Rewards, in spite of his soliciting many as donations, were significant in comparison to his much reported low cost for teaching staff and space per pupil. Lancaster was, in fact, in constant financial difficulties. It is from one of his attempts to comply with the request for accounts from the Quaker philanthropists who took

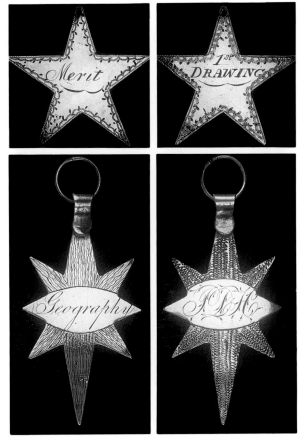

Fig. V-4

A letterpress printed card from the 1860s. These Rewards are typical of those which were sold to be cut up by the teacher into individual Rewards and accumulated by students to be traded for a larger certificate or fancy card.

over responsibility for his finances that we have the lists of prizes which give a glimpse into the magnitude of his Reward system.

In England, Lancaster is credited with influencing significantly the much belated inauguration of universal education. His influence there was immediately beset with renewed argument over the two, always festering issues which had long prevented the English from agreeing on the need for universal education—an established church and the belief in the inevitability of social classes. While he proved that schooling could be done more cheaply than previously suspected, that possibility raised the specter of educating too many people "beyond their station"—the most vehement of the arguments which the English upper classes (and often the church) used against universal education.

However, the possibility that thousands of school children who were taught to read and write might thereby rise above their "God-given station in life," may have been the lesser of the fears Lancaster provoked. Lancaster, the son of a lay preacher at a Dissenting Chapel, was a nonconformist who, after feeling himself drawn to the Society of Friends, had become a Quaker.[5] His claims of being able to educate the masses in England aroused the old religious fears which had haunted most of English history. If masses of English children were educated under nonconformist influences, the religious character of the nation might be changed. Fears of Lancaster's influence were further fanned when the Royal Lancasterian Society, formed primarily by his Quaker supporters in 1808 to help him discharge his debts,[6] was expanded into what seemed to be an effective national educational organization—the British and Foreign School Society.

It was those same fears, however, which in a convoluted way guaranteed Lancaster's influence on establishing universal education in England. Fears of Lancaster's nonconformist influence goaded the church parties into a counter-frenzy of educational activity and led the Church of England party to organize their own educational society, the National Society for Promoting the Education of the Poor in the Principles of the Established Church. This Society took over the work of the Society for the Propagation of Christian Knowledge which, for over a century and with the support of many Dissenters as well as the Established Church, had established and supported charity schools for the poor.

Not surprisingly, the new National (Anglican) Society also espoused a monitorial system since it was that "system" which first promised sufficiently low costs to make schooling seem possible. Certainly versions of a monitorial system had been used before Lancaster began to introduce it into his monitorial schools. Raikes had

sometimes used it in his Sunday schools, and it had also been used at Winchester College, Manchester Grammar School, and other grammar schools.[7] Indeed, in mixed age classes, using older or more advanced pupils to teach younger pupils is an idea which occurs naturally to many creative teachers as they face everyday classroom problems. Such a pedagogical system had, however, never before been widely publicized as a universal system, a panacea, for the education of large numbers of pupils.

The National Society's monitorial system was one espoused by the Rev. Mr. Andrew Bell. Bell had used older pupils to teach younger ones when teaching in a Church of England school in Madras, India, and had published his account of his school in a book, *An Experiment in Education*, in 1787. His publicists claimed, therefore, that he was the inventor of the monitorial system. While this flurry of competition ironically stimulated a favorable climate for universal education in England, it also intensified England's "religious problem" with regard to education and provoked constant examination and criticism of Lancaster's schools.

In the United States, on the other hand, Lancaster's very catechism and lesson plans for nonsectarian moral instruction fitted well with the goals of American charity school founders. The Americans were trying hard to find a way to ignore denominational and Protestant/Catholic boundaries in order to reach the churchless poor. The First Day (Sunday School) Society of Philadelphia had already demonstrated the possibility and advantages of all-denomination cooperation. The Lancasterian monitorial system seemed to be just what was needed to extend that non-sectarian advantage into weekday schools for the masses.

Lancaster did not claim to be the originator of the monitorial system (using older pupils to teach younger ones). The system of using Rewards, a new system of spelling, and the miracles in the number of children who could be taught cheaply were the only original contributions which Lancaster himself eventually claimed to have made. As he said simply, "The system of rewards and the new method of teaching to spell are, I believe, original."

No one, however, could doubt Lancaster's considerable contribution to the development of the monitorial system. His primary contribution was the degree to which he worked out the system. The evidence of his pedagogical genius was the detail with which he set forth the requirements which automatically qualified a pupil to become a monitor, the large number of monitors whom he could profitably employ, the easily comprehended lists of the duties of all the monitors, the specification of what was to be taught and how to teach it, and the explicit instructions about how the master and the monitors were to reward the learners.

This boy's been diligent at school,
And learned to read and write,
For which his Father gave to him,
This very pretty kite.

Reward of Merit with wood engraving of kite, circa 1840. Kites are recorded as having been given as Rewards of Merit as early as circa 1800, as evidenced by Lancaster's journal, where he lists Rewards that he took with him when visiting a school in Bristol, England.

111

Fig. V-5

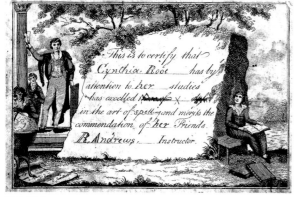

Fig. V-6

Working out the giving of Rewards was given as much importance, and was set forth with comparable detail, as were the teaching instructions for the monitors.

Monitors were given elaborate manuals that explained procedures and lesson plans—a system which also trained them as future masters. All procedures—from entering to leaving the building, from keeping attendance to keeping records of Rewards earned, from writing to calisthenics—were analyzed and prescribed. The motto, "A place for everything and everything in its place," was another Lancasterian admonition. Carefully kept records with tallies for every recitation became a trademark of the his method. Early, neatly handwritten monitorial teachers' records can be found in various kinds of exercise books, and as the methods were widely adopted, class-books with examples of detailed methods of record-keeping were widely sold by booksellers and distributed by Sabbath school societies (Fig. V-5).

In addition to devising new teaching methods, Lancaster also realized the need for a play area outside the school where calisthenics could be done. To eliminate the confusion of going in and out, strings were attached to the boys' hats so that they could be slung across their backs during lessons. This eliminated the need to have pupils hang up their hats when they entered school and then having to get them before leaving.

The obvious pedagogical trademark of the system, memorization, could be readily observed in Lancaster's large schoolrooms noisy with recitations. In the large rooms of his schools (the largest designed for as many as 1000 pupils), clusters of pupils, each group with its "insignia of merit", could be seen standing in semi-circles facing recitation stations along the outside walls of the room, where they were reading, memorizing, and reciting the precisely dictated lessons to the one older pupil who was their monitor (Fig. V-6). It was a system for which Rewards could easily, almost automatically, be given.

The directions in Lancaster's book make it clear precisely how this "emulation and reward" and "application to learning and inspection" was to work. Rewards were given for attendance; Rewards were given for good behavior; Rewards were given to pupils who were the first to complete the lessons; Rewards were given to a whole class for winning a competition against another class; Rewards were given to the monitors who taught the winners. Rewards of lower value for lesser accomplishments could be amassed and traded for Rewards of greater value. Rewards with specific values could be traded for toys and other prizes marked with that same value. A common theme of Lancaster's lectures was that, in his schools, motivation was provided by Rewards and the emulation they inspired—not by cruel corporal punishment.

His directions for the use of hundreds of Rewards each day are in dramatic contrast to the original use of Rewards in grammar schools. There they were used to inspire an entire class to emulate the virtues of one "head boy" or the few victors of the academic contests who received Rewards at the end of the year. In Lancaster's monitorial schools Rewards were used many times a day to inspire one pupil to emulate one other pupil who had done a better lesson. For example, in discussing the lessons for printing (done by making letters in sand spread across a shallow box), Lancaster says

> Every boy is placed next to one who can do as well or better than himself: his business is to excel him, in which case he takes precedence of him.

Fig. V-7

The monitor would judge the relative proficiency of each writing exercise and erase the letters, by spreading the sand, to ready the box for the next attempts. For reading, the boys were placed in the same way:

> every reading division has the numbers, 1, 2, 3, etc. to 12, suspended from their buttons. If the boy who wears number 12, excels the boy who wears number 11, he takes his place and number; in exchange for which the other goes down to the place and number 12. Thus, the boy who is number 12, at the beginning of the lesson may be number 1, at the conclusion of it, and vice versa.

The description of their constant use and their continually changing hands gives us a clue why so few of these particular Lancasterian Rewards of Merit seem to have survived.

> The boy who has number 1, has also a single leather ticket, lettered variously, as 'Merit,'—'Merit in Reading,'—'Merit in Spelling,'—'Merit in Writing,' etc. This badge of honour he also forfeits, if he loses his place by suffering another to excel him.

While we do not know of such leather tickets in current collections of Rewards of Merit, some collections do include medals which fit this description (Fig. V-7). Benefactors of the Lancasterian charity schools were often asked to provide Rewards, and we know that some philanthropists of at least a few schools gave the schools medals to replace the more destructible tickets.

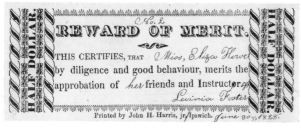

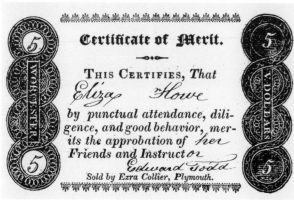

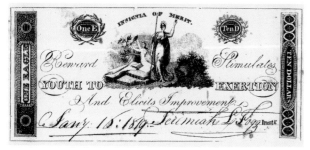

Fig. V-8

Badges lettered "Prize Book," "Prize Cup and Ball," Prize Kite," etc. were tickets which had to be retained three or four times in succession to entitle the winner to the prize lettered thereon.

Pictures by the thousands, were, however, the prizes which Lancaster regarded as the ideal Rewards. Pictures, according to Lancaster, not only lure the minds of children into a love of learning but have the great advantage of being cheap. For the best performance in subject matter lessons, a picture pasted on pasteboard (with a string for suspending it around the neck) was awarded along with a leather ticket with the place in class stamped on it. The picture was forfeited to anyone who excelled the wearer during the day, but the one who had the school's picture at the end of the day was entitled to his own picture in exchange for the return of the school's picture. Lancaster found that the younger boys in particular prized the pictures and that pictures could be made "a fund of entertainment and instruction, combined with infinite variety."

Lancaster laments in 1805 that "there is not a series of cheap, regular pictures, that would be fit to put into the hands of children." Of the tens of thousands of pictures printed annually and sold among the children of the poor, many, according to Lancaster, were mere "catch-penny rubbish" so badly designed and executed, and on such silly subjects, that they were fit only to "debase the minds of youth." Nonetheless, he notes that pictures were being sold at a halfpenny or a penny each and "cheaper at a wholesale rate." Lancaster suggests that many such prints could be cut into four or six parts, "every part a complete subject itself," so that for less than a shilling a day prizes could be afforded for a school of a hundred and twenty children—an expense which he hopes "all ladies who are patrons of schools, will adopt." These picture Rewards given daily could, according to Lancaster, "raise emulation" among the whole school.

While the quality and quantity in children's "pictures" in the early nineteenth century may not have met Lancaster's standards, pictures on Rewards of Merit and in innumerable other forms were popular purchases for children throughout the century. A search through collections of Rewards of Merit has not located a picture cut into parts and used as four or more Rewards. "Sheets printed with a number of Rewards to be cut apart by teachers, however, became a common item in print sellers' shops."

Rewards with monetary values printed on them were also popularized by Lancaster. Pupils could trade a school bank note of a particular value, later printed with "Bank of Merit" on them, for a toy or other prize valued at that amount. Even though they originally may simply have been ordinary Rewards of Merit meant for

exchanging for other Rewards, these bank note Rewards later evolved into examples of especially skillfully designed and printed examples of Rewards of Merit (Fig. V-8). They were often copies made from the designs and executions of the American engravers who had became known worldwide for their skill in producing bank notes.

Crudely penned paper tickets or small printed ones, which could be accumulated and traded for prizes to which a monetary value had been given, constituted Lancaster's Reward system for writing lessons using an actual pen. It is interesting that for the limited exercises in writing with the scarce and laboriously cut quills (only four times a week by only part of the school), the tickets were given for "exertion"—for improvement from a previous performance—rather than for comparison with another pupil. (Most writing exercises were done in sand trays, though at least one writer attributed the introduction of slate tiles for writing to Lancaster.)[8] Few, however, ever had enough opportunity to write with a pen to become really expert. Regardless of whether a "1" or a "5" was received, the value was the same until it could be traded; the difference was how quickly each of the numbers could be traded for a prize. If a number 1 was received three times, it could then be traded in for a toy worth a halfpenny; a number 5, received twelve times, could be traded for a toy worth sixpence.

Lancaster felt that "the emulation I have described as united with my methods of teaching," (which required many daily Rewards) was most useful, and most needed, with children who had no more than "common abilities." At the same time, he argued, the system gave an impetus to those who might be exceptionally gifted. Such students often remained unknown because they had no incentive to distinguish themselves—nothing to develop their latent powers. Lancaster felt that under his "mode of teaching" all must exert themselves according to their abilities, or be idle: If they exert themselves as well as they can, they will improve accordingly—if they are idle, it is immediately detected, and as rapidly punished..."

Giving Rewards of Merit for every small segment of a lesson learned was, therefore, "individualized" education. For later educational theorists, individualized lessons were often designed specifically to eliminate competition, particularly between students who were obviously of highly unequal ability. In those later "individualized" programs Rewards were given for accomplishments which were compared with the pupil's own previous accomplishments. Lancaster, while extolling his monitorial system as individualized, had pupils constantly competing against each other.

Lancaster's "emulation" was clearly an extreme case: it was part of a teaching practice which dictated in specific and minute detail what details were to be learned. Pupils were exhorted to emulate those who were first and best in memorizing one par-

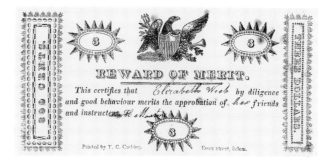

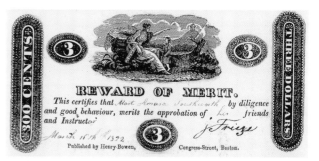

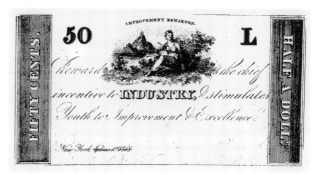

Fig. V-8

115

ticular lesson as well as to emulate those who had memorized the most lessons. His system necessitated lessons which could be easily evaluated by other students (monitors)—a criterion which meant that memorizing and repetition were not only the norm but the essence of the pedagogy. It led, in the opinion of many, not to emulation in the sense of desire to imitate general qualities which lead to success and achievement, but to "competition" in the sense of striving "to gain what another endeavours to gain at the same time." [9] A constant criticism of the monitorial system was that it inevitably fostered the desire not only to be the "best" student oneself but also the desire that someone else be worse.

As Rewards for good character as well as good work, inexpensive medals were used as a way of identifying particularly deserving youth—those who "checked vice" as well as those who excelled in their lessons. "Order of Merit" medals, on a plated chain, were not individually engraved and remained in the school. Those who were entitled to wear them formed a school "Order of Merit" which Lancaster consciously linked with the orders of merit which distinguished the nobility of a nation. Lancaster believed that it was to the advantage to any society to have such nobility designated and that it was also valuable in the society of a school. He was also not unmindful of the appeal to visiting benefactors who were thereby able to identify, immediately, youths who were considered particularly exemplary (and deserving).

Lancaster did also identify some generally superior pupils. He expected and accepted that there would always be a few pupils who were obviously of "superior merit" and that these few should "always be honoured, rewarded, and distinguished: [because] one or two lads of this description influence a whole school by their beneficial example."

Rewards for "superior merit" were also, therefore, a part of Lancaster's system. A silver watch, bought by Lancaster himself, was the highest Reward given to a student of such superior merit in his English school. For the few others of these superior students, silver pens and silver medals for "superior merit," engraved with the recipient's name and the reason for which they were given, were awarded. These special Rewards were much more similar to the disputation-day Rewards in centuries-old schools for the elite than were the thousands of lesser Rewards which he gave.

The Lancasterian system was adopted in American charity schools as early as 1807. They relied in a few cases on teachers who had been monitors in English schools but more often American teachers were hired, worked briefly in an already established school, and then relied on following the procedures as they were set forth in *Improvement in Education*. But Lancaster did eventually come to America. His own

extravagances, of money, of ego, and of hyperbole, eventually led to his forcible separation from the schools which he had influenced in England. In 1818 he emigrated to the United States to lecture, to visit monitorial schools already established, and to conduct schools himself. By that time his book was widely read; he was met with great enthusiasm; and he proved to be a popular lecturer. In Washington he was even accorded the privilege of the Speaker's chair while Congress was in session.[10]

If the Lancasterian monitorial system had been used only in a few individual charity schools established at the beginning of the nineteenth century, the influence of the Lancasterian system in the United States would probably have been quite limited. The Lancasterian system and its elaborate use of Rewards was, however, transferred into the state systems of public schools through the schools of the various "subscription societies" which had set out to establish as many schools for as many children as they could. Members of these societies (including the Sunday School societies) often worked hard, and eventually succeeded, in getting financial support for their schools not only from private contributions but also from the city or the state. They used the argument that they were supplying schools for children who had no other opportunities for schooling. Not only did these societies establish their own schools, they reminded the legislatures of the need for more and better schools each time they made their appeals for money. Their leaders continually espoused the advantages of the monitorial and reward system and pointed to the Lancasterian methods in their schools as proof that thousands of children could be educated cheaply.[11] When legislation and funds for a comprehensive school system became available, the schools which charity societies had founded were often incorporated into the public school systems.

The state of New York is often cited as the prime example of progress from benevolent society and private schools to a truly state-wide school system, and The Free School Society of New York City is often cited as the most influential of these charitable educational societies. The Free School Society, organized on the initiative of the Quaker philanthropist Thomas Eddy,[12] had the inestimable advantage of having De Witt Clinton as its president and guiding genius from its organization in 1805 until his death in 1828—years during which Clinton was also mayor, U.S. senator, lieutenant-governor, and governor of New York.[13]

Clinton was one of those American leaders who acted upon his convictions; and he was one who held the Lockean view that

> Early instruction and fixed habits of industry, decency, and order, are
> the surest safeguards of virtuous conduct; and when parents are
> either unable or unwilling to bestow the necessary attention on the

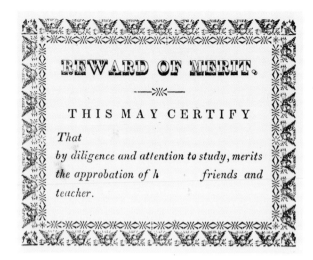

Here is a picture of some negroes at work.

The wood engraved illustration is on the reverse side of this Reward, circa 1830; the earliest known depiction of Negroes on a Reward of Merit.

education of their children, it becomes the duty of the public, and of individuals, who have the power, to assist them in the discharge of this important obligation.[14]

It was clear to Clinton that the need to fulfill this duty was urgent in New York City. Clinton dedicated himself with great fervor to creating schools for the large number of children who, because of their parents' extreme indigence, intemperance, or vice were living in "total neglect of…religious and moral instruction, and unacquainted with the common rudiments of learning."[15]

In his efforts to generate the enthusiasm among those who were needed to create, oversee, and contribute money to this considerable undertaking, Clinton also became the primary publicist and champion for the Lancasterian system. He used arguments which were scarcely less flamboyant than Lancaster's own.

Lancaster's system, wrote Clinton in 1809, was one whose "distinguishing characters are economy, facility, and expedition, and its peculiar improvements are cheapness, activity, order, and…an ardent spirit of emulation kept continually alive."[16] He explained to his potential contributors that Lancaster's "judicious distribution of Rewards, calculated to engage the infant mind in the discharge of its duty, forms the key-stone which binds together the whole edifice."[17] At times his rhetoric about the Lancasterian system reached a pitch of euphoria.

> When I perceive that many boys in our school have been taught to read and write in two months, who did not before know the alphabet, and that even one has accomplished it in three weeks—when I view all the bearings and tendencies of this system—when I contemplate the habits of order which it forms, the spirit of emulation which it excites, the rapid improvement which it produces, the purity of morals which it inculcates—when I behold the extraordinary union of clarity in instruction and economy of expense—and when I perceive one great assembly of a thousand children, under the eye of a single teacher, marching, with unexampled rapidity and with perfect discipline, to the goal of knowledge, I confess that I recognize in Lancaster the benefactor of the human race. I consider his system as creating a new era in education, as a blessing sent down from heaven to redeem the poor and distressed of this world from the power and dominion of ignorance.[18]

The Free School Society did, along with other charity societies with which they allied themselves, succeed expeditiously in bringing education to poor children in New

York—using Lancasterian methods. In 1813, New York City used its share of the state's public school subsidy to assist charity schools maintained by the Free School Society, the Manumission Society, the Orphan Asylum Society and the schools of various denominations. Because of this support, many people probably thought of these schools as public schools and the Lancasterian system as a public school system after that time.

The Lancasterian system had also spread amazingly quickly in other cities. By 1811 there were Lancasterian schools in Baltimore, Washington, and Cincinnati, in addition to the schools in Philadelphia and New York City where they were first and most enthusiastically adopted. The first free (no fees) schools in cities in Virginia, Kentucky, and Connecticut were also an outgrowth of Lancasterian schools.[19]

Between 1812 and 1828 Lancasterian schools appeared from Massachusetts to Georgia and as far west as Louisville and Detroit. State Lancasterian school systems were proposed in the legislatures of several states, including New York, Pennsylvania, Maryland, and North Carolina.

Though Lancaster's school had at first taught only reading and memorization of Bible verses, he had soon worked out the system for teaching writing, simple sums, and spelling, and, as the system caught on, it was extended to the "higher branches" (Fig. V-9). Private Lancasterian institutes and academies were opened from New York to North Carolina as quickly as teachers could learn the method and find pupils for them. Mexico organized higher Lancasterian schools for the Mexican State of Texas in 1829, and between 1825 and 1836 the New York legislature passed thirteen special acts for the incorporation of Monitorial high schools. Of the charity schools of the several societies in which the Lancasterian system was adopted, nowhere had it been done with more enthusiasm or with more public comment than in the African Free Schools of New York City. These schools for African-Americans were among the schools which used the monitorial system for years after it had fallen out of favor in mainstream public schools. Both the use of the method, and particular customs associated with the method, remained in some schools and communities well into the twentieth century.

The story of African-American schools in New York parallelled both the attempts to provide charity (or missionary) schools throughout the colonial period and, later, the rise of the Lancasterian system and its elaborate Reward giving.

Africans had lived in New Amsterdam from 1626 when a group arrived as indentured servants to the Dutch. After their period of labor was worked off, about forty free Africans lived in the colony. As early as 1704, the Society for the Propagation of the Gospels in Foreign Parts sent a "catechist," and schools for Africans in New York City were known at various times thereafter—1704-1712, 1741, 1760.

Fig. V-9. The Lancasterian school system was expanded to include teaching the "higher branches" such as geography. This is a silver, hand-wrought medal, circa 1820s.

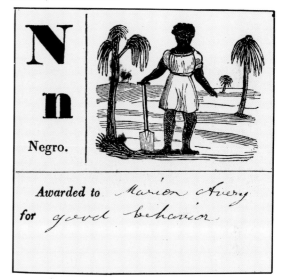

A wood engraved Reward of Merit, circa 1840. Although there were millions of Rewards of Merit printed in the nineteenth century, this one is from the only alphabet series known. The complete alphabet, printed on one sheet, was available with or without hand coloring. It is one of the earliest examples that depicted a Negro.

Small Rewards of Merit, such as the ones above and on the opposite page, were given frequently and in some cases, when they accumulated, could be traded for a larger more fanciful certificate; these examples are circa 1815 through 1850.

The situation for the schools, however, became worse, not better, as time passed and the number of slaves increased and far exceeded the number of freedman who lived in the city.[20] At the time of the Slave Plot in 1712 the argument was made that "Since slaves were held to have no souls, a man teaching them the Bible might well be giving them radical notions instead."[21] In addition an ordinance ordering African and Indian slaves not to be out after night without "A Lanthorn and Lighted Candle therein,"[22] (which would have to be supplied by their masters) effectively made it impossible for most to attend school. The situation was even worse after an uprising in 1741, when the school master was hanged for having been "a principal promotor and [having encouraged] this conspiracy where the inhabitants would have been butchered in their houses, by their own slaves, and the city laid in ashes."[23]

Schools for African-Americans in New York City[24] were organized again when the Society for the Promotion of the Manumission of Slaves was organized in 1785 and founded a school for boys in 1787 and for girls in 1792. The Society's leaders, including John Jay (chairman-president), Alexander Hamilton, and such honorary members as the Marquis de LaFayette, were dedicated to supporting and protecting the schools while they engaged in their principal work, abolishing slavery in New York. (Abolition was finally accomplished in 1827.)

Almost half of all the slaves left in the North lived in New York State in 1785 especially in the region of New York City. White charity organizations, several of them organized as Lancasterian Societies, provided schools in other parts of the state as well, but The Manumission Society's 1787 school was the first to be organized after the Revolution.[25] The Lancasterian system was introduced into the African Free Schools in 1809, a time when a large proportion of the parents of the pupils (about forty in one school) were still slaves. According to Charles C. Andrews, who was principal until 1832,[26]

"The introduction of this excellent plan produced a very favorable change in the school and its affairs generally; the number of pupils soon increased, and their order and general decorum became objects of favorable remark, even among those who had previously been in the habit of placing but little to their credit.[27]

The Exhibition Day was, as in most of the charity schools, particularly important as the principal occasion for publicity and public approbation. "Gentlemen from different parts of the union and various parts of the world…[came and] it afforded also a good opportunity of eliciting an opinion in relation to their capacities from some of the best judges in the community."[28] Remarks in *The Commercial Advertiser*, May 12th, 1824, mark the tenor of the times and the hoped-for outcome:

Those who believe, or affect to believe, that the African race are so far inferior to the whites, as to be incapable of any considerable degree of mental improvement, would not require stronger testimony of the unsoundness of their opinions....[they] could not...[fail] to notice the vast difference in the appearance of those children and the idle ones who are suffered to grow up uncultivated, unpolished, and heathenish in our streets, etc..." [29]

Fig. V-10

The *Minutes of the Common Council* about the school's exhibition that year also recorded that the performances were "a clear and Striking Proof of the value of the Monitorial System of education." [30]

The "program" for an exhibition included presentations such as "Girls arithmetical table class" (Fig. V-10), or "Drawing upon the board, before the company, an accurate map of the United States, after which a critical examination in American Geography." But the most interesting part of the programs may well have been the selection of recitations. Most were recitations of famous speeches or poems, but some were written by the pupils and some were written by benefactors for the pupils to recite. A particularly charming one was spoken by a seven year old who concluded the ceremonies with

> All things must have a beginning and an end. I am come to begin my public speaking, and to end the present exercises which I hope have been performed to your satisfaction." [31]

Others of the recitations, however, were obviously chosen by the pupil speakers for a hoped-for effect on the "distinguished" visitors present—one of the few occasions on which such appeals could be made directly. A pupil's recitation of "O Africa" in 1824 ended with a ringing

> [This appeal] is made to a nation of freemen, who profess to believe all men are by nature free and equal—for this is the motto on the corner stone of their national magnificence..." [32]

Recitations such as this one (and another which included references to the lack of job prospects, and, even if a job were offered, the refusal of other workmen to work with African-Americans), were a dramatic contrast to the phrases of "gratitude" which were included in some of the speeches written for a pupil by a benefactor.

The discipline, standards of achievement, and the public reward-giving associated with the Lancasterian system, apparently served the teachers and pupils of the

Fig. V-11

African Free School well in the first half of the century—both in eliciting "favorable remark(s)" and financial support and in teaching children. Unfortunately, the former African Free Schools were among those which felt most strongly the disappointment and discrimination of having no choice but to continue using the Lancasterian system—the cheapest and most limited pedagogical system available—for some years after the other schools of the Public School Society were able to use methods which required better equipment and more teachers. (see Chapter Six)

Among the schools in which the Lancasterian system was used the longest were those of the Shaker communities. Brother Seth Youngs Wells (1767-1847), of New Lebanon, New York, who had been a public school teacher and principal before joining the Shakers, used the system himself. In 1823, while making a series of visits to other East coast Shaker societies "to encourage their programs of education and to establish schools," he trained Shaker teachers in the Lancasterian method. The Shakers changed and adapted the Lancasterian system to their own ways, as did many others through the years, but there were vestiges of Lancasterian methods in Shaker education as late as 1950 when the Sabbathday Lake School in Maine was closed.[33] Rewards of Merit, hand made by members of the Shaker communities, are particularly sought-after by collectors of American school art.

Among the customs associated with the Lancasterian schools, the highly publicized use of Rewards of Merit fanned the popularity of the giving of Rewards of Merit to the pupils of local schools by individuals and by civic organizations. This custom, once begun, was also more slowly and less dramatically abandoned than was the Lancasterian system in its entirety—a "system" which was subject to the dictates of the new normal school teachers and state school-system administrators when they gained organizational power at mid-century. A particularly fine example of a paper Reward given by a civic organization is the diploma, 9½ x 11½", printed (in gold and blue on embossed white-coated stock) for the Summit County Agricultural Society by Beebe and Elkins, printers, of Akron, Ohio (Fig. V-11). The inscription reads:

> This diploma is awarded to George H. Root for best specimen of penmanship. N. W. Goodhue, Sec'y. and Daniel Hine, Pres't. Akron, October 13, 1853.

In the classrooms, both the influence of the highly structured monitorial and Reward system on the public schools, as well as the later diminution of their use in the public schools, happened because the monitorial charity schools were gradually or suddenly incorporated into the first truly state-wide school systems.

In New York, though The Free School Society's schools were receiving state subsidies assigned to charity schools from 1815, they were not yet public "in the modern sense of being fully tax supported, nor truly democratic in the sense of offering education to all young people." [34] In 1826, however, the Free School Society was renamed The Public School Society, and in 1842, when a public Board of Education was established, the schools of the non-governmental agencies or societies which were receiving funds, including those of the Public School Society, were brought under its control. [35] The Society's schools had used Lancasterian methods from its inception, and the system could be observed in general use until 1853, [36] during which time "it virtually monopolized school instruction and became educational dogma." [37]

When the New York schools stopped using the Lancasterian system in 1853, [38] it is said to have been "abandoned throughout the United States." It is not believable, of course, that the system could have been entirely abandoned even in the public schools in New York state, and certainly not in all the schools in the nation, during the course of only one year. Nonetheless, for a combination of reasons the system did fall from its preeminent place in educational boosterism with surprising suddenness.

One of the reasons for the abandonment of the monitorial system, with its hundreds of daily Rewards, was that it was never successfully adapted to small schools. In small classes of children of widely different ages, there were too few pupils at any one level of learning to provide both monitor and a sufficient number of pupils to compete in mastering the lessons. The Lancasterian system had never, therefore, had much effect in smaller schools, especially those in the South and Middle West. When the Eastern states developed their state-wide systems, those state school systems included not only their large city schools, which had been so well suited to the monitorial system, but their small town and rural schools as well.

The problem of adapting the Lancasterian methods to small schools had been raised from the beginning. In 1825 in Connecticut, where there was already a fair supply of Massachusetts district-type schools, the governor told the legislature that he had no doubt that schools on the Lancasterian model ought to be established in areas in which two hundred to one thousand children could be brought together. [39]

Joseph Carrington Cabell (1778-1856), the Virginia state legislator who was the loyal friend and co-worker with Thomas Jefferson in the founding of the University of Virginia, wrote to Joseph Lancaster in 1819 taking up the points he had read in the *Edinburgh Review*: "Beautiful & useful as it [the Lancasterian method] is when applied to schools of a certain size, it is wholly inapplicable to small seminaries; at least it loses all its advantages." In a letter to Lancaster, Cabell pointed out that though it could be

Segment of a large, printed sheet of Rewards, circa 1825 were typical of those awarded to students in the Lancasterian schools. The number of them which were dispersed was enormous, as monitors were instructed to give out hundreds of them per day.

seen to be "immensely valuable in large towns where great numbers can be brought together into one school....the greater part of the population, especially in the Southern section is thinly scattered over a vast extent of territory."[40] And Cabell felt that the value of the Lancasterian system to the nation would depend upon its applicability to small country schools.

Not that Cabell at that time wished to avoid Lancasterian methods. He even suggested that in Virginia they might be willing to consolidate schools to get thirty students if they could, by so doing, use the Lancasterian system. Regardless of how highly recommended or publicized the Lancasterian monitorial system was, Cabell had correctly identified the reasons why the method was not destined to hold sway in *all* American schools. However, although the monitorial aspect of the Lancasterian system was seldom adopted in these small public schools, some of Lancaster's teaching methods and other aspects of his system did become incorporated into schools too small to become true monitorial schools.

One easily adapted part of the system was the continued emphasis on rote memorization, as old as catechetical teaching, and, with the memorizing, the giving of Rewards. Another was the semi-annual "Exhibition" to which the charity schools had energetically dedicated themselves as money raisers and demonstrations of success. In very small schools, the celebration was often adopted not only as a day of public accountability to parents and town officials but also as a celebration carried out according to the social customs of the community.

Throughout the raging popularity of the Lancasterian system in the large city schools, individual teachers in small schools continued to give Rewards according to long established custom in their own particular school or according to their own best instincts. Their Rewards included both the handmade and printed Rewards of Merit usual in small schools, but also the Rewards familiar in Lancasterian schools which, while they were not being used as part of a strict monitorial system, were suitable for their own methods and their own community's smaller schools.

We have heart-warming records of what Rewards of Merit meant to children in the smaller, more isolated schools even when the widely available printed Rewards of Merit, the same ones used in Lancasterian schools, were given instead of more unique ones. Clearly the dissemination of information about the Lancasterian schools and their Rewards, particularly about the Bank of Merit, made its way to a great variety of small city and rural school exhibitions.

As late as 1874, for example, Myra Judd, a student in a small school, wrote a letter to her Auntie Hattie,[41] describing an occasion of immense importance in her life.

I will tell you with gladness that every time that I look up to the wall
that I see the Diplomer which is mine it was presented to me by Mr.
Barnard you must come up and see it, it says

National bank of merit
by this known that in Westhampton
on the 12th of Nov 1872
Myra L. Judd
received this Certificate

having by good Conduct and Lessons has obtained the above number
of shares (that is 2 shares) during the 2 1/2 months of school taught in
the Center of the town Nellie A. Barnard teacher

Even the happiness of the Myra Judds of the world in receiving Rewards in
their own small communities, however, was precarious. The reaction against Rewards
of Merit, particularly in the public schools, built to a crescendo after the middle of the
century. It seemed that just when the Bank of Merit system of Rewards had reached the
smaller schools, the trend toward abandoning Reward giving in the cities was gather-
ing momentum.

The older established schools, the fee-paying schools, and the schools for more
advanced pupils, had also gone through a period of increased emphasis on the giving of
Rewards as the practices of giving thousands of Rewards in the monitorial system had
been growing to its zenith. As the halfway mark of the century passed, however, the
practices of giving Rewards began to be questioned by some of the patrons of all types
of schools. In all cases, the evolution in thinking about Rewards paralleled, and was
affected by, the development of that which may be America's greatest contribution to
the world—a comprehensive system of public schools available to all.

A Reward of Merit given to an adult when released
from the famous New-Gate Prison in East Granby,
Connecticut. One of the staff must have been a
teacher before working at the prison as the
language of the commendation follows exactly that
of a Reward of Merit. New-Gate Prison was operating
between 1773 and 1827. The prisoners were kept in
abandoned underground copper mines, where
no lights were allowed. An Englishman, Edward
Kendall described New-Gate in 1807: "This estab-
lishment, is designed to be from all its arrange-
ments, an object of terror, and everything is
accordingly contrived to make the life endured in
it as burdensome and miserable as possible."

1. Joseph Lancaster, *Improvements in Education, As It Respects the Industrious Classes of the Community, Containing, Among Other Important Particulars, An Account of the Institution for the Education of One Thousand Poor Children, Borough Road, Southwark; and of the New System of Education On Which It Is Conducted*, (London: Darton and Harvey, 1805).

2. Lancaster, Joseph, *No. 1 Manual*, Box 4, Lancaster Manuscript collection, American Antiquarian Society, Worcester, Massachusetts.

3. Caroline Goodfellow, *A Collector's Guide to Games and Puzzles*, (Secaucus, New Jersey: Chartwell Books, 1991), 49-50.

4. Joyce Taylor, "Joseph Lancaster and the Origins of the Lancasterian System of Education with an Introduction," *The Shaker Quarterly* 19, no. 3 (Fall 1991): 76.

5. Taylor, 74.

6. S. J. Curtis and M. E. A. Boultwood, *An Introductory History of English Education Since 1800* 4th ed., (Foxton, England: University Tutorial Press, 1970), 8.

7. Ibid.

8. Taylor, p. 76, quotes Thomas Bernard, *The New School* (1809), "for the general use of slates we are indebted first to Mr. Lancaster."

9. *The Oxford Universal Dictionary*, 3d ed, s.v. "competition."

10. Ellwood P. Cubberley, *Public Education in the United States* (Boston: Houghton Mifflin Co, 1947), 131.

11. Cubberley, 122-125.

12. Lawrence A. Cremin, *American Education: The National Experience 1783-1876* (New York: Harper & Row, 1980), 444.

13. Cubberley, 134. Clinton was U. S. senator from New York from 1806 to 1811 and lieutenant-governor from 1811-1813. He ran unsuccessfully for the presidency against Madison in 1812, and was later governor of New York for three terms.

14. Ibid.

15. De Witt Clinton, "To the Public. Address of the Trustees of the Society for Establishing a Free School in the City of New York, for the Education of such Poor Children as do not Belong to, or are not Provided by any Religious Society," *New York Evening Post*, 21 May 1805, 3, reprinted in Wilson Smith, ed, *Theories of Education in Early America 1655-1819* (Indianapolis and New York: The Bobbs-Merrill Company, 1973), 342.

16. Ibid, 352-353.

17. Ibid.

18. Wilson Smith ed., *Theories of Education in Early America 1655-1819* (Indianapolis and New York: Bobbs-Merrill, 1973), 354-355.

19. Cubberley, 129-135.

20. Eve Thurston, "Ethiopia Unshackled: A Brief History of the Education of Negro Children in New York City," *Bulletin of the New York Public Library* 69: 4 (April 1965), 212. Thurston is here quoting from James Egert Allen, *The Negro in New York* (New York 1964), 11. Mrs. Schuyler Van Rensselaer, *History of the City of New York in the Seventeenth Century* (New York 1909), I, 466. Stephen Jenkins, *The Story of The Bronx* (New York 1912), 96.

21. Thurston, 213.

22. *Minutes of the Common Council of the City of New York* III, 30-31, IV, 51-52, 86-87.

23. Thurston, 214, quoting T. Wood Clarke, "The Negro Plot of 1741," *New York History* xxv 3 (April 1944) 177.

24. Thurston, 211-216.
Since 1703, when the first "catechist to Negroes and Indians," Elias Neau, was sent by the Society for the Propagation of the Gospels in Foreign Parts, the schoolmasters of African-Americans periodically had been attacked as inciters of rebellion.

25. Carleton Mabee, *Black Education in New York State* (Syracuse, New York: Syracuse University Press, 1979), 17.

26. Charles C. Andrews. *The History of the New York African Free-Schools, From Their Establishment in 1787 To The Present Time; Embracing A Period of More Than Forty Years: Also A Brief Account of the Successful Labors, of the New York Manumission Society: with an Appendix.* (New York: Mahlon Day, 1830).

According to Andrews, the African Free School was the second Lancasterian or monitorial school in the United States. See Mabee, 21-23, for a discussion of Andrews' principalship. Some of Andrews' former pupils had great faith in him although he was white "because he was admittedly a thorough teacher, a good disciplinarian, and had faith in the capacity of blacks to learn." Other blacks, however, forced his resignation in 1832 because of his support for the American Colonization Society for American Blacks.

27. Ibid., 17.

28. Ibid., 35.

29. Ibid., 39, quoting *The Commercial Advertiser*, May 12th, 1824.

30. Thurston, 217, quoting *Minutes of the Common Council* xiii, 244.

31. Andrews, 43. The verse appearing under the chapter heading is taken from a very long poem on the Monitorial system, "Lines: On the manner of conducting a Monitorial School," which was spoken by a pupil at one of the public examinations.

32. Ibid., 39.

33. Taylor, 71-72.

34. Smith, 345.

35. Lawrence A. Cremin, *American Education: The National Experience 1783-1876* (New York: Harper & Row, 1980), 164-168.

36. Ibid, 345.

37. Ibid., 346.

38. Carter V. Good, ed., *Dictionary of Education* (New York: McGraw-Hill, 1973), 328.

39. Cubberley, 135.

40. Joseph C. Cabell to Joseph Lancaster, Warminster, Virginia, July 1, 1819, A.L.S., Joseph Lancaster Papers, American Antiquarian Society.

41. Gardiner-Malpa Collection.

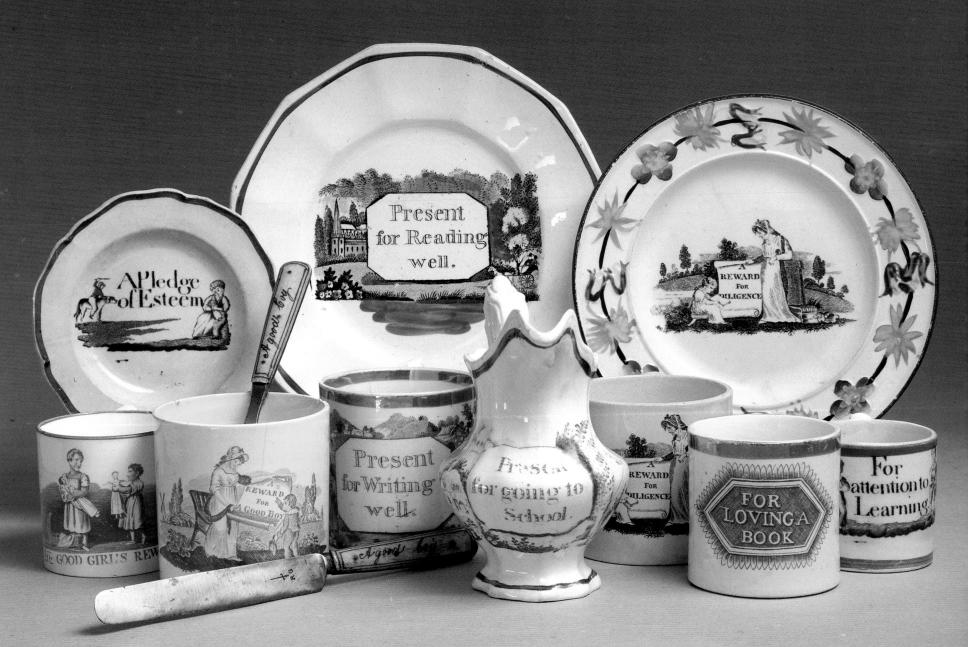

Fig. VI-14

CONTROVERSY—IN PHILOSOPHY AND PRACTICE
Emulation for honor or encouragement for all

Emulation therefore may justly be regarded as the main-spring of life,—as a divine spark, infused by the Creator in the breast of every intelligent being at his birth, which causes him to soar upward and onward, in the career of life.

City of Boston "Report on Medals," 1848

...the practice of offering prizes in our schools, is wrong in tendency, operating mischievously upon the social, moral, and intellectual nature of those whom it is intended to benefit.

The Indiana School Journal, November, 1859

 ineteenth-century Americans were not all frontier settlers nor all urban poor, nor did Sunday Schools and Monitorial Schools satisfy the pervasive longing for more education. As the need for more schools became increasingly apparent it was not the charity schools, established for thousands of poor children, which newly prosperous parents wished their children's schools to emulate; rather they wanted schools which would have the success and prestige of the influential schools of long history.

Some of the earliest schools had not only survived, but had acquired the glory of having been the originals—of having played a part in shaping the nation. The first colonial schools, and the commitment to education which had led to their establishment, were among the most enduring legacies from the pre-revolutionary era. It was those "prestigious" schools, and those established in the eighteenth century in imitation of them, which many wished to imitate as new American school traditions were created. And these older schools were also beginning to have ever grander Exhibition Days and School Festivals with important end-of-term Rewards presented during the ceremonies.

For the grammar schools, the inspiration for the grander Exhibition Days may have been a desire to elaborate on the sixteenth-century "disputation" days, but there were more recent influences for the early nineteenth-century enthusiasm for awards

129

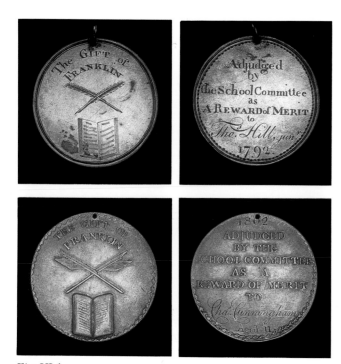

Fig. VI-1

and ceremonies. In the late seventeenth and eighteenth centuries, the practice of awarding distinctions, badges, and particularly medals, usually on ceremonial occasions, had become an increasingly frequent part of European civic life. Colonial governments also, under British governors, had given out medals, rewards and privileges, and many colonials had rushed to be included. Furthermore, it was not just the colonists who participated. When a peace treaty was concluded with an Indian tribe, the British gave peace medals bearing the King's image to the tribal chief.

In the light of this growing trend, there was, after the Revolution, an understandable desire for the United States and its institutions to take their place as the givers, not just the recipients, of honors, prizes, and medals. America too had events to commemorate, accomplishments to recognize, leaders to honor, and treaties to verify. Furthermore, for both adult society as well as school children, to encourage emulation of those who were the most accomplished was considered one of the most effective ways to nurture a moral populace and its future leaders.

The Gift of Benjamin Franklin—School Medals

The new nation had a preeminent leader, Benjamin Franklin (1705-1790), who had been a participant in the ceremonial giving of honors to an extent equaled by few who were not of royal birth.[1] Franklin's experiences in the scientific and diplomatic circles of England and France led him to view the giving of medals and prizes as a part of civic life. The much honored Franklin, the quintessential American and defender of Republicanism and Democracy, regarded the giving of medals as a custom appropriate to a new democratic Republic in which the giving of hereditary titles and honors was not acceptable. It was Franklin who, through a bequest to the city of Boston, introduced the giving of medals into the public schools of the United States, and with these medals also increased the importance of the annual Exhibition Days at which they were presented. While his gift of medals may only have been a footnote to the remarkable accomplishments of his lifetime, it was of considerable importance to the on-going discussions and evolution of American pedagogy.[2]

In his will, Franklin stated:

I was born in Boston, New England, and owe my first instructions in literature to the free Grammar Schools established there, I therefore give one hundred pounds sterling to...(be) put out to interest, and so continued at interest forever, which interest annually shall be laid out in silver medals, and given as honorary awards by the directors

of said free schools, for the encouragement of scholarship in the said schools...[3]

Franklin was particularly grateful for the opportunities which had been opened to him by the education he had received in America's first school, the Boston Latin School, established in 1635. It was a gratitude which is all the more noteworthy because of the very short time he had been allowed to attend. His father, who was "unable without inconvenience to support the expense of a college education," gave up his first intention that Benjamin should become a minister, took him from the grammar school, and sent him to a school for writing and arithmetic. Franklin, who could not remember when he did not know how to read, still remembered at the end of his life that during his one year of grammar school in 1714, he rose "gradually from the Middle of the Class of that Year to be the Head of it, and farther was remov'd into the next class above it, in order to go with that into the third at the end of the year." Franklin's stay in the reading and writing school was also short; he had entered the grammar school at age eight and left the reading and writing school at age ten to assist his father in his business as a tallow chandler and soap-boiler.[4]

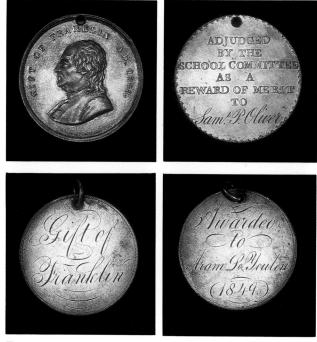

Fig. VI-1

In the years which later generations would spend in finishing high school and college, Franklin, with very little formal education, became one of the most highly educated men of his generation—through self education. Apprenticed to his brother James, a printer, when he was twelve years old, he borrowed books to read, entertained himself by writing imitations of London *Spectator* essays, and wrote and printed his own broadside ballads. By the age of fifteen he was also writing the Silence Dogood essays for his brother's *New-England Courant* newspaper, the first newspaper to feature humorous essays and other literary pieces.[5]

Franklin, throughout his adult endeavors as a writer, philosopher, and scientist, maintained an interest in how and what people learned and what might best be taught in schools. He gave considerable thought to the need for an education which would complement that of the Latin grammar schools with more practical instruction, and also to the problems brought about when the private schools, which often did offer more practical courses, vanished when the one teacher whose school it was, could not, or did not, continue teaching.

In 1743, he first drafted a plan for an academy at Philadelphia. The academy would offer, in a permanent building, more practical studies as well as those studies of the Latin grammar schools. He published his *Proposals Relating to the Education of Youth in Pennsylvania* in 1749, in which he set forth a curriculum based on the writings of six authors on education including Milton and Locke.[6] The proposal came to

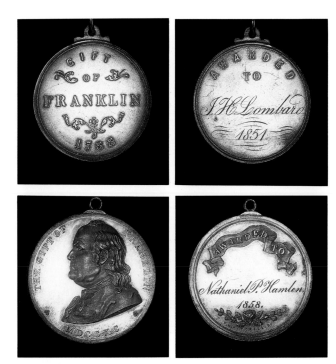

Fig. VI-1

fruition, however, only after he had turned over the care of his printing house to his partner, David Hall, having

> flatter'd myself that, by the sufficient tho' moderate Fortune I had acquir'd, I had secur'd Leisure during the rest of my Life, for Philosophical Studies and Amusements; I purchas'd all Dr. Spence's Apparatus, who had come from England to lecture here; and I proceeded in my Electrical Experiments with great Alacrity; but the Publick now considering me as a Man of Leisure, laid hold of me for their Purposes...[7]

The first "publick purpose" was the Academy. Franklin appealed for subscriptions for the proposal "of some publick-spirited Gentlemen," (some of whom were, in fact, members of Franklin's debating club, the Junto), and the subscribers then chose twenty-four Trustees. Nonetheless, it fell to Franklin even to superintend the renovations of the premises, which "I went thro'...the more chearfully, as it did not then interfere with my private Business."

Like many academies and seminaries, Franklin's was intended to serve the younger pupils as well as the older ones in the "Academy and Charitable School in the Province of Pennsylvania." Five years after its opening the Academy was chartered as "the College, Academy and Charitable School in the Province of Pennsylvania," the constitution of which provided for two schools, a Latin school and an English school. In 1779 the more advanced segment of Franklin's venture was reorganized into the University of the State of Pennsylvania.[8]

Franklin's original idea was to begin with pupils who had only been taught to "pronounce and divide the Syllables in Reading, and to write a legible Hand."[9] For these pupils Franklin specifically describes the use of Rewards and of "Publick Exercises" in a manner reminiscent of the earliest schoolmaster's manuals. Spelling, he suggests, is

> best done by Pairing the Scholars, two of those nearest equal in their Spelling to be put together; let these strive for Victory, each propounding Ten Words every Day to the other to be spelt. He that spells truly most of the other's Words, is Victor for that Day; he that is Victor most Days in a Month, to obtain a Prize, a pretty neat Book of some Kind useful in their future Studies.

In the third class, in their reading of history

> Let Emulation be excited among the Boys by giving, Weekly, little Prizes, or other small Encouragements to those who are able to give

the best Account of what they have read, as to Times, Places, Names of Persons, etc.

In the Sixth Class

Once a Year, let there be publick Exercises in the Hall, the Trustees and Citizens present. Then let fine gilt Books be given as Prizes to such Boys as distinguish themselves, and excel the others in any Branch of Learning; making three Degrees of Comparison; giving the best Prize to him that performs best; a less valuable One to him that comes up next to the best; and another to the third. Commendations, Encouragement and Advice to the rest; keeping up their Hopes that by Industry they may excel another Time. The Names of those that obtain the Prizes, to be yearly printed in a List.[10]

In 1753, after getting the Philadelphia Academy underway, the second of his intentions for his life of leisure—to proceed "in my Electrical Experiments with great Alacrity"[11] —led him indirectly to his first experience in the medal-giving ceremonies of England. He sent his first accounts of electrical experiments to his friend, Peter Collinson, who had previously sent Franklin a pamphlet about German experiments in electricity together with a glass tube for the experiments. Collinson had Franklin's accounts read at the Royal Society for Improving Natural Knowledge in London. Although his reports at first elicited some laughter, his experiments with electricity eventually won him not only respect of scientists in England and on the continent, but also led to his election to the esteemed Royal Society. The Society also presented Franklin with a medal of Sir Godfrey Copley for the year 1753 "the delivery of which was accompanied by a very handsome speech of the president, Lord Macclesfield, wherein I was highly honoured."[12]

From 1757 to 1785, Franklin's life was spent more in Europe than in the United States. He was in England between 1757 and 1762 as the agent for Pennsylvania; in England from late 1764 to early 1775 as the agent of Pennsylvania, Georgia, New Jersey, and Massachusetts; and in France from late 1776 to May 1785, first as a commissioner to France from the Continental Congress, and, after Independence, as the Minister Plenipotentiary from the United States. He was not only officially a government representative and negotiator, he was regarded in social and scientific circles as the preeminent American. In all of these roles, he participated in the many ceremonies which accompanied a public life in Europe; indeed he had more occasion to participate in European ceremonial occasions than did all but a very few

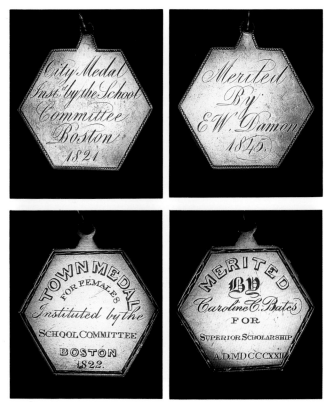

Fig. VI-2

133

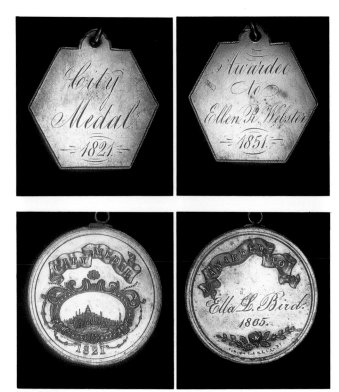

Fig. VI-2

Europeans. Among the occasions of his first years was the coronation of George III, which he attended in 1760.

Franklin's experience of ceremonial occasions, however, was unlike many of those of previous generations which had been associated with royal prerogatives and hereditary privilege. They included a remarkable number of occasions on which he was awarded honorary degrees[13] or was given membership in the Scientific Societies of European countries. Furthermore, he was intimately involved in both the practical and philosophical aspects of political independence while at the same time being immersed in the culture of England and France, the countries with which he was negotiating. For Franklin, ceremonial occasions and the giving and receiving of honors and awards were an accepted part of the life of a celebrated man, not a means to advancement or a change in style of living. Throughout his public life he remained an active scientist and also maintained his printer's interest in the graphic arts while he was fulfilling his diplomatic duties.

In the fateful year of 1776, when the Continental Congress ordered, in January, new designs for fractional dollars, Franklin applied his considerable experience and talent as a printer and designer to the creation of the "Fugio" design with thirteen linked circles which was later used on the first United States coin, the Fugio cent of 1787.[14]

While in Paris representing the newly independent nation, Franklin quickly became aware of the great popularity there of medals and medallions.[15] Even though it was in Italy that medals had returned to fashion during the Renaissance, by the time Franklin arrived in Europe, France was becoming the leader in producing medals of artistic merit.[16]

Franklin described in 1782 a medal he "had a mind to strike" (the Libertas Americana Medal) in honor of France's aid to the Americans in the victories at Yorktown and Saratoga. This medal was to represent

...the United States by the figure of an infant Hercules in his cradle, strangling the two serpents; and France by that of Minerva, sitting by as his nurse, with her spear and helmet, and her robe specked with a few fleurs de lis[17]

Franklin arranged for the striking of the medal, which was engraved by Augustin Dupré in France, and then, with the concurrence of Congress, used it for diplomatic purposes. At the same time, he also arranged for one ordered by Congress (engraved by Pierre Simon Duvivier, another of France's preeminent medal engravers), to honor a Frenchman, Lieutenant-Colonel François Louis Teisseidre de Fleury, for gallant conduct with the Continental Army at the battles of Fort Mifflin,

Brandywine, and Stony Point. Both medals were, in fact, ready before the first medal voted by Congress in 1776—to honor George Washington—was struck.[18] Franklin presented the medals in gold to the King and Queen and in silver to each of the ministers "as a monumental acknowledgment, which may go down to future ages, of the obligations we are under to this nation." Franklin notes that "It is mighty well received, and gives general pleasure."[19] In July of 1783, Franklin was also referring to the Libertas Americana Medal when he spoke of having made the "Grand Master of Malta a Present of one of our Medals in Silver."[20]

Franklin thus had considerable experience with the part which "publick exercises" and the giving of prizes, honors, and medals were playing in civic life, before he wrote his will which introduced the giving of medals in the free schools of Boston.[21]

Though Franklin may have remembered his time at the Latin School most fondly, his bequest was clearly made for use in all of the "free schools," seven at the time of his bequest, which included three reading and three writing schools. And it was the practical administration of those medals which, unintended, disseminated the prestige and customs associated with the Boston school medals to the schools of many more communities. A city-wide committee, not merely one teacher, was needed to select among students who had been taught by different masters in several schools. Decisions and carefully considered regulations were made by the Boston School Committee for all of the Boston schools—decisions which less expensive paper Rewards of Merit, bought or handmade, and given at the decision of one teacher, in one school, had never required.

By deciding the procedures for awarding the Franklin Medals and incorporating them into their public records, the decisions of the Boston School Committee resulted in a kind of "institutionalization" of both the educational philosophy behind their use (emulation) and of the procedures for selecting the recipients. Other school systems, when deciding to introduce end-of-the-year awards, found it natural to look for guidance to the regulations made by that first Boston Committee.

The subcommittee of the Boston School Committee which dealt with the Franklin Medals established the rules for selecting the recipients, and recommended that, with the funds available for twenty-one medals, three medals should be given to each of the seven schools (Fig. VI-I). The rules were

> (1) They were to be given only to boys, (2) no boy who had received a medal in one school could be considered a candidate in another, and (3) twenty of the best boys in the upper class were to be examined by the sub-committee and the medals bestowed according to the results.

Fig. VI-3

Fig. VI-4

Fig. VI-4

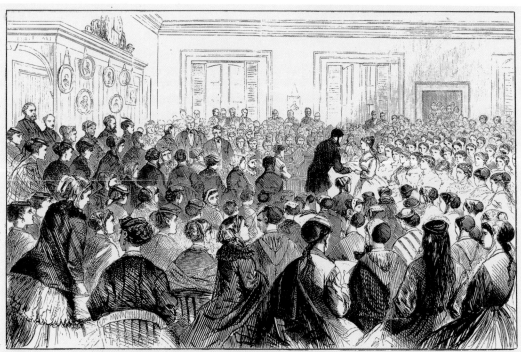

PRESENTATION OF THE "KELLY MEDAL" AT THE PUBLIC GRAMMAR-SCHOOL No. 45, NEW YORK CITY.
[SKETCHED BY STANLEY FOX.]

Fig. VI-5

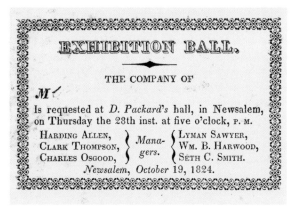

Fig. VI-6

The decision that the Medals would not be awarded to girls was not because Franklin so specified, but because girls were not in school when Franklin was a pupil. Indeed, girls were not admitted to the public schools until the year of Franklin's will. Changes in regulations were considerably more difficult to bring about than making the original ones and, in 1821, rather than attempting to change the rules for the Franklin Medals, a special award for girls, The City Medal, was introduced [22] (Fig. VI-2).

The stipulation against receiving two medals was because the same boys usually attended a writing school one half-day, and a reading or grammar school the other half; and some attended the Latin grammar school after completing the more elementary English grammar, and reading and writing schools. They therefore were required to elect, or their masters to elect for them, in which school they would compete for the medal.

The Medals were awarded at the Annual Exhibition Day (Fig. VI-3). The Franklin Medals hung from a light blue neck ribbon and the later City Medals hung from a white neck ribbon in a manner also reminiscent of adult medal-giving ceremonies.[23] Medals for the years 1792 to 1800 were engraved, but the medals after 1800 were struck from dies which resembled the designs of the first ones. The words on the Medals were, "Adjudged by the School Committee as A Reward of Merit to ." That phrase, "A Reward of Merit," appeared on the medals until 1851 when new dies were made. The first obverse designs were the device of crossed pens above an open book, and for the Latin school, a stack of books below the Latin inscription "Detur Digniori" (Let it be given to the most worthy). It was not until around 1830 that the bust of Franklin appeared on the Medals.

Exhibition Days – Variety in Rewards from a Diversity of Schools

The annual awarding of the Franklin Medals also gave more publicity to, and set more precedents for, the annual School Festival (Fig. VI-4) or Exhibition Day itself. As the established schools put more emphasis on these celebrations, the charity schools inaugurated their own, and the cities came to regard the ceremonies as a demonstration of civic accomplishment. Both "Exhibition Days" at which the Medals and other end-of-term Rewards were given, and city-wide School Festivals in honor of all those who were graduating became regular events in many cities. They became more elaborate and more important to civic pride as the number of pupils steadily rose and as they slowly evolved into what in many places would eventually be called "Commencement" exercises. By the late 1860s in Boston and New York they had become truly memorable civic occasions.

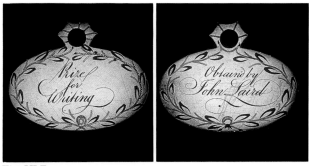

Fig. VI-7

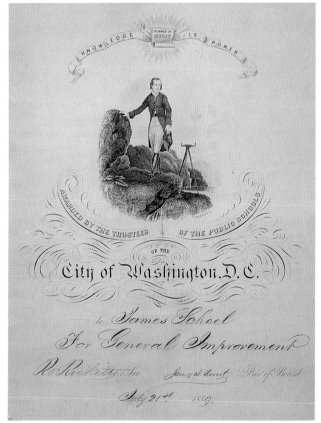

Fig. VI-8

Fig. VI-9

Fig. VI-10

Fig. VI-11

A story in *Harper's Weekly* in 1868 about the giving of the Kelly Medal at the Public Grammar School No. 45, begins with the sentence "The public Schools of New York City are acknowledged to be the most excellent in the world" and continues in the tone of a Chamber of Commerce publicity release (Fig. VI-5). In Boston in 1869 at the School Festival, the Mayor gave each graduate a bouquet in a ceremony "enlivened by music from the orchestra, followed by refreshments, followed by promenading and dancing in the hall."[24]

It was these large public school occasions, particularly the very large gatherings of the latter part of the century, which made the school celebrations famous. Such events, including the school dance or ball, however, were also common in New England at private schools and academies from the first part of the century—a time when dancing was also a widely accepted part of everyday life. In her diaries Margaret Hall, a visitor to the Eastern seaboard in 1827, discusses some such occasions which were the predecessors to the later celebrations. She describes an endless succession of balls in Boston and New York. She remarked that she felt in danger "of being danced to death in this [area of the] country where even the professors join in the amusement" (Fig. VI-6).

The increase and elaboration of these end-of-term celebrations also eventually affected the terminology of Rewards of Merit. There may have been schools in which the end-of-term awards were the only ones given, but in most schools other kinds of awards—handmade or printed, paper or more substantial—continued to be given throughout the term. The terms "Prize" and "Reward of Merit" had occasionally been used interchangeably, but Exhibition Day Rewards of Merit, which included objects of some value as well as paper certificates, began more frequently to be referred to as prizes (Fig. VI-7) in order to distinguish them from daily classroom Rewards. It was also not unusual, however, for the recipient of an end-of-term medal or prize to be determined by the greatest number of previous, smaller Rewards received. All were, nonetheless, in all senses, Rewards of Merit, and a great variety of awards can be found bearing the words "Reward of Merit" (Figs. VI-8, 9, 10).

Special funds for appropriate special gifts, gifts which were more "important" as end-of-term awards, were increasingly sought. Though many public schools or underfunded struggling private academies found gold or silver medals and other more costly awards an unaffordable luxury, the provision of such medals and prizes became a favorite philanthropy for "leading citizens" (Figs. VI-11, 12).

These Exhibition Days also opened the way for a variety of other new kinds of Rewards. The variety of objects given as school Rewards included books, pens, mugs, plates, or objects made especially for the school and the occasion. One of the oldest of the traditional Rewards, one which never waned in popularity, was the Reward book.

Such Rewards were usually a commercial edition of a book chosen by a teacher but, in some schools, the book was bound in fine leather with elaborate embossing and inscriptions (Fig. VI-13).

China mugs and plates with messages or illustrations printed on them, often given to the younger children, became especially popular. Special occasion or Reward pottery was a lesser part of English "commemorative pottery" produced for the celebration and remembrance of specific occasions, particularly of events which the whole nation wished to celebrate or mourn.

The production of English commemorative pottery began during the decades of the colonization of New England and, because the pottery pieces celebrated important events, they, like medals, were associated with honors given to adults.[25] Of significance for Americans, it was during the years of George III, the king who reigned as America achieved independence, that the production of ceramics became one of England's first great industrial accomplishments.

The making of earlier commemorative pottery, produced long before mass-production techniques were possible, had well established the custom of incising or adhering all sorts of mottoes, verses, admonitions, and designs, on the pottery. "Applied" or brush painted decoration had been possible from the 1730s, but the output had still been limited to the individual work of a few men. In the 1750s, however, design printing on china became possible after a potter of tin-enamelled earthenware succeeded in his quest for a way to transfer designs to china. Working with a mezzotint engraver, who created a suitable copper plate for holding the paint, and a merchant stationer, who produced a usable transfer paper, "the Art of Printing Earthen Ware with as much Beauty, Strong Impression, and Dispatch as it can be done on paper"[26] was perfected. This enabled the potters to use the smooth curved ceramic surface for engravings and text copied from all kinds of printed materials. Since George III began his reign and was married in 1760 just after this transfer printing onto pottery had been developed, commemorative china celebrating his life flooded the English market from the first year of his reign.

Improvements in the composition of English earthenware were made throughout the eighteenth century by such men as Josiah Wedgwood and Josiah Spode. By the beginning of the nineteenth century, the English china manufacturers were ready to flood the American market with china sturdy enough to withstand exporting, cheap enough to be afforded, and appealing enough to be bought with great eagerness.[27]

Among the most popular exports to the American market was English Yellow-Glazed Earthenware, a type of creamware or pearlware[28] characterized by an overall yellow glaze which had been used "since time immemorial."[29] The transfers on the yel-

Fig. VI-12

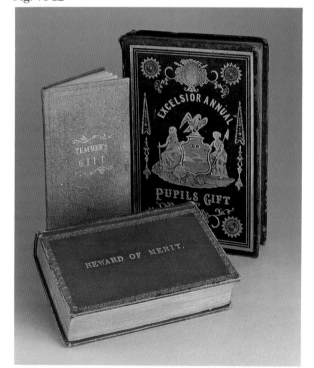

Fig. VI-13

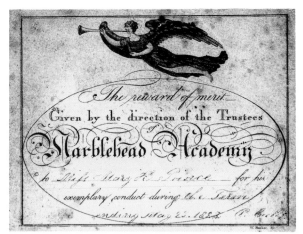

Fig. VI-15

Broadside with wood engraved illustration, dated 1840. Teachers and sometimes clergy would establish fee-paying boarding schools where they would double as instructors and substitute as parents to students who came from considerable distances to attend.

low ware which was shipped to the United States not only included religious admonitions, verses of obedience to parents, sayings from Poor Richard's Almanac, lines from Isaac Watts, illustrations from children's books, lines from first readers, and alphabet designs, but they also bore simply the words "Reward of Merit."[30] Unfortunately, because the finished ceramic surface could not be written on by the teacher or by a visiting benefactor, it is usually impossible to identify these Rewards with specific pupils, teachers, and schools without corroborating written evidence. This is true not only of mugs[31] and plates, but also of the kites and other toys of the kind mentioned by Lancaster in his lists of Rewards. All, even those with mottoes such as "Present for Reading Well," might have been given by parents, particularly parents who were still fulfilling their historic responsibility to teach their children to read before sending them to any school.

Whether given by a teacher at school, or a parent at home, however, the mugs, plates, and other china Rewards were undoubtedly particularly valued because they publicly displayed the approbation which the child had received. Most homes had at least a shelf on which the family's more valued dinnerware and mementoes were displayed; to have a Reward of Merit mug on that shelf reminded all visitors of the honor. The younger children thus had a Reward which could give them the same feeling of special accomplishment as did medals to their siblings (Fig. VI-14, page 128).

George III was a patron of Joseph Lancaster's schools, and one of the last commemoratives of his reign is thought to have been made for the pupils of the Lancasterian schools. The transferred illustration of a bowing child receiving a book from George III bears the motto, "I hope the time will come when every poor child in my dominions will be able to read the Bible." The plates, printed either in blue or more rarely in a "Pratt palette" of three colors, are presumed to have been issued in 1820 to be distributed as a commemoration of the King's death.[32]

During the first half of the century, when the Exhibition Day celebrations were gaining in popularity and Reward mugs were introduced, the great state public school systems were only slowly becoming fully established. In the largest cities, fee-paying schools emerged to offer instruction which would fill gaps in the curriculum of existing schools, while in the more rural areas, seminaries, academies (Figs. VI-15, 16), and institutes (Figs. VI-17, 18) were often established as boarding schools to meet the needs of families scattered over a wide area. Some of these institutions were intended to exist only until free public schools became fully available. Others, whose founders had intended them to be permanent, did not survive bad management, lack of sufficient funding, and years of unpredictable enrollment. Those which did survive often originally intended to, and did, adjust their curriculum and purposes as the educational

needs of their area changed. Some remained high school level boarding schools; a few continued to offer special courses (particularly in business or art); and others, after a period with both preparatory departments and collegiate courses, became four-year colleges. These schools also had their Rewards and Exhibition and Festival Days shaped by their own circumstances and the desires of the community.

A somewhat unusual example of the giving of Rewards among the high school level boarding schools are those of

Mrs. Okill's Female Boarding School
In the City of New York

For eight years, Miss E. A. Townsend attended this school, and in each of those years except the first, she was the recipient of a steady flow of Rewards of Merit. Between 1828 and 1836 Miss Townsend saved seventy of the Rewards she received. On them Mrs. Okill wrote, above her signature, the reason of each presentation:

> ...for good conduct during the last six weeks
> ...for correct deportment during the past fortnight
> ...for correct recitation in French
> ...for excellent recitation in French
> ...for having passed an excellent review

On a few, there is, however, different language.

> Miss Townsend has had the honor of drawing for the French Gold Medal, having by her excellent review obtained the head of her class.

It seems that upon meriting enough honors, the best scholars could draw for medals for specific subjects. Should the scholar not be lucky enough to draw the winning ticket with the words "Gold Medal," she would instead receive a paper Reward acknowledging her achievement:

> Miss Townsend has drawn for the French Medal but fortune has not decided in her favor.

On other occasions when Miss Townsend did not win the valued prize, she did receive yet another form of a Reward, one on which was printed

> This is considered equal to the Gold Medal to obtain which requires excellence during four weeks.

All of the Okill/Townsend Rewards are printed in either orange, blue or black ink and are illustrated and typeset with wood engraved blocks (Fig. VI-19).

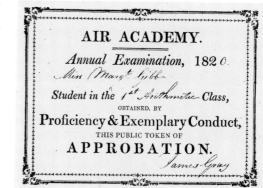

Fig. VI-16

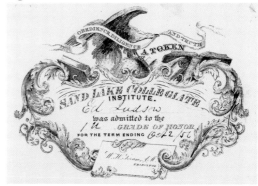

Fig. VI-17

Fig. VI-18

141

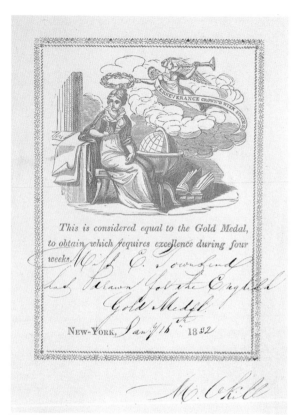

This is considered equal to the Gold Medal, to obtain which requires excellence during four weeks. Miss E. Townsend has drawn for the English Gold Medal.

New-York, January 16th 1832

M. Okill

Fig. VI-19

At the end of Miss Townsend's scholastic career at Mrs. Okill's School, an eight year course of study, she received a most unusual "Testimonial" (Fig. VI-20). This prize is a fancifully gold stamped and personalized black leather case which contains, under glass, a copperplate engraved coated stock card Reward printed for this special event.

Like Mrs. Okill's Female Boarding School, many of the various institutions, particularly on the East Coast, not only had their own kinds of celebration days, they also offered rewards, medals, and prizes in their prospectuses from the time of their founding as an incentive for enrollment. In schools serving small towns having widespread rural populations, on the other hand, the practice of giving more costly awards, including medals, often came later, both as an indication of increased prosperity and as an affirmation of a dedication to scholarship and high standards.

The Chauncey Hall School, established in Boston in 1820, was an example of a school first established to supplement the curriculum of the older city schools. It also provides an example both of the assumption that medals should be part of a school's program—whether in a charity school or in a much smaller, fee-paying school—and that medals need not be given for succeeding in a competition against other pupils.

At the time the Chauncey Hall School was established, the Boston Latin School still taught little more than Latin, Greek, and mathematics. The English grammar schools, which corresponded approximately to Junior High or Middle Schools and were attended by "the great body of the youth of the city,"[33] offered English and commercial education. The public schools for young children, called primary schools, were just "struggling into existence,"[34] and the first one opened the same year as the Chauncey Hall School, 1819-20.

The prestigious Latin School had morning sessions, then dismissed the pupils to go home to dinner and expected them to return for more instruction between 3 and 6 p.m. The Chauncey Hall School was at first an "intermediate" school which, between the Latin School's two sessions, provided instruction in reading, spelling, and other subjects not offered in the Latin School.

By 1831 the Chauncey Hall School had become fully recognized in its own right, and both semi-annual exhibitions and a medal system had been instituted. The medals (Fig. VI-21), beginning with a single gold medal in 1830, were never awarded in a competition for the highest rank in class, but rather were awarded for coming up to a certain high standard in both lessons and conduct, and an increasing number were awarded yearly as more pupils came up to that standard. Gradually more medals were given and different grades of both gold and silver medals were awarded to as many candidates that came up to prescribed standards in specified lessons.

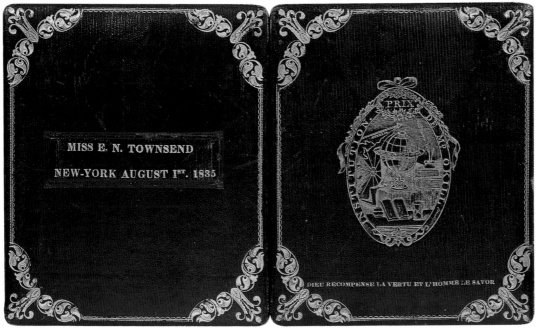

Fig. VI-20

Fig. VI-20

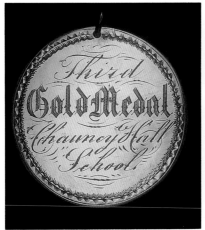

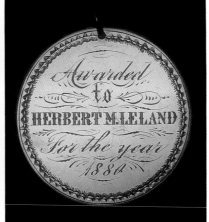

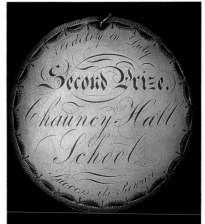

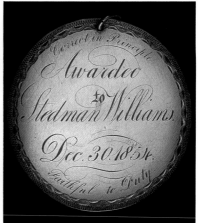

Fig. VI-21

Fig. VI-21

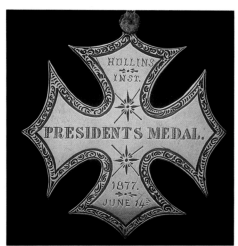

Fig. VI-22

Fig. VI-23

While the Chauncey Hall School originally supplemented the curriculum available in a city, the Roanoke Female Seminary in Virginia was among the many seminaries, institutes, and academies established to provide a higher education than was then easily available elsewhere for the pupils it served. It is an example of a seminary with a decidedly rural history, and one which matured into a twentieth-century college. From Roanoke Female Seminary (1838), to Valley Union Seminary (1843), to Hollins Institute (1855) to Hollins College (1910), the present distinguished college had a history during its Seminary and Institute days of struggles and successes quite unlike those of the schools of the Northeastern United States. For Hollins, the tradition of awarding medals came relatively late.

The first Seminary on its site was for women only, but when it became the Valley Union Seminary (1843), it admitted both men and women. It did so then under "The Valley Union Education Society of Virginia," the word Union connoting nonsectarian (as were the Sunday School Unions), and, in this case, co-educational (though, as customary, in separate classes). Unfortunately, the principal advocate and director of the Seminary found that he could not manage the young Virginia males. The most high spirited of those youths brought firearms (which were strictly forbidden), fought with drawn knives, and killed ducks or chickens to roast in their cottage fireplaces.[35]

These difficulties, combined with "the necessary confinement of the female scholars in a mixed school [which was] altogether incompatible with comfort and health," caused the principal and trustees to revert to an all-female institute in 1852. They were determined to give to women a curriculum and instruction calculated to discipline the mind, and "to give vigor and expansion to all its powers."

Through the remarkable, and remarkably long, leadership of Charles Lewis Cocke and his family, the Institute endured through constant hardships. Through the sudden change of currency in 1856 (which caused the loss of both the board's money and also of the private funds of the institute's principal benefactor), through the deaths of students in epidemics of typhoid fever (1856-57) and pneumonia (1867), through the Civil War and, with even more difficulty, through the Reconstruction period, Hollins Institute continued to graduate students. Though the War did not come on the campus, commencement in 1863 was interrupted by the news of the Yankee burning of Salem from which smoke was visible.[36]

It was during 1870, a year when the rigors of Reconstruction were still upon them, that the Hollins Board decided to confer gold medals at the close of each session—the President's medal for scholarship, a medal for a literary composition, and one for excellence in music.[37] The medals were clearly associated with a determination to

emphasize the high standards of scholastic achievement for which the institute was, and increasingly wished to be, known. The medal illustrated (Fig. VI-22) is from 1877, a year when there were more than usual students from outside Virginia "because Virginians were impoverished" and supplies and amenities were scarce.

Throughout the century, Exhibition Day and School Festival announcements, surviving Rewards, and occasional letters from parents testify to the importance which schools and parents placed on the giving of Rewards.

Correspondingly, the honor of being on a school visitation committee grew in visibility and importance as the number of schools, pupils, and Exhibition Days increased. Those legally responsible for the schools—the benefactors and officers of charity societies who heard recitations of the charity school pupils, and the selectmen or school committee members who attended the examinations for the public schools—were increasingly seen as people of great civic stature.

A printed invitation of 1821 (Fig. VI-23) presented by the selectmen with respectful compliments to William Barry, Esq., requests his accompaniment at the visitation of the Boston Schools. Not only was the occasion one of civic responsibility, it apparently also served as a significant social occasion for the visitors. The invitation informs Barry that:

The Exercises will Commence as follows.
ELIOT, FRANKLIN, AND MAYHEW SCHOOLS, AT 8 O'CLOCK A.M.....BOYLSTON, ADAMS, AND DERNE STREET AT 10:30 A.M.....LATIN SCHOOL AT 1, P.M.

THE INVITED GUESTS

Will assemble on the Lower Floor of the Latin School House, and move in procession from thence to dinner, at FANEUIL HALL, at half past three o'clock, precisely.
Boston, August 17th, 1821.

These were the visitors for whom the "Exhibitions" were officially made, who reported on the state of the schools, and, who presented Rewards. In the case of the charity schools they were also usually benefactors. As in Boston, records of the school committees of both public and private schools sometimes interestingly illuminate the local history of the exhibitions and the giving of the specific medals (Fig. VI-24).

The paper Rewards of Merit and other school ephemera which refer to those prizes also frequently add to our understanding of their use. Among the ephemera of private schools in the Gardiner-Malpa Collection is a beautifully hand-written Reward

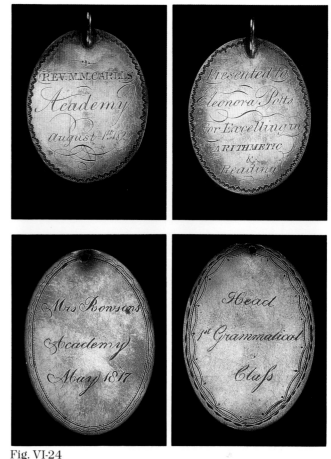

Fig. VI-24

Above—A silver medal given at the Rev. M.M. Carll's Academy in August of 1829. It was "Presented to Eleonora Potts for Excellence in Arithmetic and Reading."

Below—A silver medal given at Mrs. Ronson's Academy in 1817 for being "Head—1st Grammatical Class."

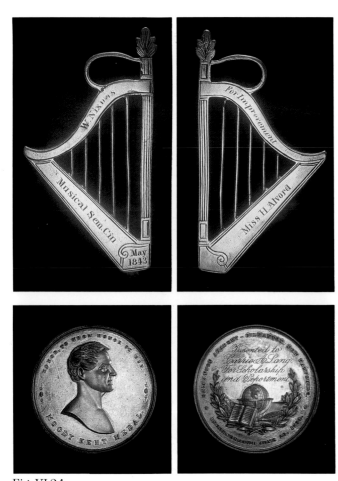

Fig. VI-24

Above — An unusual form for a Reward. This silver medal, dated May 1843, is from W. Nixon's Musical Academy at 4th and Walnut Street, Cincinnati, Ohio.

Below — This Moody Kent Medal was given for Scholarship and Deportment at the Gilmanton Academy in New Hampshire. It was most likely struck for the school by the United States Mint. Circa 1850.

of Merit, given at Miss Guliker's School on Cambridge Street, Boston, two years before the Chauncey Hall School was established. Miss Guliker's school combined needlework with study. It announced a

Prize
Given to Miss Blanchard
for
attention to Study, Needlework, etc.
with obedience & amiable Deport-
ment during her last Quarter
at
Miss Guliker's School
Cambridge Street, Boston
January 20, 1818

An 1826 broadside prospectus for the Germantown Academy near Philadelphia, includes the information that "*public examinations* shall take place, and a distribution of suitable premiums"[38] shall occur.

Mrs. Fritz's "Boarding and Day School for Young Ladies, at Brookline, Mass." in its fifth year in 1857, devotes twenty percent of its prospectus to informing prospective clients that

At the close of the session, a prize of a gold medal will be awarded, by a vote of the school, to the pupil whose example of fidelity and general good conduct is deemed most worthy of imitation. The Principal will also award prizes to young ladies having perfect reports throughout the year.[39]

As late as 1876, Miss Putnam's English, French & German Family and Day School, in Boston, informed prospective parents and students that "A gold medal will be awarded to each pupil who shall remain to complete the entire course contemplated by the school." It is a curious offering, because by 1876 the public schools had been giving beautifully-printed diplomas at their end-of-term Exhibition Days; yet this is an appeal to the era when, in many schools, if one did not receive some kind of Reward of Merit, there was no evidence of ever having attended.

Opposition to Rewards

The giving of Rewards of Merit in American schools did not gradually diminish as pedagogical fashions changed; rather Rewards had begun to generate controversy as their importance had grown. As the patrons of different schools in different locations began giving medals, school records give evidence of an on-going struggle with the phi-

losophy underlying the giving of awards. Some had prizes clearly based on a competition to be named the one "best" student; others went to great lengths to establish the giving of Rewards but not to engender the competition of one student against another.[40]

In 1848, Abbot Lawrence, at the request of B. A. Gould, the head of the Public Latin School, contributed $2000 for prizes (medals) for accomplishment in specific subjects of study, but a portion of the money was to be given as a

> reward of those whose industry and diligent application manifest a desire to improve, though the least gifted by nature; and also a portion for good conduct in general, embracing moral rectitude and gentlemenlike deportment.

The prizes were distributed in both the Latin School and English High School, and in 1858, Thomas Sherwin reported that forty or more medals were distributed in each year in the English School alone.

As fee-paying schools closed when public schools became available, recurring controversies were common over what the public school policy with regard to Rewards should be—especially whether giving Rewards to only a few pupils was appropriate in a democracy. The argument erupted particularly early, forcefully, and publicly, in Boston—over the Franklin Medals. The discussions in Boston may have been local, but they presaged the arguments which would become much more strenuous towards the latter part of the century in school board and parents' meetings across the country.

The first agonizing reconsideration of the giving of the Medals came in 1838 when the Boston School Committee addressed themselves to the evil of the "present system." After five pages of reaffirming the reasons for giving Rewards—including the argument that "A system of government by rewards and punishments seems to be in accordance with ascertained principles of human nature"—the Committee addressed what they saw as the problem with their system: the examination.

> The Committee have seen with regret the intense excitement and painful tension of feeling to which the candidates for the medals are wrought up, as this examination comes on. The children evidently feel that much depends upon the hazard of a die, and hope with trembling. An excitement of this kind is, in the opinion of your Committee, hurtful to the mind and to the affections. If a child does not appear so well as usual, and sometimes the most meritorious fail from that modesty which often accompanies true worth, much suffering is the result. If the same child expected a medal, and fails to get one, the disappointment both to child and parent is extreme. The Committee have heard

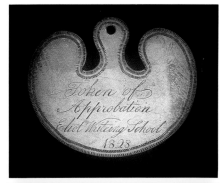

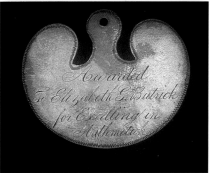

Fig. VI-24
A silver medal from the Elliot Writing School, dated 1828, given as a "Token of Approbation to Elizabeth G. Buttrick for Arithmatik." This unusual kidney-shaped medal was hand cut and engraved.

of cases of this nature, where the anguish of spirit in the child forced its way in paroxysms of suffering dreadful to behold....Such cases may not happen often. They should not happen at all. Protect the young, guardians of education, against the sharp sense of injustice. Injustice never cuts so deeply, or causes such a pang as in the tender heart. A spirit stricken in childhood may be crushed for life.

The Committee's recommendation was to abolish the examination, and to distribute the Franklin Medals according "to the result of an arithmetical scale of rank to those who stand highest in that scale," and that

> in making out the scale, good conduct and general deportment should enter as an element into the scale of rank, and receive the same regard as excellence in any one branch of learning taught in the schools; and in case of an exact equality in the amount of the scale of rank of different individuals, which is not very likely to happen, then this element of conduct should decide the question of precedence.[41]

Nine years later, in 1847, the underlying philosophical questions about "emulation," those questions originally posed by Locke and Rousseau, erupted once again. The 1847 Committee expressed themselves strongly against "emulation" as a motivation in education, and recommended abolition of both the Franklin and the City Medals. The effects were pernicious for both boys and girls, the committee felt, but "with reference to girls, the influence of medals is...wholly and exceedingly bad." A boy, they argued,

> may be prepared by them to struggle more desperately and more successfully in the contest for wealth, distinction and power; but we believe that the love of distinction has no tendency to form in a woman any of those qualities which are her crowning grace and ornament, as a friend, a sister, a daughter, a wife or a mother, and still less to give her the humility and self-forgetfulness which shall prepare her to be a faithful servant of God...[42]

The negative arguments also included the problems of elitism, the bad effect on the much more numerous students who were not winners, the singling out of a particular kind of ability to reward, and the unfair "permanence" which the prestige of getting a medal at a young age bestowed. And, as always, there was the overarching argument that emulation deflected the ablest pupils from developing a love of learning for learning's sake.

The arguments about the sexes reflected contemporary mores, but the action taken also reflected a legal practicality, one which school boards would find a problem from that time onward. The City Medals for girls had been established by a school committee; therefore they could be abolished by a school committee. The Franklin Medals for boys, on the other hand, were a legal bequest which could not easily be broken.

Both the City Medal and the School Festival or Exhibition, held in Faneuil Hall were abolished, but, as it turned out, only for 1847. In the following year, another committee was appointed to re-examine the issue and they argued "strenuously in favor of a judicious use of the principle of emulation in schools." They argued both that it was unjust to withdraw the prizes from students who had, on entering the schools, been promised that they would be given and that

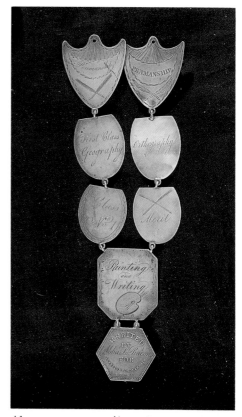

Above — see opposite page —

> a contract existed between the School Committee and the pupils of the first classes of the Grammar Schools, to the effect, that if the latter performed their duties faithfully, they should be entitled to a certain number of Silver Medals to be awarded to the best scholars in each School.

> (medals) are not generally regarded as pernicious by the community,...they are esteemed as valuable, and sought for with interest, by all classes of our citizens, at the various "Exhibitions of Manufactures and the Arts,"—they are held forth as incentives to improvements in Agriculture, and its various branches—and as inducements to develop the hidden truths of Science, and render them subservient to man's comfort and happiness—instead of diminishing they are being constantly increased in number, by the munificence of distinguished individuals...[43]

The centrality of their seventeen pages of arguments is that emulation

> is paramount to every other influence in the world pervades every fibre of our social system will still exist in defiance of all our efforts [to banish medals]—immutable—supreme;...

It is the report of this committee which states that emulation is "the main-spring of life," [44] and concludes by stating that "It is inherent to all,—regardless of sex, age, or position; and, from the cradle to the grave, it is ever present, as the twin Sister and companion of Hope."

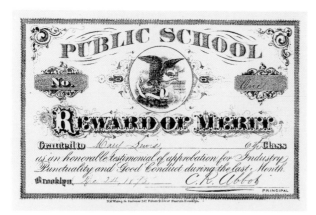

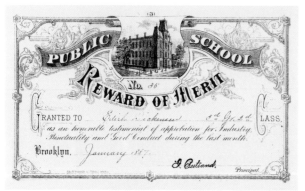

As the nineteenth century entered into its third quarter, lithography helped to enlarge the size of Rewards of Merit. These two Rewards measure eight by six inches, yet are small as compared to other examples of this post 1850 period.

Not only did this committee not agree with the decision to abolish the Medals, it proposed to placate some of the criticism by an extension of the prize system, because the character of "our population is rapidly changing from the influx of foreign immigration," and "Men will rarely labor voluntarily, without a tangible reward as a motive." They recommended neatly engraved certificates, of different designs, six certificates to be awarded in the second, third, and fourth classes of each of the Grammar Schools at the Annual Exhibitions.[45] The six handsome Diplomas of Merit were awarded to the lower classes "so far as is known, with happy and healthful influences." [46]

In the next few decades of the mid-century, many schools began to use these much larger and more elaborately printed Rewards of Merit. In New York, in the 1860s, two such Rewards were approved by the Board of Education, one specifically for the Grammar School for Boys (measuring twenty-one inches by sixteen inches) (Fig. VI-25), and the other for the Grammar School for Girls.[47] These Rewards, signed by the Principal and the Secretary and Chairman of the Board of Trustees, were given for "punctual attendance and correct Deportment and Diligence," and were presented to students at the end-of-term Exhibitions along with the Medals and other Rewards.

As the popularity of medals continued to pervade American life throughout the century, they ranged from the most highly prized Congressional Medals to cheap tokens which were used as sales incentives to buy particular products—some of which were close copies of medals given as honors. The writer of the 1848 Boston School Committee's report may have been convinced that "The discovery of the peculiar malignancy of Medals is of recent date, and is still confined comparatively to a few individuals," [48] but as their use grew, so also grew the number of people who did come to regard school medals as having a "peculiar malignancy." Boston, as the city with the oldest free schools, was the earliest to experience the controversies, primarily because it was among the earliest cities to have medals in what were truly public schools. And the Boston School Committee had not heard the last of the arguments or the problems.

Until 1851 a varying number of medals were given annually "and pretty freely." [49] That year it was decided that they should be given on the basis of one medal to sixty students and that general scholarship and more especially good conduct should be the chief considerations in making the awards. By 1858 the City Treasury had been subsidizing the cost of the increased number of medals "for many years," and in 1867, when from 100 to 150 Franklin Medals were being given each year, the City Medals were abandoned, and the Franklin Medals were awarded only in the English High School and the Latin High.[50] Feelings of injustice about this decision were not eliminated, however, since thirty-two years later, in 1899, a proposal was made at the meet-

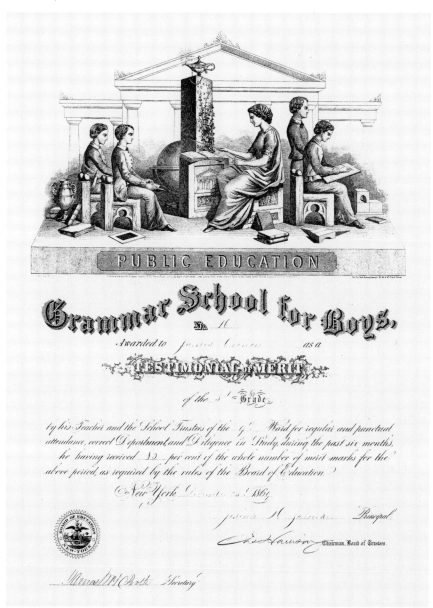

Fig. VI-25

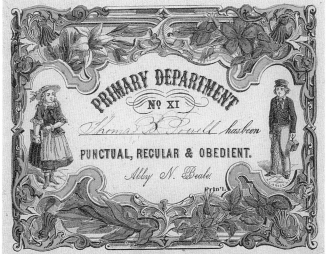

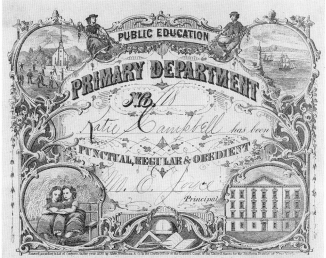

Above—Public school Rewards were supplied by the Board of Education to schools throughout the system. The only customizing of these generic Rewards was the occasional printing of the school number upon them; most, however, only provided blank space for the number to be written in.

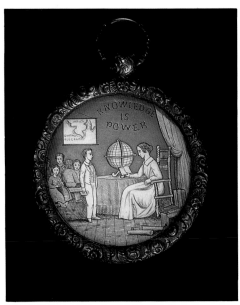

Fig. VI-26

ing of the Board of Aldermen [51] not only to reinstate the giving of Medals in all of the grammar schools, but to award them retroactively to all boys who since 1867 would have received the Medals had they been given. The argument was, of course, that this was what Franklin had intended.[52]

In 1933 financing the Medals again became a problem. The income available would not cover the number of Medals previously given, but the schools were allowed to make up the money themselves.[53] In 1915, there were questions about varying scholastic percentages being used from year to year in order to fit the number of Medals.[54] In 1935, a policy was issued stating that "The Board of Superintendents shall determine the award of Franklin Medals, and no other medals or prizes shall be awarded in any of the schools except with the express approval of said Board." Girls were awarded Franklin Medals in schools which admitted girls, which in the Boston Latin School happened in 1977. Under current regulations they are awarded to the top seven percent of the graduating class.

The historian for the Chauncey Hall School, Thomas Cushing, acknowledged the controversies over awarding medals but, writing in 1895, he made haste to defend them. Cushing argued that the Chauncey Hall School system of giving medals for coming up to a certain set standard seemed "to eliminate completely the idea of rivalry which is considered objectionable in most systems of awarding medals." He also pointed to what he apparently regarded as a guarantee of objectivity and fairness—those weekly reports which had to be signed by a parent.

In the African Free schools in New York, on the other hand, the identification of the schools with the giving of Rewards had become a matter of considerable ambivalence—feelings which were inextricably bound up with exasperated disappointment about the general neglect of their schools.

The charity schools of the Public School Society were turned over to the Board of Education of New York City in 1853, the year in which it has been said that the Lancasterian system was abandoned. Not only was the Lancasterian system not abandoned nor modified in the Colored Free Schools, but, under local school boards with minimal political power, the Lancasterian system remained while the schools went into a period of distressing deterioration. As the public schools were being built, instead of keeping up with the new school buildings and the books and equipment being afforded to white children, African-Americans complained that they were being forced, by lack of teachers and lack of books, into the most mechanistic monitorial methods with an emphasis entirely on rote memorization. The continuation of public examinations and Exhibition Days, and the public praise which was often still reported, was a bitter contrast to their neglected, underfunded schools.

In 1857 The New York Society for the Promotion of Education Among Colored Children presented [55] an appeal which, school by school, documented the appalling conditions of the school buildings for African-American children, and contrasted them with the "almost palatial edifices, with manifold comforts, convenience and elegances which make up the school-houses for white children in the city of New York," and concluded that by contrast, the

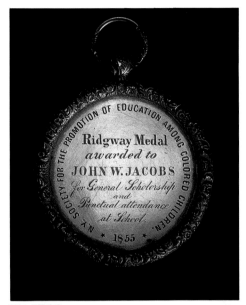

Fig. VI-26

> colored children are painfully neglected. Pent up in filthy neighborhoods, in old and dilapidated buildings, they are held down to low associations and gloomy surroundings.

But after referring to "the filthy neighborhood and the old and dilapidated buildings," they continued to quote the comments of the Superintendent about the examinations on the previous Exhibition Day as a reason why the schools were deserving of support.

> Yet Mr. Superintendent Kiddle, at a general examination of colored schools held in July last, (for silver medals awarded by the society addressing your honorable body) declared the reading and spelling equal to that of any schools in the city. [56]

The writers, who were African-Americans, realized that they could not yet rely on their logical and legal argument that colored children should have equal opportunities for schooling because "there is no sound reason why colored children should be excluded from any of the common schools supported by taxes levied alike on whites and blacks, and governed by officers elected by the vote of colored as well as white voters." [57] Rather, they still found themselves relying on favorably impressing a white benefactor who had attended their Exhibition Day, as they had felt they had to do when they needed to prove that African-American children were intelligent enough to benefit from schooling.

The Society's 1855 Ridgway medal for general scholarship and punctual attendance (Fig. VI-26) is among the most elaborate of school medals, an appearance of affluence which obviously contrasted painfully with the conditions of the schools described by the Society.

Perhaps the most complete presentation of the arguments against school Rewards appeared also in 1847. David P. Page's *Theory and Practice of Teaching* was one of the most widely-used manuals of pedagogy in the mid-nineteenth century and it was one which members of the 1848 Boston School Committee might have read, or whose author they might have heard speak. [58] Many of their arguments are similar and could well have come from Page's book.

Fig. VI-27

Fig. VI-28

Emulation, Page wrote, is desirable if by it is meant the child's desire for progress and improvement. But this is self-emulation, directed only to the achievement of all the child's potentialities. If, on the other hand, emulation means "a desire of surpassing others, for the sake of surpassing them" then it could be "an unworthy and unholy principle," since the child will hope as much for the failure of his competitors as for his own success. If carried into later life, such a disposition might lead to ambition such as that "found in the breast of Napoleon, who sought a throne for himself, although he waded through the blood of millions to obtain it."

After all this raving against prizes, however, Page offered a much softened argument against what he differentiated as Rewards of Merit. Rewards of Merit, he presumed incorrectly, were always given for accomplishments other than being "head of the class." "As expressions of the teacher's interest in the children, and of his approval of their well-doing, they may serve a good end," he admitted.[59] Nonetheless, though he professes no strong objection to them in principle, he damns them with reservations and contends that they may become burdensome to the teacher who has to buy them, and that it was preferable to do without them and to rely entirely on the atmosphere of the classroom. He advocates appeals to the conscience of the pupils, and a personality such that "the commendatory smile of the teacher, shall be the richest of all rewards."[60]

When Page mentions the selection problems he begins with the age-old objection that prizes could never be fairly awarded because judges seldom agree, but he also brings up the arguments which were becoming the most loudly discussed—that competitors were not equally prepared. He invoked the heterogeneity of the student population in contrasting the pupil who did not have to work, had an ample library at home, and had parents who encouraged him (and could answer even his difficult questions), with the pupil who had none of these advantages. Within a few years after the appearance of Page's book and the Franklin Medal controversy, New York teachers had resolved "that the practice of offering prizes in our schools, is wrong in tendency, operating mischievously upon the social, moral, and intellectual nature of those whom it is intended to benefit."[61] The New York resolution was quoted, among other places, in a teachers' journal in Indiana; the teachers' professional communication network was working. It was not, however, the discussions of the new leaders in education which most fomented the arguments, but rather the practical experiences of the ever growing number of teachers. In the short run, the expansion of public education, by its very numbers, created a huge new demand for Rewards of Merit; in the long run, it led to the decline of their use.

The arguments used for the provision of schools for everyone had heightened the reformers' identification of the schools with democracy and egalitarianism. All children needed to be educated in order to make intelligent voting choices and to succeed in the increasingly complicated industrial system. Teachers began to question even more the effectiveness of learning by rote repetition and recitation, whether it was employed in the manner of the earliest town schools or with the methods of the monitorial schools. In the one, a child waited for his or her turn to recite the lesson to the teacher; in the other, monitors listened to very strictly limited lesson segments.[62] The monitorial methods worked only if there were enough students and if the lessons were limited to suit the mechanistic Lancasterian practices. Both types of rote memorization were often painful and difficult for both teacher and pupil to sustain.

Perhaps, more and more teachers reasoned, if their lessons were not so dull, school would be more appealing and children would not need artificial, competitive, stimuli such as Rewards on the one hand or whipping on the other. The question also arose because the views and methods of the Swiss educational writer Johann Heinrich Pestalozzi (1746-1826) were coming into favor, and it was the Pestalozzian pedagogy which was being discussed in the new normal schools for the training of teachers.

Children, Pestalozzi believed, should be educated close to their natural surroundings, like the farm on which he and his wife had brought up their own son. The teacher should "rely on activities with which the child was familiar at home."[63] It was important to appeal to the senses before appealing to reason, much less to memory; so Pestalozzi emphasized "learning by doing...the natural goodness and curiosity of children, and...the importance of love to the learning process."[64]

Pestalozzi's ideas began circulating in America as early as 1806 among the founders of Utopian communities, and some textbooks written in the context of Pestalozzian pedagogy appeared as early as 1820. Furthermore, both in England and America an Infant School Movement had developed in the late 1810s to establish schools for younger children, usually between the ages of two and seven years. The Infant School teachers had turned to Pestalozzian ideas by the late 1820s, creating schools in which the very young were to be in a "quasi-domestic environment under the supervision of a quasi-maternal female teacher."[65] But it was not until mid-century that Pestalozzian methods came into the mainstream of American education, probably most forcefully through the work of Horace Mann (1796-1859), superintendent of schools for Boston, and Edward Augustus Sheldon (1823-1897), superintendent of the Oswego, New York school system.

Fig. VI-29

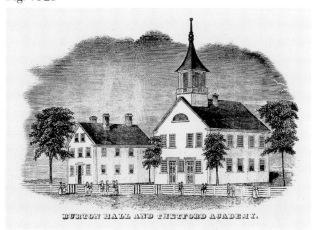

Private academies and seminaries used the images of their buildings much the same as manufacturers and retailers would, in order to promote the image of their success. The lettersheet above, dated 1849 depicts the Burton Hall and Thetford Academy, Vermont as perhaps it actually appeared, although many such illustrations were embellished to help sell parents on the benefits of paying tuition for a private school education.

Fig. VI-30

Fig. VI-31

Although Mann is better known, Sheldon was ultimately the more influential because his ideas were propagated throughout the country, and to some extent throughout the world, through the normal school[66] which he established in Oswego. Sheldon and his students had distilled, and reduced, Pestalozzi's theories into a single method of learning by doing—"the object lesson" in which pupils analyzed objects through their senses and then described them. As Pestalozzi suggested, the object lesson was supposed to reach the children through their senses, rather than through their response to purely verbal cues.[67] The teacher's role is set forth in the *Course of Study, Oswego Schools, 1859-60*:

> the object is not so much to impart information as to educate the senses; arouse, quicken, and develop the perceptive and conceptive faculties, teach the children to observe, and to awaken a spirit of inquiry. To this end the pupils must be encouraged to do most of the talking and acting. They must be allowed to draw their own conclusions, and if wrong led to correct them. The books should be used only for reference and as models for the lessons to be given.[68]

The object lesson, conducted in this manner, did away with the need for memorization and thereby with the reason for a large number of Rewards. Also, learning was now supposed to be fun, or at least not alienating, and Rewards were supposed to be, for that reason, less necessary; they played only an insignificant role in Pestalozzian pedagogy.

Such new views spread much more quickly in the last half of the century than they would have done in earlier decades because of the courses in the "Art of Teaching" at institutes and seminaries[69] (Fig. VI-27), in normal schools, and through teachers' organizations. The arguments for school expansion had heightened awareness of the overwhelming scope of the schooling problem and the need for efficient training of teachers. As normal schools proliferated, so too did an effective network among all the teachers. Teachers' organizations and teachers' journals began to share news of the latest ideas about teaching across the land. Summer "teachers' institutes" were organized for those who could not attend normal schools during the regular term. The standard pedagogical textbooks, including those of authors like Page, were also widely available—often passed from the lucky ones who attended the normal schools to those who could not leave their teaching posts.

As the arguments about pedagogy and the attitudes toward Rewards of Merit were changing, so also the printed Rewards of Merit were gradually evolving into other forms, some of which, ironically, sometimes seemed to promote even greater competitiveness than traditional Rewards.

In some schools, versions of what later would become report cards began appearing during the first few years of the nineteenth century. In their earliest form, such a record of performance was called a "weekly" or "monthly bill" (Figs. VI-28, 29) and "bill" referred only to the number of recitations which were successfully or unsuccessfully heard.

By the 1840's, "bills" had become "reports," and that which they reported was much more than just the number of properly executed recitations the student was able to produce on command. On one of these reports, each course of study was given a numerical grading equal to "perfect, good, medium, and bad." The final number then positioned the student in the appropriate "rank" (Figs. VI-30, 31, 32).

Handmade or printed Rewards of Merit, or medals or "prizes," were increasingly supplemented or replaced by a monitors' record sheet or weekly parents' reports for every pupil. Gradually, certificates (Fig. VI-33) for completion of the month or term, tickets of promotion, and diplomas (Fig. VI-34) became usual for all pupils, even for the younger children of the primary schools. During the evolution of school reports the transition can be seen also on the traditional printed Rewards of Merit. Teachers begin to add other performance records to the Rewards. For example, in the Gardiner-Malpa Collection on a simply designed Reward of Merit, in handwriting almost too tiny to read, we find statements of both rank in class and promotion.

DELIGHTFUL TASK TO REAR THE TENDER THOUGHT

THIS certifies that the bearer James Wilder
is at the head of his own class, and has behaved
in school in such a manner, as to deserve the love of
his parents, and the praise of his instructor
for his studious habits has been raised
from his own class to the first class in which
he now stands near the head.

Fig. VI-32

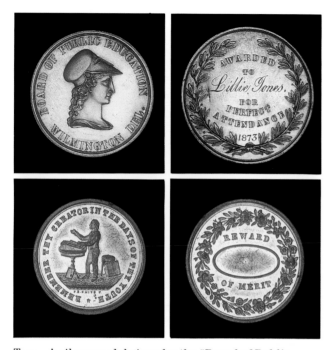

Top — A silver medal given by the "Board of Public Education, Wilmington, DE" in the early 1870s. This piece was struck by the United States Mint. The Mint would recommend an engraver to a customer, who then would hire the engraver to cut the dies for the particular medal needed. The Mint would then strike the medal for a fee. The above is adorned with the bust of Athena, the Greek Goddess of knowledge and wisdom, an illustration found frequently on mid nineteenth-century medals.

Bottom — A tin medal made by F.B. Smith, medalist, circa 1845. At this time tin, also known as white metal, was held in higher esteem than copper and of course less than gold or silver. This medal has struck upon it "Remember Thy Creator In The Days Of Thy Youth."

The Reward of Merit given to Mary Teller has a record of "credit marks, 6444," noted on it by the teacher.

A fifth-monthly report appears on the back of an 1848 Reward of Merit:

Reading - fair for a beginning
Spelling - pretty good
Pronunciation - distinct
Deportment - quite satisfactory
General Remarks - an interesting, pleasant,
promising youth

A particularly charming hand-written Reward of Merit/Report Card, given to Mary Sayler by J. S. Sandbach reads:

Beaverdam School, Janry 24th 1834
This Card
is designed to exhibit a
brief view of Miss Mary Sayler's
progress during one quarter.
Her studies included
Reading, Writing, Arithmetic & Geography
which appear as follows -
Wrote 53 copies
Arithmetic 358 questions
Geography 373 do.
We are also proud to have it to say that
her behaviour has been such as to
merit our approbation
Teacher J. S. Sandbach

Changing attitudes toward Rewards of Merit also coincided with the rapid development of the American paper and printing industries. Previously unimagined varieties and quantities of printed forms became available, cheaply, to schools as well as to industry.

Report cards and certificates of achievement were both handed out on Exhibition or Festival Days, and later at "Commencement" ceremonies, where the practice, in suitably modified form, still continues. Many of the certificates or diplomas

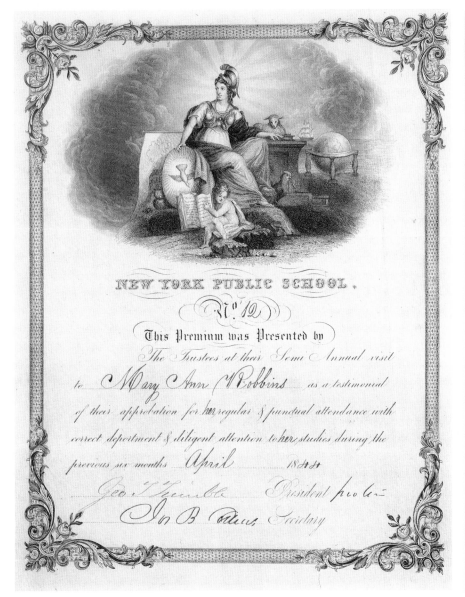

Fig. VI-33

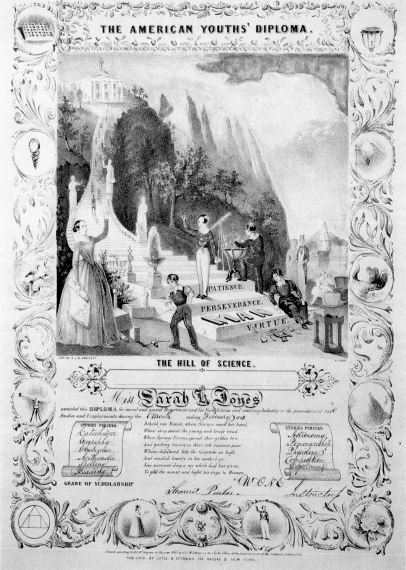

Fig. VI-34

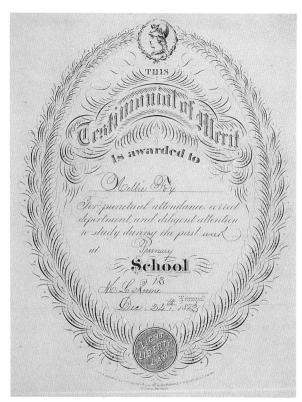

This ornate lithographed "Testimonial of Merit" designed with a magnificent Spencerian border was used in the public school system in New York; it is from Primary School 13 and dated 1873.

were visually very appealing — a worthy example of the printer's art and a commanding addition to parlor walls in the homes of the recipients. But at no time did Rewards of Merit given by one teacher to a particular child in his or her classroom entirely disappear.

The individuality of Rewards printed by local printers at the request of a particular teacher diminished during the second half of the nineteenth century as the large, highly mechanized city printers and lithographers produced Rewards of Merit in large quantities and sold them through teachers' magazines and stationers' advertisements. But those Rewards which beautifully exemplified the printer's art also appealed to many teachers and pupils, just as the more personally created ones had done for previous generations. Furthermore, new forms of Rewards, and new justifications for them, were to arrive at the turn of the twentieth century—not from educators, but from experimental psychologists.

NOTES

1. See John Sallay, "The Boston School Medals," *The Numismatist* (April 1978), 677-706, for a discussion of the Boston School Medals.

We are especially indebted to John Sallay, a member of the Ephemera Society and a specialist on school medals, for his bibliographical help, his generosity in consulting with us, and for photographs of school medals from his collection for inclusion in this chapter.

2. John Sallay has traced the spread of school medals from Boston through the rest of New England and the Eastern seaboard in the early eighteenth century. From the Eastern seaboard the practice of giving medals spread to the Middle States and only later reached the Southern and then the Western states.

Franklin was also involved in the first decisions by the Continental Congress to give medals on behalf of the newly independent nation. America's first medal was a gold medal for George Washington in appreciation of his driving the British out of Boston. It was voted in 1776 by the Continental Congress to which Franklin was a delegate. In 1779 Franklin arranged to have struck in Paris a medal which was voted to Lieutenant-Colonel de Fleury, a Frenchman in the Continental Army, for gallant conduct at Stony Point.

J. F. Loubat, *The Medallic History of the United States of America 1776-1876* (New Milford, CT: N. Flayderman, 1967), x. See also Evans E. Kerrigan, *American War Medals and Decorations* (New York: Viking Press, 1964), 63-64.

3. Malcolm Storrer, *Massachusetts Historical Society* 55, (October, 1921-June, 1922), 190.

4. Benjamin Franklin, *Franklin: Writings*, ed. Leo Lemay (New York: Literary Classics of the United States, 1984), "The Autobiography," 1313-1314.

5. Ibid., "Chronology," 1471.

6. *Franklin: Writings*, "Proposals Relating to the Education of Youth in Pensilvania," 323-335. Franklin proposes among his list of Studies which are likely to be "most useful and most ornamental," "*Antient Customs, religious and civil*," which there will be occasion for explaining because they are frequently mentioned in History. For the teaching of these ancient customs, he recommends the use of the "*Prints of Medals, Basso Relievo's, and Antient Monuments.*" He footnotes (p 335) that "Plenty of these are to be met with in *Manofaucon*; and other Books of Antiquities."

7. Franklin, *Writings*, "The Autobiography, Part Three," 1420.

8. Lawrence Cremin, *American Education: The*

Colonial Experience, 1607-1783 (New York: Harper & Row, 1970), 401-404.

9. Franklin, *Writings*, "Idea of the English School—Sketch'd out for the Consideration of the Trustees of the Philadelphia Academy," 348.

10. Ibid., 348, 351, 353.

11. Franklin, *Writings*, "The Autobiography, Part Three," 1418-1422.

12. Franklin also received honorary Master of Arts degrees from Harvard and Yale in 1753.

13. Franklin's honorary degrees included the degree of Doctor of Civil Law from Oxford University in England and St. Andrews University in Scotland.

14. Franklin, *Writings*, "Chronology," 1488.

15. Franklin was also aware of commemorative medallions made of porcelain in England. Josiah Wedgwood, one of the ardent founders of the Society for the Suppression of the Slave Trade, issued, in 1788, a solid white Jasper medallion with black relief inscribed "Am I Not A Man And A Brother?" and sent some of the medallions to Benjamin Franklin in Philadelphia. Franklin responded saying that "the medallions would be as effective as the best written pamphlet in calling attention to the issue." See David Buten with Jane Perkins Claney and contributions by Patricia Pelehach, *18th Century Wedgwood: A Guide for Collectors & Connoisseurs* (New York: Methuen, 1980), 87.

16. *The Columbia Encyclopedia*, 2nd ed., s.v. "Medal" and "Pisanello." The cast medals predominant in the 15th century had largely been superseded by die-struck medals in the 16th, and the design and execution of die-struck medals became a French specialty during the 19th century.

17. Franklin, *Writings*, letter "To Robert R. Livingston, Passy, March 4, 1782," 1042.

18. J. F. Loubat, *The Medallic History of the United States of America 1776-1876* (New Milford, CT: N. Flayderman, 1967), x, 90.

19. Ibid., "Letter from Benjamin Franklin to Robert R. Livingston, Secretary for Foreign Affairs, April 15, 1783," 91.

20. Franklin, *Writings*, "To Robert R. Livingston," 1072.

21. Loubat, 41, 93. The 1784 and 1786 medals in honor of Benjamin Franklin were executed by Augustin Dupré, "one of the most distinguished medal engravers of the latter part of the 18th century." On both appear the words "Eripuit Coelo Fulmen Sceptrumque Tyrannis" (He drew fire from heaven and wrenched the scepter from tyrants.)

22. City of Boston, Records of the School Committee, "A Study of the Award of the Franklin Medals, 1788-1953," 2.

23. Sallay, 694.

24. Report of the School Committee, Boston 1869. (Boston: Alfred Mudge & Son, 1870), 309.

25. One of the earliest commemorative pieces is, for example, a mug celebrating the coronation of Charles II in 1660.

26. George Bernard Hughes. *English and Scottish Earthenware 1660-1860* (New York: The Macmillan Company), 123. The quotation comes from the Journal of the House of Commons of 1753. The potter was Henry Delamain; the mezzotint engraver was John Brooks; and the merchant-stationer, was Theodore Janssen.

27. In 1876, at the Centennial Exposition at Philadelphia, it was clear that American ceramics were "nothing to approach even the lower grades of European ware." The pottery with the strongest American character (as contrasted with those influenced by various European wares) was in the "humbler wares, the Pennsylvania German pottery crocks and plates." Garth Clark, *A Century of Ceramics in the United States 1878-1978* (New York: E. P. Dutton in Association with the Everson Museum of Art), xi, 2. According to Alice Morse Earle, *Collecting China in America* (New York: Charles Scribner's Sons, 1892), 66, merchants in Boston were importing china from 1773, and by 1778 china began to pour into other American ports.

28. "Creamware" or "Queensware" was a pottery invented by Josiah Wedgwood in 1780, which allowed for fast production, less wastage, constancy of quality, and easy decoration. Wedgwood did not patent his creamware, and considerable quantities of it were produced by many other potteries. See David Buten with Jane Perkins Claney and contributions by Patricia Pelehach, *18th Century*

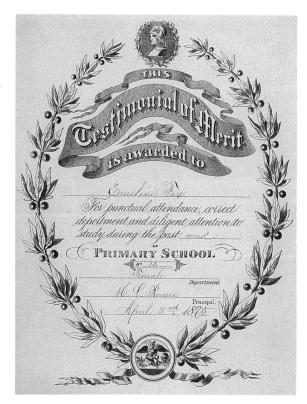

A lithographed "Testimonial of Merit" from the same Primary School 13, but redesigned just over a year later, dated 1875.

161

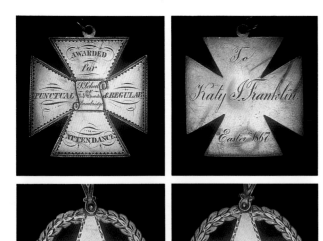

Above — A Sabbath school silver medal in the form of a Maltese cross awarded for "Punctual and Regular Attendance, Cambridge, Massachusetts — Easter 1867."

Below — A silver medal in the form of a laurel wreath and star given at St. Bridget's Academy, for excellence in Grammar, circa 1830.

Wedgwood: A Guide for Collectors & Connoisseurs (New York: Methuen, 1980), 4. Creamware is "what might be called the first modern pottery."

Jubilation: Royal Commemorative Pottery from the Collection of James Blewitt, Bethnal Green Museum of Childhood, Exhibit May to September 1977 (Ipswich, England: W. S. Cowell, 1977), 5.

29. J. Jefferson Miller, *English Yellow-Glazed Earthenware* (Washington, D.C.: Smithsonian Institution Press, 1974). From the foreword by Donald C. Towner, London 1973, Hon. Secretary, English Ceramic Circle, xi.

30. For a more extensive list of the design and illustrations used on mugs and plates, see Katharine Morrison McClinton, *Antiques of American Childhood* (New York: Clarkson N. Potter, 1970), 177-183.

31. From about 1757 to 1800, souvenir mugs for the seaside resort of Lowestoft on the east coast of England were a specialty of the Lowestoft porcelain factory. See J. Jefferson Miller II, *18th-Century English Porcelain: A Brief Guide to the Collection in the National Museum of History and Technology* (Washington, D.C.: Smithsonian Institution Press, 1973), 87, 93.

32. For a discussion of this plate, see John and Jennifer May, *Commemorative Pottery 1780-1900: A Guide for Collectors* (New York: Charles Scribner's Sons), 31-35. A patent for the process by which three colors, blue, red, and yellow, could be affixed from a single transfer with a single firing was taken by the firm of F. & R. Pratt in 1848 but had been developed and elaborated by F. W. Collins and A. Reynolds before that time. (May, 10)

33. Thomas Cushing, *Historical Sketch of Chauncey Hall School, with catalogue of teachers and pupils, and appendix. 1828 to 1894* (Boston: Press of David Clapp & Son, 1895), 5.

34. Ibid., 6.

35. Frances J. Niederer, Hollins College: *An Illustrated History*, 2nd ed. (Charlottesville: The University Press of Virginia, 1985), 10.

36. Ibid., 10, 15-17.

37. Dorothy Scovil Vickery, *Hollins College 1842 to 1942: An Historical Sketch Being an Account of the Principal Developments in the One Hundred Year History of Hollins College* (Hollins College, Virginia: Hollins College), 1942.

38. Germantown Academy, 1826, broadside prospectus titled "Education," Gardiner-Malpa Collection.

39. "Boarding and Day School for Young Ladies, at Brookline, Mass.," prospectus, Gardiner-Malpa Collection.

40. City of Boston, *Rules of the School Committee. Regulations of the Schools. 1858*, "The Lawrence Prizes," 245-248.

41. City of Boston, City Document—No. 30, "Distribution of Medals," School Committee, December 11, 1838, 5-9.

42. City of Boston, City Document, No. 20, "Report on Medals," 3-7.

43. City of Boston, City Document, No. 23, "Report on Medals, &c." In Report of School Committee, May 17, 1848, 3.

44. City of Boston, "Report on Medals," 1848, 13-15. The quotation at the beginning of this chapter is taken from this Report.

45. City Document, No. 23, May, 1848, 17.

46. N. S. Dickinson, *Boston Almanac for the Year 1849* (Boston: B. B. Mussey & Co.), 1849. 88-89.

47. See the Rewards of Merit facsimile portfolio available for purchase with this book.

48. City of Boston, "Report on Medals," 1848, 11.

49. Malcolm Storrer, *Massachusetts Historical Society*, January, 1922, 192.

50. Medals were given in the Mechanics Arts High School, later Boston Technical High, from 1897; the High School of Commerce, from 1914.

51. City of Boston, City Document 149, 1899. Proceedings of the Board of Aldermen, Monday, October 23, 1899.

52. This was to be done by transferring $7000 from the Franklin Fund (a separate bequest of £1000 in Franklin's will to be loaned to deserving artisans of Boston) to the Franklin Medal Fund. The proposal was not enacted. See Howard Husock, *The Boston Globe Magazine, May 17, 1987*, 17. Franklin

bequeathed £2,000 to Philadelphia and Boston "to assist 'the rising generation.'" "Virtuous and benevolent citizens" were to lend the money at low interest rates to "young artificers" trying to start their own business. After the first century following his death, much of the fund was to be distributed to finance "public works." The money had grown to more than $4 million in Boston, and a public debate was held about how to spend the money. The debate was still going on (because of a challenge by the heirs which delayed the decision until 1904) when this proposal to ask for money to award these medals retroactively was made. In Boston the money was eventually used, along with money from Andrew Carnegie, to establish the Franklin Union; in Philadelphia a significant amount of the money was given to the Franklin Institute, to build a science museum.

53. Boston Public Schools, letter from the secretary of the School Committee, to Mrs. H.C. Underhill, Michigan, September 19, 1928.

54. Boston Public Schools, letter of the secretary of the School Committee to Joseph Lee, June 7, 1915, from the Chief Clerk.

55. Herbert Aptheker, ed. *A Documentary History of The Negro People in the United States* (New York: The Citadel Press, n.d.), 399. Their carefully-documented findings supporting their requests for improvement in the education of African-American children were presented to a special commission appointed by the Governor to investigate the city's schools. African-American children were admitted to the city schools in 1884. See also Carolyn Mabee, *Black Education in New York State: From Colonial to Modern Times* (Syracuse, New York: Syracuse University Press, 1979), 155.

56. Ibid., 398-402.

57. Ibid., 401.

58. Ellwood P. Cubberley, *Public Education in the United States: A Study and Interpretation of American Educational History* (Boston: Houghton Mifflin, 1947), 388. David P. Page was the principal of the first State Normal School in New York. His *Theory and Practice of Teaching* sold over 100,000 copies before the expiration of the copyright in 1889 after which three publishers issued new editions.

59. David D. Page, *Theory and Practice of Teaching: or, The Motives and Methods of Good School-Keeping*, 14th ed. (New York: A. S. Barnes and Co., 1852), 132-135.

60. Ibid., 138.

61. Ibid.

62. Robert L. Church, *Education in the United States: An Interpretive History* (New York: Free Press, 1976), 15. Not all teachers had taught by rote, of course, and "in a few instances district schoolmasters ran schools at a much higher level of efficiency and used quite imaginative techniques to enhance learning."

63. Ibid., 96.

64. Idem.

65. Lawrence Cremin, *American Education: The National Experience, 1783-1876*, 389. See also Cubberley, 139.

66. "Normal School" was the name given to a school that trains teachers, chiefly for the elementary grades. It comes from a translation of the French *école normale*, originally the name of a school founded as a model for other teacher-training schools. Columbia Encyclopedia, 2d ed., s.v. "normal school."

67. Report of the Boston School Committee, 1869. Within a short time, the object lesson was also criticized for having become a rigid system.

68. Cubberley, 386.

69. See Cubberley, 372-382. By 1810 the Lancasterian higher schools evolved classes for educating monitors as teachers. The first teacher-training school was established privately, in 1823, in Concord, Vermont; from 1827 New York appropriated state aid to the academies for the education of teachers; and the first state normal school (the name used for teacher training schools) was opened in Lexington, Massachusetts in 1839. By 1860 there were thirteen public normal schools and six private normal schools. The establishment of these normal schools was controversial, however, because many academies had added one or more courses in the "art of teaching" and regarded the establishment of the normal schools as both as a criticism and a competition for their programs.

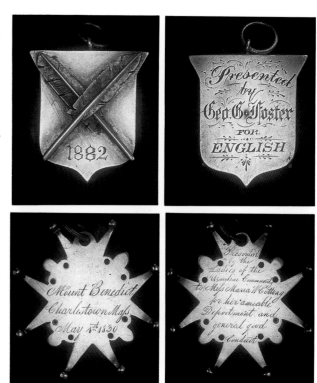

Above — The crossed quills on this manufactured silver Reward reflects back to the earlier design of the Franklin Medals. It is dated 1892 and is hollow.

Below — A very unusual form of a silver medal given as Mount Benedict (Seminary) in Charlestown, Massachusetts, May 4th. "Presented by the Ladies of the Ursuline Community to Miss Maria W. Cotting for her amiable Deportment and general good Conduct."

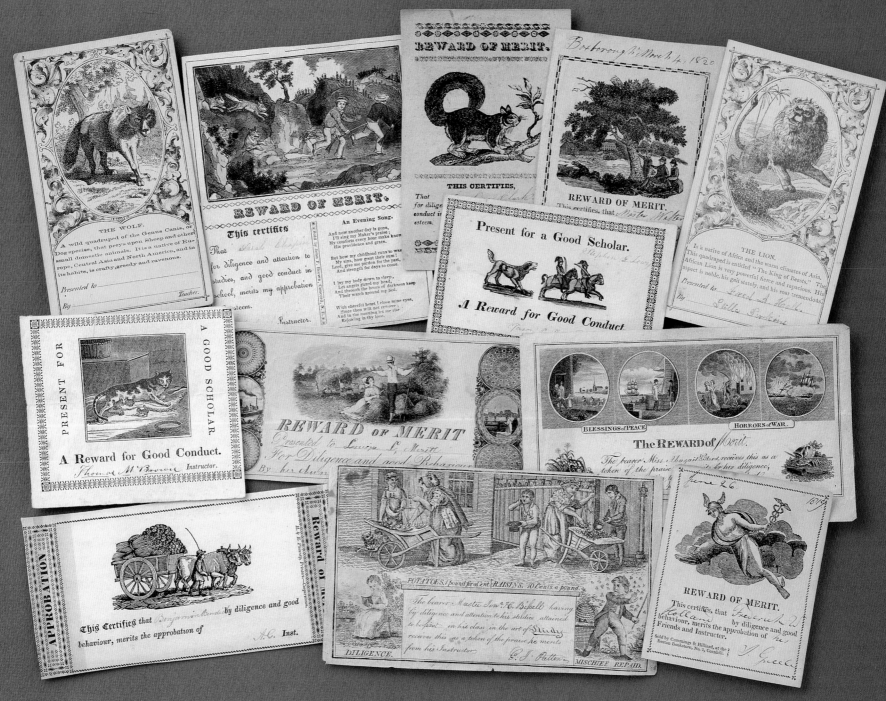

This group of Rewards demonstrates the variety of printing methods utilized as early as the 1810's, through the 1870's. Included are wood engravings, as well as black-and-white and chromolithographs. Another group is pictured on pages 168, 169.

THE PRINTING ARTS
Displayed on Rewards of Merit

And thus we see, that a single Leaf of Paper,
tho'not valuable in its self; yet when come to be
part of a Collection, may be of good use, not only
in respect of the Matter it Treats of, but as to the
Mark of the Paper, the Date, Printer's Name,
Country, Title, Faculty, etc.[1]

An Essay on the Invention of Printing
Douglas C. McMurtrie

 rinted Rewards of Merit can provide fascinating and diverse illustrations of a long, historically rich period of American printing. As examples of printing technology, Rewards of Merit range from those which were printed from stock blocks and crude wood cuts to engraved copperplates, from those printed from the stones used by the nineteenth-century chromolithographers to the late twentieth-century computer-generated and copier-multiplied Rewards. One of the most important and most interesting stories of Rewards of Merit, one separate from the pedagogy and the philosophical arguments, is how the changing technology of printing modified Rewards of Merit during the span of the nineteenth century.

When the first colonists brought their culture to the New World, printing was less than two centuries old, and during that time printing press technology had remained relatively unchanged. Work was done by hand: two strong men working at top speed could only produce 200 to 250 impressions an hour[2] on wooden presses brought to the colonies from England.

For the supply of type, the reliance on England meant that printers were in constant need of replacements of the worn type they did have. Benjamin Franklin and a few other printers of that period managed to devise ways of making supplements to their meager supplies of type. One, Abel Buell, of Killingworth, Connecticut, "without any other aid than his own ingenuity, and perhaps some assistance he derived from

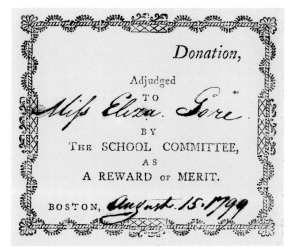

Fig. VII-1

Fig. VII-2

165

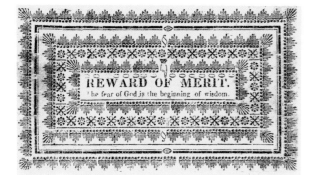

Fig. VII-3

Fig. VII-4

books" devised several fonts of "tolerably well executed"[3] type which some other colonial printers used. He may well have used some of this type to print one of the earliest surviving Rewards of Merit which is owned by the Connecticut Historical Society. Binney Ronaldson, the first type foundry which could supply type regularly to printers did not exist, however, until 1796.

Paper too had largely been imported. The first paper mill was built in 1690 by William Rittenhouse and William Bradford in what is now within Philadelphia. The output of this mill, when it was working, however, was small, as was that of others which were established, and though papermaking spread throughout the colonies, there was always a scarcity of paper, "partly because of the rapid expansion of business, and partly because Britain objected to the establishment of any business which would interfere with her exports."[4] The production of paper had been facilitated by the intro-duction of pulp machines from the Netherlands in 1756, but scarcity of rags was a seri-ous problem for the mills and grew worse as demand increased. Even when a paper mill was started in 1794 by the American printer, Isaiah Thomas, most stages in the production of paper were still performed by hand and were painfully slow. During the Revolution the shortage of paper so interfered with military orders and records that those who were skilled in papermaking were relieved from military service.[5]

At the outbreak of the American Revolution, therefore, printers in the colonies were just beginning to get by without English-produced equipment or paper, and, because of the interruption of supplies from Europe, the war considerably stimu-lated the printing and paper-making industries. The increase in American printing supplies in the following decades was an example of just how successful the new nation would become in producing its own manufactured goods.

For the production of paper, the 1810 census enumerated 202 paper mills; by 1840 there were 400; 700 existed by 1870. Rags remained scarce, but experiments with almost every conceivable alternative were tried. By 1831, the discovery that chlo-rine could be used to clean pulp made possible the use of other materials, particularly straw, and finally, in 1853, more and more wood pulp could be used in books and newsprint. Solving the problem of the scarcity of rags greatly facilitated the increase in paper production; by 1870 almost twenty million pounds of paper was produced every day.

The growing demand for type led to the establishment of the first type-foundry in America by Binney and Ronaldson in 1796; by 1816 there were sixteen foundries and by 1860 there were thirty-two. More abundant type and paper would have been of little use, however, had the presses themselves remained as inefficient as those of the

166

eighteenth century. The great technological breakthrough with presses was the introduction, in 1814 by *The Times* of London, of the steam-powered Koenig-Bauer rotary press, which could print eleven hundred sheets an hour. By 1810 the first daily newspaper in the United States, the *Philadelphia Daily Advertiser*, had been supplemented by 358 others. Newspaper printing obviously stimulated the development of more efficient presses and was greatly expanded by the successful steam-powered press; but in addition small hand-presses, so-called card presses, and jobbing platen presses solved the problem of hand-press printing for large quantities of billheads, business cards, and advertising material. By the late 1830s it was possible to print as many as two thousand cards in an hour.

These developments made it possible for a print shop to publish a newspaper while still maintaining smaller presses for job printing. The fact that there are no extant printed Rewards of Merit from the seventeenth century, and very few from the eighteenth century, suggests that not until this array of printing equipment and supply of paper became available could printed Rewards of Merit have been produced in any numbers.

The prominence of New England names in the early history of American printing reflects the particular importance that Puritans placed on the printed word. For nearly forty years the press was entirely in Puritan hands (Virginia actually forbade the introduction of printing). The early settlers of Massachusetts understood the importance of controlling printing, since printed broadsides, common by the 1620s in the cities of England and the Netherlands, had been used against them. When they got their opportunity, they were determined to use the press to preserve their power—in the state and, eventually, in the classroom. Furthermore, the impact of their control of the press helped to spread Puritan ideas throughout the other colonies. As we can see in the religious motifs of so many of the early Rewards of Merit, the beliefs of the Massachusetts Puritans had a remarkably long-lasting influence on later Americans. Their views of children, their religious ideas, and their styles of language and design are evident in the Rewards of Merit which became numerous in the first half of the nineteenth century. Only very gradually, over three centuries, has this influence faded.

Equipment and ideology go some way towards explaining how printed Rewards of Merit originated, but the economics of publishing was also an important factor. The first concern of most colonial printers was to secure contracts for the printing of Assembly proceedings and government papers, since that was the surest way to insure enough income at least to cover expenses. The printer could then turn to other work to provide profit. One of the most important of these profitable staples was legal and com-

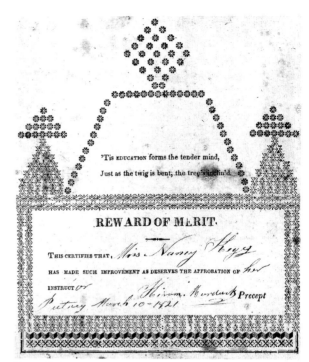

Fig. VII-5

167

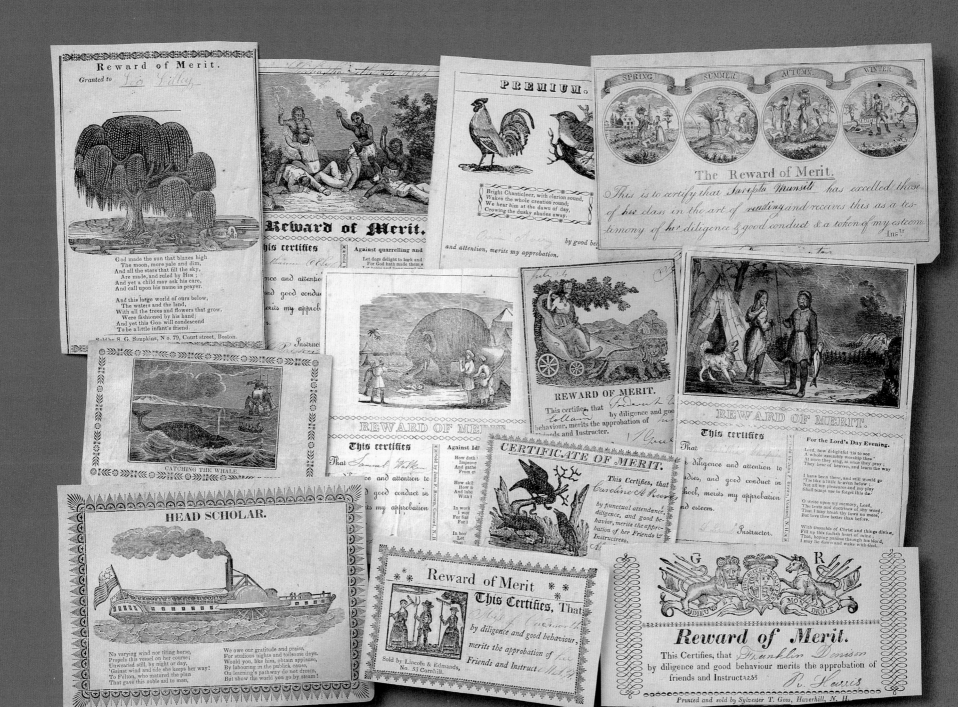

"'Tis Education forms the tender MIND!
"Juſt as the TWIG is bent, the tree's inclin'd."

"Delightful Taſk! to rear the tender Tho't!
"And teach the young idea how to Shoot."

THE BEARER
is hereby recommended for ſtudious
attention; and receives the thanks and appro-
bation of Inſtructor, for amiable
behavior in School.
OLIVER KENDALL.

Fig. VII-6

This Reward from the 1830s, typifies the prevalent use of stock woodcut illustrations and ornaments.

mercial blank forms. Warrants of all sorts, indentures, billheads, bills of lading, insurance and other ships' papers, "Ready Reckoners" (for reckoning commonly used mediums of exchange such as tobacco and other currencies), and the ever-popular almanacs were daily necessities in the colonies. Printers kept them in stock or were ready to print them in quantity as their customers needed them. Besides the press and fonts of type required for publishing a journal or newspaper, the colonial print shop often had another press free to print, at a few hours' notice, orders for suddenly-needed forms, broadsides, billheads, tickets, separately printed advertisements and mortuaries.

Constant experience in printing such forms could quickly be transferred from one kind of form to another—including certificates and Rewards of Merit desired by teachers. When presses became common, and paper more available, printed Rewards of Merit became another staple for some job printers, and the verses, illustrations, and typography of Rewards of Merit were often printed with the stock blocks and type of previous jobs. One of the earliest printed Rewards of Merit came from the shop of Isaiah Thomas. It was glued onto the back of the front board of a book which was itself given as a Reward (Fig. VII-1).

The principal decorations, or illustrations, of the early presses in Europe (and of the earliest and crudest of the American colonial presses) were in many ways copies of manuscripts produced before the advent of printing. The magnificence of the illuminated manuscripts of the Renaissance was defined partly by the intricate, skillfully designed and executed initial letters which began each page or paragraph. It is not surprising, therefore, that type founders strove to imitate those manuscripts—in lettering and illustration. Except for the richly illustrated title pages produced from copperplate engravings in the European centers of printing (particularly Amsterdam), decorative initials, rules, and borders, cut into wood blocks, were the only illustrations used during the early years of printing.

While colonial printers could not purchase elaborate blocks, they did build up their own stock of devices—borders, rules, and stock woodcut illustrations (some made by themselves and some imported) as well as verses and aphorisms used on various printing jobs. Letterpress provided very little possibility for pictorial illustrations, but what there was depended primarily on the insertion of these small woodcut blocks. The only illustrations to appear before 1700 were, in fact, woodcuts, (some experts argue that some may have been metal cut in the woodcut manner); since they were the only illustrations available in the colonies, they were popular no matter how crude they may have been. Once wood engravings were in a printer's stock, they were used not once but many times for many different printing jobs. Designs of conventionalized

leaf and flower forms were common, and English and Scottish foundries sent such small units as a crown, harp, hourglass, skull-and-crossbones, and a variety of arabesques, all of which could be combined and recombined either for borders or for larger decorative patterns.[6]

Combining these blocks onto trade cards, broadsides, chapbooks, wrappers, etc., especially when done by barely literate assistants, often amounted to a kind of folk art.[7] It was from just this kind of combination that some of the most striking, as well as the most puzzling, Rewards of Merit were composed—especially those using motifs of death. In one such composition the border of the Reward of Merit is composed of a repetition of a stock skull and crossbones block (Fig. VII-2).

Another Reward relies on the decorative use of border elements for visual appeal with the exception of a tiny pointing hand (Fig. VII-3). In very small type in the center are the words, "The fear of God is the beginning of wisdom."

On very few occasions did printers use the word "Merit" alone, yet one example (Fig. VII-4), so simply put together, would lead one to expect to find many similar Rewards. However, the use of the one word is unusual.

A particularly creative composition which has not only the border but the shape of the Reward of Merit composed of woodcut fleurons (printers' flowers) was given by a teacher in Putney, Vermont, in 1821 (Fig. VII-5). His verse, "'Tis Education forms the tender mind, Just as the twig is bent, the tree's inclin'd," was a motto frequently used on Rewards of Merit of different designs. It is, for example, also the first quotation on a Reward of Merit printed for Oliver Kendall, with an urn and swag at the top and a border of printers' fleurons (Fig. VII-6). The border devices are ones used by Benjamin Franklin, his sister-in-law, Ann, Isaiah Thomas, and twenty-eight other colonial printers before 1775.[8]

One selling technique which a printer used with the public was to claim that he had a larger number of pictorial cuts in his stock than did a competitor. On occasion a printer would issue broadsheets with a display of the cuts available for use in advertising, as illustrated on the Reward of Merit given by Daniel Boodey in 1832 (Fig. VII-7). This Reward is printed as the centerpiece of a larger display, having twenty-five different illustrations and five quotations surrounding it. In addition, eight different type styles are displayed in the seven lines of letters on the Reward. It was at least an ingenious vehicle for advertising—except that the teacher's name, but not the printer's, is printed on the sheet.

A curious yet similar Reward, related by its design elements, is one given to William D. Banchard by Instructress L. S. Foster (Fig. VII-8). This Reward for "diligence

Fig. VII-7

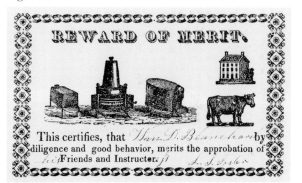

Fig. VII-8

171

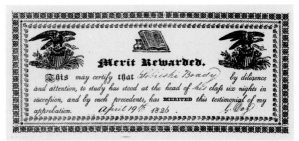

Fig. VII-9

Fig. VII-9

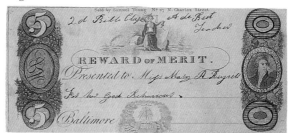

Fig. VII-10

and good behavior" suggests the likely benefits—food (cow), warmth (stoves), and shelter (house), in addition to displaying the cuts which the printer could use elsewhere.

Since copyright laws had not been established, copying the work of another printer or engraver was not regulated and doing so was routinely attempted. Copying was limited only by the capability of a craftsman of lesser ability to reproduce that of the most skilled engravers. Since seventeenth, and early eighteenth-century colonial printers usually could not afford to buy very many engravings or employ skilled engravers from abroad, they began attempting to copy the engravings of the Europeans and of each other. Widespread copying and the standard use of certain types of images helps explain why illustrations, found in one book, or broadside, appeared, often most incongruously, on other pieces of printed material. Not to be ignored is the practical business decision of utilizing one cut for as many purposes as possible, thereby saving extra expenditures for varied illustrations (Fig. VII-9).

The outbreak of the Revolution not only greatly increased the manufacture of paper, type, and presses in America; it brought with it another crisis which was to affect the design of peculiarly American imprints—particularly ephemera. The financially-strapped Continental Congress was forced to print large quantities of paper money, which they wanted to protect from counterfeiting. These bank notes, tiny because of the shortage of paper, were printed with a variety of metal borders or wood-engraved ornaments and specially cut insignia. They often displayed the printer's name quite prominently.[9]

Benjamin Franklin, who had printed money for Pennsylvania, New Jersey, and Delaware, made one of the most famous attempts to print money which could not be copied. He devised the scheme of using a plaster cast of a leaf from which he was able to make a metal casting that would last through thousands of impressions before wearing out. It was impossible for an engraver to copy faithfully every least vein in the printed leaf; and since no two leaves are alike, copies were easily detectable. Some of the smallest and most curious Rewards of Merit in the Gardiner-Malpa Collection are a group of three done much later (ca. 1830) but replicating Franklin's early idea, utilizing a leaf to make a unique impression.

American paper money and bills of exchange were from the first engraved on copper, and some were fair imitations of the elaborate trade cards and billheads engraved in England by such masters as Hogarth. But even the better engravings could be faked; at least one issue of Continental currency had to be withdrawn because the counterfeit bills were engraved more skillfully than were the genuine bills.[10]

The interest in bank note engraving influenced the design of Rewards of Merit (Fig. VII-10) and naturally coincided with the patriotic concerns of independence and

172

new nationhood. Patriotic motifs became almost an American obsession. Both those used on bank notes and those devised for other ephemera naturally became familiar on Rewards of Merit as well (Fig. VII-11, 12).

American engravers did not confine their increasing skills to bank notes, even though many got work and encouragement from that employment. Among well-known late eighteenth and early nineteenth-century American engravers who produced cuts used on Rewards of Merit was Abner Reed (1771-1866). Reed, who made plates for bank notes for the Hartford (Connecticut) Bank in 1792, later gave instruction to John Cheney (1801-1885) and John Warner Barber (1798-1885),[11] who also engraved for the printing of Rewards of Merit.

Nathaniel Jocelyn (1796-1881), a member of the Hartford Graphic Bank Note Engraving Company,[12] was another Reward of Merit engraver. Two Nathaniel Jocelyn Rewards from the collection are illustrated, one primarily engraved in the calligraphic style by Nathaniel and his brother Simon Smith Jocelyn (see Chapter One), and the other, shown here, which depicts an unusual, happy, scene of children just dismissed from school. This Reward has been hand colored, pasted on a card, and surrounded by a home made paper frame painted green. Such treatment suggests that this Reward of Merit was proudly displayed at home (Fig. VII-13).

Cheney engraved largely for "Annuals,"[13] and his scene engraved on a Reward of Merit may well have been one of those drawings. It shows, somewhat unusually, young "gentlemen" (in top hats) playing one of the various bat and ball games which early settlers brought with them from England (Fig. VII-14).

The John Warner Barber engraving, in the topological drawing genre, is particularly interesting to residents of New Haven, Connecticut, who can recognize the mountains in the background as one of their famous landmarks (Fig. VII-15).

One of England's most skillful engravers was to have unprecedented significance in America because his excellent engravings were copied in detail by Alexander Anderson who became America's preeminent engraver. Thomas Bewick (1753-1826) grew up in the English countryside near Newcastle-on-Tyne, where from a very young age he drew the animals of the countryside in their natural habitat. Bewick developed a way of using a graver on the end-grain of the fine-grained box tree. When it was cut across the grain and polished, it provided an excellent surface for engraving and could withstand tremendous pressure in printing. The small circumference of the tree limited the blocks to about five inches square, but any number of blocks would be fastened together at the back with nuts and bolts. With this "white-line" method of wood engraving, Bewick produced exquisitely detailed vignettes of country scenes, characterized

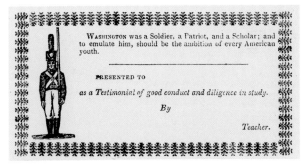

Fig. VII-11

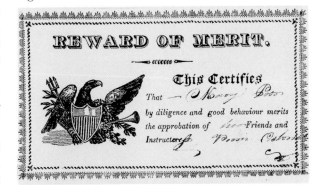

Fig. VII-12

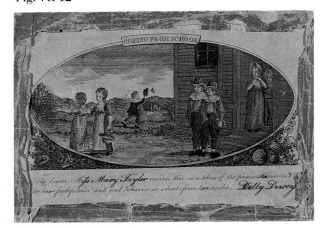

Fig. VII-13

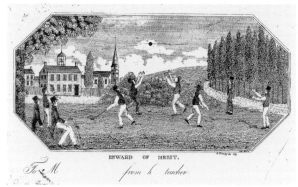

Fig. VII-14

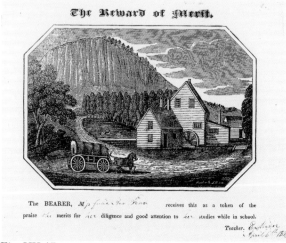

Fig. VII-15

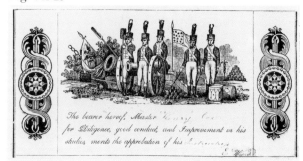

Fig. VII-16

particularly by a romanticized depiction of trees and plants. Bewick was a prolific engraver and copies of his woodcuts illustrated innumerable books.

In 1790 Bewick produced *The History of Quadrupeds*, in which his wood engraved illustrations of the animals of the world were printed above a description of each animal. In 1816 he produced in a similar vein *A History of British Birds*.

Bewick's influence in America came from the copies made of his work by "the father of American wood-engraving," Alexander Anderson (1775-1870). Anderson taught himself Bewick's white-line technique and copied a great number of Bewick's cuts for American books—most notably for *A General History of Quadrupeds*, published in New York in 1804. He had copied in reverse 233 wood engravings from Bewick, over 100 tailpieces (engravings placed as an ornament at the end of a chapter or at the bottom of a page), and added four additional animals of American origin.

The legacy of Anderson's extremely popular wood engravings of the quadrupeds, copied from Bewick's equally popular English quadrupeds, can be seen on Rewards of Merit on which a single quadruped is depicted, frequently when there seems to be little relationship to the rubric on the Rewards. Anderson's work can be found in hundreds of publications of all kinds. A woodcut signed by Anderson and used on a Reward of Merit depicts soldiers ready for battle (Fig. VII-16). Anderson's initials are found just below the mouth of the largest canon. Often he did not sign his engravings when they were used for smaller Rewards of Merit and chapbooks, many of which were sold by Mahlon Day and the American Tract Society.

Anderson's prolific output stimulated others to become wood engravers. There were no more than twenty professional wood engravers in the United States in 1840, but by the time of Anderson's death in 1870 there were about four hundred.[14]

The influence of these artists was by no means limited to Rewards of Merit. Many illustrations found on Rewards of Merit, by Jocelyn, Reed, Anderson, and others, appeared first, and no doubt again later, in the innumerable spellers, readers, chapbooks, and tracts which were printed for children in the late eighteenth and nineteenth centuries (Fig. VII-17). These engraved images could appear in such mass-produced forms because in 1823 a new printing technology, stereotyping, made it much more feasible to print in quantity and still preserve the original type for a much longer time (Fig. VII-18). In stereotyping, a papier-mache cast was made of the type and the casting produced stereotypes from which the printing was done.

This new printing technique was swiftly utilized by tract societies, which were dedicated to supplying literature for the moral improvement of children. American tract societies grew out of admiration for the Religious Tract Society of London which, like the Sunday School Society, had grown up in England during the latter part of the

Sweet puss! see how demure she sits;
The mice how they scamper and run,
When pussy but pulls off her mits,
And sharpens her claws for some fun.

A group of Rewards of Merit with wood engravings of animals that reflect the influence of Thomas Bewick and Alexander Anderson.

RURAL SCENES,

OR

A PEEP INTO

THE COUNTRY;

FOR CHILDREN.

COOPERSTOWN:
STEREOTYPED, PRINTED AND SOLD BY H. & E. PHINNEY.
··········
1829.

Fig. VII-17—for all four illustrations.

CHOICE COLLECTION

OF

RIDDLES & CHARADES,

BY

PETER PUZZLEWELL, Esq.

Embellished with neat engravings.

COOPERSTOWN:
Printed and sold by H. & E. Phinney.
1849.

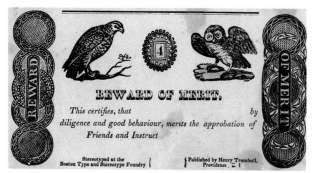

Fig. VII-18

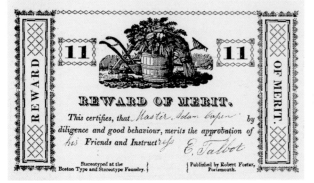

Fig. VII-18

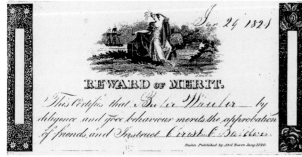

Fig. VII-19

eighteenth century. The first tract society in the United States was formed in 1803, and at least forty other tract societies were active by 1825, by which date they had distributed over eight million tracts for adults and children—most of them reprinted from those of the English tract society. In the very year that stereotyping was invented, the New England Tract Society, which had alone issued nearly four million tracts, began to print from stereotype plates and to illustrate its tracts with woodcut images. By the end of 1824 almost every tract was illustrated with crude woodcuts made by the Boston wood engravers Harlan Page, William Croome, and Abel Bowen.[15] Bowen's work is identifiable on Rewards of Merit which bear his imprint (Fig. VII-19).

Children's publications for the Tract Society were issued in various shapes and sizes with profuse woodcut illustrations, and in varicolored paper wrappers. The pattern of these toy books was not original with the society. A number of American publishers had begun issuing paper-covered "toys" for children during the last two decades of the eighteenth century but, for the tract societies, they became a stock-in-trade.

In 1824, Alexander Anderson, who had copied Bewicks' Quadrupeds so faithfully, copied many of the English engravings of the London Society's tracts for the American Tract Society of Boston. The output of the Tract Society kept increasing until, by 1849 and 1850, over one million of the toy books were printed each year. The very quantity of American Tract Society children's illustrations, and the fact they were in turn copied, guaranteed that American Tract Society illustrations were likely to be seen in many other places including on Rewards of Merit.

Looking back at the first two hundred years, few could doubt that black on white printing, from the crudest of woodcuts to the most magnificent copperplate engravings, had a deep influence on American life. Thomas Bewick's methods of wood engraving, stereotyping that greatly increased the possibilities of tract and book production, and the patenting of steel-engraving in 1810, allowed millions of churches, schools and individuals to have their Rewards, certificates, and invitations printed with decorations designed by the most talented, and well-trained graphic artists. As technologies improved to accomplish both the high-volume printing need for newspapers and books and the low-volume needs of small business, institutions, and individuals, printers began to operate larger and more productive shops.

Samuel Dickinson maintained a vast print shop in Boston (1830-1849). The shop had fifteen rooms covering an area of 14,283 square feet, with no fewer than 31 presses—from a ten horse-power steam engine driving three Adams power presses, eleven hand presses to three Voorhies rotary presses capable of printing two thousand cards an hour. There was also an assortment of cutters for cards and shavers for stereotype plates. Dickinson estimated that the shop consumed fifty thousand pounds of

176

metal in a year and printed 138,240,000 pages of books, 64,000 circulars, 25,000 commercial and lawyer's blanks, 20,000 bank checks, 50,000 billets, 500,000 billheads, 300,000 shop-bills and hand bills, and 2,000,000 labels, not to mention 1,201,520 cards. Dickinson advertised "many beautiful patterns for Marriage Cards, Rewards of Merit &c.[16] (Fig. VII-20). Typical of the type of work done by Dickinson's shop is a Reward of Merit printed in gold on a beautifully embossed white coated stock card for a single teacher, A. J. Manchester of the Shurtleff Grammar School in North Chelsea (Fig. VII-21).

In 1834, another new printing technology began to affect dramatically the American scene—and the scenes which became familiar to Americans. Lithography, a printing process which was to open the way to affordable and, gradually, to colorful pictures for the walls of American homes, became a major industry. Lithography not only made printing any Reward of Merit much more economical, but it also finally fulfilled the promise of "art for all."

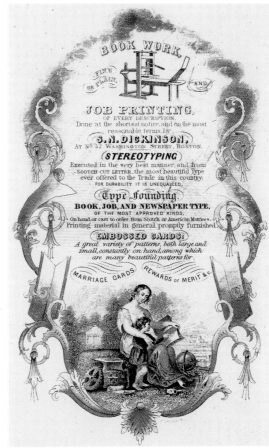

Fig. VII-20

NOTES

1. Douglas C. McMurtrie, Introduction to John Bagford, *An Essay on the Invention of Printing, The Philosophical Transactions of the Royal Society,* 25 (1706-1707), 2397-2407.

2. Jack Golden, "The Role of Printing Arts in Industrial Development," *The Ephemera Journal,* Volume I (1987): 4-7.
 Information and statistics on the development of paper, the Binney Ronaldson type foundry, the speed of printing equipment, and the output of Samuel Dickinson's press come from the first article, "The Role of Printing Arts in Industrial Development," 4, 5, and 7.
 "Business, Advertising, Printing and Ephemera," *The Ephemera Journal* (1989): 3–19.

3. Isaiah Thomas, *The History of Printing in America.* (New York: Weathervane Books, 1970), 28.

4. Edwin Sutermeister, *The Story of Papermaking,* (Boston: S. D. Warren Co., 1954), 13.

5. Ibid., 13.

6. Clarence P. Hornung and Fridolf Johnson, *200 Years of American Graphic Art: A Retrospective Survey of the Printing Arts and Advertising since the Colonial Period* (New York: George Braziller, 1976), 22.

7. John Lewis, *Printed Ephemera: The Changing Use of Typeforms and Letterforms in English and American Printing* (Ipswich, Suffolk. W. S. Cowell, 1962), 11. Lewis says that in England where jobbing printers (as opposed to book printers) were often illiterate, this kind of work often amounted to "practising peasant art."

8. Elizabeth Carroll Reilly, *A Dictionary of Colonial American Printers' Ornaments and Illustrations.* (Worcester: American Antiquarian Society, 1975).

9. Hornung and Johnson, 31.

10. Ibid., 24.

11. Reward of Merit in the collection of the Connecticut Historical Society.

12. William Dunlap. *A History of the Rise and Progress of The Arts of Design in the United States* (Boston: C. E. Goodspeed, 1918) III, 110.

13. Ibid., 289.

14. Ibid., 48.

15. Lawrance Thompson, "The Printing and Publishing Activities of the American Tract Society from 1825 to 1850," *The Papers of the Bibliographical Society of America,* 35, 2 (April-June 1941), 85-86.

16. Golden, "The Role of Printing Arts In Industrial Development," 5-6. The quotation is from the Boston Almanac of 1846.

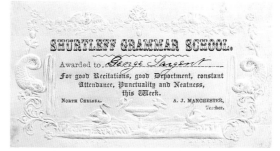

Fig. VII-21

177

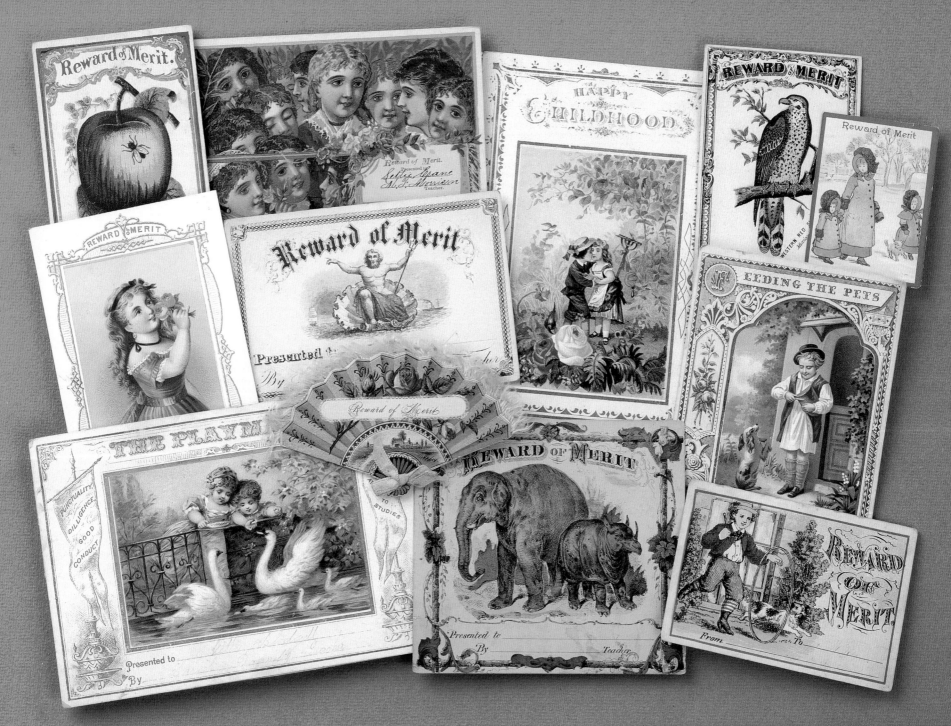

Chromolithography enhanced the vivid reproduction of color on Rewards of Merit compared to printing color by letterpress.

THE COMING OF COLOR
The Change in Message and Appeal

...within a few decades, public taste has been
lifted out of the sluggish disregard for the beau-
tiful...and now seeks to adopt the decorative
accessories, which beneficent enterprise has so
cheapened as to place them within the reach
of all, to the ornamentation of its homes.[1]

National Lithographers Association, 1893

olor printing, in red and black, had first been accomplished in America as early as 1718; but Andrew Bradford's first success in Philadelphia,[2] did not lead to full color printing for almost another century and a half. That dream began to materialize fully only in the 1850s, after printers had thoroughly experimented with lithography.

For generations, drawing and painting with inks, watercolors, and oil paint had been the only means to satisfy the natural desire to reproduce the colorful glories of land, sea, and sky. Illustrated manuscripts and watercolors in decorative styles had been deeply satisfying gifts for those who were fortunate enough to receive them. They, however, were never sufficiently numerous to satisfy the yearning for color. As the population grew and more ephemera printed in one color was handed out to masses of people, the possibility for color on these printed pieces became ever more tantalizing.

The most obvious way to add color to printed materials was to hand color on the already printed image. Such routine coloring was done by the artistically interested, and it was done for wages. Watercolors were applied to Rewards of Merit by workers painting free hand, sometimes utilizing stencils; or it was done assembly line fashion by coloring one or two small sections at a time and passing the sheet of Rewards on to a co-worker to paint another section (Fig. VIII-1).

Rewards of Merit from wood engravings, metal engravings, and letterpress printing can all be found decorated with painted embellishments. Some were expertly done with colors chosen with a subtlety which would highlight, rather than obscure,

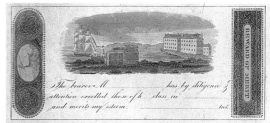

Fig. VIII-1

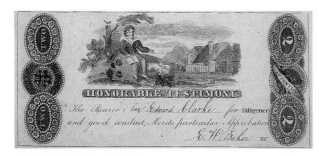

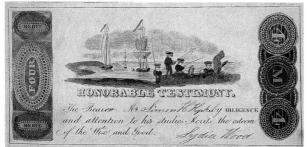

Fig. VIII-2

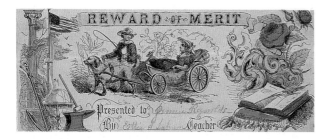

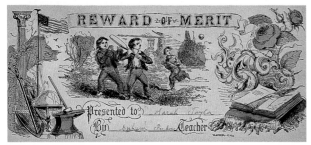

Fig. VIII-3

even the finest of copperplate engravings[3] (Fig. VIII-2). In others, the coloring, sometimes with vibrant bright daubs, appears to proclaim the anxiety of a colorist concentrating more on speed than exactitude (Fig. VIII-3).

Although printing with colored ink had also been possible since Bradford's experiment in 1718, it had always been limited by difficulty in obtaining a supply of usable ink. Printers formulated their own inks until separate ink manufacturers were established soon after the Civil War. In order to produce a colored ink, particularly one which could be used to print with accurate registration, much greater understanding of the properties and chemistry of the ingredients was required than for black ink. After overcoming the difficulties with ink and the tediousness of achieving proper registration, there was still the problem of time. To print impressions in two colors did not take simply twice the time required for printing in one color, it could take as much as four times longer than printing with black ink alone.[4]

Since Rewards of Merit were probably never among the most profitable of the printers' staples, it is not surprising that, prior to 1850, we find very few that were printed in colors other than black. There are a few, however, which were particularly well done (Fig. VIII-4).

When accurate registration of printing in color was still difficult, one way to achieve color was printing in a color wash. This process eliminated the worry of accurate registration, and when done only on a border it did not obscure the image and the message (Fig. VIII-5). Unfortunately, on the most colorful examples, the full rainbow of colors obscured both the design and the message which had been predominant when it was printed in blue on white (Fig. VIII-6).

All of these techniques for color printing, many of them successful and satisfying within their limitations, were still being carried on as the new printing process, lithography, was being introduced. There were also still explorations of older printing techniques without color, along with the new experiments in printing photographs, through the last third of the nineteenth century—a period which, for most observers, was overwhelmingly characterized by the extension of lithography into chromolithography. Lithographic printing in black, or in one color, made an enormous contribution to enriching the printed image. Because of its lower cost with greater efficiency, its possibilities for text and illustrations combined, and its capacity for simulating both letterpress and copperplate engraving in one process, lithography was a printer's dream. It was also the dream of American industry whose need for advertising and various other kinds of commercial printing was growing rapaciously.

Lithography on stone, one of the most revolutionary developments in the history of printing, was invented by Aloys Senefelder in Munich in 1798. It was utilized

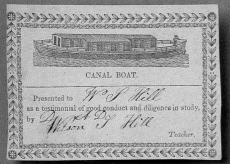

CANAL BOAT.

Presented to _W S Hill_
as a testimonial of good conduct and diligence in study,
by _Wilson D S Hill_

Teacher.

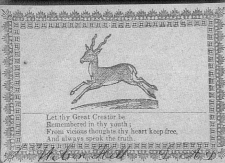

Let thy Great Creator be
Remembered in thy youth;
From vicious thoughts thy heart keep free,
And always speak the truth.

Fig. VIII-4

REWARD OF MERIT

Presented to _Le Roy Brown_
as an honorable testimony of
approbation for industry, punc-
tuality and good conduct.

Miss Rhoda Miller Teacher.

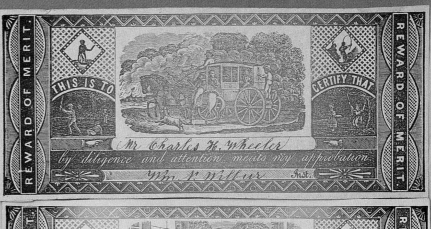

REWARD OF MERIT. THIS IS TO CERTIFY THAT REWARD OF MERIT.

Mr Charles H. Wheeler
by diligence and attention merits my approbation.
Wm L Wilbur Inst.

REWARD OF MERIT. THIS IS TO CERTIFY THAT REWARD OF MERIT.

James L. Mason
by diligence and attention merits my approbation.
Inst.

REWARD OF MERIT

H. & E. Phinney, Printers--Cooperstown.

This Certifies that _Mary Gregory_ by diligence
and attention to her studies, merits my approbation.

John Ferris Pub. Inst.

Fig. VIII-5

REWARD OF MERIT. THIS IS TO CERTIFY THAT REWARD OF MERIT.

by diligence and attention merits my approbation.
Inst.

Published and Sold by GEORGE B. BASSETT, 115 Chapel Street, New Haven, Conn.

Fig. VIII-6

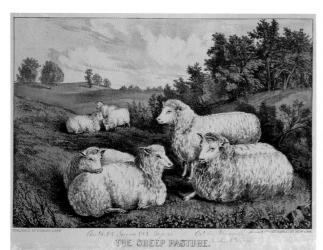

Fig. VIII-7

Fig. VIII-10

almost immediately by printers in Europe, but it was not introduced to America until 1821, two years after the publication of the English translation of Senefelder's *A Complete Course of Lithography*.[5] Lithographs were printed in a "planographic process"—the image to be printed was neither relief, as in a wood-cut on which the image projects above its background, nor intaglio, as in an engraving on metal on which the image is incised or cut below the surface of the metal. Rather, the image of a lithograph was at a level with the surface. No special engraving or cutting skills were required, because the artist drew on the surface of a finely polished limestone (or, later, specially prepared zinc or aluminum plates) with grease crayons, pens, or pencils. Printing was accomplished by the principle that grease and water repel each other. The inks used in lithographic printing adhered only to the drawn image and not to the clean surface of a washed stone.[6] Lithography brought Lancaster's dream of pictures, pictures by the thousands, for adults and children, to reality. Furthermore, the advances from lithography to chromolithography later brought full color to all.

Even after its introduction, lithography did not replace previous printing techniques immediately. Ten years after the firm of Barnet and Doolittle introduced Senefelder's lithography to New York there were still only three lithographers with eight presses. The dramatic success of the process, however, is evident in the fact that by 1890 there were 700 lithographers employing 8,000 people running 4,500 steam presses and 5,000 hand-presses.[7]

Lithographic printing affected all of America's business and cultural life. After its advent in America new forms of illustrations and reproductions of famous works of art could be cheaply printed for hanging on the walls of American homes; business benefitted because of the new attention which derived from the many different kinds of advertisements which could be printed and distributed to thousands of people. Lithography made it possible for creative entrepreneurs to use pictorial material in ways never done before.

Possibly the most dramatic impact of lithography in America was made by one of the first printing firms which fully utilized lithography process, the firm of Nathaniel Currier and James Ives. During the lifetime of their business, 1857 to 1907, Currier and Ives used lithography to produce prints for all. Most of their printing was done in black ink and color was provided by hand watercoloring, but they did produce a limited quantity of chromolithographic prints and a considerable number of chromolithographic trade cards. One of the firm's greatest contributions came from the employment of a growing number of American artists to create scenes depicting all

aspects of everyday American life. Their subjects ranged from religious scenes to rural life, from railroads to prints of trotters and political leaders. They produced pictures in abundance which could familiarize people in all sections of the country with the most interesting views of the rest of the country. Perhaps most interestingly, their artists created pictorial reports not only of great commemorative events, but also of "sensational news." Before radio, movies, or television, they thus brilliantly exploited lithography's possibilities not just to supply decorative printing to all, but also as a medium for pictorial information which could be permanently displayed. There were more than seven thousand pictures in their print series.

Currier and Ives are not known to have printed Rewards of Merit, but their prints were often given as gifts and prizes. It is not surprising, therefore, to find a Currier and Ives print with Reward of Merit written on it (Fig. VIII-7). The print of a sheep illustrated here also served as an end-of-term certificate of attendance since it has the number of days attended written on it.

As Currier and Ives led the way in showing off the possibilities of lithography, other printers quickly employed this new process to produce less expensive and more efficient printed materials of all kinds. Among the printers of Rewards of Merit, lithographs were widely produced, often with the addition of various hand-decorated techniques. As always, some clearly displayed the time-pressured coloring of assembly line painting (Fig. VIII-8), but others had color applied in a variety of creative and pleasing techniques. A series of fruit, flowers, and Bibles is particularly colorful and well done, apparently with a combination of stencil and free hand painting. Not only are the bright colors carefully applied on the intended elements (Fig. VIII-9), but shading in a second color has been applied to the pear and peach and some of the leaves. On another series of lithographed, watercolored Rewards, varnish has been added to the bright colors of the scene in the central oval to make them more vibrant, but the borders surrounding the oval have been colored with a light wash similar to the coloring which was done on virtually all Currier and Ives prints (Fig. VIII-10).

Among the printer's varied inventory were tradecards, some of which were printed from stock cards. This type of card was preprinted without the name of a particular business. When they were sold, only the name of the user had to be inserted in a blank space provided. No additional art work was necessary. This method therefore offered a cheaper way for buyers to satisfy this part of their printing needs. An unusual crossover use for stock trade cards was that they were also offered as Rewards of Merit (Fig. VIII-11). In such cases, instead of a business name being inserted into the blank

Fig. VIII-11

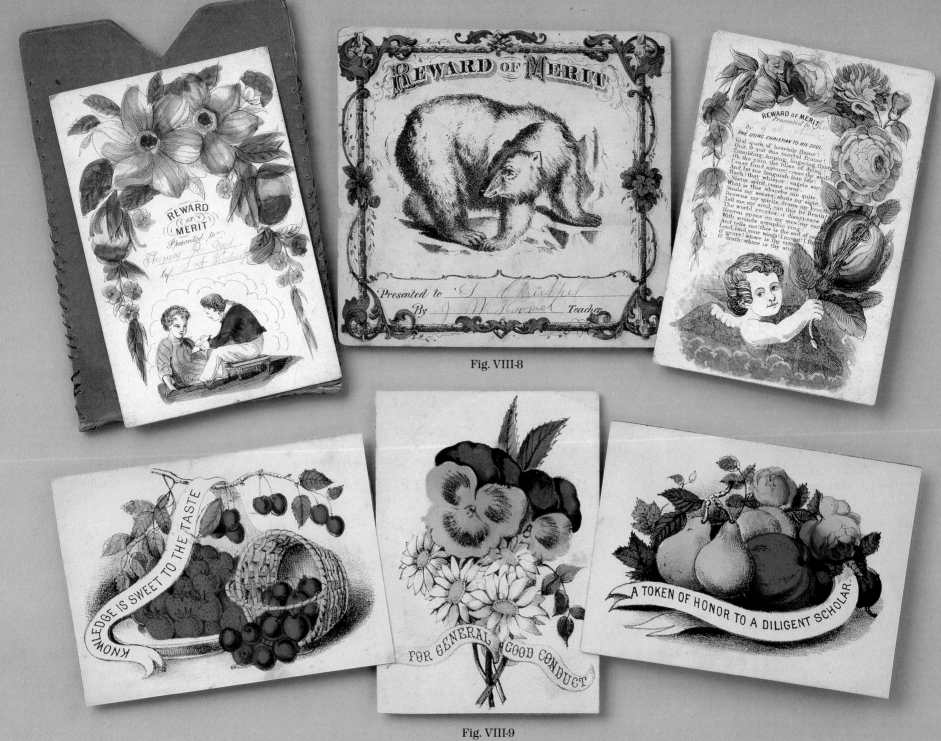

Fig. VIII-8

Fig. VIII-9

space provided, the words Reward of Merit appear along with the appropriate verse.

Color was provided for the bank note design Rewards, lithographically reproduced from engravings, by printing in one color. It was now possible to reproduce lithographically the best of the bank note designs from any of the previous eras of breakthrough bank note engraving—the Revolutionary War to the Civil war. When fancier, more special, Rewards were desired, lithographic printing could be done with varying degrees of creativity (Fig. VIII-12).

A publisher/printer who made fascinatingly creative use of lithography, and who probably printed more Rewards of Merit than any other printer in the last half of the century, began his business in the 1850s. This printer and entrepreneur was Charles Magnus (1826-1900). Magnus's firm (1850-1900) could not compare with Dickinson's as a large volume printer and publisher, or to Currier and Ives as a preeminent publisher of art. The specialties he did develop, however, and the lithographic techniques he perfected, also greatly added to the impact lithography had on American life. Fortunately, these techniques were also particularly applicable to the printing of Rewards of Merit.

Charles Magnus was a kind of jack-of-all-the-publishing-trades—print publisher, map maker, bookseller, stationer, marketing expert, and salesman. His first two jobs were as a salesman for a German silk concern and as a publisher (in partnership with his brothers in New York) of *Deutsche Schnellpost*, a German American newspaper. Those experiences seem to have heightened his natural genius for sensing what the public would consider "news" combined with an uncommonly good marketing sense. He also knew how to select news which made arresting pictorial material, and he knew how to print it and package it for sale.[8]

Magnus left Germany for political reasons after the 1848 upheavals, but he still had ties to Europe. He sold his printed paper in Germany and France as well as in many parts of the United States. His New York firm was small, but his audience was international.[9]

Charles Magnus was primarily a lithographer throughout his publishing career, but he also printed woodcuts, and steel, copper, and stone engraved plates, the prints from which he later reproduced with lithography. He was particularly expert at one color printing, using such colors as gold, bronze, green, or purple; and he, too, created his multi-colored prints by using free hand or stencil watercolor processes executed to a particularly high standard.[10]

The variety of Magnus's output can perhaps be best imagined from his own advertisement, found along the border of several maps (1859-1860), on the backs of

Fig. VIII-12

Above, packaging envelopes. Below, a Reward of Merit from the 1870s. This particular type was always printed with gold ink on coated card stock; the illustration was printed separately and later glued on the card by the manufacturer.

ballad books, and undoubtedly on other products where there was space. The ad interestingly reveals the possibilities for the use and reuse of a vast store of "different little engravings" which became his trademark.

>Views of American Cities, &c.—the well known souvenirs of each and every state....Games—annually 24 new/observe engraved not woodcut. Playing cards. Superior Artistic Photographs.....Reward Cards—1000 different little Engravings. 500 Vignettes for/Notes, Drafts and Check books of all the different Banks in North America.

The advertisement goes on to invite the public to subscribe for the *"Parlor and Tourist's Book*, which would contain *100 Steel Plate Views* of American/and European Cities, &c with a reliable description, and many Maps are added to illustrate a Tour of 900 miles." During his lifetime Magnus was known for his maps, which kept his attention on the growing tourist trade. The one United States map he published focuses on railroad and water course routes.

Between 1855 and 1878, Magnus also published some timely news sheets, but Magnus's news sheets offered little competition for Currier & Ives. His particular expertise and interest lay with his use of "City Views,"[11] those extremely elaborate engraved successors to the topological drawings of colonial North America. Magnus copied many of the city views of other publishers and then added his own elements. He usually converted the large original color lithographs to smaller line drawings or engravings, so that clear details could be retained in the small lettersheet size. These were then hand colored. He might add borders, a foreground figure, or a tower to the skyline; but many were imitated down to the smoke from chimneys and the number of window panes. The lettersheets which he eventually produced, however, "seem to be transfer lithographs or perhaps another type of copy engraving."[12]

Magnus used, and reused, and redesigned, into a seemingly endless variety of decoration, the various elements of his larger prints. He changed colors, combined designs, masked part of a design, and engraved new elements to add to the scenes; he printed vignettes, figures, and borders, in new combinations. His stationery, however, because of the scenes printed upon them which originated with his City Views, are of increasing interest to collectors. The city view scenes, reduced in size for lettersheets, also appear on his Rewards of Merit.

One of his successful sales gimmicks was to print sections of one large image on separate envelopes. It was then necessary to buy four or more envelopes to assemble the entire view, a view which he also sold as a single large print.

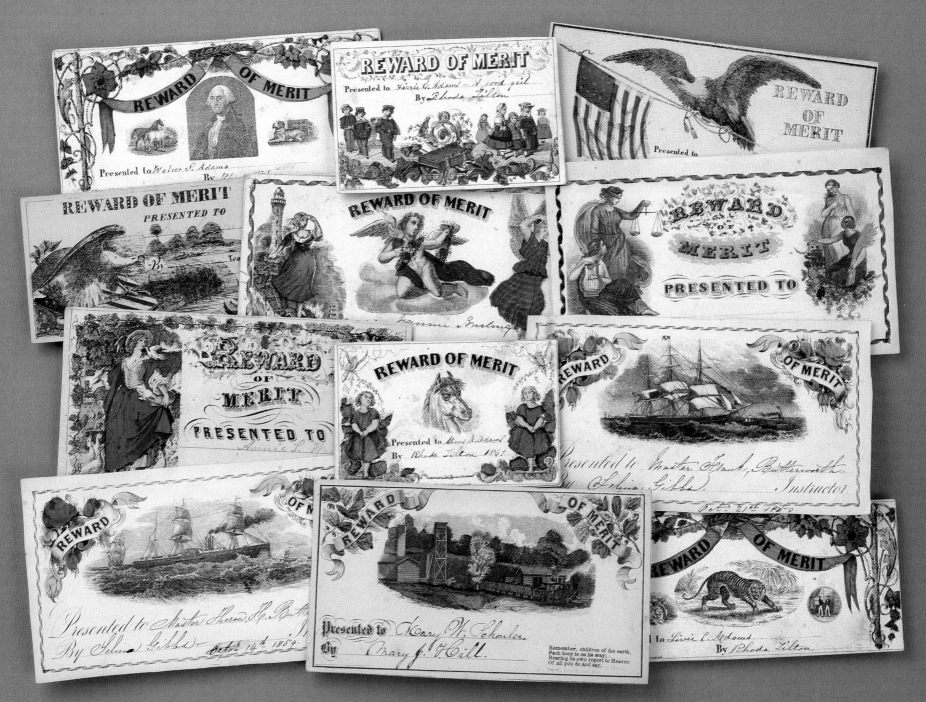

A small sampling of lithographed Rewards by Charles Magnus, one of the most prolific creators of Rewards in the nineteenth century. All of these hand-colored examples, with such diversity of subject matter, are from the mid-1860s through the 1870s.

Fig. VIII-13

Two lithographed Rewards from a\21 card\set depicting Presidents of the United States. Sold in\Illinois by D.A.K. Andrus, a stamp dealer in the 1870s.

During the Civil War, Magnus began to develop his own distinctive use of lithographic printing. He made a specialty of maps of the battlefields. He was one of the very few persons given passes to visit all of the Union camps, hospitals and battlefields. He visited the scenes of many of the battles in order to get photographs which he then printed on the margins of his maps, prints, and lettersheets. One of his Civil War series called "Camp Scenes" exhibits Magnus's mix and match, cut and paste, or photomontage technique at its best. Magnus chopped the camp scene photos apart, and recombined groups of the figures and added hand-drawn trees over the seams.

On one of his Rewards of Merit we can see one example of the way he used new images to the maximum. This Reward has a portrait of the Union Commander-in-Chief, Winfield Scott—no doubt one of many times it was used (Fig. VIII-13). Magnus published an elaborate print with McClellan, the previous Commander-In-Chief, with a portrait of his various generals, all of whom were surrounded by an elaborate cartouche composed of combinations of soldiers and sailors in different poses. These portraits, and the soldiers and sailors, often appeared on other products. State seals, eagles, flags, allegorical female figures, soldiers, sailors, and presidential portraits, were then used for lettersheets, songsheets envelopes, and Rewards of Merit.

After the war Magnus published a new version of City Views by using the same technique he had used for the battlefield scenes. In an analysis of his sheets, it appears that the copying was done by actually tracing on the photo in pen and ink. The image was bleached to wash out the tones of the underlying photograph, the key features were outlined in ink, then enlivened by hand-drawn figures and flags and finally were transferred in a reduced size to a lithographic plate. Thus, thousands of copies could be printed cheaply, stencil colored if desired,[16] and sold for as little as five or six cents each.

Charles Magnus's Rewards of Merit were put together in much the same way as were the lettersheets. For those who enjoy working puzzles, comparing envelopes with lettersheets and Rewards of Merit in order to find the same figures in different scenes is fascinating. For Rewards of Merit he often did choose elements which would appeal particularly to children; there are many showing occupations such as surveyors or railway workers and many which picture ships.

On typical uncut sheets (Fig. VIII-14) of Rewards of Merit (which were sold intact for the teacher to cut apart), it is usual to find eight or twelve Rewards of the same size and the same design. On Magnus's uncut sheets, in contrast, there are as many as twenty Rewards (Fig. VIII-15). His Rewards are printed vertically and horizontally, with different designs and different sized illustrations, and with no duplicates among them. The sheets appear in the one color printing which he developed with

188

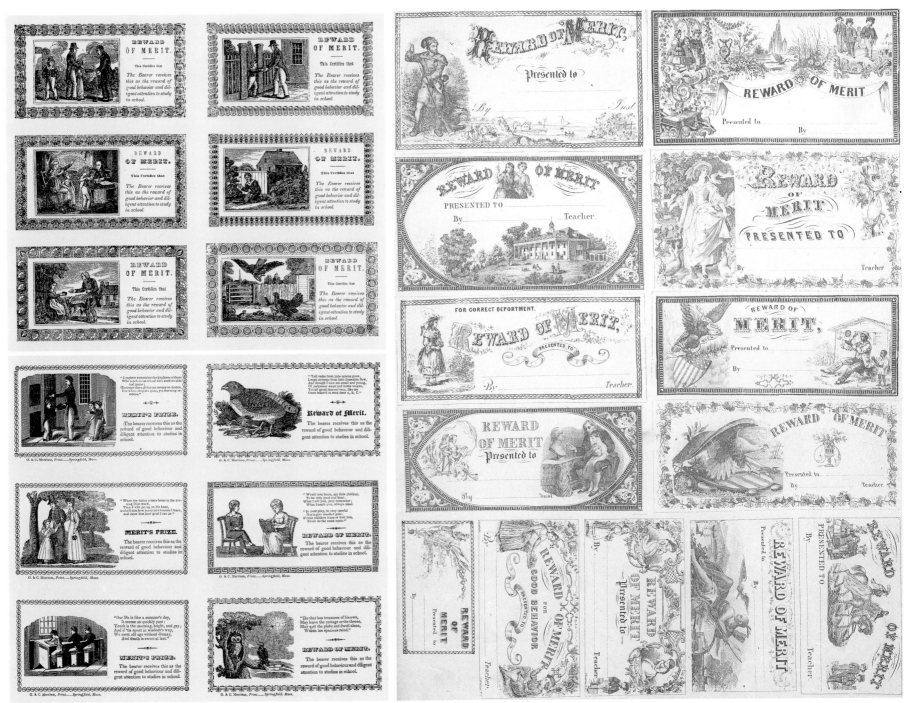

Fig. VIII-14

Fig. VIII-15

Fig. VIII-16

such success. Unfortunately most of the separate Rewards do not bear his imprint, so that when they were cut apart, one could not tell that they were his. Most of the Rewards were printed on these large uncut sheets, but there are a few which are printed on coated stock, as was true of a small percentage of the other ephemera which he sold.

Ironically, his chief innovation was something of an anachronism: he hand-colored stationery in the heyday of chromolithography and redrew photographs at a time when most printers were experimenting with photoengraving and photome-chanical screen processes.[17] Magnus achieved just about every possible effect with the techniques available at the beginning of his career; but more extensive and attractive use of color came into being during the last third of the century and other printers of Rewards of Merit were quick to take advantage of it. Charles Magnus was perhaps not a good example of those most innovative printers who took advantage of all of the possi-bilities of the revolutionary technologies in printing which came so quickly from 1860 to 1900. His own techniques, and his continued printing of Rewards of Merit over a long period of time, however, contributed greatly not only to the rich story of American printing but also to that of the use of Rewards in America's schools.

The "era of lithography," of which printers such as Currier and Ives and Charles Magnus were such interesting representatives, gradually blended into the era which became the culmination of the combined glory of the artist and the printer—chromolithography.[18]

In chromolithography, the image is composed of at least three colors, each applied to the print from a separate stone. The colors of a chromolithograph *are* the picture itself.[19] Credit for the invention of chromolithography is also disputed, but it originated in Germany. The Düsseldorf Academy, from 1826 to about 1860 was a great center for lithographers, attracting students from America as well as other parts of Europe. The first American chromolithograph was produced in Boston in 1840, but the early chromolithographs were often crude affairs, sometimes resembling badly stencil-painted lithographs. Blocks of color were juxtaposed with no effort to suggest gradation of tones.

Great refinements of technique were introduced in the 1860s. Immense care was given to polishing the stones and preparing the printing surface. Despite stren-uous efforts, no American stone could be found which had quite the properties of the limestone quarried in Solenhofen in Bavaria, large quantities of which were imported. Pigments, too, were all imported, and each lithographer had his own formula for grinding and mixing them into a varnish made by boiling linseed oil (which at one stage had to be purified by frying onions and stale bread in it). The resulting ink was

190

then applied to the stones by artists called *chromistes*, specialists in the delicate task of drawing mirror images on the stones.

The *Atlantic Monthly* of March 1869 contained a lengthy description of the complete process of producing a chromolithograph of Eastman Johnson's painting, *Barefoot Boy*. Twenty-six stones were required, weighing close to two tons and worth about fourteen hundred dollars. Three months were required to prepare the stones, and five months to print an edition of a thousand copies. The author marvels as the various impressions were made, gradually building up to the finished image. After ten, he suggests, many people would say the picture was ready; but sixteen more, some adding only infinitesimal amounts of ink, were required before the chromolithograph (now virtually indistinguishable from the original painting, but copies of which sold for only five dollars) was finished.[21]

This of course represents the very top end of the market for chromolithographs. Far less care was required to print Rewards of Merit; but the results were nevertheless remarkable, as can be seen from the examples illustrated (Fig. VIII-16). Among the possible uses of chromolithography was the frequent practice of using chromolithographs in combination with other kinds of printing. A Reward of Merit, printed by Colton, Zahm, and Roberts, for example, is comprised of two separately printed pieces fixed to each other. The basic card is lithographed in one color and upon it is glued a smaller chromolithographed stock image. This practice enabled a lithographer to print many of the same basic cards yet increase sales by changing the colored images glued upon them.

It was the newer American companies which expanded into chromolithography while building on the popularity of lithographs. Of these, the most famous was Louis Prang and Company in Boston which, in its quick adoption of advanced machinery, consistently high quality of work, and relentless self-advertisement, became a quintessential American enterprise.[22] Prang, and others, produced the multitudes of highly colorful Rewards of Merit of the later nineteenth century.

Louis Prang, like Charles Magnus, left Germany in the wake of the collapse of the 1848 revolution, with his hopes for a democratic Germany dashed. He had however received a thorough training in chemistry—essential for chromolithography—and printing, especially on calico. After his arrival in Boston in 1850, he engaged in a number of trades; during this time he taught himself how to engrave on wood and paint on stones.

Prang began working as a chromolithographer in 1856. At first he worked with a partner, Julius Mayer, but by 1860 he had seven presses and was able to buy out

Fig. VIII-17

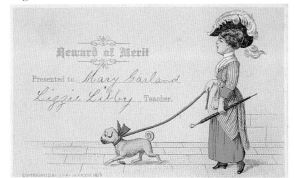

Fig. VIII-18

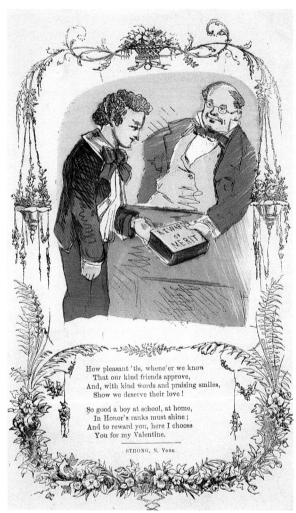

How pleasant 'tis, whene'er we know
That our kind friends approve,
And, with kind words and praising smiles,
Show we deserve their love!

So good a boy at school, at home,
In Honor's ranks must shine;
And to reward you, here I choose
You for my Valentine.

STRONG, N. YORK.

Fig. VIII-19

Mayer's interest. Like Magnus, he was able to profit from the insatiable public appetite for pictorial representations of Civil War scenes. In 1867 he built a "printory", or print factory, containing fifty presses. It was Prang's "printory" which prepared the chromolithograph of *Barefoot Boy* described above.

The quality of Prang's work was of course essential to his success; but he was also an innovator in technology and marketing. Mass production of chromolithographs was not possible until the earlier hand presses had been replaced by steam-driven ones, which were quickly installed in Prang's print factory. He also pioneered the use of zinc "stones" which, although not quite as good as Solenhofen limestone, were cheaper and not subject to the hazards of transatlantic transportation.

The lush, vibrant colors of chromolithography which became a part of everyday American life in every printed form imaginable, from soup labels to wall hangings, predictably began to appear on Rewards of Merit. Illustrations used on other printed materials had always, from the days of extremely limited selections of stock blocks, appeared on Rewards of Merit. In this late nineteenth-century proliferation of printed materials, even more incongruous illustrations began to appear on Rewards of Merit, but now they appeared in full color. Series depicting children playing were perhaps explicable in an age when children had become much more sentimentalized. In a few cases Rewards of Merit could be found on an advertisement itself—particularly advertisements of products used in the schools (Fig. VIII-17).

In the Gardiner-Malpa Collection, a Reward of Merit chromolithographed in 1879, illustrating a fashionable lady walking her beribboned dog, seems particularly to signify an end to an era when the message from a teacher was an integral part of the giving of Rewards of Merit (Fig. VIII-18).

Because many of the chromolithographed Rewards of Merit were printed much like greeting cards, valentines, and fancy stationery, with attention to pleasing color and design, they seem to bear little relationship to the schoolrooms in which they were given. The influence was also reciprocal. The valentine printed by T. W. Strong illustrates a teacher giving a Reward of Merit to a boy in school (Fig. VIII-19).

Rewards of Merit printed by Prang have a colorful floral design and a sententious maxim recommending diligence, honesty, and going to bed at a reasonable hour—purely secular virtues appropriate to the heroic age of American capitalism. On later ones, while still given as Rewards of Merit (and still including sage advice as old as *Poor Richard's Almanac*) the words "Reward of Merit" have disappeared (Fig. VIII-20).

Many of the later Rewards have no message; very few reflect any educational philosophy. They do not mirror what was taking place specifically in the schools. For

these reasons they are regarded by some to be of little interest in comparison to those less colorful Rewards which interpret the values of teachers and parents.

However this may be, in the era of color it was natural to assume that a child would most prize the most elegantly printed, most colorful chromolithograph. As a reflection of the chromolithographer's art and of the public's fascination with that art, chromolithographed Rewards of Merit provide particularly satisfying wide-ranging, cheerful, colorful examples of the product of a great American enterprise (Fig. VIII-21).

The previously unimagined plentitude of printed materials, and the glorious color of chromolithography, was not the last stage of Rewards of Merit. The form changed, as it had in previous generations, but the twentieth century also had its uses for, and its own interpretations of, Rewards of Merit.

Fig. VIII-20

Fig. VIII-21

NOTES

1. Spokesman for the National Lithographers' Association in 1893, quoted in Peter C. Marzio, *The Democratic Art: Pictures for a 19th-Century America* (Boston: David R. Godine, 1979), 5.

2. Jack Golden. "The Role of Printing Arts in Industrial Development." *The Ephemera Journal,* vol. 1, 8.

3. Of all the copperplate engraved Rewards of Merit studied by the authors, only a very few examples have been found printed in two or more colors.

4. Jack Golden, "The Role of Printing Arts in Industrial Development," 8.

5. Peter C. Marzio. *The Democratic Art: Pictures for a 19th Century America.* (Boston: David R. Godine, 1979), 6-7.

6. Ibid.

7. Golden, "The Role of Printing Arts in Industrial Development," 10.

8. Raymond Marsh, "Some Characteristics of Charles Magnus and his Products," *The American Philatelist*, 62 (September, 1949), 972.

9. Zinkham, Helena. "The Pictorial Lettersheets of Charles Magnus: City Views on Stationery." Slide Lecture Presented at the 18th North American Print Conference, New York City, 1986.

 We are indebted also to Helena Zinkham for her generous bibliographical help.

10. Robert W. Grant, *The Handbook of Civil War Patriotic Envelopes and Postal History*, ed. Gordon McKinnon, vol. 1, 4-27.

11. Zinkham, p. 7.

12. Grant, 427.

13. Zinkham, 10.

14. Marsh, 975.

15. Zinkham, 9.

16. Ibid., 12.

17. Ibid., 17.

18. The precise definition of chromolithography is debated, particularly with regard to the difference between a chromolithograph and a tinted lithograph. An essential difference is that although two or three stones are used in a tinted lithograph, the image is printed from only one stone and is not affected by the tints which are applied.

19. Marzio, 9.

20. Marzio, 64-90, has a complete description of the techniques of chromolithography.

21. Quoted in Marzio, 75-78. The article notes that as many as fifty-two stones had been used in some landscape chromolithographs.

22. Its name is still known to American children through its line of watercolors.

W.A. MOZART — BIRTHPLACE — REWARD CARD
T. PRESSER CO., PHIL'A

GEORGE FRIEDERICH HAENDEL — BIRTHPLACE — REWARD CARD
T. PRESSER CO., PHIL'A

JOHANN SEBASTIAN BACH — BIRTHPLACE — REWARD CARD
T. PRESSER CO., PHIL'A

FRANZ SCHUBERT — BIRTHPLACE — REWARD CARD
T. PRESSER CO., PHIL'A

LUDWIG VAN BEETHOVEN — BIRTHPLACE — REWARD CARD
T. PRESSER CO., PHIL'A

JOSEF HAYDN — BIRTHPLACE — REWARD CARD
T. PRESSER CO., PHIL'A

FR. CHOPIN — BIRTHPLACE — REWARD CARD
T. PRESSER CO., PHIL'A

GIUSEPPE VERDI — BIRTHPLACE — REWARD CARD
T. PRESSER CO., PHIL'A

RICHARD WAGNER — BIRTHPLACE — REWARD CARD
T. PRESSER CO., PHIL'A

A complete set of these "Reward Cards For Music Pupils" consisted of 16 chromolithographed cards. The reverse side of each card contained a short biography and autograph of the composer plus a small manuscript facsimile portion of a well-known musical composition. Circa 1890.

CONDITIONING
Twentieth-century theory for eighteenth-century practices

Just as the meaning of money is understood by
almost every adult, the meaning of tokens is
understood by nearly every child.[1]
Establishing a Token Economy in the Classroom
Stainback and Payne, 1973

xpense of printing and scarcity of paper had set obvious limits on the number of Rewards of Merit in the seventeenth and eighteenth centuries. By the late nineteenth and the early twentieth century, the proliferation of printed paper was so great that its very commonness contributed to the diminishment of immediately recognizable "Rewards of Merit." As many more children came into schools, as the country coped with the multiplicity of religious beliefs, and as the art of printing flourished and the use of printed forms proliferated, the variety of styles and kinds of Rewards became so great that they were often unrecognizable as "Rewards of Merit."

"Reward of Merit," the title, gradually became less and less frequent. The traditional Rewards of Merit, printed in sheets and cut by the teachers, were replaced by an increase in all kinds of printed school ephemera from attendance sheets and printed class lists to school superintendent's annual reports. Unfortunately the messages, the verses which so interestingly depicted the evolving theology and child rearing practices of the previous centuries, tended to disappear as twentieth-century priorities evolved.

Among the most well-produced school ephemera were teachers' souvenir cards. Many of them are particularly attractive, and might be considered the school-room versions of "carte de visites." The most interesting have a photograph of the teacher on them. With photographic printing, teachers of modest means could give their likenesses just as aristocrats and other wealthy school benefactors had done in

Fig. IX-1

195

Fig. IX-1

Fig. IX-2

previous centuries. Such mementoes became popular Exhibition Day parting gifts, or special occasion gifts, from the teachers (Fig. IX-1).

For a particular group of teachers, Reward cards with pictures of famous people became synonymous with their subject. Music teachers, for example, continued to use more Reward cards than did teachers in other subjects. For pupils in school music classes as well as in private lessons, collecting a series of composer cards became something to look forward to. The hope of the teacher remained that either competition to merit more cards than other pupils had, or emulation inspired by the composer's biography printed on the card, would provide the incentive to keep their pupils practicing (Fig. IX-2).

A particularly long-lasting tradition in twentieth-century reward giving came about as a logical progression from the use of chromolithographic "scraps" which Victorian children came to cherish. "Scraps", lusciously colored vignettes of flowers, fruits, fancily dressed children, and other appealing things, were die cut, sold singly or in sheets, and were eminently collectible. Many a late nineteenth-century scrapbook was filled with a child's collection of those colorful "scraps" along with prized valentines and cards to which other scraps had been lavishly attached in stationers'[2] workshops.

By the first decades of the twentieth century there was another kind of "scrap" which had a lasting appeal for teachers and pupils—stars. Teachers pasted gold, silver or red stars on school papers. Gold was usually reserved for the best work, silver for next best, and colored stars according to the teacher's own system (Fig. IX-3).

During the two world wars the gold and silver stars awarded to good pupils in school were part of a far more serious iconography. Children were well aware of the stars on the American flag (Fig. IX-4) and of the stars on the shoulders of the generals and admirals they admired. Earning a star was a great accomplishment for either child or adult. In the Great War, stars on banners or adhesive labels identified which American household had loved ones in the armed forces.[3]

Though the phrase "Reward of Merit" may have been used less and less frequently as the nineteenth century drew to a close, the concept of, and the single word, "merit" was by no means forsaken. "Merit" and "being deserving of merit" were ever more emphasized by the charitable and self-help organizations. Another use of the word, "Merit Badge", became almost universally familiar to American youth after 1911 and 1913 when Sir Robert Baden-Powell founded the Boy Scouts, and Juliette Low founded the Girl Scouts on the model set up by Baden-Powell.[4] The Scouting movement came very much out of the philanthropic mind set of the nineteenth century—self-help, practical self-education, and helping others to help themselves.

"Merit Badges" were the incentive for accomplishing set goals and for progressing from one skill to another. Boy Scouts earned merit badges for learning how to survive in the wilderness; Girl Scouts for learning how to manage at home. Scouts earned each merit badge, as described in their manuals, for a specified number of skills mastered. For scouts interested in camping, tying a certain number of different knots had to be mastered. In child care, a list of skills from testing babies' bath water to putting on diapers had to be exhibited. Like the school Reward systems before them, Merit Badges were cumulative in value, and earning a certain number of badges earned a higher reward. Girl Scouts who earned the requisite number of merit badges became First Class Scouts; boys became Eagle Scouts.

Another era in school Rewards was yet to come, however, one which began to be taken seriously only after the mid twentieth century. In spite of the rancor of the arguments about the reprehensibility of encouraging "emulation" which had raged since the 1840s, a peculiarly twentieth-century version of Rewards in schools appeared on the educational scene. Not only were Rewards once again to be used, but a system of using hundreds of Rewards, ones of smaller value to be exchanged for those of larger value, became popular once again. This time it was the preoccupation not only of teachers but also of professors of education and school boards—all intent on raising standards and on accountability.

Alan Kazdin, a historian of behavior modification, unequivocally identifies the nineteenth-century Rewards, particularly those of the Lancasterian system and of the Excelsior School system, as "reinforcement programs" of the kind which "became popularly known as behavior modification." In the peculiarly twentieth- century language of the behaviorists, he says:

> Reinforcement programs have been relatively common in the school classroom where systems based upon points, merits, demerits, and similar tangible conditioned reinforcers, are used to control behavior. An elaborate example of such a program was the educational system of Joseph Lancaster (1778-1838), which was implemented in countries throughout the world.

The new system rivals the Lancasterian system for the numbers of Rewards used, but the name "Reward of Merit" was dramatically changed; by the 1970s, Rewards became "reinforcers." It is possible, however, for even a twentieth century "reinforcer" to be a traditional kind of Reward of Merit. Reinforcers, like the prize toys in Lancaster's schools, are those things which the pupil wants.

Fig. IX-3

Fig. IX-3

CERTIFICATE OF AWARD

This Certifies That

Madeline Sebasky

A pupil of the Public Schools of Vermilion County, Illinois, is commended for

EXCELLENCE IN SPELLING

having received Fifty Perfect Spelling Lessons, for the School Year 1935-1936.

Given at Danville, Illinois, this 24th *day of* April *1936.*

L. A. Tuggle

Edith Milburn
Teacher

County Superintendent of Schools

Above and opposite page — A pair of photo-offset lithographed Rewards of Merit folders for the years 1935 through 1937, awarded to students in Danville, Illinois, for 50 and 100 perfect spelling lessons.

For students of educational methods, the rationales set forth for this latest system of Rewards "explained," or even experimentally "proved", why the Lancasterian system of Rewards had worked, and why they had failed when they did fail. Ironically, however, few teachers teaching in the 1950s and later had ever seriously thought about the Lancasterian system, and most researchers interested in the new system had scant interest in Lancaster's methods for teaching the masses.

The twentieth-century version of frequent, and elaborately systematized, giving of rewards to school children grew out of "scientific research." It was not research originally done on or for school children, but research by neurologists interested in the functioning of the brain. The subjects of the original research were animals—dogs, rabbits, pigeons, and mice; and the experimenters were neurologists or experimental psychologists. Their work is described as research on "conditioning"—conditioning laboratory animals to learn simple tasks. The translation of the results of these investigations into teaching programs for children in classrooms became the behavior modification or token economy programs of the late nineteen fifties and sixties. "Behavior mod" became another teaching "buzzword" of educational methods.

The father of the work which led to these programs was the Russian scientist, Ivan Pavlov (1849-1936), whose interest was how the cerebral cortex, the brain, functioned. He wanted to identify how higher nervous processes affected, and were affected by, experience. Pavlov's principal contribution is often said to have been that he devised "objective, controlled" methods with which to study such effects. He experimented with a dog and conditioned it, (in teaching vocabulary, he "taught" it) to salivate at the sound of a bell—a sound which, during the experiments, Pavlov paired with giving the dog a reward of food. He developed methods for measuring exactly how much saliva the dog produced, when the dog produced it, and how many "experiences" with the bell and the food it took to condition or "teach" the dog to salivate merely at the sound of a bell.

Pavlov's research was elaborated by several notable Americans, particularly E. L. Thorndike (1874-1949) and John B. Watson (1878-1958), both of whom did research with animal conditioning and both of whom became interested in the implications for conditioning children to better habits and more efficient learning.

Watson was the author of one of the first—and astonishingly widely sold—childrearing manuals, *Psychological Care of Infant and Child*, published in 1928. It appeared on the scene at a time when the influx of American immigrants provided a ready market of women who wanted to be taught how to raise their children in a truly American fashion. Watson's "habit training" became the by-word for efficient (and many thought "heartless") child rearing.

198

Thorndike, a professor at Columbia University Teacher's college, was especially interested in learning not only in the laboratory but also in the classroom. He conducted, along with his colleagues, numbers of experiments in children's reactions, and how to condition them to more efficient learning. His considerable reputation, in fact, rests primarily on being identified as "among the first to seek a scientific basis for educational practice." [5] Thorndike's book, *Educational Psychology*, was a model of controlled, objective experiments.

It was however, another behaviorist, B. F. Skinner (1904-1989), who, with his colleagues, spent a career refining "behaviorism"—the theory on which the classroom behavior modification programs and their reward systems are based.

As in Lancaster's time, many school administrators, teachers, and parents who were worried about the degeneration of youth and the failure of schools to properly "educate" them, jumped on this twentieth-century educational bandwagon. This time it was the translation of animal behaviorism into school programs. They were hoping for instant success with vast improvements in discipline and test scores. Skinner's own definition of learning, "the process by which behavior, or the potentiality for behavior, is modified as a result of experience," seemed to hold the answer to the problems of many teachers, particularly those who were trying to teach children who could not even seem to sit still for five minutes.

As with the Lancasterian system, some uses of behavior modification were highly successful; other uses led to tedious, repetitive, rote learning which did not easily transfer to analytic or creative thinking. But, as with the Lancasterian system, when behavior modification programs were used, the use of rewards in schools once more became an astonishingly visible and dominant part of each child's school day.

A child, working alone at a table, with a workbook, a timer, and a small pile of M&M candies—such was the kind of reward giving scene which began to appear in American classrooms in the 1960s. An M&M was given as a reward for completing one exercise or question, or even simply for working without distraction for a certain number of minutes. A chart, kept by an adult who was often a teacher's aide, was a record of the tasks done, the time taken, and the rewards given, and it often bears a resemblance to the monitor's charts from a Lancasterian school. Behavior modification was also characterized by working according to set schedules on specific tasks for expected rewards. This twentieth-century program can also be used for whole class purposes, such as rewarding a class with five minutes extra on the playground for walking quietly through the hall on their way out, or rewarding a class for earning an average test score above that of other classes.

Fig. IX-4

Fig. IX-5

Behavior modification, however, was particularly espoused, and continues to be used, for particular children whose disruptive behavior interferes even with their own ability to become sufficiently calm to concentrate on school work. Like the nineteenth-century Reward of Merit given for "not whispering," the chosen reward in a behavior modification program can be earned for a particular specified accomplishment such as "sitting still for five minutes." Unfortunately for its use as a universal teaching panacea, many children can sit still for a few minutes, and refrain from whispering while the teacher is talking.

Perhaps the greatest difference between Lancaster's system and behavior modification, or token economy, programs is that the latter are frequently designed with great care for one individual child in order to help that child's specific difficulties. The rewards of the behavior modification programs are called "reinforcements" because they are meant to "reinforce" a particular behavior of a particular child. Designs for one particular child was certainly not the case in the Lancasterian system where one master could teach four hundred pupils.

Behavior modification programs still exist, and some of the techniques are used for some purposes by teachers made familiar with them in their teaching methods courses. They seem, however, to have passed through their zenith of popularity. A generation of teachers has come to understand behaviorist theories and the importance of understanding exactly when, under what circumstances, and how many rewards should be given for maximum results.

Though teachers trained since the 1960s understand the methods involved in this far more technical use of reward giving, nurturant reward giving, by teachers responding instinctively to pupils whom they know well, is also still a part of teachers' classroom methods and will probably never disappear. Few would deny that it is a natural part of teaching at its most responsive.

Though the title, Reward of Merit, seldom appears on late twentieth-century Rewards, and today's Rewards often have a very different look from the skillfully printed and hand created Rewards of the past, their use, however, does continue. Printed certificates are now sold in bulk, and designs for school Rewards are published for copying on ditto machines or photo copiers, and rubber stamps with appealing designs are sold through teacher's supply houses.

One such rubber stamp (Fig. IX-5), used in 1962 is worthy of mention here as it is a unique aberration of Reward giving, perhaps reflecting the most confused and tumultuous decade of the twentieth century. In 1962 the eight year old son of Ed and Agnes Jablonsky, of Oakdale, New York, was the recipient of this stamped impression on one of his school papers.[6] The antithesis of a Reward of Merit, it suggests that even

an angel of God disapproves of this student's work. No "reinforcers" are evident here, no words of worthy approbation. Instead this message is "NOT GOOD! I CAN'T EVEN LOOK!," a message that Thorndike and Skinner would probably have taken issue with and a message contrary to two hundred years of teachers' experience in rewarding students with their approbation and esteem.

Rewards of Merit continue to be given to the present day and pupils continue to bring them home with pride. Proud parents can be found in offices or libraries photocopying the Rewards to mail or fax to grandparents. Other proud parents exhibit Reward "bumper stickers" on their automobiles.

Following the "fashions in collecting" of their young charges, many teachers started pasting on stickers sold in strips in the variety stores of the 1970s—the latest version of the collectible chromo "scraps" or the stars of previous generations. Perhaps the prize for the most revolutionary Rewards of Merit of the twentieth century, however, belongs to those which are "computer generated" (Fig. IX-6). Using graphics to design their own Rewards, and running those programs as they need them, teachers can produce Rewards with or without the pupil's name, for whatever accomplishment merits the Reward, on a few minutes' notice. Varied examples of such computer-generated Rewards may also become treasured artifacts—artifacts which display the evolution of the design and printing possibilities of the computer, while reflecting the happiest and most successful days of today's school children.

Fig. IX-6

Top — A computer generated George Washington Reward, circa 1990. Bottom — The "Enormous Effort Award," given to Will Rae in March of 1994 for doing exceptionally well in music class. Will was a first grade student at the Noah Wallace School in Farmington, Connecticut. Obviously, two-hundred and fifty years of giving, receiving and displaying Rewards of Merit, continues on.

NOTES

1. William C. Stainback, Susan B. Stainback, James S. Payne, Ruth A. Payne, *Establishing a Token Economy in the Classroom*, (Columbus, Ohio: Charles E. Merrill Publishing Co, 1973), vii.

2. See Ruth Lee Webb, *A History of Valentines*, Wellesley Hills, Mass: Lee Publications, 1952, for an interesting discussion of the women who pasted together the elaborate chromolithographed and paper lace valentines.

3. One such label, a design of blue stars with a red frame, appeared as "Service Stamps" patented 6 November 1917, published by Ernest Dudley Chase,

Boston. Other designs are also known.

4. Patricia McLaughlin, "On the Merits of Merit Badges," *Merchandiser*, Oxon Hill, Maryland, April 1989.

5. J. Harold Stevenson, "How Children Learn The Quest for a Theory," in William Kessen, ed., *Handbook of Child Psychology*, 4th ed., Vol. I, 218.

6. This fragment of student Jablonsky's school papers was received by Al Malpa in 1982. Mrs. Agnes Jablonsky sent it, unsolicited, after reading an article mentioning Malpa's collection of Rewards of Merit in *Family Circle Magazine* in 1981.

City and business directories were substantial sources for the information contained in this Directory. In addition, local histories, biographies, newspapers, census records, obituaries, and biographical dictionaries were also consulted.

The layout of the information is as follows:

The first line contains the name as it appears on a Reward of Merit or related material. In parenthesis follows what the abbreviations stand for or first names where it has been possible to locate them. To the right appear the years the subject was in business.

The second line defines the type of trade(s) in which the subject was engaged.

The third line is the first location(s) of the business.

From the fourth line on is information pertaining to the subject, business locations, information about business affiliations; or information about that particular Reward of Merit, including those from the Gardiner/Malpa Collection, identified as G/M.

NOTE TO READERS

Should you have a Reward of Merit imprinted with a name which does not appear in this Directory, please send a photocopy to Alfred P. Malpa, 276 Main Street, Farmington, CT 06032. This information will be incorporated into later editions in which an acknowledgment of your contribution will also appear.

A

Abbot, T. (Theodore)　　　　　　　1823-1864
　Bookbinder, bookseller
　388 Washington Street, Boston, MA

Adams, James　　　　　　　　　　1805-1829
　Printer, publisher
　various locations, Portland, ME

1805-1823 James Adams Jr. 1823 Adams, Paine & Woodbury. 1824 Adams and Paine. 1825-1827 James Adams Jr.

Adancourt, Francis　　　　　　　1803-1832
　Publisher
　Columbian Bookstore; various locations, Troy, Lansingburgh, NY

1803-1837 Lansingburgh. 1807-1832 Troy.

Aldrich, Dunbar (see Ide & Aldrich)

Allen, A.J. (Andrew J.)　　　　　　1809-1863
　Manufacturer of account books, publisher, stationer
　State Street, various locations, Boston, MA

1809-1822 publisher, stationer. 1823-1824 66 State St.; publisher, stationer. 1825-1849 72 State St., Andrew J. Allen & Co. (with Jeremiah Milner Allen); stationers. 1837-1846 A.J. Allen; stationer. 1846-1849 72 State St., Andrew J. Allen & Co. (with Jeremiah and Fred Allen);

and 1850-1853 80 State St., Andrew J. Allen & Co.; and 1854-1863 74 State St., Andrew J. Allen & Co.; stationers.

American Banknote　　　　　　　　1861-76+
　Engravers, printers
　12 Royal, 36 Natchez Street, New Orleans, LA

American Baptist Publication Society　1824-1883+
　Publishers
　21 S. 4th, N. 6th, Arch, Chestnut Streets, Philadelphia, PA

1824-1841 Baptist Tract Society. 1842-1883+ The American Baptist Publication & Sunday School Society or the American Baptist Publication Society.

American Sunday School Union　　1825-1870s+
　Publishers
　146, 316, 1112 Chestnut St., Philadelphia, PA

On a particular yearly report card, the typeset date of 1826 was written over with the year - 1836. On it is also printed "North Market St. Sabbath School." Such pieces were of a dual purpose - they rewarded the child with a watercolored picture and were also the first such ephemeral items to begin reporting, through a listing of grades, the skills or behaviors that had been acquired.

Anderson, Alexander　　　　　　　1793-1869
　Copperplate & wood engraver
　New York, NY; Jersey City, NJ

1787 New York at the age of 12 he made his first attempt at copperplate engraving. 1796 graduated from Columbia College with a degree in medicine. 1798 abandons medicine for engraving. 1820+ works almost exclusively on wood. For many years he was employed by The American Tract Society. He had been particularly interested in the work of English engraver Thomas Bewick. Anderson improved on Bewick's technique so much that he became recognized as the Father of Wood-Engraving in the United States. (See illustration on p. 174).

Anderson & Cameron　　　　　　　1875-1882
　Printers, stationers
　Fulton, Ann Street, New York, NY

1875-1876 96 Fulton St.; stationers. 1877-1879 123 Fulton & 46 Ann Streets; printers. 1881 117 Fulton St.; stationers. 1882 117 Fulton St., William J. Anderson; stationer. Printed and sold packages of American School Cards depicting Birds & Animals, Ideal Heads, & Domestic Friends.

Andrews, A.H. & Co.　　　　　　　1885-1889+
　Publishers
　27 Franklin Street, various locations, Boston, MA; Broadway, New York, NY

1885 27 Franklin St., Boston; school & church furniture. 1886-1888 611 Washington St., Boston; school & church furniture. 1889 by this time they were also operating out of 686 Broadway, NY. The item of ephemera in the collec-

tion is not a Reward of Merit, but an insert card. It is titled, "Aids to School Discipline or Rewards of Merit." It contains information on the use of Rewards of Merit.

Andrus, D.A.K.　　　　　　　　　　1870s+
　Stamp dealer
　P.O. Box 723, Rockford, IL

"PRESIDENTS. This set of 21 cards, one of each President, only 12 cts. Post Paid." Two of the cards are illustrated on page 188.

Andrus, William　　　　　　　　　1824-1849
　Bookbinder, bookseller, printer, publisher
　Hartford, CT; Ithaca, NY

1823-1824 Hartford, CT; traveling auctioneer for his brother, a bookseller. 1824-1834 moved to Ithaca, NY. formed firm of Mack and Andrus (Ebenezer & William); bookbinders, booksellers, printers, publishers. 1824-1844 Andrus, Woodruff & Gauntlet (John P. Gauntlett). 1835-1842 Mack, Andrus & Woodruff. 1844-1849 Andrus, Gauntlet & Co. 1849 William Andrus dies. William Andrus Jr. joins the firm. 1869-1870 Andrus, McChain & Co. 1873-1878 41 East State St., Andrus, McChain & Lyons. 1888-1929 41 East St., Andrus & Church.

Armstrong, Samuel T.　　　　　　　1813-1827
　Bookseller, printer
　Cornhill Square, various locations, Boston, MA

1813 50 Cornhill Sq., Round La.; bookseller. 1816 50 Cornhill Sq., Pitts La.; bookseller., 1818-1823 50 Cornhill Sq., Bulfinch St.; bookseller. 1825 Crocker & Brewster affiliation, later a dissolution and acquisition leaves Crocker & Brewster the sole owners.

Atwood & Brown (Moses Gilman & ...)　1830-1834+
　Bookbinders, booksellers, printers
　"south of Phenix Hotel", Concord, NH

1830 Hoag & Atwood (with Charles Hoag); bookbinders, booksellers, printers. 1834 Atwood (without Brown); bookseller, printer.

Avery, Samuel　　　　　　　　　　1809-1867
　Printer, publisher
　various locations, MA; NY; RI

1809 79 State St., Boston, acquired printing office occupied by Joshua T. Cushing. 1810-1811 10 Court St., Boston; printer. 1811-1818 91 Newbury St., Boston; printer. 1818-1819 89 Court St., Boston; bookseller. 1819-1821 Providence; publisher. 1822 New York. 1823-1867 East Braintree; printer.

B

Babcock, Sidney (see Babcock, William B.)　1815-1884
　Bookseller, printer, publisher, stationer
　121 Chapel Street, New Haven, CT; Charleston, SC

1815-1825 New Haven, John Babcock & Son (Sidney);

printers, booksellers. 1819-1820 Charleston, S. & W.R. Babcock (with William & John); booksellers, printers. 1821 Charleston, S. Babcock (with William & John); booksellers. 1825-1859 Charleston, S. Babcock & Co. (with William); booksellers. 1824-1884 New Haven, Sidney's Press; booksellers, printers. Babcock's trade card from circa 1850 states: "Special attention given to the jobbing of school books & stationery."

Babcock, William B. (see Babcock, Sidney)

Bacon, E. (Ephraim) 1825+
 Publisher
 66 Chestnut, No. 92 South Third, 39 Cherry Street, Philadelphia, PA
1821 66 Chestnut St., "Bacon & Hart;" music store 1823-1824 gentleman. 1825 39 Cherry St.; publisher. One G/M item is a facsimile scarf, designed as a Reward of Merit. He possibly worked as a publisher through 1827.

Baker, Pratt & Co. (James S. & William T.) 1874-1879+
 General school furnishers
 No. 19 Bond, 142 Grand Street, New York, NY
Printed on a G/M Reward is the copy: "This is a sample of our, Aids to School Discipline, the half merit is shown on the circular. Samples of the others - One Merit, Twenty-five Merits and One Hundred Merits - sent on application." The front of this Reward of Merit has printed on it "Love the Good. Hate the Evil;" "Love, Purity, Obedience."

Barber, J. (James) 1850-1867
 Copperplate printer.
 Phoenix Building, New Haven, CT
Same address as J.W. Barber.

Barber, J.W. (John Warner) 1814-1885
 Engraver, printer, publisher
 East Windsor, various locations, New Haven, CT
1814-1821 East Windsor, at the age of 16, Barber was apprenticed to Abner Reed. 1823-1824 New Haven; engraver, publisher. 1840-1845 61 Church St.; engraver. 1846-1847 26 Exchange St.; engraver. 1848 located over 27 Church St.; engraver. 1849-1852 30 Exchange St.; engraver. 1853-1854 15 Pheonix Building; engraver, publisher. 1855-1858 engraver, publisher. 1859-1864 book publisher & plate printer. 1865-1872 221 Chapel St.; engraver. 1873-1881 Insurance Building; engraver. 1882-1885 196 George St., his office and home.

Barber, W. (William) 1809-1841
 Printer, publisher
 Newport, RI
1809-1817 Rousamaniere (Lewis) & Barber; publishers. 1810-1817 bookseller, printer. 1817-1841 William & J.H. Barber (John); publishers. 1809-1841 publisher of "Newport Mercury." One Reward of Merit found, privately printed for the Marblehead Academy is imprinted "Given by the Board of the Trustees."

Bartlett (see Collier, Ezra)

Bassett, George B. 1843-1869
 Bookbinder, bookseller, publisher, stationer
 115, 263 Chapel Street, New Haven, CT
1843-1844 bookbinder. 1846 117 Chapel, Bassett & Bradley; bookbinders, booksellers. 1847 B. & Bradley. 1848 Bassett & Bradley (Luther P. Bradley), "School Books & Stationery, a general assortment, for sale cheap." 1849-1853 115 Chapel, G.B. & Co.; bookbinders, booksellers. 1854 G.B. & B. & Co. 1855-1868 263 Chapel, Bassett & Barnett (Edwin); bookbinders, booksellers, publishers, stationers.

Beckley-Cardy Co. 1920s
 Chicago, IL

Beebe & Elkins 1848-1880
(Joseph Alvin & Richard S.)
 Booksellers, printers, publishers
 East Market Street, Akron, OH
1832 Cuyahoga Falls, in business with brother, Oliver B.; bookbinders. 1838 East Market St., established Akron's pioneer bookstore. 1841 added drugs to book trade business with Dr. Perkins Wallace. 1848-1867 Beebe & Elkins; booksellers, druggists, printers, publishers. 1867-1880 Beebe & Elkins; booksellers, druggists. Printers of a large, gold embossed coated stock Diploma given as a prize by the Summit County Agricultural Society for "Best Specimen of Penmanship." (See p. 122).

Bennett, Backus, Hawley (see Bennett & Bright)

Bennett & Bright (Dolphus & Edward A.) 1826-1876
 Booksellers, printers, publishers
 various locations, Utica, NY
1826-1830 D. Bennett & Co.; printers, publishers. 1831-1840 Bennett & Bright; booksellers, printers, publishers. 1840-1846 Bennett, Backus & Hawley (with Charles Backus & Horace Hawley); booksellers, printers, publishers. 1847-1854 printers. 1855-1857 publisher's agents. 1858-1876 printers.

Berlin & Jones (Henry C. & George H.) 1850-1880+
 Envelope manufacturers and printers
 134 & 136 William Street, New York, NY
1853-1855 Berlin & Jones operating separate stationery stores. 1856 formed partnership. 1857-1858 Berlin & Jones; envelope manufacturers. 1858 color printing at a separate address from envelope manufacturing.

Black & Sturn (see Snyder, Black & Sturn)

Black, William 1850-1856+
 Stationer
 various locations on Eighth Ave., New York, NY
1850 15 Eighth Ave. 1851-1853 17 Eighth Ave. 1856 25 Eighth Ave.

Bond, J.W. & Co. (John W. & James H.) 1840-1876+
 Booksellers, stationers
 44, 86 and 90 West Baltimore Street, Baltimore, MD
Sold Rewards of Merit printed by Slote, Woodman & Co.

Boston Bank Note & Litho Co. 1887-1975
 Engravers, lithographers
 47 Franklin Street, various locations, Boston, MA
1887-1897 47 Franklin St. 1898-1910 name changed to Boston Bank Note Co. 1911-1952 77 Washington, St. 1953-1960 141 W. 2nd St. Rewards of Merit not titled as such, but headed with the words: "HONOR" and "Excellence In Deportment."

Boston Type & Stereotype Foundry 1822-1861
(see Cummings & Hilliard)
 Printers, type founders
 Salem Street, various locations, Boston, MA
1823-1825 Salem St., near the North Church, previously Timothy H. Carter & Co. 1826 Carter moves to Cummings & Hilliard. 1826-1829 in Boston City Directories "orders (for Boston Type & Stereotype Foundry) can be left with Cummings & Hilliard." 1826, 1831, 1844 37-39 Congress St., J.G. Rogers; agent for type foundry at this location. 1844 Spring La., James W. Shute; agent for Boston Type & Stereotype Foundry. 1848-1852 Spring La., J.M. Shute; agent. 1850 Spring La., George Deake; agent. 1851-1852 Spring La., John K. Rogers; agent. 1853, 1861 Spring La., two separate companies appear: Boston Type Foundry, J.K. Rogers & Co.; Boston Stereotype Foundry, Charles J. Peters; agent.

Bowen, Abel 1811-1850
 Engraver
 Court Street, various locations, Boston, MA
1812-1817 12 Court St.; engraver on wood. 1818-1820 Devonshire St.; engraver. 1821-1815 Congress Sq. (with Alexander D. McKenzie); copperplate engraver. 1823 (with George P. Bowen); engraver, printer. 1823-1824 H. & A. Bowen (Henry & Abel); printer, publisher. 1824 1825; engraver, printer. 1825-1826 2 Congress St. (with William S. Pendleton); engraver, printer. 1827-1830 2 Congress St.; engraver, printer. 1831-1832 19 Water St.; engraver. 1833 19 Water St.; xylographic engraver. 1834-1838 47 Court St.; engraver and printer. 1834-1850 Berwick Co. (with John H. Hull, John C. Crossman, Alonzo Hartwell, William Croome, George W. Boynton, Daniel H. Craig, N.B. Devereux Jr.). 1839 10 Joy's Building; engraver and printer. 1843 17 Blossom St.; engraver. 1846-1849 17 Old State House; engraver. 1849-1850 30½ School St., residence but same business address as his brother, Henry Bowen. Abel Bowen did engravings for (Reward of Merit) publishers: Cummings & Hilliard, Munroe & Francis, Lincoln & Edmunds.

Bowen, Henry 1818-1874
 Book agent, printer, publisher
 Devonshire Street, various locations, Boston, MA
1818-1820 Devonshire St.; printer, publisher. 1820-1823 10 Congress St.; printer, publisher. 1823-1824 H.& A. Bowen (Henry & Abel); printers, publishers. 1825-1826 169 Washington St.; printer, publisher. 1826-1827 4 Province House Row, Bowen & Cushing (with John D.

Cushing); printers. 1827-1828 Bowen & Cushing (with Thomas C. Cushing, Jr.); printers, publishers. 1827-1830 4 Province House Row, Henry Bowen; printer. 1831-1833 19 Water St.; printer. 1834-1839 16 Devonshire St.; printer. 1843-1848 book agent. 1848-1850 30½ School St.; book agent. 1850-1851 97 Washington St.; book agent. 1852, 1853 97, 86 Washington St.; book agent, collector. 1855 95½ Washington, St.; book agent, collector. 1857-1859 13 Bromfield St.; librarian at Massachusetts Charitable Mechanics Association. 1860 28 State St.; printer. 1860-1874 collector for M.C.M.A. 1874 502 E. Fourth St.; collector, printer.

Brett Litho Co. 1852-1947
 Lithographers
 Philadelphia, PA; New York, NY

1852-1859 Philadelphia. 1862-1870 New York, Brett & Co. 1871 New York, Fairchild Brett. 1872-1947 Brett Litho Co. name adopted. Trade card (1890's) designed particularly for "Esterbrooks Celebrated Steel Pens, New York, NY & Camden, NJ" and printed in blank banner, "Reward Of Merit." (See p. 191).

Brown, H. (Hori) 1811-1824
 Printer
 Leicester, MA

Printed sermons, pamphlets, etc.

Brown, John E. (see Cory, Edward) 1832-1838+
 Bookseller
 Market Square, Providence, RI

1832-1838 19 Market Sq.; bookstore.

Brown (John Edwin) (see Marshall & Brown; Cory, Edward)

Brown, S.P. (Samuel) 1840s
 Printer, publisher
 Peterboro, NH

1847-1848 newspaper publisher. Lost the business in 1848 to his printer for non-payment of bills. The masthead of Brown's newspaper the "Messenger" was "We'll Try." His trade card reads "S.P. Brown. Book and Job Printer. and manufacturer and dealer in Writing Books, Peterborough, NH."

Buell, Abel 1762-1805
 Engraver, typefounder
 Killingsworth, New Haven, Hartford, CT

Apprenticed to goldsmith, Ebenezeer Chittenden of East Guilford, CT. About 1762 established his own shop in Killingsworth. 1764 convicted of "Altering Sundry of the Bills of Publick Credit" (forgery of colonial currency). 1770 moved to New Haven; copperplate engraver. 1773/4 produced his first important copperplate engravings. 1775-1778 was forced to abscond from Connecticut because of debt. 1778 he returned, as his debts had been paid by his wife, Aleeta. 1784 achieved his chief work as an engraver in the publication of a wall map (41 by 46 inches) of the territories of the United States according to the Peace of 1783. Through 1799

worked as an engraver in New Haven. 1799 moved to Hartford, worked sometimes as an engraver, silversmith, armorer. 1805-1813 Stockbridge, MA; silversmith, Christian revivalist.

Bufford, J.H. & Sons 1835-1876+
 Engravers, lithographers, publishers of prints
 Boston, MA; Cincinnati, OH; New York, NY

1835-1839 New York; lithographer, publisher. 1840-1850 Boston, John H. Bufford & Co.; lithographer. 1850 associates with Benjamin W. Thayer. 1844-1852 J.H. Bufford & Co. 1851-1873 John H. Bufford; lithographer. 1873-1876+ John H. Bufford & Sons (with Frank G. & John H. Jr.); engravers, lithographers. 1864-1865 Cincinnati, John H. Bufford operated a branch of the company.

Bulwinkle, John M. 1874-1912+
 Stationer
 Fulton Street, Brooklyn, NY

1871 bookkeeper. 1874-1879 342 Fulton St.; stationer. 1880-1912+ 413 Fulton St.; stationer.

Burrill, Nathan 1809-1824
 Bookbinder, bookseller, printer, publisher
 Haverhill Bookstore, Haverhill & Ipswich, MA

1809-1814 Haverhill; bookbinder. 1814 Greenborough & Burrill; publishers. 1814-1818 Burrill & Tileston; bookbinders, booksellers, publishers. 1818-1824 bookseller. 1820-1822 Burrill & Hersey; publishers. 1823-1824 bookseller, printer, publisher. The only record of Burrill doing business in Ipswich is his imprint on a Reward of Merit dated 1821.

C

Canfield & Robins (Philemon & Gurdon) 1811-1852
 Printers, publishers
 Philadelphia, PA; Elizabethtown, NJ; New York NY; Hartford, CT; Rochester, NY

1811-1814 Philadelphia, P.& R. Canfield (Russell Canfield). 1814-1815 Elizabethtown, P.& R. Canfield. 1823-1829 Hartford. 1829-1830 New York. 1834-1840 Hartford. 1844 Canfield & Warren (John & Philemon Canfield and Ansel Warren), Rochester. 1845-1847 Rochester, Canfield & Warren (John, Joseph A., Philemon Canfield and Ansel Warren), Rochester. 1849-1852 Hartford.

Cheney, John 1820-1830+
 Engraver, lithographer
 Hartford, CT; Boston, MA; New York, NY

1820-1825 Hartford with Asaph Willard. 1821 Cheney engraved a Reward of Merit and later that year produced a copperplate engraving made up of 8 Rewards of Merit, each one illustrated with a different animal. 1826 he moved to Boston and was employed by William S. Pendleton, an engraver and lithographer. Abel Bowen was also working at this same establishment. 1828 he produced lithographs while working for Pendleton.

1829-1830 New York City. 1830-1834 In Europe, Paris and London to study art. 1834-1837 Boston. 1840, 1845 in Philadelphia. Later he drew upon stone for some Boston lithographers and in 1854 went to Europe again.

Chicago Lithographing Co. (see Shober, Charles & Co.)

Childs. Sc (Shubal D. Childs Sr. & Jr.) 1837-1864
 Engraver
 Chicago, IL

1837-1864 Shubal D. Childs was joined by his son in 1851. 1864+ Shubal D. Childs Jr.

Clapp & Francis (Joshua B. & Simeon) 1814-1838
 Printers, publishers
 New London, CT; Boston, MA

1814 Vermont? - Joshua Clapp. 1818-1828 New London, Clapp & Francis; publishers. 1836-1838 Boston, Joshua Clapp; printer.

Clark, A. (Asahel) 1825-1835
 Engraver, printer
 various locations, Albany, New York, NY

1825-1835 11 Daniels St., Albany; engraver. 1825-1834 Rawdon, Clark & Co. (with Ralph Rawdon); engravers, copperplate printers. 1828 35 Merchant's Exchange, New York, Rawdon, Wright & Co.; engravers. 1830-1833 11 Daniels St., Albany; engraver. 1834 33 Merchant's Exchange, New York, Asahel Clark; engraver. 1834 35 Merchant's Exchange, New York; Rawdon, Wright, Hatch & Co.; engravers.

Cleis, T.H. 1880s
 Chromolithographer

Cleveland Printing Co. 1887-1920+
 Bookbinders, booksellers, printers, publishers, stationers
 27, 29, 31 Vincent Street, Cleveland, OH

Also known as the Cleveland Printing & Publishing Co., they had offices in Chicago, IL and New York, NY.

**Cochrane & Sampson
(Parker E. & Clarence)** 1873-1890
 Printers
 9, 30 Bromfield Street, Boston, MA

1873-1880 9 Bromfield St. 1881-1884 30 Bromfield St. 1885-1886 30 Bromfield St., Cochrane & Co.; printers. 1887-1890 30 Bromfield St. Cochrane, Parker E.; printer. In the G/M collection is a Reward of Merit that was used as a report card.

Colesworthy, S.H. (Samuel H.) 1829-1875+
 Bookbinder, bookseller, stationer
 69, 92, 96 Exchange, 102 Federal St., Portland, ME

1829 Milk & Exchange St., opened his first bookstore. Over the next 27 years expanded his business and moved several times. 1856 sold business to William B. Stearns who subsequently failed; Colesworthy returned to run the company. 1869 joined by his son Samuel H. Colesworthy Jr. 1875 102 Federal St., Colesworthy Sr.; stationer. 92 Exchange St., Colesworthy Jr.; bookseller.

Collier, Ezra 1822-1828+
Bookseller, circulating library, publisher
Plymouth, MA

1829 Collier formed a partnership with William Sampson Bartlett under the firm name of Collier & Bartlett. For some few years prior to 1828 Collier is thought to have had a small print shop. 1830 Collier & Bartlett firm is dissolved. Collier possibly left Plymouth at this point.

Colton, R. (Rufus) 1823-1836
Printer, publisher
Woodstock, VT; Saint Thomas, Ontario

1823 Woodstock, apprentice to David Watson; printer, publisher. 1823-1826 (with David Watson); printer, publisher. 1826-1830 printer, publisher. 1830 R.& A. Colton (Alonzo, brother to Rufus); printers, publishers. 1830-1832 printer, publisher. 1834-1836 St. Thomas; bookseller.

Colton, Samuel (Horton) 1827-1835
Printer, publisher
Worcester, MA

1827-1829 Samuel H. Colton & Co. 1830-1835 Samuel H. Colton & Co. (with John Milton Earle).

Colton, Zahm & Roberts 1830-1880+
Map makers, publishers and later, chromolithographers
86 Cedar Street, various locations, New York, NY

1830-1850 Joseph H. Colton; map publisher, printer. 1850-1854 86 Cedar St., Joseph H. Colton & George W. Colton; map publishers, printers (presumably his son). 1854-1859 172 Williams St., Charles B. Colton joined George & Joseph, (presumably a second son). 1859-1864 18 Meekham St., George W. Colton. 1863-1864 George W. Colton advertised in city directory as the "author of Colton's maps, atlases." 172 William St., Joseph & Charles continue as chromolithographers. 1864-1868 172 Williams St., George, Joseph & Charles worked together. 1868-1869 172 Williams St., Colton, Zahm & Roberts (Lester A. Roberts & Herman F. Zahm); art publishers. 1869-1872 Colton, Zahm & Roberts; publishers. 1873-1877 Colton, Zahm & Roberts; chromolithographers. 1877-1880 Colton, G.W. & C.B.; publishers.

Cook, David C. 1875-1911+
Publisher.
46 State Street, Chicago, IL

From catalog dated 1911, "Reward Cards with Bible Text," "36th year in business." Cook published Sunday School Reward Cards, some of which were printed with "Lessons" & "Questions" pertaining to biblical teachings.

Cory & Brown (see Cory, Edward) 1831-1832
Booksellers
17 Market Square, Providence, RI

Various affiliations on Market Sq. between Edward Cory, John Cory, William Marshall and John Brown during the mid to late 1830s.

Cory & Daniels (Edward & George) (see Daniels, George)

Cory, Edward 1828-1832+
Bookseller, printer, stationer
various locations on Market Square, Providence, RI

1828-1830 bookseller. 1830-1831 13 Market Sq.; bookseller. 13 Market Sq., Cory, Marshall & Hammond (Edward, William & John); booksellers, stationers. 1832 9 Market Sq., E. & J.W. Cory (Edward & John); book and job printers. 9 Market Sq., Edward Cory; printing office. 19 Market Sq., with John E. Brown; bookstore. 1836-1837 9 Market Sq., with John W. Cory; printer. 1836-1838 19 Market Sq., John E. Brown; bookstore. 1838 1 Market Sq., J.W. Cory; bookseller, publisher. 1841-1842 1 Market Sq., J.W. Cory (with B. Cranston & Co.); bookseller, publisher.

County Bookstore 1840s ?
Booksellers
Barnstable, MA

Cozans, P.J. (Phillip) 1850-1867
Bookseller, stationer
107 and 122 Nassau Street, New York, NY

1850-1856 Nassau St., Phillip J. & Michael T. Cozans both had seperate establishments at various locations on this street & Broadway; booksellers. 1856-1857 107 Nassau St., Phillip J. Cozans; stationer, Michael T. Cozans; bookseller. 1856-1867 Phillip J. & Michael T. Cozans together at 107 and subsequently 122 Nassau St.; booksellers. This name appears at the bottom of a Reward of Merit which also bears the name of "Jos. Laing & Co., N.Y." (see Laing & Co.)

Crocker & Brewster (Uriel & Osmyn) 1818-1826+
Booksellers, printers, publishers
50, 59 Cornhill Square, 47, 51 Washington Street, Boston, MA

1811-1818 Crocker apprentices with Samuel T. Armstrong. 1818-1820 Crocker; printer. 1818-1825 Crocker & Brewster; booksellers, printers, publishers. Both Brewster & Samuel T. Armstrong were silent partners. 1821-1826 New York, Crocker & Brewster; booksellers, printers, publishers.

Cummings & Hilliard
(Jacob A. & William) 1812-1827
Booksellers
No. 1 Cornhill Square, Boston, MA

1812-1823 No. 1 Cornhill Sq., Cummings & Hilliard. 1823-1825 Cummings, Hilliard & Co. (with Timothy H. Carter). 1825-1827 134 Washington St., Cummings, Hilliard & Co. (with Timothy H. Carter & Charles C. Little). 1827 Hilliard, Gray & Co. (with Harrison Gray at same address. (see Hilliard, Gray & Co. for continuation)

Cushing & Appleton (see Cushing, Thomas C.)

Cushing, T.C. (Thomas Croade) 1785-1824
Bookseller, printer, publisher
Essex Street, Salem; Charleston, MA

1785-1786 Charleston, Allen & Cushing (with John Wincoll Allen); publishers. 1786-1790 Salem, Dabney & Cushing (John Dabney); printers, publishers. 1791-1824 printer, publisher. 1794-1797 Cushing & Carlton (William Carlton); booksellers. 1797-1801 bookseller. 1801-1824 Cushing & Appleton (John Sparhawk Appleton); booksellers.

D

Daniels, George (P.) 1830-1847
Bookseller, printer, publisher, stationer
5 Market Square, Main Street, Providence, RI

1836-1838 5 Market Sq.; bookstore. 1841-1842 200 Main St. Daniels specialized in the sale of school books and supplies. He was the most prolific seller of Rewards of Merit in Rhode Island during the 1830s and 1840s.

Day, M. & Co. (Mahlon) 1815-1844
Booksellers, printers, publishers
374-76 Pearl Street, New York, NY

1815-1836 Day & Turner (with Charles Turner). 1837-1844 Mahlon Day & Co.

Dennis, A.L. & Bros. 1838-1877+
Bookbinders, booksellers, lithographers, printers, stationers
248 Broad Street, various locations, Newark, NJ

1838-1852 Alfred L. Dennis; bookseller. 1852 248 Broad St., Alfred L. Dennis; bookseller and Martin R. Dennis; stationer. 1854-1862 A.L. Dennis & Bro., booksellers, stationers. 1862-1865 Martin R. Dennis; stationer. 1865-1877+ Martin R. Dennis & Co. (with Charles H. Ingalls); booksellers, stationers.

Dickinson, S.N. 1830-1857
Printer, typefounder
No. 52 Washington Street, 4 Wilson La., Boston, MA

1830-1845 Samuel N. Dickinson, printer. 1846-1847 Samuel N. Dickinson & Co. (with C.C.P. Moody); printers. 1857-1848 S.N. Dickinson; printer. 1848-1849 4 Wilson La., S.N. Dickinson; typefounder. 1849-1857 Dickinson Type Foundry. Dickinson's imprint appears on a Reward of Merit printed for the "Shurtleff Grammar School, North Chelsea"(MA). (See p. 177.) On his billhead, dated 1845, Dickinson lists "Rewards of Merit."

Dobelbower, James 1870s
Printer
510 Minor Street, Gettysburg, MD

A Reward from the G/M collection has printed across the top of the card, "National Homestead at Gettysburg."

Dodd & Stevenson (Henry & James) 1814-1831
Printers
Salem, NY

1804-1814 Dodd & Rumsey (Henry & David). 1814

Dodd, Rumsey & Stevenson. 1814-1820 Dodd & Stevenson. 1823-1831 Dodd & Stevenson.

Dorr & Howland 1821-1865
(Enos & Southworth Allen)
 Booksellers, publishers
 Worcester, MA

1821-1835 Dorr & Howland; bookbinders, booksellers, publishers. 1831-1842 Dorr, Howland & Co. (with John Coe); bookbinders, booksellers, publishers. 1842-1852 Dorr & Howland; booksellers. 1853-1865 Enos Dorr & Co. (with Asa L. Burbank); booksellers.

Dunbar, F. (Franklin) 1825-1834
 Bookseller, publisher
 Taunton, MA

It is only known that he worked approximately 9 years before his death in 1834.

Durrie & Peck (John & Henry) 1818-1857
(see Peck, Horace C.)
 Bookbinders, booksellers, publishers, stationers
 various locations, New Haven, CT

John Durrie and Henry Peck had separate businesses but went into partnership as Durrie & Peck in 1818 on Church St. 1830 Durrie & Peck listed as doing business at the "Sign of the Ledger" on Church St. After 1830 they moved to a new location at 70 Chapel St., and remained in business there until Durrie died in 1857. 1863 firm was re-organized under the name Peck, White & Peck, the principal partner being Horace C. Peck.

Dutton (see Ide & Dutton)

E

Ela, George W. 1828-1843
 Printer, publisher
 Concord, Dover, NH

1823-1828 apprenticed to Jacob B. Moore. 1828-1829 Dover, George W. Ela & Co. 1830 22 Washington St., Dover. 1830-1831 Ela & Wadleigh (with George Wadleigh). 1831-1833 Concord, McFarland & Ela (with Asa McFarland). 1834-1838 Concord, George W. Ela. 1838-1840 Concord, Ela & Flanders (with John W. Flanders). 1840-1841 Concord, George W. Ela. 1841-1842 G.W. & J.H. Ela (with his cousin, Jacob Hart Ela). 1842 Concord, Ela & Blodgett, (with Augustus C. Blodgett). 1842-1843 Concord, Ela, Blodgett & Osgood, (with John R. Osgood).

Endicott, G & W (George & William)
 359 Broadway, New York, NY 1845-1848

Firm was composed of George and younger brother William, who carried the business on under his own name after George's death in 1848. From 1848-1851 doing business as William Endicott & Co. William died in 1851. From 1852-1886 it continued in business as Endicott & Co., one of the leading lithographic firms in the nineteenth century.

F

Fisher, J. (James Abraham) 1838-1866
 Bookseller
 Boston, MA; New York, NY; Philadelphia, PA;
 Baltimore, MD; Cincinnati OH

1838-1852 71 Court St., Boston; bookseller. 1849-1860 71 Court St., Fisher & Bros. 1849-1860 74 Chatham St., New York, Fisher & Bros. 1860-1861 68 Bowery, Fisher & Bros. 1850-1876 various locations on North and South Streets, Philadelphia. 1863-1864 64 W. Baltimore St., Baltimore, Fisher & Bros. 1865-1866 Fisher & Dennison (Alfred & Thomas). Fisher and family were operating simultaneously out of several cities.

Fisher, J. (John K.) 1820s
 Engraver
 20 State Street, Boston, MA

1825 20 State St.; engraver. Does not appear in city directories, 1822-1823, 1826-1828.

Fisher, W.R. & Co. (see Fisher, J.) 1838-1866
 Publisher, paper manufacturer's warehouse
 22 Pearl Street, Cincinnati, OH

This firm was most likely part of the Fisher family companies which operated as booksellers and publishers in several major cities. (see Fisher, J. and Turner & Fisher)

Flagg & Gould (Timothy & Abraham J.) 1813-1833
 Printers
 Andover, MA

A Reward from the G/M collection was undoubtedly from a Sabbath school; and most probably one from a series of similar Rewards.

Forbes, Del (D.A.) 1830s-1860s
 Printer
 29 Gould Street, New York, NY

During the 1830's, he was also in business as "S. & D.A. Forbes." There were, during this same period, two other Forbes in New York City doing business: 1828-1838 John Forbes; printer. 1833-1867 Elisha Forbes; engraver on wood, engraver, designer. All three never shared the same business address, but there is a high probability that they were related and doing the same type of work.

Foster, Robert 1825-1826

This imprint appears on a Reward of Merit along side the imprint of the "Boston Stereotype" company.

Fouch, A.J. & Co. 1897-1934
 Printers, publishers, manufacturers
 11 Pioneer Street, Warren, PA

"Catalog of School Supplies, Teachers' Supplies, Books, Cards, Etc for the year 1913-1914." This catalog contains several pages describing Rewards of varying types with suggestions as to how they may be used. No Rewards have been found with this company's imprint upon them. They were most likely acting as distributors for Rewards produced by unidentified printers and lithographers.

Francis, David (see Munroe & Francis) 1805-1852
 Bookseller, printer
 18 Hanover Street, various locations, Boston, MA

1805 18 Hanover St.; printer. 1806-1807 Williams Court; printer. 1809 Suffolk Place; printer. 1813 90 Newbury St.; printer. 1821 90 Newbury St., owned and operated "Juvenile Repository and School Book Store;" bookseller. 1825 364 & 366 Washington St.; circulating library.

G

Gallaudet, P.W. 1816-1819
 Publisher
 No. 59 Fulton, Water, John Street, New York, NY

"ANNIVERSARY REWARD, RULES FOR GOOD LIVING, Sunday School Tract, No. III. at his Theological Bookstore. Has for sale, a collection of (various religious books)- Rewards, from 2 1/2 to 6 (cents), Tickets, 12 1/2 cts per 100." This information is from Gallaudet's Sunday School Tract, printed in 1819 by J. Seymour, sold at Gallaudet's Theological Bookstore. No Reward printed by Seymour or sold by Gallaudet has been found. (See p. 98).

Gibson, John 1850-1895
 Lithographer
 Beekman Street, NY; Cincinnati, OH

John Gibson worked in New York doing business as J. Gibson. He had an informal business arrangement with his brothers who described themselves as "Lithographic Publishers" in Cincinnati, Ohio and operated under the name Gibson Litho Co. and Gibson & Co.

Gilman, W. & J. (Whittingham & John) 1793-1851
 Printers, publishers
 Middle, State, Federal, Essex Sts, Newburyport, MA

1793-1803 Whittingham Gilman a printer in Ohio. 1805-1849 W. & J. Gilman (with John Gilman, brother); printers, publishers. They also had an affiliation with Charles Whipple of Newburyport; bookseller. 1849-1851 John Gilman, alone as printer.

Glazier, Franklin 1810-1863+
 Bookbinder, bookseller, publisher, stationer
 No. 1 Kennebec Row, Hallowell, ME

1810-1820 possibly working as bookseller or publisher. 1820-1824 Goodale, Glazier & Co. (with Ezekiel Goodale & Andrew Masters); booksellers, publishers. 1824-1828 Glazier & Co. (with Andrew Masters); booksellers, publishers. 1828-1847 Glazier, Masters & Co.; booksellers, publishers. 1847-1863+ printer, publisher.

Glazier & Masters Co. (see Glazier, Franklin)

Glover, D.L. (De Lay) 1846-1863
 Engraver, photographer
 1846-63 various locations, Boston, MA; Syracuse, NY

1846 25 Merchant's Exchange, Boston; engraver. 1847-1848 Boston; engraver. 1849-1951 1 Summer St., Boston; engraver. 1851-1853 228 Washington St.,

Boston; engraver. 1855 24 Wieting Block, Syracuse, NY; engraver, photographer. 1857-1863 13 Wieting Block; engraver, photographer.

Goss, Sylvester T. 1818-1836
 Bookseller, printer, publisher
 Boston, MA; Haverhill, NH

1818 Boston, Hall & Goss (with Jason Hall); printers. 1818-1819 Boston, Hews & Goss (with Abraham Hews Jr.); printers, publishers. 1819-1820 Boston, printer. 1819-1827 Haverhill; printer, publisher, bookseller. 1830-1836 Boston, printer.

Gould (see Flagg & Gould)

Gray, H.I. 1830s?
 Cumberland, ME

Possibly Harrison Gray of Boston, MA and Portsmouth, NH. Although there are no Maine records of H.I. Gray having been in business there, his Rewards may have been sold in the shop of a Maine bookseller or stationer.

Greenough, M. 1820+
 Publisher
 Lebanon, NH

1820 Tavernkeeper in Lebanon, NH. No other record found.

Griffin, J. (Joseph) 1813-1830
 Bookseller, bookbinder, printer, publisher
 Brunswick, Portland, ME

1813-1819 Andover, MA, apprenticed to Flagg & Gould; printer. 1820 Griffin & Haselton (with B.B. Haselton); booksellers, publishers. 1821 Portland, Griffin & Tappan (with Amos C. Tappan); publishers. 1822 Brunswick, Griffin & Weld (with Charles Weld); booksellers. 1824-1830 Brunswick; publisher. 1873-1874 member of Maine Press Association.

Grogan, M.A. (Michael) 1886-1897
 Lithographer, printer, stationer.
 131 William Street, 62 John St., New York, NY

1886-1892 131 William St. 1893-1897 62 John St. He was likely working in the printing trades prior to 1886.

Guilford, W.O. (William) 1871-1896
 Bookseller, stationer, supplier of school materials
 Bank Street, various locations, Waterbury, CT

1871-1874 56 Bank St., opened a book, stationery, news and toy store. 1875-1876 with brothers, purchased a bindery from Porter & Dean, operated it as Guilford Bros. 1878-1886 business comes into the possession of W.O. Guilford. 1887-1896 joint stock company is formed, business moved to No. 25 Canal St., Arthur H. Tyrell manager, followed by W.O. Guilford. A G/M bookmark with the following advertising copy printed on the back: "Dealer in School & Miscellaneous Books, Reward Cards, Stationery, Fancy Goods & c."

H

Hall & O'Donald (Willard N. & Chas. R.) 1884-1890
 Binders, printers, publishers, stationers
 200-202, 206 4th Street, Logansport, IN

1878 Logansport, Willard N. Hall established a "general printing and publishing" business. 1883-1884 200-202 4th St., Willard N. Hall still listed separately; job printer, bookbinder, blank book manufacturer. Chas. R. O'Donald listed without a business address; printer. 1884 firm of Hall & O'Donald officially formed, although a dated imprint appeared as early as 1882. By 1886 the business was described in "The History of Cass County," as being "one of the most successful enterprises in the city and one of the largest of the kind in northern Indiana." 1889-1890 200-202 4th St.; (and) wholesale and retail stationers.

Hammond, John S. (see Cory & Brown) 1816-1874
 Printer, publisher
 various locations on Market Square, Washington Street, Providence, RI

1816-1828 printer. 1827 Miller & Hammond; printers. 1829-1831 Marshall & Hammond (William & John); printers, publishers. 1830-1832 4 Market, John S. Hammond; printer. Cory, Marshall & Hammond (Edward Cory); booksellers. 1831-1834 Cranston & Hammond (Barzillai Cranston); printers, publishers. 1835-1838 1 Market Sq., John S. Hammond; bookseller, printer. 1838-1842 associated with B. Cranston & Co.; printers. 1838-1842 associated with B. Cranston & John W. Cory; publishers, booksellers. 1841-1842 5 Market, John S. Hammond; bookseller; 1842-1851 grocer. 1851-1867 associated with Knowles, Anthony & Co. (Joseph & Henry B.); printers. 1868-1873 Hammond, Angell & Co. (John & Albert N.); printers, publishers. 1874 printer.

Hammond & Stephens Co. 1894-1994
 Publishers & suppliers of educational forms
 1845 North Airport Road, Fremont, NE

Post card size, stand up die cut Reward, illustrated with a portrait of George Washington, printed in red: "Harold Harden is commended for Punctual and Regular Attendence for two months, and is entitled to this testimonial. Given at Ebro, Minnesota, this 5th day of February, 1926" - "I hope that I shall always possess firmness and virtue enough to maintain what I consider the most enviable of all titles, the character of an honest man."

Harris, Clarendon 1842-1848
 Bookseller, printer
 100 Main Street, Worcester, MA

1842-1848 bookseller, printer.

Harris & Jones (J.G. & E.S.) 1890-1959
 Lithographers, publishers
 31 Pearl Street, various locations, Providence, RI

1890 31 Pearl St.; using the "Huber Rotary Zincographic Press." 1892-1893 78 Westfield St.; agents for Providence Lithographic Co. 1895 102 Westfield St., Harris, Jones & Co.; publishers. 1906-1959 353 Prairie Ave., Harris, Jones & Co.; publishers. The examples in the collection are Sunday school Rewards of Merit.

Harris, J.H. (John Holmes) 1827-1860
 Printer, publisher
 Ipswich, Boston, MA; Bath, ME

1827-1828 Ipswich; printer, publisher. 1832-1833 Bath; printer, publisher. 1843-1860 Boston; printer.

Hawes, Noyes P. 1829-1873
 Bookseller, bookbinder, publisher, stationer
 High & Market Street, Belfast, ME

1829 Corner of High & Market St., Hawes took over Fellowes & Simpson (first book and stationery store in Belfast) and then operated a bookstore and circulating library there. 1830 17 Main St., sold "superfine beaver hats." 1831 purchased book bindery. 1871, 1873 Exchange St., Portland, in business as Bailey & Noyes; bookbinders, booksellers, stationers.

Hayes 1840s ?
 Printer

Hebberd & Co. 1880s
 Stationers ?
 31 Broadway, New York, NY

A G/M card was published by Ogilvie & Co., and another one quite similar was published with the Ogilvie & Co. imprint. Hebberd and Co. glued their label over the Ogilvie & Co. imprint. "At from 40 cents to $2 per hundred. The usual price of our handsome cards, which we sell at 75 cents per hundred, is $2. Send 30 cents for a full set of samples."

Herline (see Thurston & Herline)

Herrick, W. & C.K. (William &...) 1846-1863+
 Chromolithographers, engravers
 Manchester, NH; New York, NY

1846-1847 Manchester; William Herrick; engraver. 1848 moved to New York. 1862 W. & C.K. Herrick. (C.K. was probably the brother of William); chromolithographers. Later, William moved to San Francisco and subsequently went into insurance. The imprint of W. & C.K. Herrick, has been found printed on a gold band around a package of 8 Rewards of Merit, entitled, "THE GEM REWARDS" dated 1863, all of which are illustrated with Biblical scenes. The same imprint is also found on a group of chromolithograph Rewards of Merit showing children at play. (See pages 86 & 87).

Hill, Horatio & Co. 1829-1834
 Bookseller, printer
 Main Street, No 1. Hill's Block, Concord, NH

1829-1834 Hill & Barton, printers of the "New Hampshire Patriot."

Hilliard, Gray & Co. (William & Harrison) 1827-1842+
Booksellers, publishers, stationers
112, 134 Washington Street, various locations, Boston, MA

1827-1831 advertisements for Boston Type and Stereotype Foundry note that orders can be left at Hilliard, Gray & Co. 1843-1846 Harrison Gray continues with T.H. Webb; booksellers.

Hilliard (William) (see Cummings & Hilliard)

Hinds, Justin 1798-1840
Bookseller
Walpole, Hanover, NH

1798-1808 Walpole. 1808-1840 Main St., Hanover.

Holcomb, J.R. & Co. 1873-1881+
Printers, publishers
Mallet Creek, OH

1865-1872 J.R. Holcomb followed a variety of pursuits including house painting. 1873 York Center, established a card printing business. 1875 published bi-monthly "The Teacher's Guide," a school journal. 1879 formed the partnership "J.R. Holcomb & Co." (with J.D. Holcomb). 1880 Charles Holcomb admitted to the partnership - "The Teacher's Guide" became a monthly publication and enjoyed a wide circulation. 1881+ continued operating as a large printing & publishing business. Publishers of a Reward of Merit entitled "A Gift Of Remembrance."

Hoogland, William 1814-1841
Engraver
New York, NY; Boston, MA

1814-1821 New York. 1821-1828 Boston, working with Abel Bowen. 1828-1841 New York.

Howe, E.D. (Eber) 1822-1836+
Printer
Painesville, OH

1822-1836 Howe was the publisher of "The Painesville Telegraph."

Howland, Henry J. 1835-1864
Printer
175, 171, 212 Main Street, Worcester, MA

Howland, S.A. (see Dorr & Howland) 1842-1852
Bookseller, publisher
Worcester, MA

Hoyt, Fogg & Breed 1871-1873+
(Edward, Samuel & Lewis C.)
Booksellers, stationers
337 Congress, 92 & 193 Middle Sts., Portland, ME

1868-1871 337 Congress St., Hoyt & Fogg, listed as the Maine Sabbath School Depository, Wholesale & Retail. 1871-1873 Hoyt, Fogg & Breed. 1875-1886 Hoyt, Fogg & Donham, (Greenville M. Donham).

Hubbard, John F. 1816-1847
Publisher
Norwich, NY

1816-1828 publisher. 1828-1834 publisher with Ralph Johnson. 1834-1847 publisher. Apprenticed to H. & E. Phinney, printers at Cooperstown, NY.

Hubbard & Johnson (see Hubbard, John F.)

Huntington, Eleazor 1816-1841
Engraver, publisher
Main, Charter Street, Hartford, CT

1816 came to Hartford from New York City, also worked engraving maps with Asaph Willard. 1821 "Huntington & Pelton, Bank-note Engravers, Die Sinkers and Printers." 1828 Main St.; engraver and copperplate printer. 1838-1841 8 Charter St.; engraver.

Hutchins, John (see Miller & Hutchins)

Hutchinson, E. 1818-1851
Printer
Hartford, Woodstock, VT

1818-1827 Hartford; printer. 1829-1851 Woodstock; printer.

Hyde, William (see Shirley & Hyde)

I

Ide & Aldrich (see Ide, Simeon)

Ide & Dutton (Lemuel N. & Edward P.) 1846-1869
Booksellers, publishers
102, 106, 138 1/2, 135, 140 Washington Street, Boston, MA

1846-1849 138 1/2 Washington St., Lemuel N. Ide listed but no profession stated. 1849-1852 138 1/2 Washington St.; bookseller, publisher. 1853-1857 106 Washington St., Ide & Dutton; booksellers, publishers. 1858-1864 106 Washington St., Edward P. Dutton & Co.; booksellers. 1865-1869 135 Washington St., E.P. Dutton & Co. (with Charles A. Clapp); booksellers. 1858 Lemuel N. Ide no longer listed, but Edward P. Dutton & Co. is formed (with Charles A. Clapp). 1865 E.P. Dutton & Co.; booksellers.

Ide, Simeon 1812-1868
Publisher
various locations, VT; NH; MA

1809-1812 Windsor, VT, apprenticed to Oliver Farnsworth; printer. 1812-1813 Windsor, VT; printer in "Washingtonian" office. 1813-1814 Brattleboro, VT; printer in William Fessenden's office. 1814-1815 Rutland, VT; printer (with Major William Fay). 1815-1816 New Ipswich, MA; printer, publisher, bookseller. 1816-1817 Brattleboro, VT; printer. 1817-1818 Brattleboro, VT; printer, publisher. 1818-1821 Windsor, VT; Ide & Aldrich; publishers. 1821-1832 Windsor, VT; publisher. 1832-1834 Windsor, VT, Ide & Goddard; publishers. 1835-1838 Claremont, NH; printer, paper manu-

facturer, bookbinder. 1862 Auburn, NY; paper mill operator. 1862-1864 New York City; typesetter & stereotyper. 1864-1868 Claremont, NH; printer.

J

Jackson Daily Citizen Print. 1837-1905
Publishers
Mechanic Street, Tompkins, MI

"Card of Honor" for the "Model Scholar," privately printed for "W. Irving Bennett, County Superintendent" from Jackson County. Another example with "1882" written over a printed "187.." is entitled "Card of Merit."

Jocelin, N. (see Jocelyn, Nathaniel)

Jocelyn, N. & S.S. 1818-1843
Engravers
New Haven, CT

1818-1843 Nathaniel Jocelyn went into business with his brother Simeon Smith Jocelyn in 1818 and formed N. & S.S. Jocelyn. (See p. 20).

Jocelyn, Nathaniel 1813-1843
Engraver
New Haven, CT

1813 studied engraving under George Munger. 1816 entered into partnership with Tisdale, Danforth and Willard in the Hartford Bank Note and Engraving Co. 1818-1843 in partnership with his brother, Simeon Smith Jocelyn. Nathaniel became a portrait painter in 1820 and exhibited at the National Academy in 1826. (see Jocelyn, N. & S.S.) 1823 Nathaniel Jocelin legally changed name spelling to Jocelyn.

Johnson, Ralph (see Hubbard, John F.)

Jones (see Harris & Jones)

K

Knapp & Rightinyer (Joseph F. &...) 1840s-1856+
Lithographers
New York, NY

Knapp's imprint is found on a large Reward of Merit, done specifically for the Ward School in New York City. Although drawn by Knapp it was lithographed by David McLellan and published by Leavitt & Allen. This work was done prior to his joining the firm of Sarony & Major in 1856, then becoming Sarony, Major & Knapp.

Knowlton & Rice 1825-1854
(George Willard & Clark)
Printers, publishers, booksellers, papermakers
Watertown, NY

1825-1853 printers, publishers, booksellers. 1854 papermakers. 1854 Knowlton retires.

Kronheim (see Wemple & Kronheim)

L

Laing, Jos. & Co. 1850-1870+
 Engravers, lithographers
 66, 117 Fulton Street, New York, NY
Laing listed himself as a lithographer and sometimes in later years as an engraver. He worked as Joseph Laing, Joseph Laing & Co. or Laing & Laing. On a Laing Reward, the following appears at the bottom: "PUBLISHED BY P.J. COZANS, 107 NASSAU ST. NEW YORK."

Laing & Laing (see Laing, Jos. & Co.)

Laughlin, A.S. 1870-1908
 Engraver, stationer (watchmaker, optician)
 1 Chapel Block, Main Street, Barnet, VT
In the G/M collection is a "Weekly Report Card" with the following advertising copy printed on the back: "A full supply of Rewards, Deportment Cards & Envelopes."

Lazell, Warren 1844-1850
 Bookseller
 177 & 205 Main Street, Worcester, MA
Lazell sold Rewards of Merit published by Dorr, Howland & Co. These Rewards of Merit, although identical to the Dorr, Howland & Co. Rewards do not have their names imprinted on them, instead, Warren Lazell's name appears on the reverse. (see Dorr, Howland & Co.)

Leavitt & Allen (George A. & John K.) 1852-1862
 Booksellers, printers
 27 Day Street, various locations, New York, NY
Both Leavitt & Allen had separate bookstores in New York City before their affiliation. Leavitt had a previous affiliation with John F. Trow (Leavitt, Trow & Co.). Previous to George Leavitt, there was a Jonathan Leavitt operating a bookstore at the same location which George would eventually have, presumably, Johnathan was the father. They published Rewards of Merit printed with the following credit: "Designed and Written by Knapp and Rightinyer," (see Knapp and Rightinyer) and "Lithographed by David McLellan." (see McLellan, D.)

Lincoln & Edmands 1809-1834
(Ensigns & Thomas Jr.)
 Booksellers, printers
 53 Cornhill Square, 59 Washington St., Boston, MA
1809 53 Cornhill Sq. 1825-1834 59 Washington St.

Livingston 1870's
 Printer
This imprint appears on a Reward of Merit printed specifically for the "Manchester Public School."

Loomis (Loomis Foundry) 1811-1849
(George Jepson Loomis)
 Bookbinder, bookseller, printer, publisher
 Albany, NY
1811-1815 bookbinder. 1815-1830 G.J. Loomis & Co.; bookbinder. 1830-1849 bookbinder, bookseller, printer. 1850 business sold.

Loring, James 1793-1848
 Printer, bookseller
 Spring Lane, various locations, Boston, MA
1793-1798 operated a type foundry in the Spring La. district of Boston as Manning & Loring, (William Manning). 1798 James Loring; printer. 1800 Water St.; printer. 1806-1813 Spring La.; printer. 1800-1813 Manning & Loring (William Manning); booksellers. 1816-1823 2 Cornhill Sq., James Loring; printer, bookseller. 1826-1828 132 Washington St.; bookseller, printer. 1829-1848 132 Washington St.; bookseller. After 1852 there was a firm named J. Loring & Son doing business in Boston, but no trade was found listed with it.

M

Magnus, Charles 1850-1900
 Lithographer
 New York, NY; Washington, DC
1854-1868 12 Franklin St., NY. 1858-1865+ 520 7th St., Washington, DC. 1869-1871 138 Canal St., NY. 1872-1873 550 Pearl St., NY. 1884-1898 1 Chambers St., NY.

Manning & Loring (William & James) 1796-1813
(see Loring, James)
 Booksellers, printers
 Spring Lane, Boston, MA
1796-1800 Spring La.; printers. 1803-1813 2 Cornhill; booksellers, printers. It would appear that after 1813 James Loring took over the business.

Marshall & Brown 1832-1837+
(William & John Edwin) (see Cory, Edward)
 Booksellers, printers
 19 Market Square, Providence, RI
1832 Marshall & Brown; bookstore. 1836-1837 Marshall, Brown & Co. (John E. Brown); booksellers. 1836-1837 William Marshall & Co.; printers.

Marshall, William (see Marshall & Brown) 1828-1836+
 Bookseller, printer
 19 Market Square, Providence, RI
1828 4 Union St.; printer. 1830-1832 12 Market Sq.; printer. 1836-1837 19 Market St., William Marshall & Co.; Marshall, Brown & Co. (Charles Brown & others); printers. 1836 Marshall, Brown & Co.; booksellers.

Mass. S.S. Society Depository 1820s
 No. 13 Cornhill Square, Boston, MA
A G/M example from the Massachusetts Sabbath School Society Depository is a "Sunday School Certificate."

Maverick, Peter (Jr.) 1832-1845
 Engraver, lithographer
 various locations, New York, NY
1832-1833 409 Broadway. 1835-1836 29 Sullivan St. 1836-1837 60 Sullivan St. 1843-1844 60 Thompson St. 1843-1845 7 Laurens St. Peter Maverick Jr. was the son of engraver and copperplate printer Peter Maverick.

Mayer, Ferdinand & Co. 1845-1877
 Lithographers
 various locations, New York, NY
1846-1847 35 Beekham St., Nagel & Mayer. 1848-1849 3 Spruce St., Ferdinand Mayer & Co. 1849-1850 4 Spruce St., Ferdinand Mayer & Co. 1850-1853 93 Williams St., Ferdinand Mayer & Co. 1855-1877 35, 96, 98 Fulton St., Ferdinand Mayer & Sons.

Mayer, Merkel & Ottman 1875-1885
(Vincent, Augustus & J.)
 Lithographers
 various locations, New York, NY
1869-1870 141 Fulton St., Mayer & Merkel. 1871-1874 22-24 Church St., Mayer & Merkel. 1874-1878 24 Church St., Mayer, Merkel & Ottman. 1879-1885 23 Warren St., Mayer, Merkel & Ottman. 1886-1906 Puck Building at 39 E. Houston St., Ottman Lithographic Co.

McIntosh, W.C. 1883-1891
 Importer, jobber, manufacturer, publisher
 116 Orange, Center Street, New Haven, CT
1883-1891 consistently advertised the sale of "Sunday School Reward Cards" in addition to other "chromo advertising (and holiday) cards." The company name appears on a wrapper holding a group of chromolithograph Rewards of Merit. The Rewards have no imprint upon them, but the wrapper's label is imprinted: "25 Reward Cards (Day School) No. 501, W.C. McIntosh, Publisher."

McLellan, D. (David) 1851-1866
 Lithographer, some wood engraving
 26 Spruce, 55 Beekham Street, New York, NY
1851-1858 26 Spruce St.; lithographer. 1855-1864 David McLellan & James McLellan. 1864-1866 David McLellan & Brothers (with James & John McLellan). 1868-1870 J.R. McLellan Lithographers. 1871 John McLellan.

Merkel (see Mayer, Merkel & Ottman)

Merriam, Charles (see Merriam G. & C.)

Merriam & Co. (see Merriam, Ebenezer)

Merriam, E. & G. (see Merriam, Ebenezer)

Merriam, Ebenezer 1798-1858
 Bookbinder, printer, publisher
 Brookfield, MA
1798-1818 E. Merriam & Co. (with Dan Merriam, brother). 1818-1823 E. Merriam & Co. (with Dan & George Merriam). 1823-1831 E. & G. Merriam (with George Merriam, his brother). 1831-1858 Ebenezer Merriam.

Merriam, G. & C. (George & Charles) 1831-1875
(see Merriam, Ebenezer)
 Bookseller, printer, publisher
 West Springfield, MA

Merriam, Moore & Co. 1843-1867
(William & Homer Merriam, Ransom B. Moore)
 Bookbinders, booksellers, publishers, stationers
 9 & 10 Cannon Place, Troy, NY

1843-1847 W. & H. Merriam (William & Homer); bookseller. 1847-1850 Merriam Moore & Co. (William & Homer Merriam & Ransom B. Moore); booksellers, publishers, stationers. 1851-1856 Merriam, Moore & Co. (Homer Merriam & Ransom B. Moore); booksellers, stationers. 1857-1858 Merriam, Moore & Co. (Homer Merriam, Ransom B. Moore & Henry B. Nims); booksellers, stationers. 1858-1867 Moore & Nims (Ransom B. Moore & Henry B. Nims); booksellers. Letterhead dated 1850, advertising to sell School Rewards, along with books, ink, pencils, cards and almanacs.

Miller & Hutchens (John & John) 1815-1826
 Bookbinders, booksellers, printers, publishers
 various locations, Providence, RI

1813-1814 Miller & Mann (William M. Mann); printers, publishers. 1814-1815 Miller, Goddard & Mann (William G. Goddard); printers, publishers. 1815-1823 Miller & Hutchins (John Hutchins); booksellers, printers, publishers. 1823-1834 for a short time in 1826, did business as Miller & Grattan (Edward Grattan); printers, publishers. 1834-1836 John Miller & George Paine; printers, publishers.

Mirick, C.A. (Charles A.) 1830-1841+
 Printer
 West Brookfield, Worcester, MA

Worcester, Mirick & Bartlett (with Ephraim Bartlett). 1839 C.A. Mirick. 1841 West Brookfield, C.A. Mirick & Co.

Mudge & Corliss (Alfred & Horatio A.) 1848-1849+
 Printers
 12 School Street, various locations, Boston, MA

1840-1842 12 School St., Mudge & Evans (Alfred & John D.); printers. 1843-1853 21 School St., Alfred Mudge; printer. 1848-1849 21 School St., Mudge & Corliss; printers. 1854-1857 21 School St., Mudge & Son (Frank H.); printers. 1858-1883 34 School St., Mudge & Son; printers. 1884-1904 located at 24 Franklin St.; printers. 1905-1908 24 Franklin St., Mudge & Son, Frank D. Allen; assignee printers. 1909-1911 55 Franklin St., The Mudge Press (Frank H.); printers. The Reward used at the "Franklin School," printed specifically for use there.

Munroe & Francis (Edmund & David) 1802-1853
(see Francis, David)
 Booksellers, printers
 various locations, Boston, MA

1802 Half-Court St.; printers. 1803 71 State St.; printers. 1805-1807 Court St.; printers. 1810-1821 4 Cornhill Sq.; booksellers. 1821-1823 4 Cornhill Sq.; booksellers, printers. 1825-1840 128 Washington St.; printers, booksellers. 1841-1842 Devonshire, corner of Spring La.; booksellers, printers. 1843-1846 Devonshire St. 1846-1853 Devonshire, cor. of Water St. In the 1830's David

Francis operated a circulating library and the bookstore.

Murphy (John) 1837-1876+
 Bookseller, printer, publisher, stationer
 146 & 178 Baltimore St. and other locations on
 Baltimore Street, Baltimore, MD

1837-1839 Murphy & Spaulding. 1840-1876+ working either alone or as John Murphy & Co.

N

Nelson, T. & Sons 1880s
 London; Edinburgh; NY

A Reward used as a sample and imprinted "Picture Reward Cards," pasted to a package.

Newton & Tufts (Walter & ...) 1850s
 Printers, publishers

Newton was also a paper manufacturer. No record of Tufts.

O

Ogilvie & Co. 1880-1994
 Publishers
 Rose Street, New York, NY

1880 29 Rose St., John S. Ogilvie, J.S. Ogilvie & Co.; publisher. 1881 25 Rose St., and 1882-1883 31 Rose St., both listed. 1885 31 Rose St., both listed; books. 1886 31 Rose St., both listed; 1887-1888 57 Rose St., both listed. 1889-1908 57 Rose St., John S. Ogilvie; publisher. 1909-1938 57 Rose St., John S. Ogilvie Publishing Co. 1938-1994 various locations in Brooklyn and New York.

The collection contains, in addition to a Reward of Merit, an advertising card for Rewards of Merit. This card has a temperance illustration on it. (see Hebberd & Co.) On the card also appears the following advertising copy: "We desire to call attention to our fine assortment of Reward Cards, suitable for distribution in Sunday School classes. The gift of a handsome card with a scripture Text on it, from a teacher to a scholar, is often the means of doing great work. Our prices are very low, ranging from 40 cents to $2. per hundred. A full set of Samples, comprising of 40 cards will be sent for 30 cents."

Oliphant & Skinner (see Skinner)

Orr, N. & Co. (Nathaniel) 1844-1878+
 Engravers
 75 Nassau, 52 John Street, New York, NY

1844-1846 engravers as Nathaniel Orr & Co. (with his older brother, John William Orr). 1848 in partnership with James Richardson. 1849-1878+ worked as an engraver independent of Richardson. During the 1850's he was one of the leading wood engravers in the country and his work appeared in many of the books and periodicals of the time.

Ottman (see Mayer, Merkel, & Ottman)

P

Patten & Co. (James Madison) 1840-1845
 Printer, publisher
 53 & 68 Orange Street, New Haven, CT

1840-1845 printer & compiler of the New Haven City Directories. 1844-1845 editor, publisher of the "Farmer's Gazette."

Peck, Horace C. (see Durrie & Peck) 1842-1867
(see Smith & Peck)
 Bookseller, publisher, stationer
 NE 3rd & Mulberry; 113 N 3rd Sts, Philadelphia, PA

1842-1845 Smith & Peck (with Cornelius Smith); booksellers, stationers. 1846-1858 Horace C. Peck; bookseller, stationer. 1859-1862 Peck & Bliss (with Theodore Bliss); booksellers, publishers, stationers. 1863 NE 3rd St. Theodore Bliss & Co. continue at the same address. 1863 Horace Peck moves to New Haven, CT to purchase and reorganize the firm of Peck, White & Peck the successors to Durrie & Peck. 1867 Horace Peck retires and firm is taken over by his son, Henry H. Peck.

Phelps, A. (Ansel) 1811-1855
 Bookseller, printer, publisher
 various locations, Greenfield, MA

1811 printer, publisher. 1812-1823 Denio & Phelps (John Denio); booksellers, printers, publishers. 1815-1817 bookseller, printer, publisher. 1823 A. Phelps & Co. (with Jonathan A. Saxton); printers, publishers. 1823-1824 bookseller. 1823-1824 Phelps & Saxton; printers, publishers. 1824-1827 bookseller, printer, publisher. 1827-1829 Phelps & Clark (Alanson Clark); printers, publishers. 1827-1829 bookseller. 1829-1841 Phelps & Ingersoll (Charles J.J. Ingersoll); printers, publishers. 1829-1837 bookseller. 1841-1847 S.S. Eastman & Co. (Samuel S. & George S. Eastman); printers, publishers. 1847-1848 C.J.J. Ingersoll & Co. (Charles J.J. Ingersoll); printers, publishers. 1848-1849 Phelps & Rice (Levi W. Rice); booksellers. 1849-1868 S.S. Eastman & Co. (Samuel S. Eastman); printers, publishers. 1853-1855 Phelps & Ingersoll (George L. Ingersoll); booksellers.

Phillips, Smyth & Van Orden Printers 1901-1905
 Bookbinders, lithographers, printers, publishers
 Clay, Sacramento Street, San Francisco, CA

1901-1904 508 Clay St. 1905 511 Sacramento St., Phillips is no longer with the company but is a printer at this address.

Phinney, Elihu 1807-1854
 Bookseller, publisher
 various locations, Otsego, Cooperstown, Buffalo, NY

1807-1813 Otsego, H. & E. Phinney (with Henry Frederick Phinney, brother of Elihu); booksellers, publishers. 1813-1814 Cooperstown, H. & E. Phinney (connected with Israel W. Clark). 1814-1849 Cooperstown, H. & E. Phinney. 1849-1854 Cooperstown, Buffalo, Phinney & Co. (Henry & Elihu).

Phinney, H. & E. (see Phinney, Elihu).

Prang, Louis et al 1856-1897
 Lithographer
 various locations, Philadelphia, PA; Boston, MA
1856 Philadelphia, Rosenthal, Duval & Prang. 1857-1860 14 Kirby St. Boston, Prang & Mayer. 1861-1862 34 Merchants Row. 1863-1868 159 Washington St. as Louis Prang & Co. 1869-1874 2182 Washington St. 1875-1897 286 Roxbury St.

Presser, Theodore & Co. 1883-1950s
 Music and magazine publisher
 1004 Walnut, various locations on Chestnut Street,
 Philadelphia, PA
1883 he started his publishing career by producing his magazine "The Etude" in order to increase the public's awareness of and access to piano music. 3000 copies were sold the first year and by 1926, 50 million had been sold. He thrived as music publisher at the following addresses: 1885-1886 1004 Walnut St.; 1887-1888 1704 Chestnut St. 1889-1890 1704 Chestnut St.; 1892-1893 1704 Chestnut St.; 1894 1706 Chestnut St.; 1896-1897, 1900 1708 Chestnut St.; 1901 1708 Chestnut St. 1903-1918+ 1708, 1710, or 1712 Chestnut St.; Presser was the best known music publisher in post Civil War Philadelphia. Rewards of Merit published by his firm were advertised in "The Etude." 1896 he advertised 68 different "composer cards;" these were not Rewards of Merit, but post cards. 1900 he advertised 13 "Reward Cards;" each was illustrated with: the bust of a famous composer, a view of the home in which he was born, a few measures of his music, his autograph and a very brief biography. 1911 he advertised 14 "Reward Cards" and a "Music Prize Card" which came in its own special envelope. The "Music Prize Card" was awarded to the student after the 14 "Reward Cards" had been earned. 1915 he advertised 16 "Reward Cards." In later years, more cards were added. (See pages 194 & 196).

Purse, Edward J. 1858-1868
 Printer
 102 Bryan, 6 Whitaker Street, Savannah, GA
May have been working prior to 1858. One of the G/M Rewards was specially printed for the schools in Savannah, Georgia. It states: "Public Schools, Savannah. Boy('s) Grammar."

R

Rand & Avery 1853-1876+
(George C. & Abraham Avery, Jr.)
 Printers, publishers
 Cornhill Square, 117 Frankiln Street, Boston, MA
1842 George C. Rand. 1843-1852 3 Cornhill, George C. Rand & Co. 1852-1856 3 Cornhill, using their own names seperately at the same address. 1856-1866 3 Cornhill, Avery & Rand. 1866-1870 Avery & Rand (with Orrin F.

Frye also). 1870-1873 Avery, Rand & Frye. 1874-1876+ Rand, Avery & Co. (with Samuel Johnson, John C. Rand & George C. Rand). Rand & Avery imprint appears on a Reward of Merit, printed for the Hancock School.

Reed, Abner 1797-1825+
 Engraver, painter, printer
 various locations, NY; CT
1792 awarded a contract to produce the first bank-note plates for the newly incorporated Hartford Bank, the second oldest bank in New England. He was one of the first bank-note engravers in the country. 1793-1794 Albany, NY; teacher. 1797-1803 East Windsor, CT; engraved many plates for Hudson & Goodwin. 1803-1808+ Hartford, Reed & Stiles (Samuel); engravers. Did engraving for John Law, New York City. 1811-1821 East Windsor, CT; engraver. 1821-1827 East Windsor, Reed & Stiles. 1825 Stiles opened shop in Utica, NY, Reed handled firm's New England business. 1828-1847 East Windsor; engraver. 1820-1850 engraved sporadically. 1847-1851; New York City; engraver. 1851-1856 Toledo, Ohio; engraver.

Rice, L.L. 1830s
 Printer
In the G/M collection is a Reward typeset with the teacher's name. The practice of printing Rewards of Merit for a specific teacher was unusual.

Roberts, R. (Robert) 1841-1850
 Engraver
 various locations on Nassau Street, New York, NY
1841-1844 70 Nassau St.; wood engraver. 1845 150 Nassau St.; wood engraver. 1846, 1848-1849+ 150 Nassau St.; engraver.

A 4.5 inch by 6 inch illustration in a G/M Reward was not designed specifically as a Reward of Merit, but has been found several times used as such. This example is a single sheet which shows both the engraver's name plus that of the publisher, Turner & Fisher (of MA; MD; NY; PA; OH). (See p. 34). Upon this Reward is written "Merit of Reward, for Table." The word "Table" in this case most likely means the Ten Commandments, or perhaps a table of numbers or laws; this Reward of Merit was given for the recitation of either. (see Turner & Fisher)

Robinson, Lewis 1816-1845
 Bookseller, map publisher,
 merchant, manufacturer
 various locations, VT; OH
1816-1845 Weathersfield, VT worked in the office of Isaac Eddy, called himself Lewis Roberson. 1823-? South Reading, VT; all trades listed. 1836-1845 Akron, OH (with Samuel & Levi Manning); bookseller, map publisher. 1844-1845 Stanstead, Quebec, Canada, L. Kingsley & Co.; booksellers, map publishers.

Russell & Cutler (see Russell, John)

Russell, John 1784-1823
 Publisher, printer
 Springfield, Boston, MA; New York, NY
1784-1785 Springfield, Brooks & Russell; publishers. 1785-1786 Springfield, Stebbin & Russell; publishers. 1787 Springfield, Russell & Webster; publishers. 1788 New York; publisher. 1795-1796 Boston, J.N. Russell; publisher. 1796-1800 Boston, John Russell & Co.; printers, publishers. 1800-1813 Russell & Cutler; printers, publishers. 1813-1818 Boston, Russell, Cutler & Co.; publishers. 1818-1823 Boston, Russell & Gardner; publishers. 1823 Maine; retired.

S

Saint Mary's Seminary of Saint Sulpice 1805-1821+
 attached to Saint Mary's Church
 & Chapel, Baltimore, MD
In 1805 a manuscript Reward of Merit was given, glued to the frontispiece of Captain Cook's "Three Voyages." In 1821, a printed Reward of Merit appears, inserted in the "Prize Book" Weem's "Life of George Washington."

Sampson (see Cochrane & Sampson)

Seibert, M.W. (Martin W.) 1853-1900
 Lithographers
 various locations, New York, NY
1853 121 Fulton St., Henry Seibert; lithographer. 1854 120 Fulton St., Henry Seibert; lithographer. 1860 93 Fulton St., Henry Seibert; lithographer. 1861-1868 93 Fulton St., Henry Seibert & Brothers. 1869-1879 182 Williams St., Henry Seibert & Brothers; lithographers. 1879-1892 12 and 14 Warren Streets. 1893 Rose St. corner of New Chambers. 1894-1900 411 Pearl St.

Seibert, M.W. (Martin W.) 1854-1885
 Job printer
 various locations, New York, NY
1854-1859 17 N. William St. 1860 20 N. William and 223 William St. 1861 Centre and Reade Streets. 1862 Reade and Centre Streets, Matthew Seibert; job printer. 1863 28 Centre St., Matthew W. Seibert; job printer. 1864 28 Centre St., Martin W. Seibert. 1865-1869 5 Frankfort St. 1870 28 Frankfort St. 1871-1883 26 Frankfort St. 1884-1885 24 N. William St. A large 8″ x 12″ Reward of Merit, printed for the Hoboken Academy in New Jersey.

Shepard, C. & Co. 1835-1864+
 Bookseller, stationer
 various locations, New York, NY
1835-1836 189 Broadway; bookseller. 1837-1841 262 Broadway; bookseller. 1842-1843 253 Pearl St.; bookseller. 1844-1846 191 Broadway; bookseller. 1847-1849 189 1/2 Broadway; bookseller. 1851-1862 151 Fulton St.; stationer. 1863-1864 440 Broadway; stationer. 1866-1868 A. or Alex. C. Shepard at the same address as Chauncey Shepard, possibly his son.

Shirley, Arthur 1804-1864
Printer, publisher
No. 3 Mussy's Row, Exchange Street, Portland, ME

1804-1805 Jenks & Shirley (with William Jenks, Jr.); printers. 1808-1814 publisher. 1814-1819 A. & J. Shirley (with Joshua Shirley); publishers. 1819-1825 printer, publisher. 1815-1826 Shirley & Edwards (with John Edwards); printers, publishers. 1827-1830 (with William Hyde); printers, publishers. 1830 Shirley, Hyde & Co. (with William Hyde & ?); printers, publishers. 1831-1842 printer, publisher. 1842-1851 Arthur Shirley & Son (with George H. Shirley); publishers. 1851-1864 publisher.

Shirley & Hyde (see Shirley, Arthur)

Shober & Carqueville Litho Co. (see Shober, Charles)

Shober, Charles & Co. 1856-1883
Lithographers
various locations, Philadelphia, PA; Chicago, IL

1856-1857 Philadelphia. 1858-1860 in partnership with Charles Reen. 1860-1883 Shober & Carqueville Lithographing Co. (with Edward Carqueville). 1870-1878 also dba Chicago Lithographing Co. 1878-1883 Shober associated with Chicago Bank Note Co.

Shores, James (Sr. & Jr.) 1812-1857
Booksellers, stationers
Daniel Street, Portsmouth, NH

1812-1814 James F. Shores & Co. (with Charles Peirce). 1815-1836 bookseller. 1836-1857 James F. Shores & Son (with James F. Shores, Jr.).

Simpkins, N.S. (Nathaniel) 1820-1831
(see Simpkins, S.G.)
Bookbinder, bookseller, stationer
23 Court Street, various locations, Boston, MA

1820 23 Court St.; bookseller. 1825 104 Hanover St.; owned and operated the Suffolk Circulating Library. 1821-1826 1 Brattle St.; bookbinder, bookseller, stationer. 1827-1831 Nathaniel S. Simpkins & Co. (with Samuel G. Simpkins).

Simpkins, S.G. (Samuel) 1827-1831+
(see Simpkins, N.S.)
Bookseller, stationer
Simpkin's Bookstore, Court Street, Boston; Barnstable, MA

1827-1831 listed in business with his brother N.S. Simpkins. Rewards of Merit are found with either brother's imprint alone.

Skinner, Thomas M. 1814-1839
(see Oliphant & Skinner)
Paper manufacturer, printer, publisher
New London, Colchester, CT; Auburn, NY

1814 New London; printer. 1814-1815 Colchester, Thomas M. Skinner & Co. (probably with Fredrick W. Prince); printers. 1816-1817 Auburn, NY, Skinner & Crosby (with William Crosby); printers, publishers.

1817-1818 Auburn, NY; printer, publisher. 1819 Auburn, NY (with Augustus Buckingham); printers, publishers. 1819-1821 Auburn, NY (with Fredrick W. Prince); printers, publishers. 1822-1824 Auburn, NY; printers, publishers. 1824-1825 Auburn, NY, (with G.A. Gamage). 1826-1832 Auburn, NY; printer, publisher. 1829-1837 Auburn, NY; paper manufacturer as the Auburn Paper Mill and as Skinner & Hoskins (with George Skinner & Ebenezer Hoskins); printers, publishers. 1833-1839 Oliphant & Skinner (Henry Oliphant); printers, publishers.

Slote & Co., Daniel 1853-1935
(see Slote, Woodman & Co.)
Blank book manufacturer, publisher, stationer
Broome Street, various locations, New York, NY

1853 230 Broome St., Daniel Slote; books, clerk. 1857-1858 102 Nassau St.; stationer. 1859-1871 90 John St.; blank books. 1872 90 John St.; books. 1873 90 John St.; merchant. 1874 90 John St.; books. 1875 119 Williams St.; books. 1876-1879 121 Williams St.; blank books. 1880-1917 119 Williams St.; Daniel Slote & Co.; blank books. 1918-1919 395 Broadway, Daniel Slote & Co.; blank books. 1920-1935 395 Broadway, Daniel Slote & Co.; stationers. One G/M Reward is a large "Testimonial of Merit" used at "Grammar School No. 56."

Slote, Woodman & Co. 1870-1880s
(see Slote & Co., Daniel)
Blank book manufacturers, publishers, stationers
119 Williams St., various locations, New York, NY

Although much reference is available about Daniel Slote & Co. little has been found about his relationship with Woodman as producers of items of ephemera. The two together were likely also working under the Daniel Slote & Co. name. 1880-1917 119 Williams St., Daniel Slote & Co.; blank books. 1918-1919 Daniel Slote & Co. 395 Broadway; blank books. 1920-1935 395 Broadway; stationers. Slote, Woodman & Co. were approached by Mark Twain to be the publishers of his self pasting Scrap Book for collectors, "a scrap book not to make money out of, but (invented and patented) to economize the profanity of this country." Slote, Woodman & Co. did publish some of Twain's other works. Rewards with Slote, Woodman & Co. name are dated 1870, 1873. (see Bond, J.N.)

Smith & Peck (Cornelius & Horace C.) 1842-1845+
(see Peck, Horace C.)
Publishers
Philadelphia, PA

No Reward of Merit has been found listing Smith & Peck, although they are mentioned on a Durrie & Peck Reward. Cornelius Smith is listed as a "gentleman" from 1866-69.

Snyder, Black & Sturn 1856-1960
(George S., James B., & Hermann S.)
Lithographers
87 Fulton, 92 William Street, New York, NY

1856-1872 Snyder, Black & Sturn. 1872-1960+ Snyder & Black.

Society For Promoting Christian Knowledge 1880s
Publishers
London, England

Although this Society was founded in 1698, evidence of their involvement with Rewards of Merit comes from an empty envelope labeled "24 Picture Tickets for Rewards." Thus far, no identifiable Rewards of Merit have been found.

Spooner, Moses 1827-1867
Printer
Worcester, MA

1828-1829 Spooner & Merriam (with Ebenezer Parsons Merriam); printers. 1829 Moses Spooner. 1829-1831 Spooner & Church (with Edwin C. Church); printers. 1831-1832 Moses Spooner & Co. (with Henry J. Howland and Edwin C. Church); printers. 1839 Spooner & Howland (Henry J.); printers. 1842 (with Howland and Merriam); printers. 1844-1867 printer. Spooner had various business partners at different times. Ebenezer P. Merriam, who apprenticed with Isaiah Thomas, taught Spooner the printing trade.

Stedman, E. (Ebenezer) 1803-1828
Bookbinder, bookseller, circulating library
Newburyport, MA

Worked in circulating library of Edward M. Blunt.

Stevens, (Samuel) 1828-1833
(see Wadleigh, George)
Bookbinder, bookseller, publisher
Dover, NH

1828 publisher. 1830 bookbinder, bookseller. 1833 bookseller, circulating library. Wadleigh was a printer who sold Rewards of Merit in the shop of Samuel Stevens. Stevens also sold Rewards of Merit printed by George W. Ela.

Stevenson (see Dodd & Stevenson)

Storer, W. (William, Jr.) 1822-1857
Printer, publisher
Hartford, New Haven, Stonington, West Hartford, CT

Prior to 1822 he was a newspaper publisher at Caldwell, Warren County, NY. 1822 New Haven; publisher. 1824 New Haven; printer. 1824 Stonington, started publishing a newspaper called "The Yankee." 1827 publisher of the same newspaper, but then called "The Stonington Telegraph." 1825-1828 Stonington; printer, publisher. 1829 the newspaper went out of business. 1838-1842 cor. Chapel & Church St., New Haven; printer. 1843-1848 New Haven; printer. 1849-1851 New Haven, Storer & Stone; printers. 1851-1855 New Haven, Storer & Morehouse; printers. 1852-1853 12 Trumbull St. Hartford, Storer by himself; printer. 1853-1857 West Hartford; printer.

Stradley, B. (Benjamin) 1870-1878+
Engraver, stationer
32 John Street, 127 Nassau Street, New York, NY

1870-1871 Benjamin Stradley; engraver. 1872-1873 B. Stradley & Co.; engraver. 1874-1875 Stradley & Landis (with Enois Y. Landis); stationers. 1875-1878 Benjamin Stradley; stationer.

Strong, T.W. (Thomas) 1842-1879
 Bookseller, engraver, lithographer, publisher
 153 Fulton, 98 Nassau Street, New York, NY

1842-1843+ at 153 Fulton St. Later he was located at 98 Nassau St. Some of the materials offered for sale in his shop were: stationery, toy books, valentines, paper toys and school books. 1871-1872 New York City directories show that Strong had affiliated himself with the Catholic Publishing House of 599 Broadway. After Strong's name appears: "(late Edward Dunigan & Bro.) Catholic Publishing House." It appears that he took over this establishment and moved his business to this address.

Swan, T. (also Swan, T. & Williams, PC) 1818-1830
 Bookseller
 various locations, Boston, MA

1818 Essex Court. 1820 15 Cornhill Sq. 1821 Belknap St. 1824 58-59 Cornhill, Swan, T. & Williams, PC; booksellers.

Swan, T. & Williams, P.C. (see Swan, T.)

T

Thomas, Isaiah 1770-1820
 Bookseller, printer, publisher.
 various locations MA; MD; NH; SC; NY; VT

1755-1766 Boston, apprentice to Zachariah Fowle, beginning at 6 years old. 1766 Halifax, Nova Scotia, Canada, for Anthony Henry; journeyman printer. 1766 Portsmouth, NH, for Daniel & Russell Fowle; journeyman printer. 1767 Boston, for Zachariah Fowle; journeyman printer. 1767-1770 Charleston, SC, for Robert Wells; journeyman printer. 1770 July 17 - Oct. 11, Boston, Zachariah Fowle & Isaiah Thomas; publishers. 1770-1775 Boston, Isaiah Thomas; publisher. 1770-1773 Newburyport, MA, Thomas & Tinges (Isaiah & Henry Walter Tinges); publishers. 1775-1776 Worcester, MA, Isaiah Thomas; publisher. 1775-1796 Worcester, The Worcester Bookstore; bookseller, printer. 1776-1778 Salem, MA, I. Thomas; printer. 1776-1778 Londerry, NH, I. Thomas; bookseller. 1778-1792 Worcester, I. Thomas; publisher. 1788 Springfield, MA; Weld & Thomas (Ezra Weld & Isaiah). 1788-1792 Boston, I. Thomas & Co. (with Ebenezer T. Andrews, John Sprague). 1789-1792 Boston, Thomas & Andrews (with Ebenezer T. Andrews); booksellers, publishers. 1792-1794 Worcester, I. Thomas; publisher. 1793-1820 Boston, Thomas & Andrews; booksellers, publishers. 1793-1796 Walpole, NH, Thomas & Carlisle; also Thomas & Co. (with David Carlisle); booksellers. 1793-1803 Baltimore, Thomas, Andrews & Butler (with Samuel Butler); booksellers. 1794-1795 Brookfield, MA, Thomas & Waldo (with Elish H. Waldo); publishers.

1796-1797 Worcester, Thomas, Son & Thomas (with Isaiah Thomas Jr., Alexander Thomas); booksellers. 1796-1802 Albany, NY, Thomas, Andrews & Penniman (with Obadiah Penniman). 1797-1798 Albany, Loring Andrews & Co. (with I. Thomas); publishers. 1797-1800 Worcester, I. Thomas; bookseller, printer. 1798-1807 Walpole, NH, Thomas & Thomas (Isaiah & Alexander); booksellers. 1799-1801 Walpole, Isaiah Thomas & Son; publishers. 1801-1802 Worcester; bookseller. 1802 turns Worcester business over to his son, and sold Albany and Troy businesses. 1803 sold Baltimore business. 1808-1809 Walpole, NH, Thomas, Thomas & Felch (Isaiah, Alexander Thomas, & Cheever Felch); publishers. 1808-1809 Windsor, VT, Thomas & Merrifield (Isaiah & Preston Merrifield); booksellers. 1809 sold business in Walpole, NH and Windsor VT. 1811-1817 Walpole, NH, I. Thomas & Co. (with Anson Whipple); booksellers. 1812-1813 Rutland, VT, Isaiah Thomas & Co. (with Anson Whipple); booksellers. 1813-1817 P. Brown & Co. (Peter Brown, Isaiah Thomas, Anson Whipple); booksellers. 1812 founded American Antiquarian Society.

Thurston & Herline (Francis E. & ...) 1856-1870s
 Lithographers, publishers
 various locations, Philadelphia, PA

1856-1866 630 Chestnut St., Herline & Hensel. 1867-1872 Herline & Co. 1863 Thurston; book agent. 1864-1865 Thurston; publisher. 1866 630 Chestnut St., Thurston & Herline; lithographers, publishers. 1867-1869 630 Chestnut St., Thurston & Co. (F.E. & M.H.); publishers. 1877 Thurston; clerk. 1880 Thurston; agent.

Thurston, Isley, & Co. (Brown & ...) 1844-1875+
 Printers
 68 & 111 Exchange Street, Portland, ME

1844-1846 Thurston, Isley & Co. 1847-1875 B. Thurston & Co. (with Stuart A. Strout and J.H. Russell.)

Toudy, H.J. & Co. 1867-1878
 Lithographers
 503 Chestnut Street, Philadelphia, PA

Treadway, R.R. 1840s
(see Boston Type & Stereotype Foundry)
 Publisher
 Warren, NY

Treadway's name appears on Rewards of Merit which also bear the publisher's name, the Boston Type & Stereotype Foundry.

Truman, W.T. (William) 1834-1847
 Bookseller, publisher, stationer
 Cincinnati, OH

1834-1843 Truman & Smith (with Winthrop B. Smith); booksellers, publishers. Also sold and published "Eclectic Series" of schoolbooks - the original McGuffey publishers. Predecessors of Winthrop B. Smith. 1843-1847 bookseller, publisher by himself. 1845 W.B. Smith

Co. is formed which by 1859 becomes the largest publisher of schoolbooks in the country.

Trumann, E.D. 1847-1858
 Bookseller, stationer
 75 and 111 Main Street, Cincinnati, OH

1847-1849 E.D. Truman; bookseller, stationer. 1852-1858 E.D. Truman & Spofford; booksellers.

Trumbull, Henry 1804-1824+
(see Boston Type & Stereotype Foundry)
 Printer, publisher
 Norwich, CT; Boston, MA; Providence, RI

1804-1812 Norwich; printer, publisher. 1815-1818 Boston; printer, publisher. 1818-1819 Boston (with Nathaniel Coverly); printers. 1820 Boston; printer. 1824+ Providence; printer. Trumbull's name appears on Rewards of Merit published by the Boston Type & Stereotype Foundry.

Tuck, Raphael 1866-1882
 Exporter, lithographer
 Coleman St., NY

1866 picture framer. 1871 exporter of Valentines by famous artists. 1881 Coleman St., Raphael Tuck & Sons; exporters and chromolithographers. 1882 Raphael retires, his son Adolph takes over business. 1884-1944 New York office location.

Tucker & Kinney 1820s
 Printers
 Syracuse, NY

Tucker Printing Co. (Tucker, David) 1841-1873
 Printer
 71 & 65 Exchange Street, Portland, ME

Tufts (see Newton & Tufts)

Turner, A.A. (Austin Augustus) 1852-1866
 Photolithographer
 Boston, MA; 15 Mercer Street, 553, 765 Broadway, New York, NY; New Orleans, LA

Turner was America's first photomechanical printer. 1850 took his first job as a house painter in Chelsea, MA. 1852 Boston, MA, employed by E.F. Campbell as a photographic operator at Campbell's Gallery. 1857-1859 10 Tremont Row, Boston, MA; Cutting & Turner; photographers. 1860-1865 Turner affiliates with D. Appleton and Co. of NY. In 1860 Appleton with Turner produced the first photolithographic printed book in the United States, entitled "Villas On The Hudson." 1864 Turner moved to New Orleans, 61 Camp St. and formed the Anderson/Turner Gallery. 1865 partnership dissolved and a new gallery "The New Orleans Photographic Co." opened at 57 Camp St. 1866 Warren M. Cohen enters into partnership with Turner.

Turner, E. (Elisha) 1828-1843
 Bookbinder, publisher, stationer
 114 Main Street, Northampton, MA

First imprint appears in 1828, business sold about 1845.

Turner & Fisher (see Turner, J.) 1838-1866
 Publishers
 MA; MD; NY; PA; OH

This firm published gifts, prizes, awards which were printed 4.5″ x 6″ in size. Some had illustrations, but no other copy. These single sheets are occasionally found used as Rewards of Merit. One in particular is imprinted: "Published by Turner and Fisher, New York and Philadelphia: J. Fisher, Boston: Turner, Baltimore: W.R. Fisher, Cincinnati." This firm was very likely connected with Fisher & Bros. and James Fisher. (See p. 34).

Turner (H.) 1840s
 Publisher
 10 North Street, Baltimore, MD

A member of the Turner family, booksellers and publishers. (see Turner & Fisher)

Turner, William 1820-1823
 Bookseller, printer, publisher
 corner of Franklin & North Streets, Baltimore, MD

U

Union Press 1851-1913
 Publishers
 15 Manchester Street, Manchester, NH

The Union Press was most likely the newspaper publishing company established by William H. Gilmore & Co. Through the latter half of the nineteenth century it was sold many times. In addition to publishing the news, the company also put their presses to work printing school stationery and other forms of printed ephemera. In this case their imprint is on a Manchester Public School Reward of Merit, dated 1878.

V

Vibbert Co., The G.S. (George Spencer) 1875-1893
 Importers, printers, publishers
 Clintonville - North Haven, CT

1875-1893 Clintonville Rd., Clintonville (part of North Haven). 1893 The firm was purchased by Wayside Publishing. No Reward of Merit found. This reference is from a Vibbert Company billhead. It lists the type of work done by the company: "Sunday School Cards, Advertising Cards, Valentines, Beveled Edge Cards, Importers of Scrap Pictures & Card Ornaments."

W

Wadleigh, George (see Stevens) 1830-1865
 Printer, publisher
 Portsmouth, Dover, NH

He learned the printing trade while in Portsmouth, NH. 1831-1863 Dover; newspaper publisher. Wadleigh's name appears on Rewards of Merit sold by Stevens, sc.

Walton's 1810-1910s
 (Walton, Ezekiel Parker & son, Eliakim Persons)
 Booksellers, printers, publishers
 various locations, Montpelier, VT

1810-1817 Walton & Goss (with Mark Goss); booksellers, printers. 1816-1818 E.P. & G.S. Walton (with George S. Walton); booksellers, publishers. 1816-1828 printer, publisher. 1829-1831 E.P. Walton & Co. (with brother, Joseph S. Walton); printers, publishers. 1835-1838 E.P. Walton & Son (with Ezekiel and Eliakam P. Walton); printers, publishers. 1839-1849 E.P. Walton & Sons (addition of George P. Walton); printers, publishers. 1849-1853 E.P. Walton & Son (Eliakem only); printer, publisher. 1868 The business was sold to Messers. Poland, who continued it into the 20th century. In the G/M collection is a Sunday School Card imprinted "Ward, Marcus & Co." A British company most likely imported chromolithographed stock cards to printers such as Walton's, who would then sell the cards in America with their own imprint upon them.

Washburn, H.G.O. (Harrison) 1834-1860+
 Bookseller, stationer
 Nesmith's Corner, Belfast, ME

1834 bookseller. 1838-1846 bought and operated the bookstore of John Dorr, at Nesmith's Corner. In 1847 he moved to 29 Main St. and remained in business there until the early 1860s.

Watson, David 1810-1867
 Printer, publisher
 various locations, MA; NH; VT;

1802-1809 Boston, MA, apprenticed to Thomas & Andrews; printers. 1810-1814 Boston, Watson & Bangs (with Thomas G. Bangs); printers. 1815 Hanover, NH; printer. 1816-1817 Hanover; publisher. 1817-1818 Hanover; printer. 1818-1832 Woodstock, VT; printer, publisher. 1832-1834 Lancaster, MA; printer. 1834-1835 New York, NY; printer. 1836-1839 Boston, MA, Boston Type & Stereotype Foundry; proofreader. 1839-1867 Concord, NH; publisher.

Wells, Thomas 1809-1829
 Bookseller, stationer
 Hanover, Market, Union Streets, Boston, MA

1809-1820 3 Hanover St. 1820 3 Hanover St., 38 Market St. 1821-1823 3 Hanover St., 36 Union St. 1825 92 Hanover St., 29 Union St. 1826-1829 bookseller, circulating library.

Wemple & Kronheim 1870-1889
 (Charles E. & Martin)
 Lithographers
 various locations, New York, NY

1870-1872 62 Cedar St., Wemple, Kronheim & Co. 1874 Wemple & Co. dissolved. 1874 62 Cedar St., Wemple, Laserowitsch & Co. (with Sidor Laserowitsch & Augustus W. Phelps. 1875-1877 Dey St., Charles Wemple & Co. (with Martin Kronheim & Henry I. Hart. 1878-1879

538 Pearl St., Wemple & Kronheim. 1880-1886 100 Reade St., Wemple & Co. 1887 100 Reade St., Wemple Litho Co. 1888-1889 84 West Broadway, Wemple Litho Printing Co. Wemple was also a frequent traveler to England. There is a good possibility that he was importing from England. Kronheim was a key British lithographer. The only known examples of Wemple's Rewards are those Rewards which were die cut in the shape of fans and illustrated with oriental motifs.

Western Engraving Co. (see Western Publishing Co.)

Western News Company, The 1880s
 Chicago, IL

"Price List Of Reward Cards, For Sale By The Western News Company, Manufacturer's Agents, Chicago, Ill." "Day School Reward Cards."

Western Publishing Co. 1863-1870s+
 Engravers, printers, publishers
 61 West Lake Street, Chicago, IL

Publishers of Holland's city directories for "all principal cities of the West & Northwest."

Whipple, Charles (see Gilman, W.J.) 1803-1859
 Bookseller
 Newburyport, MA

1803-1814 Thomas & Whipple (with Isaiah Thomas, Jr.). 1814-1859 Whipple, alone. Whipple's name appears on Rewards of Merit printed by W.J. Gilman.

White & Reed 1801-1830s+
 (Ira White, Samuel & Stephen Reed)
 Booksellers, paper manufacturers, printers, publishers
 various locations, NH; VT

1801-1809 Surry, NH. 1810-1816 Bellows Falls, VT. 1816- Newbury, VT. (with Samuel & Stephen Reed); paper manufacturer. 1816- Newbury, VT; bookseller, printer, publisher. White bought Reed's share in 1830.

Whiting Jr., R.M. 1870s
 Stationer
 342 Fulton Street, New York, NY

Public School Reward of Merit.

Wickham, O.O. (Orin) 1844-1846
 Publisher
 77 Fulton Street, New York, NY

"THE TEACHER'S CERTIFICATE" is significant as a Reward of Merit & report card. It also lists detailed behavioral characteristics to be avoided. (Also see "American Youths' Diploma, p. 159).

Wilcox, John 1891-1903+
 Publisher
 Milford, NY

No Rewards of Merit have been found with this imprint. However in their "Condensed Catalogue of Reward Cards" appears the following; "The demand now is almost entirely for cards without any printing on them

and for that reason only those marked * are printed Reward Of Merit."

Wilde Co. W.A. (William A.) 1890s
 Publishers
 various locations, Boston, MA
1880-1887 25 Bromfield St. 1898-1901 110 Boylston St. 1902-1923 120 Boylston St. 1924-1958 131 Clarendon St. In the G/M collection is a Sunday School Reward.

Willard, Fel. & Co. 1859-1876
 Lithographers
 14 Maiden Lane, New York, NY

Williams, N. Bangs 1873-1883
 Bookseller, publisher
 Butler Exchange, various locations on Westminster Street, Providence, RI

1873 Butler Exchange, N. Bangs Williams. 1875-1878 52 Westminster St., N. Bangs Williams & Co. 1879-1880 54 Westminster St. 1881 133 Westminster St. 1883-1883 Butler Exchange. Advertisments described the business as "Antique and Modern Bookstore, School Books and School Supplies, Old Books, Bought, Sold & Exchanged."

Williams, R.P. & C. 1816-1846
(Robert P. & Charles)
 Booksellers
 State Street, 20 Cornhill Square, Boston, MA
1816-1836 R.P. & C. Williams. 1837-1846 Charles Williams.

Williams, William 1807-1840
 Bookseller, engraver, printer, publisher
 Utica, NY

1807-1840 printer. 1821-1823 (with Elisha Harrington as printer). 1824 (with Ira Merrel as printer); publisher. 1824-1829 publisher. 1828-1830 Balch, Stiles & Co. (with Vistys Balch, Samuel Stiles, Joseph H. Colton and William Williams); engraver. 1830-1834 (with B.B. Hotchkin as editor); publisher. 1831-1832 Balch, Stiles, Wright & Co. (with Neziah Wright, V. Balch, S. Stiles, J.H. Colton and W. Williams); engraver. 1832-1837 (with Vistus Balch, uncertain); engraver. 1835-1840 bookseller, printer.

Y

Young, Samuel 1822-1833
 Bookseller, publisher
 North Charles, Saratoga Street, Baltimore, MD

1819 84 Sharp St.; no occupation. 1822-1831 27 North Charles St.; bookseller. 1833 7 Saratoga St.; bookseller.

SELECTED BIBLIOGRAPHY

A

Adams, James Truslow, editor-in-chief. *Dictionary of American History*, 2d ed., rev. 5 vols. New York: Charles Scribner's Sons, 1942.
Alexander, James W., D. D. *The American Sunday-School and Its Adjuncts.* Philadelphia: American Sunday-School Union, 1856.
Allen, Alistair and Joan Hoverstadt. *The History of Printed Scraps.* London: New Cavendish Books, 1983.
Allen, W.O.B. and Edmund McClure. *The History of the Society for Promoting Christian Knowledge. 1698-1898.* London: 1898.
Allport, F. G. *Social Psychology.* Boston: Houghton, Mifflin Co., 1924.
American Folk Art: The Art of the Common Man in America 1750-1900. Introduction by Holger Cahill. New York: The Museum of Modern Art, 1932.
Andrews, Charles C. *The History of the New-York African Free-Schools, From Their Establishment in 1787 To The Present Time: Embracing A Period of More Than Forty Years: Also A Brief Account of the Successful Labors, of the New York Manumission Society.* New York: Mahlon Day, 1830.
Anonymous. *The story of the Religious Tract Society (1898).*
Aptheker, Herbert, ed. *A Documentary History of the Negro People in the United States.* New York: The Citadel Press, n.d .

Axtell, James L. *The Educational Writings of John Locke.* Cambridge: Cambridge University Press, 1968.
Axtell, James. *The School Upon a Hill: Education and Society in Colonial New England.* New York: W. W. Norton & Co., 1976.

B

Bagford, John. *An Essay on the Invention of Printing.* Introduction by Douglas C. McMurtrie. The Philosophical Transactions of the Royal Society, 25 (1706-1707)
Bailyn, Bernard. *Education in the Forming of American Society: Needs and Opportunities for Study.* Chapel Hill, North Carolina: Published for The Institute of Early American History and Culture at Williamsburg, Virginia, 1960.
Benes, Peter. *Two Towns — Concord & Wethersfield: A Comparative Exhibition of Regional Culture 1635-1850.* Concord, Massachusetts: The Concord Antiquarian Museum, 1982.
Bethnal Green Museum of Childhood. Exhibit May to September 1977. *Jubilation: Royal Commemorative Pottery from the collection of James Blewitt, Bethnal Green Museum of Childhood.* Ipswich, England: W. S. Cowell, 1977.
Bewick, Thomas. *History of British Birds.* 1804.
Bewick, Thomas. *History of Quadrupeds.* London: 1797.

Binns, H. B. *A Century of Education. Being a Centenary History of the British and Foreign School Society* London: 1908.
Bishop, Selma L. *Isaac Watts: Hymns and Spiritual Songs 1707-1748: A Study in Early Eighteenth Century Language Changes.* London: Faith Press. 1962.
Borstelmann, Lloyd J. "Children Before Psychology: Ideas About Children From Antiquity to the Late 1800s," *Handbook of Child Psychology*, 1 (1983), William Kessen, Vol. ed. Paul H. Mussen, ed. (New York: John Wiley & Sons).
Bourne, Eulalia. *Ranch Schoolteacher.* Tucson, Arizona: University of Arizona Press, 1974.
Bowen, James. *A History of Western Education.* New York: St. Martin's Press, 1975.
Boylan, Anne M. *Sunday School: The Formation of An American Institution 1790-1880.* New Haven, CT: Yale University Press, 1988.
Brant, Sandra and Elissa Cullman. *Small Folk: A Celebration of Childhood in America.* New York: E. P. Dutton in association with the Museum of American Folk Art, 1980.
Brigham, Clarence S. *Paul Revere's Engravings.* Copyright by the American Antiquarian Society, 1954, 1969. (New York: Atheneum, 1969).
Brinsley, John. *Ludus Literarius: or, The Grammar Schoole.* (London: Printed for Thomas Man, 1612). English Linguistics 1500-1800: A Collection of Facsimile Reprints, no.62, R. C. Alston, ed. (Menston, England: Scolar Press, 1968).

Brown, H. Glenn and Maude O. *A Directory of Printing, Publishing, Bookselling & Allied Trades in Rhode Island to 1865.* New York: New York Public Library, 1958.

Brown, Marianna C. *Sunday School Movements in America.* New York: Fleming H. Revell Co., 1901.

Bryce, James. *The American Commonwealth.* 2 vols. New York: The Macmillan Co., 1897.

Burgess, H. J., and P. A. Welby. *A Short History of the National Society 1811-1961.* London: 1961.

Burton, Warren. *The District School As It Was by One Who Went To It.* Boston: Carter, Hendee, and Co., 1838.

Buten, David, with Jane Perkins Claney and contributions by Patricia Pelehach. *18th Century Wedgwood: A Guide for Collectors & Connoisseurs.* New York, Methuen, Inc., 1980.

C

Cabell, Joseph C. to Joseph Lancaster, Warminster, Virginia, July 1, 1819, A.L.S. Joseph Lancaster Papers, American Antiquarian Society. Worcester, Massachusetts.

Church, Robert L. *Education in the United States: An Interpretive History.* New York: Free Press, 1976.

Cirlot, J.E. *A Dictionary of Symbols.* New York: Philosophical Library, 1983. (Translated from the Spanish Diccionario De Simbolos Tradicionales.)

Clark, Garth. *A Century of Ceramics in the United States 1878-1978.* With a foreword by Ronald A. Kuchta, preface by Margie Hughto. New York: E. P. Dutton in Association with the Everson Museum of Art.

Clemens, Samuel Langhorne (Mark Twain). *The Adventures of Tom Sawyer.* Hartford: The American Publishing Co., 1876.

Clinton, De Witt. *The Life and Writings of De Witt Clinton.* New York, 1849.

Cohn, Marjorie. *Wash and Gouache: A Study of the Development of the Materials of Watercolor.* Cambridge: The Center for Conservation and Technical Studies, Fogg Art Museum and The Foundation of the American Institute for Conservation, 1977. (Catalogue of the Exhibition by Rachel Rosenfield)

Comenius, Jan Amos. *A Reformation of Schooles,* 1642. [Original in University College, London]. English Linguistics 1500-1800: A Collection of Facsimile Reprints, no. 143, R.C. Alston, ed. (Menston, England: Scolar Press, 1968).

Compayré, Gabriel. *The History of Pedagogy.* Boston: D. C. Heath & Co., 1886.

Compayré, Gabriel. *Montaigne and Education of the Judgment.* New York: Thomas Y. Crowell & Co., 1908.

Compayré, Gabriel. *Lectures on Pedagogy, Theoretical and Practical.* Boston: D. C. Heath & Co., 1898.

Compayré, Gabriel. *Herbart and Education by Instruction.* trans., Maria E. Findlay. London: George G. Harrap & Co., 1908.

Compayré, Gabriel. *Pestalozzi. Johann Heinrich.* R. P. Jago, translator. New York: Thomas Y. Crowell & Co., 1907.

Coote, Edmund. *The English Schoole-Maister,* [1596. Original—Trinity College Library]. English Linguistics 1500-1800: A Collection of Facsimile Reprints, no. 98, R. C. Alston, ed. (Menston, England: Scolar Press, 1968).

Cremin, Lawrence. *The American Common School: An Historic Concept.* New York: Bureau of Publications, Teachers College, Columbia University, 1951.

Cremin, Lawrence A. *American Education: The Colonial Experience 1607-1783.* New York: Harper and Row, 1970.

Cremin, Lawrence A. *American Education: The National Experience 1783-1876.* New York: Harper & Row, 1980.

Cubberley, Ellwood P. *Public Education in the United States: A Study and Interpretation of American Educational History.* Boston: Houghton Mifflin Co., 1947.

Cunningham, Nobel E., Jr. *Popular Images of the Presidency.* Columbia, MO: University of Missouri, 1991.

Curtis, S. J. and M. E. A. Boultwood. *An Introductory History of English Education Since 1800.* Foxton, England: University Tutorial Press Ltd., 1970.

Cushing, Thomas. *Historical Sketch of Chauncy-Hall School with catalogue of teachers and pupils with appendix, 1828 to 1894.* Boston: David Clapp & Son, 1895.

D

Darwin, Charles. *A Biographical Sketch of an Infant.* Supplement No. 24 to Developmental Medicine and Child Neurology, Vol. 13, No. 5., Spastics International Medical Publications in association with William Heinemann Medical Books Ltd. Tadworth, Surrey, London: 1971. [Originally appeared as a paper in "MIND," July 1877].

Davis, Arthur Paul. *Isaac Watts: His Life and Works.* New York: The Dryden Press, 1948.

Dexter, Edwin Grant. *A History of Education in the United States.* New York: The Macmillan Company, 1904.

Dixon, Henry. *The English Instructor.* [First published in 1728]. English Linguistics 1500-1800: A Collection of Facsimile Reprints, R.C. Alston, ed. (Menston, England: Scolar Press, 1968).

Dodge, Mary Mapes, ed. *St. Nicholas: an Illustrated Magazine For Young Folks.* XII (Part II, May – October). New York: The Century Co., 1885.

Drepperd, Carl W. *American Pioneer Arts & Artists.* Springfield, Mass: Pond-Ekberg Co., 1942.

Dunkel, Harold B. *Herbart and Herbartianism: An Educational Ghost Story.* Chicago: The University of Chicago Press, 1970.

Dunlap, William. *A History of the Rise and Progress of The Arts of Design in the United States,* Frank W. Bayley and Charles E. Goodspeed, eds. Boston: C. E. Goodspeed, 1918, vols I, II, III. (Originally published, 1834).

Dury, John. *The Reformed School and The Reformed Library Keeper* [Originally published in 1651]. English Linguistics 1500-1800: A Collection of Facsimile Reprints, no.319. R.C. Alston, ed. (Menston, England: Scolar Press, 1968).

E

Earle, Alice Morse. *Collecting China in America.* New York: Charles Scribner's Sons, 1892.

Eggleston, Edward. *The Transit of Civilization.* New York: D. Appleton & Co., 1901.

Eggleston, Edward. *The Hoosier Schoolmaster.* New York: Hill and Wang, 1957.

Eggleston, Edward. "A School of Long Ago," *St. Nicholas* (July 1885).

Elyot, Thomas. *Boke Named the Governour.* [Originally published in 1531. Original in Cambridge University Library]. English Linguistics 1500-1800: A Collection of Facsimile Reprints, no. 246. R. C. Alston, ed. (Menston, England: Scolar Press, 1968).

Erlanger, Herbert J. *Origin and Development of the European Prize Medal to the End of the XVIII Century.* Haarlem: Schuyt & Co. C.V. 1975.

F

Fielding, Mantle. *American Engravers upon Copper and Steel.* Part III: Biographical Sketches and Checklists of Engravings. Reprinted, New York: Burt Franklin. (Originally published, Philadelphia: 1917.)

Fielding, Mantle. *Dictionary of American Painters, Sculptors and Engravers.* Enlarged ed. Green Farms, CT: Modern Books and Crafts, 1974.

Finch, Christopher. *American Watercolors.* New York: Abbeville Press, 1986.

Fisher, George. *The American Instructor: or, Young Man's Best Companion, Containing, Spelling, Reading, Writing, and Arithmetick, in an easier Way than any yet published: and how to qualify any Person for Business, without the Help of a Master. By George Fisher Accomptant.* 9th ed. Philadelphia: B. Franklin and D. Hall, 1740.

Flores, Anthony. *Awards, Rewards and Marvelous Messages: Reproduction Aids for All Teachers.* Belmont, California: David S. Lake. Fearons Teacher Aids Division.

Ford, Paul Leicester, ed. *The New England Primer.* New York: Dodd, Mead and Co., 1899.

Forlano, George. *School Learning with Various Methods of Practice and Rewards.* New York: Bureau of Publications, Teachers College, Columbia University, 1936.

Fox, Nancy Jo. *Liberties with Liberty.* New York: E. P. Dutton in association with the Museum of American Folk Art, 1985.

Franklin, Benjamin. *Franklin's Autobiography: With a Sketch of His Life from the Point Where the Autobiography Closes.* Boston: Houghton, Mifflin & Co., 1896.

Franklin, Benjamin. *Writings.* ed. J. A. Leo Lemay. New York: Literary Classics of the United States, 1984.

Fuller, Wayne E. *The Old Country School.* Chicago: The University of Chicago Press, 1982.

G

Garrett, Wendell, ed. *Antiques*, Vol. CIX, No. 4, April 1976.

Givner, Abraham and Paul S. Graubard. *A Handbook of Behavior Modification for the Classroom.* New York: Holt, Rinehart and Winston, Inc., 1974.

Glubok, Shirley. *Home and Child Life in Colonial Days.* Abridged edition from Alice Morse Early, *Home Life in Colonial Days and Child Life in Colonial Days.* New York: Macmillan Publishing Co, 1969.

Golden, Jack. "The Role of Printing Arts in Industrial Development." *The Ephemera Journal*, I (1987). "Business, Advertising, Printing and Ephemera." *Ephemera* (1989). "Historical Introduction to the Art and Technique of Printed Ephemera," in Dale Roylance, *Graphic Americana: The Art and Technique of Printed Ephemera from Abecedaires to Zoetropes.* Princeton: Princeton University Library, 1992.

Good, Carter V., ed. *Dictionary of Education.* 3rd ed., New York: McGraw-Hill. 1973.

Goodfellow, Caroline. *A Collector's Guide to Games and Puzzles.* Secaucus, NJ: Chartwell Books, 1991.

Gordon, Julia Weber. *My Country School Diary: An Adventure in Creative Teaching.* New York: Dell Publishing Co., 1970, originally published, 1946.

Grant, Robert W. *The Handbook of Civil War Patriotic Envelopes and Postal History.* ed. Gordon McKinnon, vol. 1. (Hanover, Mass.: Grant 1977)

Greaves, Richard L. *The Puritan Revolution and Educational Thought: Background for Reform.* New Brunswick, N.J.: Rutgers University Press, (1969).

Griffin, Orwin Bradford. *The Evolution of the Connecticut State School System With Special Reference to the Emergence of the High School.* New York: Bureau of Publications, Teachers College, Columbia University, 1928.

Grimshaw, M. E. *Pre-Victorian Silver School Medals Awarded to Girls in Great Britain.* Cambridge, England: M. E. Grimshaw, 1985.

Grimshaw, M.E. *Silver Medals, Badges and Trophies from Schools in the British Isles 1550-1850.* Cambridge, England: M. E. Grimshaw.

Groce, George C. and David H. Wallace. *New York Historical Society's Dictionary of Artists in America 1564-1860.* New Haven, CT: Yale University Press, 1975.

Gulliford, Andrew. *America's Country Schools.* Washington, D. C.: The Preservation Press, 1984.

H

Hardy, Irene. *An Ohio Schoolmistress: The Memoirs of Irene Hardy.* ed. Louis Filler. Kent, Ohio: The Kent State University Press, 1980.

Harper's Weekly. vol. XII (No. 625) 19 December 1868. s.v. The Kelly Medal.

Harris, Elizabeth M. *The Fat and the Lean: American Wood Type in the 19th Cent.* Washington, D.C.: National Museum of American History, Smithsonian Institution, 1983.

Harris, J. Henry. *The Story of Robert Raikes for the Young.* Philadelphia: The Union Press, 1900.

Hart, Cynthia, John Grossman, and Priscilla Dunhill. *A Victorian Scrapbook.* New York: Workman Publishing, 1989.

Holbrook, Alfred. *Reminiscences of the Happy Life of a Teacher.* Cincinnati: Elm Street Printing Co., 1885.

Holman, H. *Pestalozzi: An Account of His Life and Work.* London: Longmans, Green, and Co. 1908.

Hornung, Clarence P. and Fridolf Johnson. *200 Years of American Graphic Art: A Retrospective Survey of the Printing Arts and Advertising since the Colonial Period.* New York: George Braziller, 1976.

Hughes, George Bernard. *English and Scottish Earthenware 1660-1860.* New York: The Macmillan Co.

J

Jay, Robert. *The Trade Card in Nineteenth-Century America.* Columbia, Missouri: University of Missouri Press, 1987.

Johnson, Clifton. *Old Time Schools and School Books.* New York: Macmillan, 1904.

Johnson, Clifton. *The Country School in New England.* New York: D. Appleton & Co., 1893.

Johnson, Hattie Elliott. "Old-Time 'Rewards of Merit'." *Bulletin of The Society for the Preservation of New England Antiquities.* XVI, No. 1, (July 1925).

K

Kaestle, Carl F. *Pillars of the Republic: Common Schools and American Society. 1780-1860.* New York: Hill and Wang, 1983.

Kaufman, Polly Welts. *Women Teachers on the Frontier.* New Haven: Yale University Press, 1984.

Kazdin, Alan E. *History of Behavior Modification.* Baltimore: University Publications Press, 1978.

Kelly, Rob Roy. *American Wood Type: 1828-1900.* New York: Van Nostrand Reinhold, 1969.

Knight, Edgar W. and Clifton L. Hall. *Readings in American Educational History.* New York.: Appleton-Century-Crofts, 1951.

L

Lancaster, Joseph. *The Lancasterian System of Education. With Improvements: By Its Founder, Joseph Lancaster, of the Lancasterian Institute, Baltimore.* Baltimore: Lancasterian Institute, 1821.

Lancaster, Joseph. Papers, Worcester, Massachusetts: American Antiquarian Society.

Lancaster, Joseph. *Improvements in Education, as it respects the Industrious Classes of the Community, containing, among other important particulars, An Account of the Institution for the Education of One Thousand Poor Children, Borough Road, Southwark; and of the New System of Education on which it is conducted.* London: Darton and Harvey, 1805.

Laqueur, Thomas Walter. *Religion and Respectability: Sunday Schools and Working Class Culture 1780-1850.* New Haven: Yale University Press, 1976.

Lee, Ruth Webb. *A History of Valentines.* Wellesley Hills, Massachusetts: Lee Publications, 1952.

Lefrancois, Guy R. *Psychology for Teaching: A Bear Always Usually Faces the Front.* Belmont, California: Wadsworth Publishing Co., Inc. 1975.

Lewis, John. *A Handbook of Type and Illustration.* London: Faber & Faber, 1956.

Lewis, John. *Printed Ephemera: The Changing Use of Typeforms and Letterforms in English and American Printing.* Ipswich, Suffolk: W. S. Cowell, 1962.

Lines, Amelia Akehurst. *To Raise Myself a Little; The Diaries and Letters of Jennie. A Georgia Teacher. 1851-1886.* Athens, Georgia: The University of Georgia Press, 1982.

Lipman, Jean, Elizabeth V. Warren, Robert Bishop. *Young America: A Folk-Art History.* New York: Hudson Hills Press in Association with the Museum of American Folk Art, 1986.

Locke, John. *Some Thoughts on Education.* ed. F. W. Garforth. Woodbury, N.Y.: Barron's Educational Series, 1964.

Loubat, J. F. *The Medallic History of the United States of America 1776-1876.* New Milford, CT. N. Flayderman, 1967.

Lynn, Robert W. and Elliott Wright. *The Big Little School: Sunday Child of American Protestantism.* New York: Harper & Row, 1817.

M

Marsh, Raymond. "Some Characteristics of Charles Magnus and his Products." *The American Philatelist*, 62 (September, 1949).

Marzio, Peter C. *The Democratic Art: Pictures for a 19th-Century America.* Boston: David R. Godine in association with the Amon Carter Museum of Western Art, Fort Worth, 1979.

Mather, Cotton. *Cares About the Nurseries. Two Brief Discourses. The One, Offering Methods and Motives for Parents to Catechise Their Children While Yet Under the Tuition of Their Parents. The Other, Offering Some Instructions for Children. How They May Do Well. When They are to Years of Doing for Themselves.* Boston, 1702.

Mather, Cotton. *Diary of Cotton Mather.* Vol. 1 (1681-1708), Vol. 2 (1709-1724). New York: Frederick Ungar Publishing Co., 1957.

Mattocks, Ron. *On the Move.* Villanova, Pennsylvania: American Missionary Fellowship. 1980.

May, John and Jennifer. *Commemorative Pottery 1780-1900.* New York: Charles Scribner's Sons, 1972.

McClinton, Katharine Morrison. *Antiques of American Childhood.* New York: Clarkson N. Potter, 1970.

McCullock, Lou W. *Paper Americana: A Collector's Guide.* New York: A. S. Barnes & Co., 1980; London: Tantivy Press.

McGuffey, William Holmes. *McGuffey's Sixth Eclectic Reader, 1879 Edition.* Foreword by Henry Steele Commager. New York: The New American Library of World Literature, Signet Classics, 1963.

McLaughlin, Patricia. On the Merits of Merit Badges, *Merchandiser,* Oxon Hill, Maryland, April 1989.

McMurtrie, Douglas C. Introduction to John Bagford, *An Essay on the Invention of Printing, The Philosophical Transactions of the Royal Society,* 25 (1706-1707).

Mendelowitz, Daniel M. *A History of American Art.* New York: Holt, Rinehart and Winston, Inc., 1973.

Miller, J. Jefferson II, *18th-Century English Porcelain: A Brief Guide to the Collection in the National Museum of History and Technology.* Washington, D.C.: Smithsonian Institution Press, 1973.

Miller, J. Jefferson. *English Yellow-Glazed Earthenware.* Washington, D. C.: Smithsonian Institution Press, 1974.

Miller, Hugh. *Schools and Schoolmasters or, The Story of My Education.* Boston: Gould and Lincoln, 1872.

N

Niederer, Frances J. *Hollins College: An Illustrated History,* 2nd ed. (Charlottesville: The University Press of Virginia, 1985).

Neuberg, Victor. *The Penny Histories: A Study of Chapbooks for Young Readers over Two Centuries.* (1968).

O

Olney, J. *Modern Geography.* New York: Pratt, Woodford Co., 1850.

Ornstein, Martha. *The Role of Scientific Societies in the Seventeenth Century.* Chicago: The University of Chicago Press, 1928.

P

Page, David D. *Theory and Practice of Teaching: or, The Motives and Methods of Good School-Keeping.* 14th ed. New York: A. S. Barnes and Co., 1852.

Paley, William. *Reading Made Completely Easy.* 1790.

Peters, Harry T. *America on Stone.* Reprint ed. New York: Arno Press, 1976. (Originally published, 1931).

Pinloche, Joachim Auguste. *Pestalozzi and the Foundation of the Modern Elementary School.* New York: Charles Scribner's Sons, 1901.

Pollock, Linda. *A Lasting Relationship: Parents and Children Over Three Centuries.* Hanover & London: University Press of New England, 1987.

Poole, Joshua. *The English Accidence.* [Originally published in 1646]. English Linguistics 1500-1800: A Collection of Facsimile Reprint, no. 5. R. C. Alston, ed. (Menston, England: Scolar Press, 1968).

Purver, Margery. *The Royal Society: Concept and Creation.* Cambridge, Massachusetts: The M.I.T. Press, 1967.

R

Ramsay, John. *American Potters and Pottery.* Clinton, Massachusetts, Hale, Cushman & Flint, 1939.

Reilly, Elizabeth Carroll. *A Dictionary of Colonial American Printers' Ornaments and Illustrations.* Worcester: American Antiquarian Society, 1975.

Rice, Edwin Wilbur. *The Sunday School Movement and the American Sunday School Union 1780-1917.* Philadelphia: The Union Press. 1917.

Rice, Foster Wilde. *The Jocelyn Engravers.* Reprinted from The Essay Proof Journal, July & October, 1948.

Rickards, Maurice. *Collecting Printed Ephemera.* New York: Abbeville Press, 1988.

Rickards, Maurice. *This Is Ephemera.* Brattleboro, VT: Gossamer Press, 1977.

Roberts, Clayton, and David Roberts. *A History of England: 1688 to the Present.* Englewood Cliffs, New Jersey: Prentice-Hall, 1980.

Rousseau, Jean Jacques. *Emile or On Education.* Notes, Allan Bloom. New York: Basic Books. 1979.

Rousseau, Jean Jacques. *Emile Book II. (On Education from Five to Twelve),* "Education Negative," in R.L. Archer, ed., *Rousseau on Education* (London: Edward Arnold, 1916).

Rowntree, Derek. *A Dictionary of Education.* London: Harper & Row, 1981.

Rumford, Beatrix T., Gen. ed. *American Folk Paintings: Paintings and Drawings Other Than Portraits from the Abby Aldrich Rockefeller Folk Art Center.* Boston: Little, Brown & Co., 1989.

S

Sallay, John. "The Boston School Medals." *The Numismatist* (April 1978).

Salmon, David, ed. *The Practical Parts of Lancaster's Improvements and Bell's Experiment.* [Landmarks in the History of Education] Cambridge: Cambridge University Press, 1932.

Sasscier, Agnes L. "Reward of Merit Certificates." *Hobbies: The Magazine for Collectors.* 24 (January, 1959).

Schreibeis, Charles D. *Pioneer Education in the Pacific Northwest (1789-1847).* Portland, Oregon: Metropolitan Press.

Select Poetry for Children. American Sunday School Union. Philadelphia: 1848.

Sheldon, Edward A. *Autobiography.* New York, 1911.

Shelley, Donald A. *The Fraktur-Writings or Illuminated Manuscripts of the Pennsylvania Germans.* vol. 23. Allentown, Pennsylvania: Schlechter's for The Pennsylvania German Folklore Society, 1961.

Silver, Rollo G. *The Boston Book Trade 1800-1825.* New York: The New York Public Library, 1949.

Skinner, B. F. *About Behaviorism.* New York: Alfred A. Knopf, 1974.

Smith, Wilson, ed. *Theories of Education in Early America 1655-1819.* Indianapolis and New York: Bobbs-Merrill Co., 1973.

South Street Seaport Museum. *Billheads & Broadsides: Job Printing in the 19th-Century Seaport.* New York City: The South Street Seaport Museum, 1985. (An exhibition). Essays by Stephen O. Saxe, Irene Tichenor, Wendy Shadwell, Elliot Willensky, and Ginna Johnson Scarry, with a checklist by Kate Gordon. Preface by Edmund A. Stanley, Jr., Trustee.

Staff, Frank. *The Valentine & Its Origins.* New York: Frederick A. Praeger Inc., 1969.

Stainback, William C., Susan B. Stainback, James S. Payne, Ruth A. Payne. *Establishing a Token Economy in the Classroom.* Columbus, Ohio: Charles E. Merrill Co., 1973.

Stauffer, David McNeely. *American Engravers upon Copper and Steel,* Part I: Biographical Sketches Illustrated. Reprint ed. New York: Burt Franklin. (Originally published, New York: Grolier Club, 1907.)

Stauffer, David McNeely. *American Engravers Upon Copper and Steel,* Part II: Checklist of the Works of the Earlier Engravers. Reprint ed, New York: Burt Franklin. (Originally published, New York: Grolier Club, 1907.)

Stephens, J. E. *Aubrey on Education*. London: Routledge & Kegan Paul, 1972.

Stevenson, Harold. "How Children Learn — The Quest for a Theory," in William Kessen, ed., *Handbook of Child Psychology*, 4th ed , Vol. I.

Stoudt, John Joseph. *Pennsylvania Folk-Art: An Interpretation*. Allentown, Pennsylvania: Schlechter's, 1948.

Stuart, Jesse. *To Teach, To Love*. New York and Cleveland: The World Publishing Co., 1970. [Previously copyrighted 1936, 1938, 1960 by Jesse Stuart.]

The Sunday School Hymn Book. American Sunday School Union. Philadelphia: 1826.

Sutermeister, Edwin. *The Story of Papermaking*. Boston: S. D. Warren Co., 1954.

Swett, John. *Methods of Teaching: A Handbook of Principles, Directions. and Working Models for Non-School Teachers*. New York: American Book Co., 1880.

Swett, John. *American Public Schools: History and Pedagogics*. New York: American Book Co., 1900.

T

Talbott, James, *The Christian Schoolmaster* [Originally published in 1707]. English Linguistics 1500-1800: A Collection of Facsimile Reprints, R. C. Alston, ed. (Menston, England: Scolar Press, 1968).

Tanselle, G. Thomas. *Guide to the Study of United States Imprints*. 2 vols. Cambridge, Massachusetts: Belknap Press of Harvard University Press, 1971.

Taylor, Ann and Jane. *Hymns for Infant Minds*. ed., Josiah Gilbert. London: Hodder & Stoughton, 1826.

Tebbel, John. *History of Book Publishing in the United States*. 2 vols. New York: R. R. Bowker, 1972.

Thomas, Isaiah. *The History of Printing in America*. Marcus A. McCorison, ed. New York: Weathervane Books, 1970. [First edition, 1810.]

Thompson, Lawrance. *Alexander Anderson: His Tribute to the Wood-Engraving of Thomas Bewick*. Princeton: Princeton University Press, 1940.

Thompson, Lawrance. "The Printing and Publishing Activities of the American Tract Society from 1825 to 1850." *The Papers of the Bibliographical Society of America* 35, 2 (April-June 1941).

Thorndike, E. L. *Educational Psychology*. vol. I. New York: Teachers College, Columbia University, 1913.

Thurston, Eve. "Ethiopia Unshackled: A Brief History of the Education of Negro Children in New York City," *Bulletin of the New York Public Library* 69: 4 (April 1965).

Tomas, Jan. "A Time When Good Behavior Meant a Teacher's Merit Reward." *Hartford Courant*, 10 January 1982.

V

Valcoogh, Dirk Adriaanszoon. *Valcooch's Regel der Duytsche Schoolmeesters*. ed., Pieter Antonie De Planque. Groningen: P. Noordhoff, 1926.

Vanderpoel, Emily Noyes. *Chronicles of a Pioneer School from 1792 to 1833*. Cambridge, MA: The University Press, 1903.

Vanderpoel, Emily Noyes. *More Chronicles of a Pioneer School from 1792 to 1833*. New York: The Cadmus Book Shop, 1927.

Vickery, Dorothy Scovil. *Hollins College 1842 to 1942: An Historical Sketch Being an Account of the Principal Developments in the One Hundred Year History of Hollins College*. Hollins College, Virginia: Hollins College, 1942.

W

Wainwright, Nicholas B. *Philadelphia in the Romantic Age of Lithography*. Reprint ed. Philadelphia: The Historical Society of Pennsylvania, 1970. (Originally published, 1958).

Walker, Obadiah. *Of Education*. [Originally published in 1693]. English Linguistics 1500-1800: A Collection of Facsimile Reprints, no. 229, R. C. Alston, ed. (Menston, England: Scolar Press, 1968).

Watson, John B. *Psychology from the Standpoint of a Behaviorist*. Philadelphia: J. B. Lippincott Co., 1919.

Watson, John B., *Psychological Care of Infant and Child*. New York: W. W. Norton & Co., Inc. 1928.

Watts, Isaac, D.D. *Divine Songs Attempted in Easy Language for the Use of Children*. London: J. Buckland, J. F. and C. Rivington, T. Longman, W. Fenner, T. Field, and C. Dilly, 1781.

Webb, Ruth Lee. *A History of Valentines*. Wellesley Hills, Massachusetts: Lee Publications, 1952.

Weil, Elma Allee. "Tokens." *The Antiquarian*. (January 1926).

Weiser, Frederick and Howell J. Heaney. *The Pennsylvania German Fraktur of The Free Library of Philadelphia: An Illustrated Catalogue*. Vol. 1 & 2. Philadelphia, Pennsylvania: The Pennsylvania German Society—Breinigsville and The Free Library of Philadelphia, 1976.

Weiss, Harry B. "Early American Rewards of Merit." Worcester: American Antiquarian Society.

Wesley, Revs. John and Charles. *Poetical Works of John and Charles Wesley collected and arranged by G. Osborne, DD*. London: 1871.

Whalley, Joyce Irene. *The Student's Guide to Western Calligraphy: An Illustrated Survey*. Boulder, Colorado: Shambhala Publications, Inc., 1984.

Wheeler, Robert L. "A Chance Find at the R.I.S.D. Museum Recalls When Good Little Boys and Girls in Providence won something called Rewards of Merit." *Providence Sunday Journal*. 11 May 1952 .

Wilson, James Grand and John Fiske, eds. *Appleton's Cyclopaedia of American Biography*. 7 vols. New York: D. Appleton Company, 1887.

Winton, Nelson W. "*Diary*". Havana, Chemung County, New York, 1847. Malpa collection.

Withington, Leonard. "On Emulation in Schools", Lecture IV, *The Introductory Discourse and the Lectures delivered before the American Institute of Instruction*. Boston: Carter, Hendee and Co., 1834.

Wroth, Lawrence C. *Abel Buell of Connecticut*. CT: Acorn Club, 1926.

Wroth, Lawrence C. and Marion W. Adams. *American Woodcuts and Engravings. 1670-1800*. Providence: Associates of The John Carter Brown Library, 1946.

Wroth, Lawrence C. *The Colonial Printer*. The Grolier Club of the City of New York, 1931; reprint ed., Charlottesville: Dominion Books, a division of The University Press of Virginia, 1964.

Wroth, Lawrence C. "North America (English Speaking)", in Robert Alexander Peddie, *Printing: A Short History of the Art*. London: Grafton Co., 1927.

Y

Young William. *A Dictionary of American Artists, Sculptors and Engravers*. Cambridge, Massachusetts: William Young, 1968.

Youth's Companion. (No. 28, 23 November 1938), s.v. "The Lost Reward."

Z

Zinkham, Helena. "The Pictorial Lettersheets of Charles Magnus: City Views on Stationery." Slide Lecture presented at the 18th North American Print Conference, New York City, 1986.

Zubin, Joseph. *Some Effects of Incentives: A Study of Individual Differences in Rivalry*. New York: Bureau of Publications, Teachers College, Columbia University, 1932.

Rewards of Merit was designed and produced by Jack Golden, one of the founders in 1946 of Designers 3, Inc., New York City, and was assisted by Diana Oliver Turner. Color and black and white photography by Don Manza, Wainscott, N.Y. The text was set in the digital version of Modern No. 216, a revival of the classic metal example of Modern No. 20. It was designed by Ed Benguiat in 1982 for the International Typeface Corporation, New York. Modern No. 20 appears in the 1924 and other type specimens of the Stephenson, Blake & Co., Ltd type foundry, established in England in 1830. The book was typeset by Miller & Debel Prepress, New York City, with input on a Macintosh front end, and output on an Agfa Imagesetter 9800. It was produced on 128 lb. Matt Art paper by photo-offset lithography in Hong Kong by World Print Ltd.

REWARD OF MERIT.

This Certifies, *that*
by diligence and good behaviour, merits the approbation of
Friends and Instructor.

REWARD OF MERIT.

This Certifies, *that*
by diligence and good behaviour, merits the approbation of
Friends and Instructor.

REWARD OF MERIT.

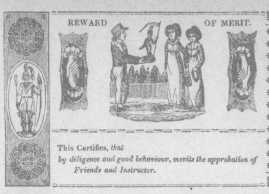

This Certifies, *that*
by diligence and good behaviour, merits the approbation of
Friends and Instructor.

REWARD OF MERIT.

This Certifies, *that*
by diligence and good behaviour, merits the approbation of
Friends and Instructor.

REWARD OF MERIT.

This Certifies, *that*
by diligence and good behaviour, merits the approbation of
Friends and Instructor.

REWARD OF MERIT.

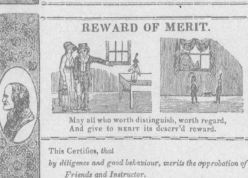

May all who worth distinguish, worth regard,
And give to MERIT its deserv'd reward.

This Certifies, *that*
by diligence and good behaviour, merits the approbation of
Friends and Instructor.

REWARD OF MERIT.

This Certifies, *that*
by diligence and good behaviour, merits the approbation of
Friends and Instructor.

REWARD OF MERIT.

This Certifies, *that*
by diligence and good behaviour, merits the approbation of
Friends and Instructor.

REWARD OF MERIT.

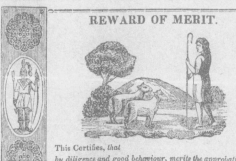

This Certifies, *that*
by diligence and good behaviour, merits the approbation of
Friends and Instructor.

This Certifies, *that*
by diligence and good behaviour, merits the approbation of
Friends and Instructor.

REWARD **OF MERIT.**

T' encourage progress, enterprize applaud,
And give to talents their deserv'd reward.

This Certifies, *that*
by diligence and good behaviour, merits the approbation of
Friends and Instructor.

REWARD OF MERIT.

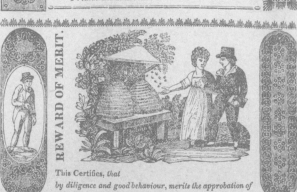

This Certifies, *that*
by diligence and good behaviour, merits the approbation of
Friends and Instructor.